SUCCESSFUL
WATERCOLOUR
PAINTING

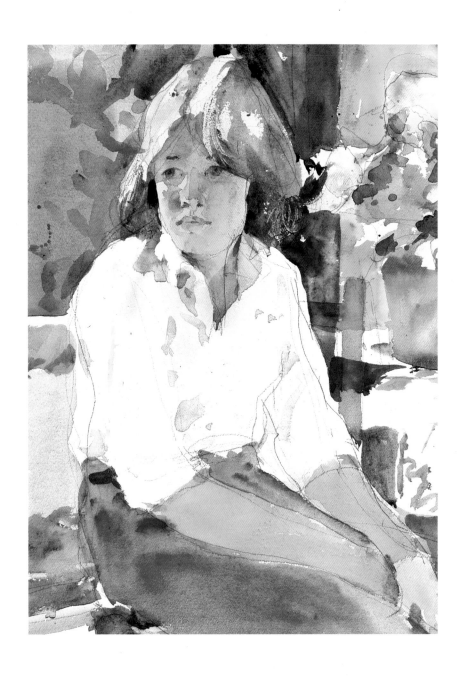

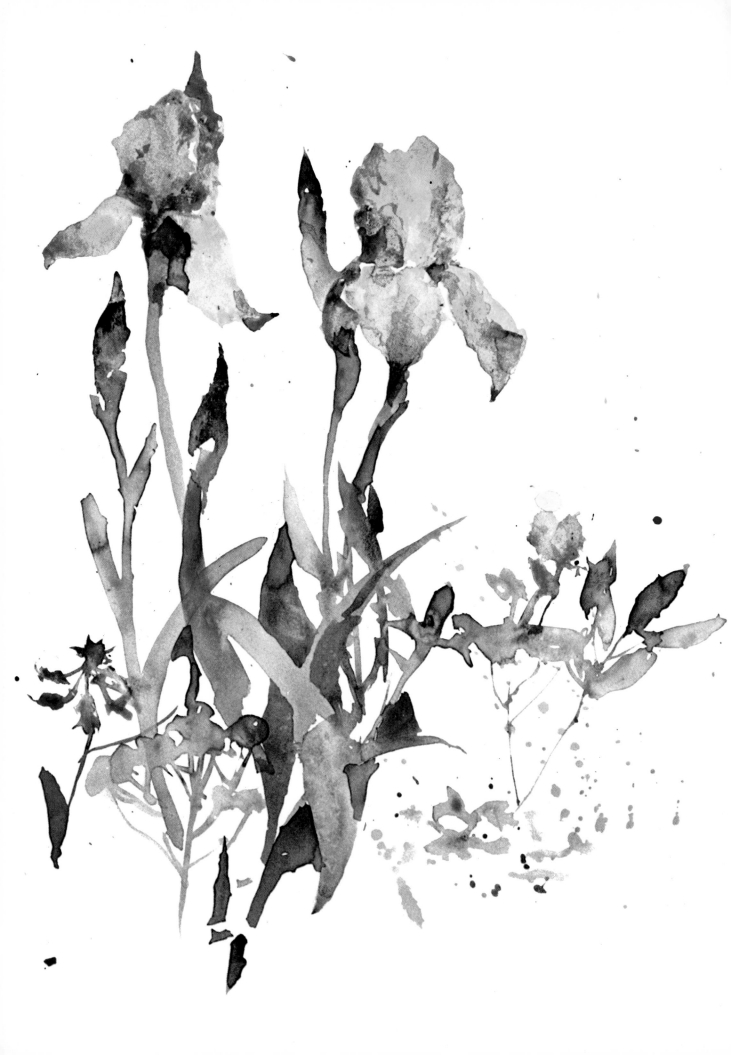

SUCCESSFUL
WATERCOLOUR
PAINTING

Introduced by Rowland Hilder OBE

COLLINS

CONTENTS

BASIC TECHNIQUES
10 Basic watercolour equipment
12 Laying a smooth wash
16 Mixing watercolours
19 Brushstrokes in watercolour
28 Warm and cool colours
32 Mixing greys and neutrals
38 Mixing greens
44 Understanding your pigments
48 Glazes and graded washes

TONE AND COLOUR
54 Tone: the interplay of light and dark
60 Mixing darks
64 Modelling form with colour
70 Using a limited palette
76 Extending your palette
78 Painting with pure colour
80 Creating impact with colour
84 Planning white areas

SPECIAL TECHNIQUES
92 Drybrush painting
96 Scratching and knifing out
102 Using broken colour
108 The spattering technique
114 Sponging with watercolour
118 Lifting out

122 Using opaque white
128 Using masking fluid
130 Vignetting
134 Weathered textures

PAINTING OUTDOORS
140 Planning an outdoor painting
146 Using artistic licence
150 Rescuing a failure
152 Composing a landscape picture
158 Winter landscapes
164 Snow, ice and frost effects
168 Aerial perspective
172 Painting waterscapes
176 Painting the sea
182 Painting skyscapes
188 Painting clouds
192 Painting sunsets
194 Painting fog and mist

PAINTING THE FIGURE
200 Painting the nude
206 Relating figure to background
212 Painting portraits
218 Painting young people

222 Glossary
223 Index

Editor: Angela Gair
Art Editor: Kathryn Alexis
Book Editor: Judith Casey
Art Director: Carol Collins

Published in 1986 by
William Collins Sons & Co Ltd
London · Glasgow · Sydney
Auckland · Toronto · Johannesburg

Designed and produced for
William Collins Sons & Co Ltd
by Eaglemoss Publications Limited

Most of this material first published in
Draw It! Paint It!
© 1986 by Eaglemoss Publications Limited
© Watson Guptill Publications Inc, a division of
Billboard Publications, Inc.

ISBN 0-00-412129-5

Typesetting by Crawley Composition Ltd
Printed in Spain by Cayfosa, Barcelona

Half title page: 'Sarah at High Hampton' by
Charles Reid
Title page: 'Yellow Iris' by Charles Ried
Contents: 'Still Life' by Richard Bolton
Foreword: 'Snow in the Morning Sun' by
Rowland Hilder

FOREWORD

"I'd love to be able to paint, but my drawing wasn't good enough at school." How often have I heard that said? Or again, "I love looking at paintings – but I am afraid that I haven't any talent for painting."

For myself, I now find that the painting of watercolours has become so absorbing and rewarding that I try to encourage those who express an interest to make a real effort to start painting. The result has been quite astonishing and I am encouraged that so many diffident beginners have found that they have unexpected ability.

I remember meeting a talented watercolourist who told me that he had no idea of painting until he was laid up with TB and had to spend a long time in convalescence. He became utterly bored and was encouraged to experiment with watercolour to help pass the time. He became addicted.

"It's the best thing that has happened to me," he said. "Painting has changed my whole life. I can now look up and see the beauty of the sky and am thrilled by contemplating the effect of evening sunlight as it graces the tops of tall trees and buildings. I have come to appreciate that we are living in a beautiful, visual world."

How can one begin to paint? *Successful Watercolour Painting* outlines a variety of styles and techniques that will be an inspiration and a guide for the beginner and provide further instruction and know-how to the initiated.

Art is a personal, subjective vehicle of expression and communication. Whether it is good or bad is very much a matter of personal opinion. So the best way to learn is to follow that which excites and interests you. Have I advice to offer? Yes, don't be afraid of learning by copying a painting you like. Goya, Turner, Cotman, Cézanne and Sargent are just a few who developed their art by copying. You will find some superb examples of watercolour painting for this purpose in this book.

For me, watercolour is a perfect medium for catching the subtle and ever-changing quality of light. It is a responsive, sensitive medium which excels in expressing the moods of nature and the inspiration of the moment.

Rowland Hilder

'Snow in the Morning Sun', Rowland Hilder, 15″×22″ (38cm×56cm).

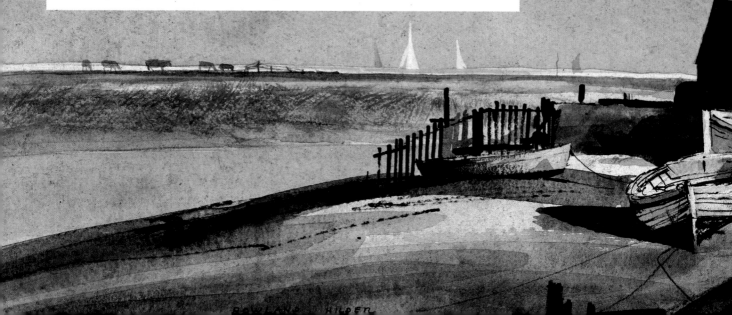

1

BASIC TECHNIQUES

Watercolour has a special delicacy and transparency lacking in most other mediums. Being less predictable than any other medium, it is the hardest to correct once the paint is on the paper, adding to the excitement of watercolour. Therefore the 'first go' must often be the last – giving unique freshness and immediacy.

Watercolour is transparent because it uses pure water into which a small amount of colour has been dissolved. When the water evaporates the white or cream-coloured paper shines through the colour like sunlight through stained glass. A good watercolour seems to have its own luminous inner light.

Master the basic techniques in this chapter – laying even and graded washes, mixing watercolours and understanding the power of pigments – and you are well on the way to achieving success.

'Cley Mill, Norfolk', Rowland Hilder, 22"×30"
(56cm×75cm). The interplay of bold wash on textured paper
helps to form this dramatic sky.

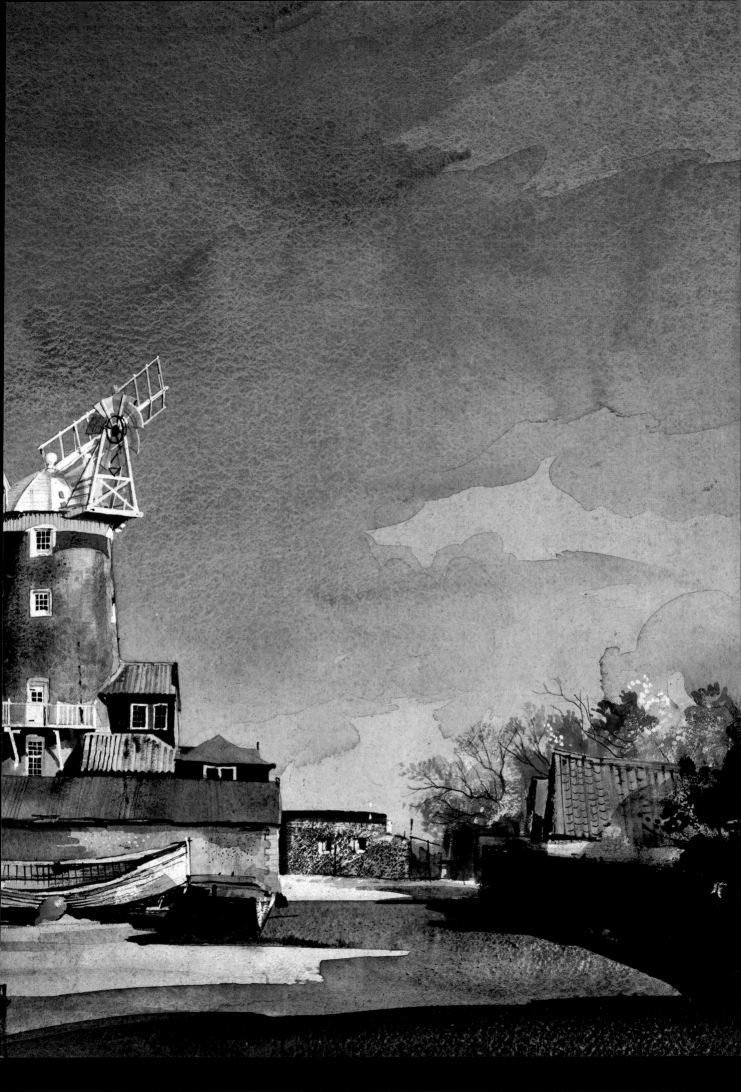

Basic watercolour equipment

Below From the left: no. 6 round sable blend, no. 3 round sable, no. 5 Chinese bamboo, no. 12 round sable blend, ½" (15mm) flat sable blend and ¼" (6mm) flat sable blend.

Here is a selection of the basic equipment needed for watercolour painting. It is probably better not to be tempted into buying a ready-filled watercolour box, but to start with a few colours. Try tubes and pans, and build up your selection gradually, as you decide which you prefer.

Paints

These are made from powdered pigment and gum arabic, and are thinned with water. They come in a wide range of colours.

Pans are less expensive than tubes. There are two sizes: whole and half pan. Pans are good for mixing small amounts of colour and for outdoor sketching, but they tend to dry out, so keep a damp cloth over the pans in your watercolour box when not in use.

Tube colour is richer than pan colour. Its consistency is easier on brushes than that of pans, as people often use a scrubbing motion to pick up colour from a pan.

Artists' quality watercolours are the best, but the less expensive students' quality watercolours often produce equally satisfying results. In students' quality paints some of the more expensive pigments are re-placed by cheaper alternatives. Different manufacturers produce slightly different ranges of colours, with a wider range in their artists' than their students' colours.

A range of brushes

These are especially important in watercolour, so don't stint on them – quality counts far more than quantity, and good brushes last for many years. Three or four brushes are enough to start with; make sure your initial selection includes large and small brushes, and flat and round ones.

The best quality brushes are red sable, but you can also buy sable blends, squirrel or ox hair. Sable blends have much of the quality of sable, but are less expensive. Ox hair is coarser and does not form as good a point as sable, but is considerably less expensive. Squirrel hair brushes are very soft and difficult to control, so are best avoided. Synthetic (nylon) brushes are inexpensive but quickly lose their point.

Flat brushes are used for laying washes over large areas. Round brushes can be used for detailed work or washes, depending on their size.

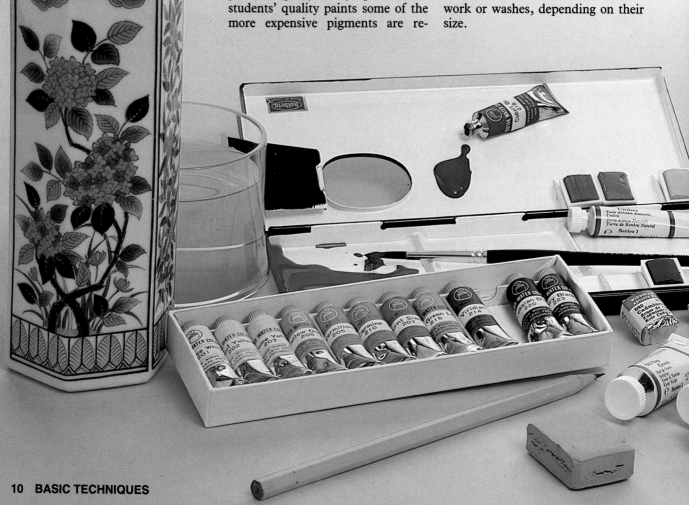

Palettes

Some sort of white, waterproof surface is needed for mixing colours. If you are using pans, the box you keep them in doubles as a palette, as the lid has wells for mixing colour. For tube colour, you can buy white palettes with wells to hold the colour and a flat surface for mixing, or you can use tinting saucers. Or try improvising with a couple of old white dinner plates; these will give you plenty of room for mixing.

Other equipment

You will need two pots or jam jars for water; one for washing brushes and the other kept cleaner for painting. Remember to change the water often. A natural or cosmetic sponge is useful for picking up excess water and lifting out colour, should you wish to make a change or correction. A cotton rag is useful for mopping up water and for cleaning brushes.

You will need soft pencils for drawing. Pencils range from 9H (the hardest) to 6B (the softest); for watercolours, 2B is generally best. A putty eraser (kneaded rubber), can be moulded to a fine point to erase pencil lines. It is very soft and will not spoil the surface of the paper.

Left A useful choice of brushes, various-sized pans and tubes of colour, a sponge in a divided tinting saucer (used for mixing colours), soft pencils and a putty eraser. The lid of the metal case forms a palette, complete with a thumb hole and plenty of room for mixing colours. The brush lying on the palette is a no. 5 round nylon.

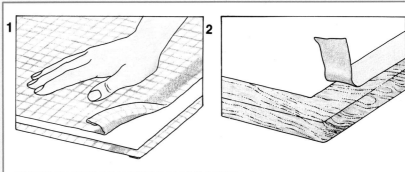

STRETCHING LIGHTWEIGHT PAPER

For watercolour painting, papers up to 140lb (285gms) need stretching so they don't cockle when paint is applied. The paper is soaked in water, expands, and is then fastened down securely so that it dries taut. Once stretched, it will not cockle when painted on.

Have ready clean paper, a roll of 2″ (5cm) wide gummed brown paper, scissors, a drawing board, two clean tea towels and a sink.

Cut lengths of gummed paper 2″ (5cm) longer than the edges of the watercolour paper. Immerse the paper in a sink filled with cold water.

1 Remove the paper after a few seconds and gently shake off surplus water. Lay it between the tea towels and smooth it over to absorb some of the moisture.

2 Place the paper on the drawing board, making sure that it is perfectly flat. Stick the gummed paper strips along each edge of the paper so that two-thirds of their width is attached to the board and one-third is stuck to the paper. This ensures that the paper will not pull away from the board as it dries. Allow the paper to dry away from direct heat for several hours. Do not use until fully dry.

Paper

A wide variety of watercolour paper is available, both in single sheets and, more economically, in pads and blocks. Paper varies in surface texture, in weight (the thickness of the sheets) and in size. You can start painting without special watercolour paper, using any paper that is not too thin or shiny, but it is harder to achieve a reasonable result, so don't linger too long on this or you will get discouraged. Whatever paper you use, white or off-white is best, otherwise it loses its reflecting power and the translucent quality of the paint is not apparent.

The surface texture of the paper is known as its 'tooth'. There are three kinds of surface:
Rough, with a pronounced tooth
NOT (meaning not pressed), with a medium tooth
Hot Pressed, very smooth, with almost no tooth.
The NOT surface is the one most generally used by artists and is the best for beginners. Paper tends to cockle (buckle) when wet, and the thinner the paper, the more it cockles. Paper is prevented from cockling by first stretching it.

PRE-STRETCHED PAPER

To save time, you can buy pre-stretched paper, available as watercolour drawing blocks. The sheets of paper are gummed around the edges, and can be separated using a palette knife or other fairly sharp implement when you have finished painting.

STRETCHING PAPER

Make sure the drawing board is kept flat while the paper is drying on it; if it is at an angle, the water on the paper drains to one side so that the paper dries unevenly and pulls off the drawing board.

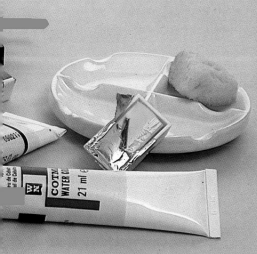

Laying a smooth wash

EXPERIMENTS WITH WASHES

☐ Lay a wash on damp paper. Take a flat 1½"-2" (4-5cm) household paint brush and dampen your paper evenly all over. A brush is better than a sponge for dampening paper as it is less likely to damage the paper surface, although a sponge is less likely to streak. You can also use the household paint brush for laying large areas of wash.

☐ Then try laying a wash on dry paper, and note the difference. You will find that the dampened paper enables your paint to flow more easily.

☆ CREATING A CRISP EDGE

To make a white 'frame' of paper around your wash, stick masking tape around the area to be painted, rubbing it down firmly so no paint can trickle under. When you lay your wash, take the brushstrokes over the edge of the masking tape.

Once you have finished painting and the wash is totally dry, carefully remove the tape to reveal clean, straight edges.

Soft papers, such as Bockingford, are not suitable as the tape lifts off the surface of the paper. Use a sized paper, such as Arches.

A wash is a useful watercolour technique for covering a large shape or background.

To practise laying a wash, use a large sable blend or ox hair brush. Either stretch a sheet of paper or use a watercolour block, about 10"×7" (25cm×17.5cm) with NOT surface. Whether you use an easel or support your painting surface on a table, make sure that it is tilted about 30° to help the paint flow gradually down the paper.

Prepare a wash by mixing a little colour with plenty of water. Allow for the wash drying twice as light as you anticipated! Prepare enough to cover the area completely, and mix it thoroughly. It is better to overestimate than underestimate the amount of wash you need.

The picture below shows the paper framed with masking tape to create a crisp edge. If you don't want to mask your paper, simply carry the wash over the edge of the paper.

1 Load your brush with wash With a long, even stroke lay a band of colour horizontally across the top of your paper, as shown. As you paint, a stream will form along the bottom of the band.

2 Pick up the stream After adding more wash to your brush, keep repeating the same horizontal stroke from left to right, picking up this stream to paint the next band. Don't paint above the stream.

3 Keep the flow going You want the paint to flow naturally down the paper, so don't apply much pressure to the brush. Once you begin to paint, never go back and retouch the wash or stop before you've completely finished applying the wash over the entire area you want to cover. Work quickly so that the stream does not have time to dry up.

4 Finish the wash When you reach the bottom of the area, squeeze the excess paint out of the brush with your fingers and stroke the bottom band again lightly to pick up the excess colour.

Don't worry if that last stroke seems lighter than the others; eventually the paint seeps down and evens out the tone. Let the wash dry in the same tilted position (at an angle of 30°), otherwise the paint will flow back and dry unevenly, leaving furry-looking paint edges where the wetter paint has run into the dry. This kind of wash is also called a flat wash because it is all the same tone.

1

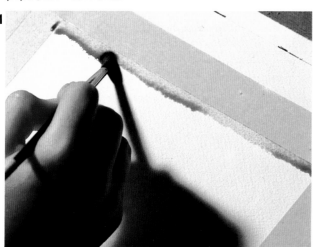

2

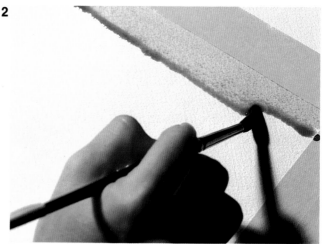

3

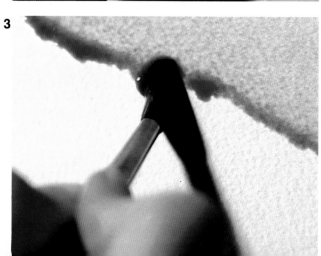

4

Soft and hard edges

Whenever wet paint meets dry paper, pigment collects and creates a darker, hard edge to the brush-strokes. This method of painting is called wet on dry.

However, you may sometimes want to soften these hard edges. The pictures below show how you can control the degree of sharpness on the edges of objects you are painting.

1 Fill a shape with colour, using a no. 6 or no. 7 round brush.

2 Thoroughly wet your brush with pure water and use it to soften part of the edge of the shape, leaving the remaining edge to dry naturally.

3 Squeeze the brush dry with your fingers, then use it to lift excess water carefully from the softened edge.

4 Grade out the paint as smoothly as you can, changing and softening this edge. You will find this particularly useful for painting draped material in figure painting or still lifes.

LOADING YOUR BRUSH

To add water to colour, load your brush with water, pick up a little colour from your palette with the tip of your brush, then stir the brush around on your palette to mix the colour and water. You can use an eyedropper to add the quantity of water you need to make a wash.

When you want to add another colour, pick it up with the tip of your brush rinsed clean, and stir it thoroughly into the mixture.

BEWARE OF FLOODING

When you soften edges your brush should not be too loaded with water otherwise the water will flood back into the shape and cause an uneven gradation of colour, bleached areas or 'tidemarks'.

1

2

2

3

3

4

4

Laying wet-in-wet

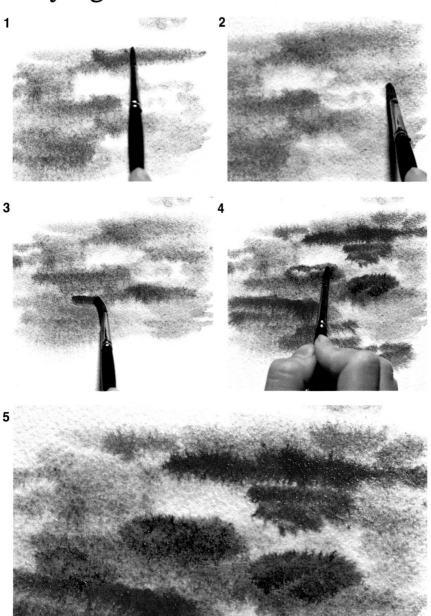

One of the classic watercolour techniques is called wet-in-wet, which means painting on wet paper or into a colour that is not yet dry. Depending on how wet you make your paper before painting on it, you can create effects ranging from soft-edged definite shapes to random, widely spread patterns. With practice, you will learn to anticipate these various results and use them purposefully.

First, take a small sheet of paper which you have already stretched, or use a watercolour block, and dampen it all over using a large brush. Now work quickly!

1 Using a no. 6 or 7 round brush, paint a colour on the damp paper to see how the colour reacts to the surface. Leave a few white spaces as you apply the colour.
2 Now paint a different colour in the white spaces.
3 Next build up some more intense patches of the first colour.
4 Then experiment with a third colour, painting several patches of it into the colours that are still damp.
5 Look closely at your painting to see how different colours behave. You'll find that with some colours particles of pigment collect on the paper's surface and give a more textured appearance to the painting. You can experiment with different colours and paper surfaces to discover this for yourself.

Painting skies

'Summer Day', the larger painting on the page opposite, uses the basic watercolour techniques of laying a wash and wet-in-wet. To paint a similar picture, start by covering your paper with a wash of ultramarine for the sky, using a large sable blend or oxhair brush. Next, paint in the ground, using raw sienna as the basis with a touch of ultramarine to make the shadows. Then use a no. 6 or 7 round brush and mix raw sienna with a larger quantity of ultramarine to create the green of the distant trees while the paper is still damp.

To give variety to the sky, try using other blues such as cerulean to wash over parts of the ultramarine. If you do this, mix a little of the same blue in the shadows of your ground. This kind of repetition helps to harmonize sky and ground.

WET-IN-WET EXPERIMENTS
These experiments will help you recreate all kinds of atmospheric effects, like banks of cloud and interesting skies. They also give you confidence to use your paint boldly in a semi-abstract way.
☐ Paint various colours on damp paper. As the paper dries, lift sections of paint off with a sponge, blotting paper or a sheet of soft toilet paper. Try painting more colour on these drier areas.

☐ Try painting some bright colour patches on to damp paper to get an idea of how strong colour and water behave together. Tilt your painting surface 90° so the paint runs.
☐ Paint on a single colour then remove some pigment by rewetting a patch with water and lifting out the colour with a squeezed out, clean brush. Compare this lighter patch with the ones you got by using a sponge or absorbent paper.

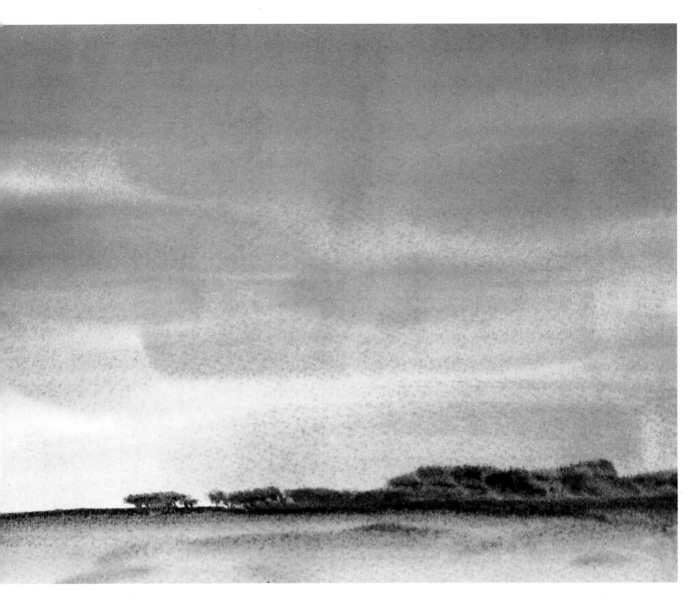

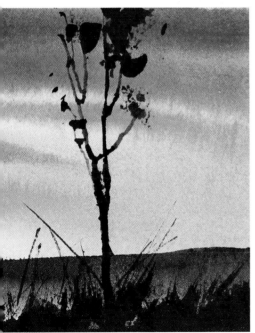

'Summer Day' (above) and 'Sunset Sky' (left) – show that the wet-in-wet technique can be used in quite different ways.

'Sunset Sky' (left) employs the techniques of wet-in-wet and soft and hard edges. Experiment with bands of colour, painting wet-in-wet, to get a similar sunset effect.

Let the background dry then, using drier pigment on your brush, paint the tree and ground. Finally, brush in wisps of grass using your brush just damp with colour so that it produces an uneven stroke (a technique called drybrush).

Most watercolours are translucent. If you want a really dark, opaque green like the one used here for the tree and ground, use oxide of chromium.

EQUIPMENT USED

For 'Summer Day' – ultramarine, raw sienna, cerulean or cobalt blue.
For 'Sunset Sky' – as above, plus alizarin crimson, lemon yellow and a dark green.
No. 12 and no. 6 or 7 sable brushes.
Watercolour paper about 10″×7″ (25cm×17.5cm).

LOOKING AFTER BRUSHES
Wash out brushes thoroughly in water when you finish painting. Shape them with your fingers so that they dry to a point, then put them head-upwards in a jar to dry.

Mixing watercolours

No matter how experienced you are, you will find this method of mixing watercolours useful. It shows you how colours work together and the mixtures take the shape of coloured 'chickens' – much more interesting than simple blobs.

Take any two medium-sized brushes, one in each hand. Wet both brushes and dip each into a different colour. Using dry watercolour paper and working from the head and tail of the 'chicken' to the centre, let the colours meet wet-in-wet on the 'body' and create new colours.

Start with a limited palette using a cool and warm version of each of the primary colours – yellow, red and blue. For example, try a cool yellow (such as cadmium lemon) and a warm yellow (cadmium yellow deep); cool red (alizarin crimson) and warm red (cadmium scarlet); cool blue (cerulean blue) and warm blue (ultramarine).

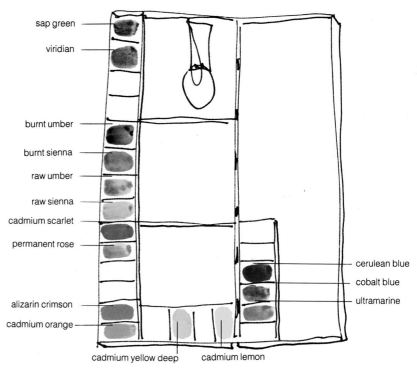

sap green
viridian
burnt umber
burnt sienna
raw umber
raw sienna
cadmium scarlet
permanent rose
alizarin crimson
cadmium orange

cerulean blue
cobalt blue
ultramarine

cadmium yellow deep cadmium lemon

Artist David Lyle Millard uses a chicken motif because it's amusing, and the wide 'belly' section shows how the colours behave when mixed.

PRIMARY MIXES

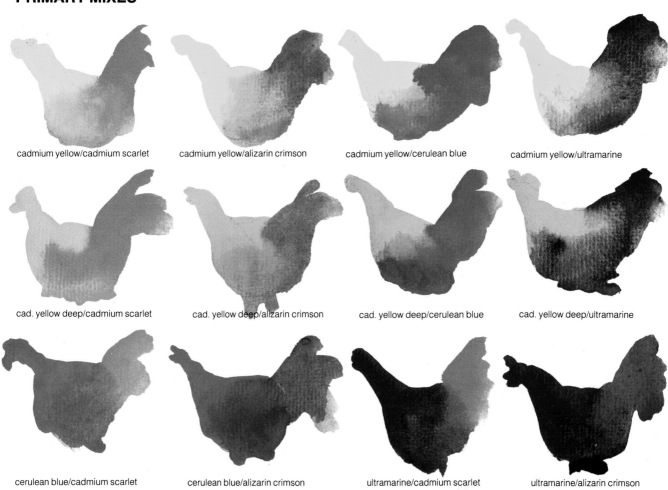

cadmium yellow/cadmium scarlet

cadmium yellow/alizarin crimson

cadmium yellow/cerulean blue

cadmium yellow/ultramarine

cad. yellow deep/cadmium scarlet

cad. yellow deep/alizarin crimson

cad. yellow deep/cerulean blue

cad. yellow deep/ultramarine

cerulean blue/cadmium scarlet

cerulean blue/alizarin crimson

ultramarine/cadmium scarlet

ultramarine/alizarin crimson

By mixing these cool colours first with each other and then with the warm hues, you will get two sets of secondary colours, one warm and one cool, a total of twelve secondary hues. For example, mix warm yellow and warm red for warm orange; then try cool yellow and cool red for cool orange. Continue the process for mixtures of yellow and blue (green), and red and blue (purple).

Then mix warm yellow with cool red, and cool yellow with warm red and so on.

For yet another set of mixtures, neutralize your colours with their complement; mix each red with each green, each blue with each orange and each yellow with each purple.

When you are familiar with all the possibilities of the basic palette of primaries and secondaries, you are ready to add more colours to your palette. Try permanent rose, cobalt blue, cadmium orange, raw sienna, raw umber, burnt sienna, burnt umber, viridian and sap green.

Neutral colours form an important part of your repertoire. Bright colours appear more vivid when surrounded by neutrals. Neutrals also tone down some of your brighter mixtures when added to them.

The set of neutral mixtures shown here – three blues with three earth colours – provide a useful collection of neutrals. As you progress, you may like to build up a colour reference file using a ring binder with sheets of paper. The system can be organized by colours (reds, blues, oranges, etc) or by primaries, neutrals and darks.

Don't stop with the mixtures shown. Keep experimenting. Build up ranges of shades to give you a comprehensive reference of colour combinations.

PLENTY OF CLEAN WATER
You will find it convenient to paint near a sink or basin so that your brushes can be cleaned after each 'chicken'.

DON'T OVERMIX COLOURS
If you mix too many paints together the colours become muddy and the object of the exercise is defeated.

Mix the colours in a large well on your palette or on a large white plate. Colours can also be mixed directly on paper, both wet-in-wet and wet on dry.

KEEP A RECORD
As you paint your 'chickens', write the names of the colours you have used beside each one. This way you can quickly and easily reproduce the effect the two colours combine to make.

NEUTRALS

cerulean blue/raw umber

cerulean blue/burnt sienna

cerulean blue/burnt umber

cobalt blue/raw umber

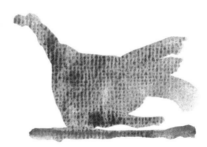

cobalt blue/burnt sienna

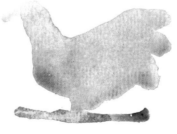

cobalt blue/burnt umber

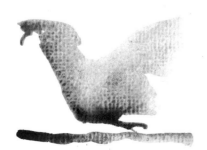

ultramarine/raw umber

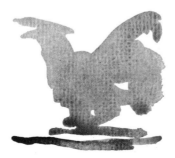

ultramarine/burnt sienna

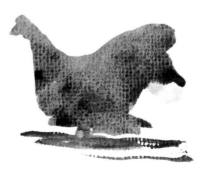

ultramarine/burnt umber

Adding and removing colour

Once you are familiar with the colours available, you can create new colours, darken existing ones, lighten or even remove others.

Laying a second colour

An overlay applied wet on dry creates an interesting effect. One colour on top of another has a different quality from the same two colours mixed on your palette or wet-in-wet on the paper. Once your first wash is dry, lay a second wash of paint over selected areas, giving the colours greater depth and intensity. This is useful for painting the uneven blues of sky and water, or for giving volume to rounded forms.

1 Start the second wash Let your first wash dry completely then mark out a new square about 3″ (7.5cm) lower. Make sure it covers some bare paper as well as part of the original wash, so you can see the pure colour of each wash and the colour they combine to make. Try using two strips of masking tape to give a hard edge at the sides.

2 Continue the wash Use the same technique – smooth, even brushstrokes across the paper – as for your first wash. When painting an overlay, hold your brush lightly and paint quickly or the action of the brush and the weight of the paint may disturb the colour beneath.

3 The final result You can see the pink, blue and, where they overlap, translucent mauve.

Lifting out

Lifting out colour from wet paint allows you to correct mistakes, create highlights and lighten areas. (For more detailed information see p.118.)

4 Using a brush Dampen your paper and paint a strong colour onto it. Before this dries, take a dry brush and remove some of the colour. To lift out from dry paint, wet the area you want to make lighter and lift out the colour in the same way, with a dry brush or sponge (see below).

5 Soft-edged effect The area of paint removed by your brush will have a soft edge.

6 Using a sponge It is easier to lift out large areas with a sponge.

7 For greater control Pinch the sponge between your thumb and forefinger for more control over the area lifted.

GETTING IT RIGHT

Remember to prepare plenty of paint before beginning a wash: it is never possible to re-mix exactly the same colour and if you try, the wash will be uneven in its colouring.

Tubes of paint are often quicker than pans when mixing colour for a wash, as you can easily squeeze large amounts from them, rather than having to scrub away at a pan.

Some colours are easy to lift out, while others have a strong staining power and are difficult to remove or change. Most colours on p.16 stain lightly and lift out reasonably well, but alizarin crimson and sap green are stronger.

Staining strength varies from one make of paint to another and from artists' ranges to students'.

Brushstrokes in watercolour

Brushwork is the essence of watercolour painting. The way in which the paint is applied affects the whole character of a picture, from the broad, bold strokes of a wash to the finer working of detail to finish a picture. Here we show you ways of holding and using brushes to achieve the two important aspects of brushwork – variety and control.

Holding the brush

There are various ways of holding a brush – the illustrations show a few approaches. The best thing is to experiment with these ideas to find the position that is most comfortable and gives you the greatest control of your brushes. Unless you are painting fine details, move your whole arm to create flowing strokes. If you paint from the wrist as though you are writing with a pencil, the strokes will look stiff and cramped.

Brushes are made with different lengths of hair and this affects the kind of strokes that can be made. It is easier to control a brush with shorter hair, but a brush with longer hair produces looser, more flowing strokes.

The pressure you exert with a brush controls the width of a stroke. For fine strokes, the tip of the brush should glide across the paper. To make wider strokes, press down with the brush. For extra control, you can rest your hand on the paper. If you do this, it is a good idea to lay a clean piece of paper under your hand to protect your painting.

A good brush for practising brushstrokes is a medium (no.6) round sable or sable blend. When you feel you've achieved a fair amount of control, you can go on to experiment with other sizes and shapes of brushes. A flat brush or a Chinese bamboo brush are both particularly expressive.

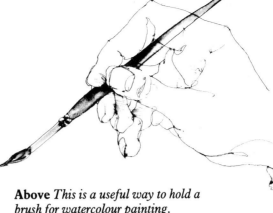

Above *This is a useful way to hold a brush for watercolour painting. Keeping your hand relaxed, hold the brush around the middle of the handle, that is 1"-1½" (2.5cm-4cm) above the ferrule (the metal part).*

Right *Only hold the brush with your fingers on the ferrule when you're working on fine details late on in a painting. This way of holding a brush gives maximum control.*

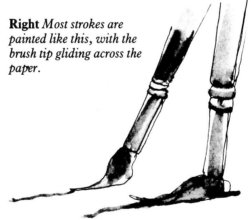

Right *Most strokes are painted like this, with the brush tip gliding across the paper.*

Left *Brushstrokes made like this, with the ferrule pressed close to the paper, are broader. This wears out brushes more quickly.*

Right *For greater control it is sometimes useful to rest your hand on the paper. Use the side of your hand with or without the extra support of your little finger. Lay a clean piece of paper under your hand to protect your painting.*

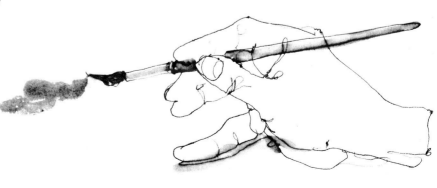

Basic long and short strokes

Try to make different shapes and sizes of strokes: broad, slim, straight, curvy, long and short. For long strokes it takes practice to make sure you load enough paint on your brush to complete the stroke. Vary the pace of your strokes: some long and slow, others short and quick. You can also try varying the density of pigment in a brushstroke, and drop in a little wet-in-wet colour at the end of some strokes.

When you have reasonable control over your brushwork and a variety of strokes at your command, you can start thinking about how you might use the characteristics of these strokes to make pictures – images such as flowers and stems, trees and branches, birds flying, potted palms and so on.

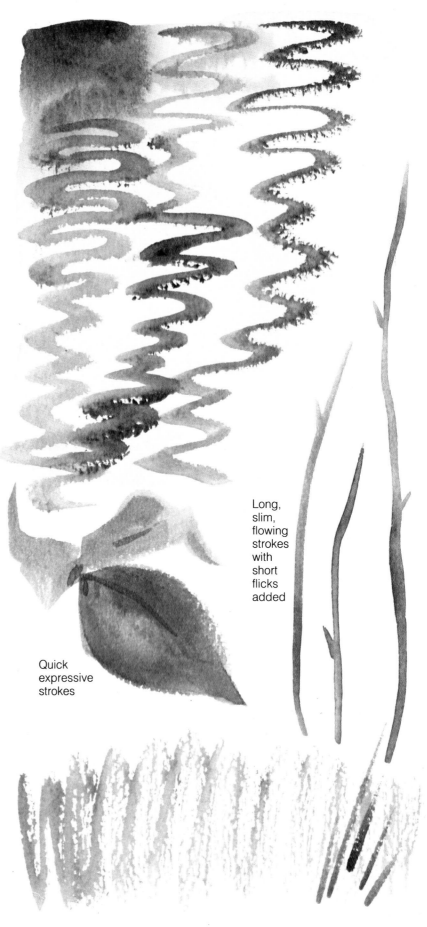

Long, wavy strokes painted on a semi-dry wash. The hard and soft edges of the strokes are a result of the paper being at an angle when the strokes were made

Long, slim, flowing strokes with short flicks added

Quick expressive strokes

DRYBRUSH
This is a useful technique for textured effects. It works best with rough watercolour paper and hog's hair brushes – sables may be too soft for the inexperienced painter. Load your brush with paint, then squeeze out most of the moisture and run the brush quickly over the rough paper surface. The paint will skim across the raised 'tooth' of the paper, creating a stippled effect. (For more detailed information on the drybrush technique, see p.92.)

Single drybrush stroke painted continuously from left to right

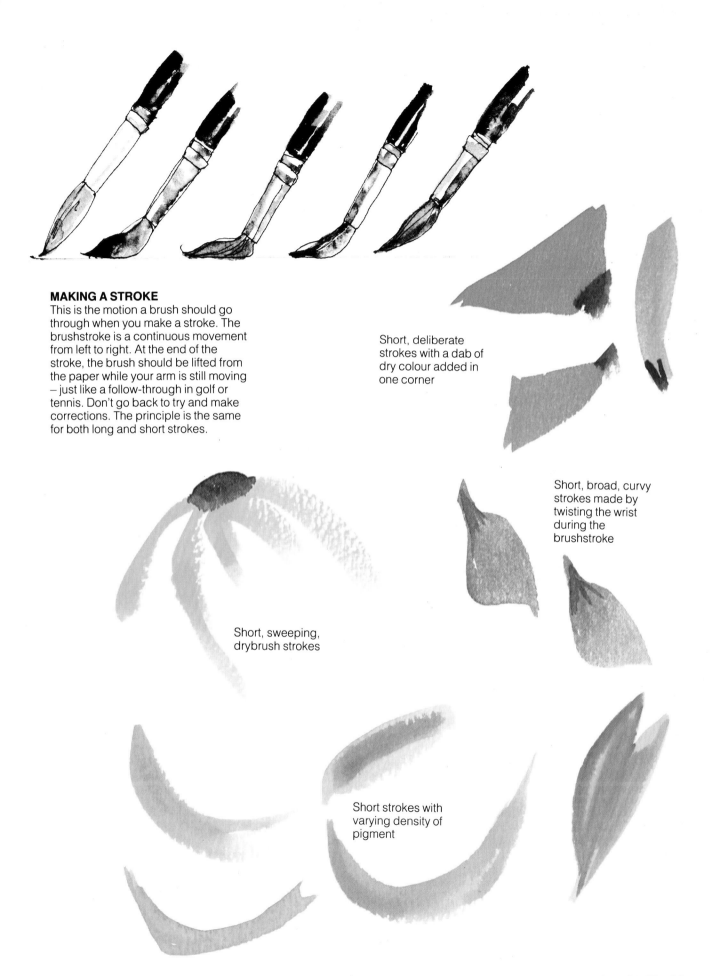

MAKING A STROKE

This is the motion a brush should go through when you make a stroke. The brushstroke is a continuous movement from left to right. At the end of the stroke, the brush should be lifted from the paper while your arm is still moving – just like a follow-through in golf or tennis. Don't go back to try and make corrections. The principle is the same for both long and short strokes.

Short, deliberate strokes with a dab of dry colour added in one corner

Short, broad, curvy strokes made by twisting the wrist during the brushstroke

Short, sweeping, drybrush strokes

Short strokes with varying density of pigment

Brushstrokes for flowers

FLOWER COLOURS

One of the joys of flower painting is that you can dabble with colour to your heart's content. But in most cases you can get perfect colour matches by mixing just a few clear, fresh colours. Here are some suggestions:

Violet Ultramarine and permanent rose is a lovely mixture, and more versatile than a tube violet.

Mauve Cobalt violet and cobalt blue make an attractive mauve, perfect for painting wild flowers.

Pink Rose doré can be used on its own for wild roses. Permanent rose is a pink tinged with blue.

Red Cadmium red (warm) and alizarin (cool) combine well together.

Orange Cadmium red and cadmium yellow give a glowing marigold orange.

Yellow Lemon yellow is light and cool and can be warmed with cadmium yellow.

The infinite variety of colours, shapes and textures found in flowers makes them one of the most attractive and challenging subjects to paint. And watercolour, with its delicate, luminous colour, is the ideal medium for portraying flowers and leaves in all their glory.

A successful flower painting has to be done swiftly and convincingly, with a minimum of surface detail. People sometimes become too finnicky, faithfully recording every detail they see. The result is a tight, stilted painting, devoid of the freshness and delicacy that attracted them to the subject in the first place. Painting is as expressive as language; don't just *copy* what you see – define the essential character of the flower you're painting and deliberately emphasize it.

Getting started

When setting up your arrangement, choose a strong light source that creates interesting patterns of light and shade. Backlighting is very effective as it gives a light, airy feeling to the flowers.

Choose a simple colour scheme to start with; an arrangement of pinks and peaches or blues and violets against a neutral background is far more appealing than a vase full of clashing colours.

Composition is important too. A busy arrangement looks best when given a mere suggestion of background, or surrounded by lots of white paper which sets off the freshness of the flowers. Try painting your subject from above or below, or concentrate on just one detail; your viewpoint is as expressive as what you paint.

Modelling forms

The subtle variations of colour seen in leaves and petals should be simplified as much as possible to retain freshness and transparency. One method is to define the shape of the leaf or petal with a watercolour line and fill it in with water. Then you can model the shape by mixing warm and cool colours wet-in-wet.

Just as light shining through a petal gives it a soft luminosity, so must you let the light reflect off your paper and up through the colours. Try not to use more than two colours in any one mixture, and build up the form with thin glazes rather than thick layers.

Brushstrokes

Painting living forms calls for fluid brushstrokes. To avoid a scratched, dry effect, make sure you have plenty of paint and water on your brush. Hold the brush at least 2″ (5cm) above the ferrule, keep your hand relaxed and let most of the movement come from the elbow and upper arm. At the end of the stroke, lift the brush from the paper while your arm is still moving – just like a follow-through in golf or tennis.

Left *Study of a pink camellia by Charles Reid. Here, all surface detail is stripped away, leaving an impression of the rich glossiness of this lovely flower. Capturing the essential character of your subject is far more important than rendering a faithful copy, and this is achieved by working quickly with loose washes.*

FRUITS, FLOWERS AND LEAVES

Plants and flowers are fascinating because they present such a challenging variety of forms.

Here are some examples of simple but effective techniques for rendering fruits, flowers and leaves. Fill your sketchbook with studies like these, and practise, practise, practise!

Painting petals

Start with a light pencil outline if it gives you more confidence. Convey the interplay of light and shadow on the curled petals by overlaying washes of warm and cool colours wet-on-dry.

Bright berries

To capture the roundness and shine of berries, keep the highlights clean and build up the form from light to dark. Here the rich blue-black of the berries is rendered with washes of neutral hue.

Foliage effects

Here are two examples of leaf shapes created by brush and paint alone, giving a more natural, broken edge. The veins are suggested by leaving a thin line of white paper, edged with dark pigment.

When painting small details, let the heel of your hand rest on the paper or use the little finger for support. The tip of the brush should form a hard line while the body of the brush may vary from thick to thin.

Sue Fowler

Jar of Anemones: demonstration

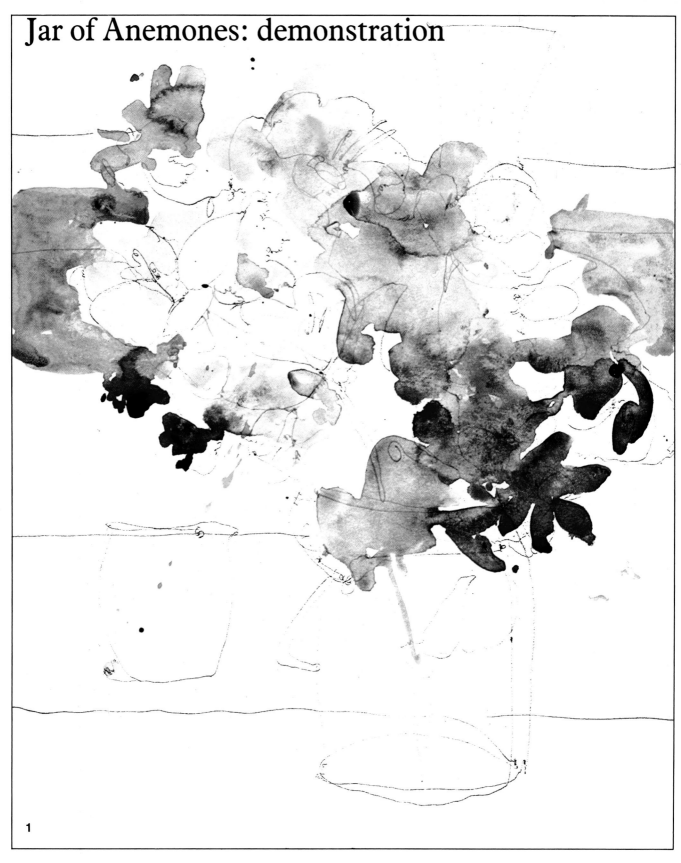

1

Capturing the delicacy of spring flowers requires a spontaneous approach. In this painting of a jar of anemones, artist Charles Reid builds up the flower forms with loose washes to create an overall impression, rather than a slavish copy.

1 Paint the lightest tones
Begin with a loose outline sketch to establish the composition. On your palette mix a light, watery puddle of ultramarine, cerulean blue and alizarin. Load a no.6 brush, give it a good shake and start painting the

lightest purple tones. Don't paint one flower at a time but plunge right in and paint the *masses* of colour – your brush should only leave the paper when it needs refilling. Modulate the colour by adding more pigment here and blot-lifting it off

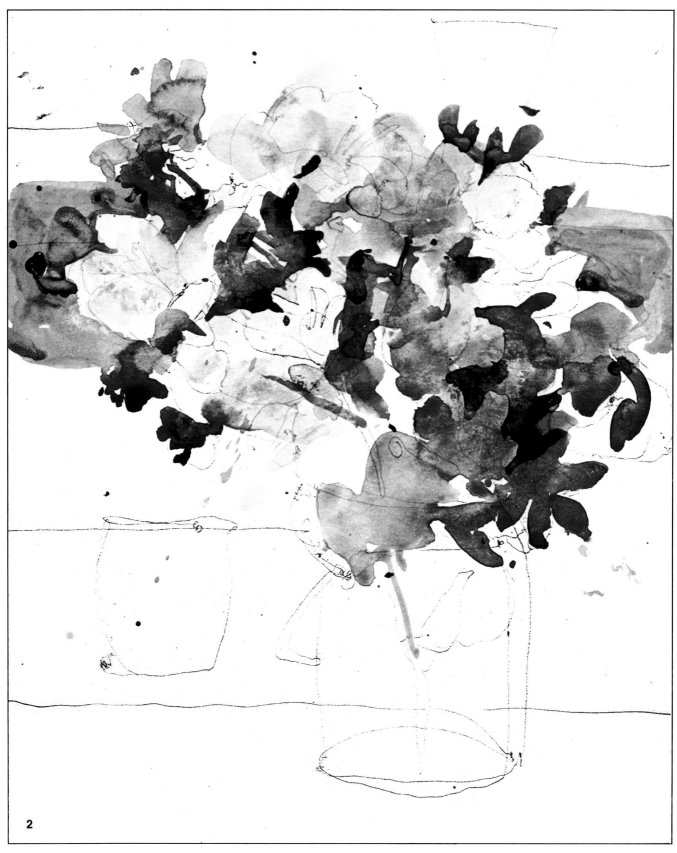

2

there; let your intuition guide you. Leave the painting to dry before going on to the next step.

2 Build up the colour

Using the same colours as in step 1, add more colour and form to the flowers (keep the colour watery but stronger). Create some soft edges by blotting with a tissue; this prevents the picture from looking rigid and tight. Paint the foliage with a varied selection of viridian and cadmium yellow mixtures.

EQUIPMENT USED
☐ A sheet of 140-lb cold-pressed paper 15″×12″ (38cm×30cm).
☐ A round no.6 brush.
☐ A palette of seven colours: cerulean blue, ultramarine, alizarin, cadmium · yellow, cadmium orange, viridian and raw sienna.

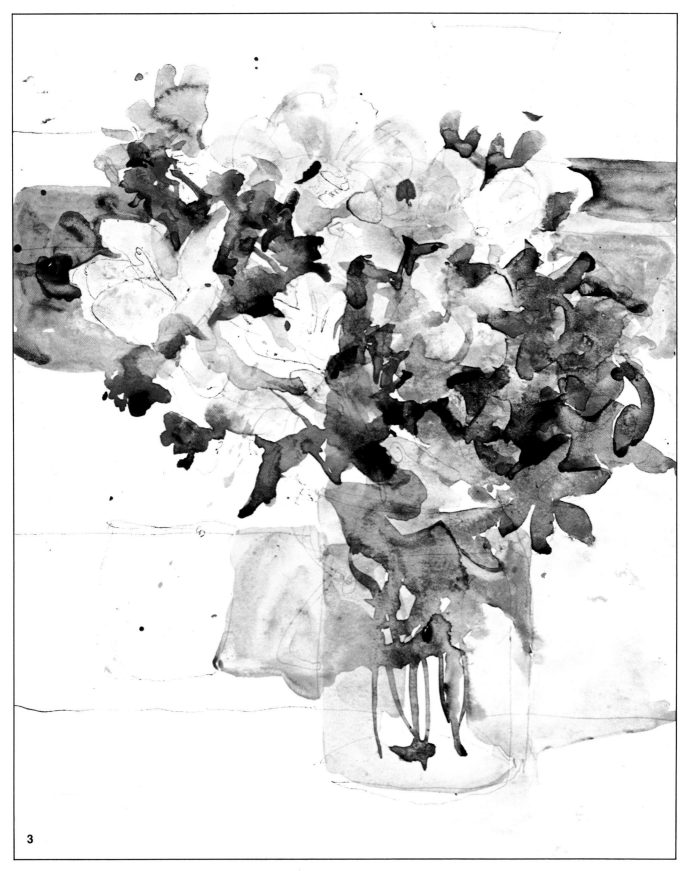

3

3 Paint the vase

First paint the stems and leaves that can be seen through the glass. (Make sure your brush points well, or switch to a smaller brush.) These greens are slightly cooler than the foliage above, so add a touch of ultramarine to the mixture. Paint the shadowy background colours – a loose blend of raw sienna and ultramarine – letting them fuse into the greens in the vase so that everything ties together. When this is dry, indicate the vase by gently brushing a wash of cerulean blue and alizarin, watered down to a pale tint, over the vase and stems. Leave some white paper showing for the highlights.

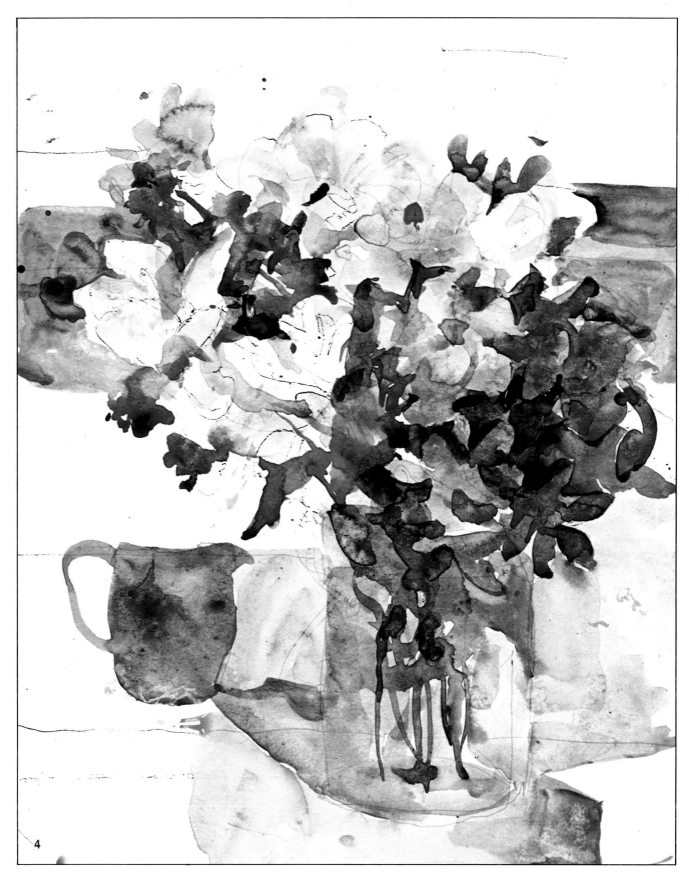

4

4 Complete the background

Paint the cast shadow to the left of the vase with a pale blend of ultramarine and alizarin. Add some light, warm washes to the table using cadmium orange. To give the picture depth, paint the small jug behind the vase using alizarin, ultramarine and raw sienna. At this point avoid the temptation to 'twiddle' – if you put in too much detail your picture will lose its charm and freshness. In the painting above the background is merely hinted at, anchoring the subject in space but not detracting from it. Notice, too, the 'breathing spaces' of white paper around the edges of the picture.

Warm and cool colours

Artists have always known that some colours give a feeling of warmth while others seem cool. The reasons are scientific, but also partly psychological – we associate certain colours with things like fire, or the cold waters of the sea.

On the colour wheel below the reds and oranges on the left side are warm while the greens and blues on the right are cool. Notice how each colour has varying degrees of warmth or coolness; manganese blue contains a lot of green and is therefore cooler than ultramarine, which contains some red.

The concept of colour temperature is an important one to bear in mind, in watercolour just as in any other medium. The mood of a picture will depend on the temperature of the colours used; the placing of warm and cool colours lends space and dimension; and the surfaces of objects can be modelled with warm and cool colours to give them a three-dimensional appearance.

Colours appear to change according to distance, time of day, atmospheric conditions, the play of light and shadow. Examine an object – say a blue vase – under different lighting conditions. Compare the warm tones cast by afternoon light to the cooler ones cast in the morning, and make watercolour sketches of your observations. Keep a note of the colour combinations you used to create the shadows and highlights.

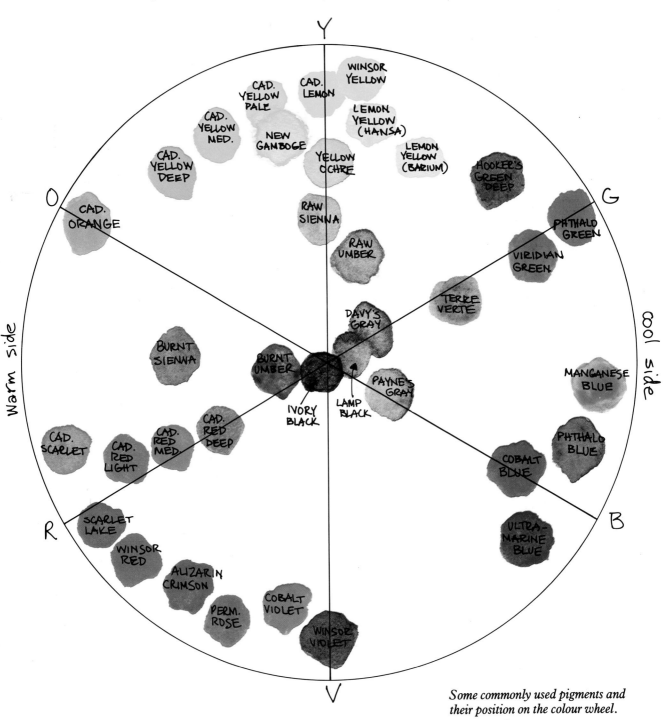

Some commonly used pigments and their position on the colour wheel.

Structuring with colour

If you think your paintings look rather flat and lifeless, it could be that you are trying to give your objects a rounded appearance by simply shading a single colour from light to dark, rather like using a pencil. In fact, shadows are not just a darker version of a colour – nor are they black! They contain elements of the opposite (complementary) colour of an object. A good rule of thumb is to define the dominant primary colour of an object and cover it with a wash of that colour. You can then model the shape by overlaying washes of cool and warm complementary colours. For example, you can give form to green foliage by adding yellow for highlights and blue for shadows.

Colour balance

As well as aiming for a balanced linear composition in your pictures, you should also give a thought to the balance of colours. It is difficult to establish a mood if your picture is a hotch-potch of warm and cool colours. Most successful paintings are composed mainly of warm colours with touches of cold, or vice versa. You can create a sense of depth, too, by keeping warm colours to the foreground and restricting cool colours to the background.

Right *'Blue and White Iris' by Charles Reid. This picture, composed entirely of cool blues, greys and greens, has a quiet, restrained mood.*

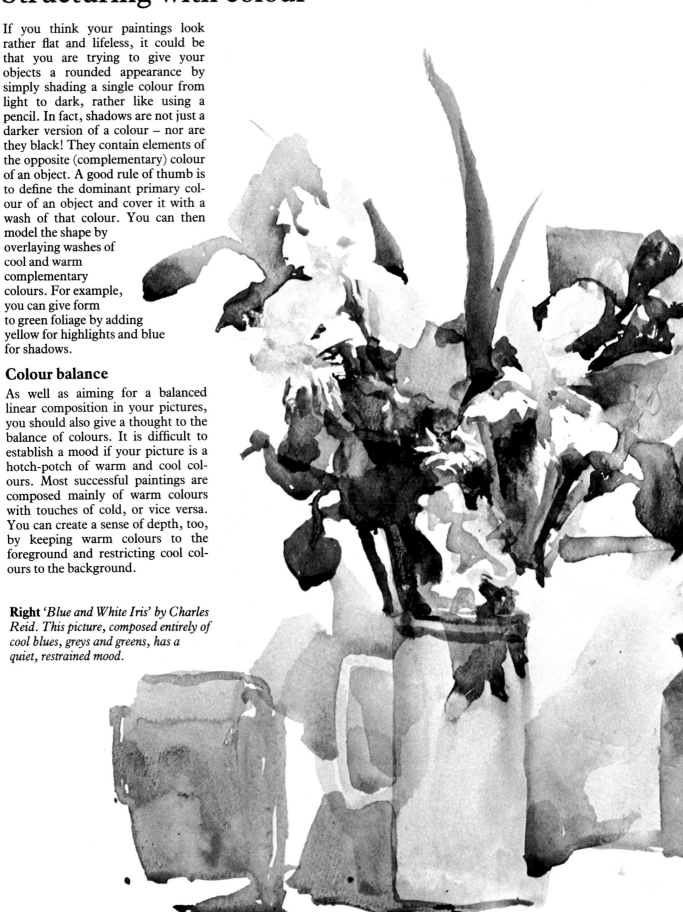

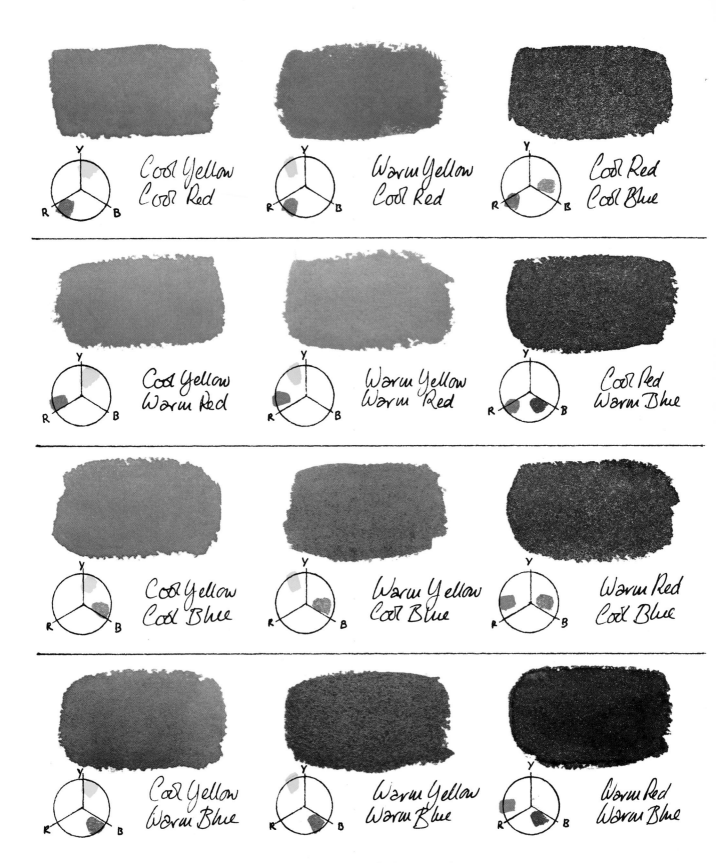

Cool Yellow
Cool Red

Warm Yellow
Cool Red

Cool Red
Cool Blue

Cool Yellow
Warm Red

Warm Yellow
Warm Red

Cool Red
Warm Blue

Cool Yellow
Cool Blue

Warm Yellow
Cool Blue

Warm Red
Cool Blue

Cool Yellow
Warm Blue

Warm Yellow
Warm Blue

Warm Red
Warm Blue

EXPERIMENT WITH COLOUR MIXES
Start by confining your mixes to the three primary colours, using a cool and a warm version of each, and compare the results of each combination (write down the names of the colours you mix together for future reference). The little colour wheels on this chart indicate where the tube colours fall on the large colour wheel shown on the previous page.

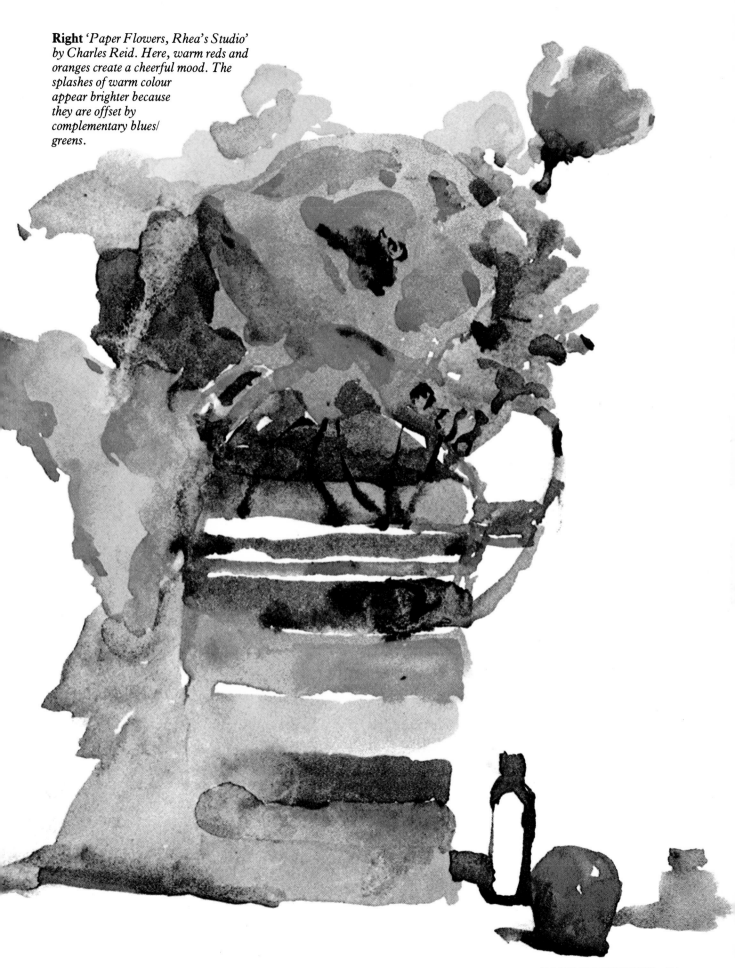

Right *'Paper Flowers, Rhea's Studio' by Charles Reid. Here, warm reds and oranges create a cheerful mood. The splashes of warm colour appear brighter because they are offset by complementary blues/ greens.*

Mixing greys and neutrals

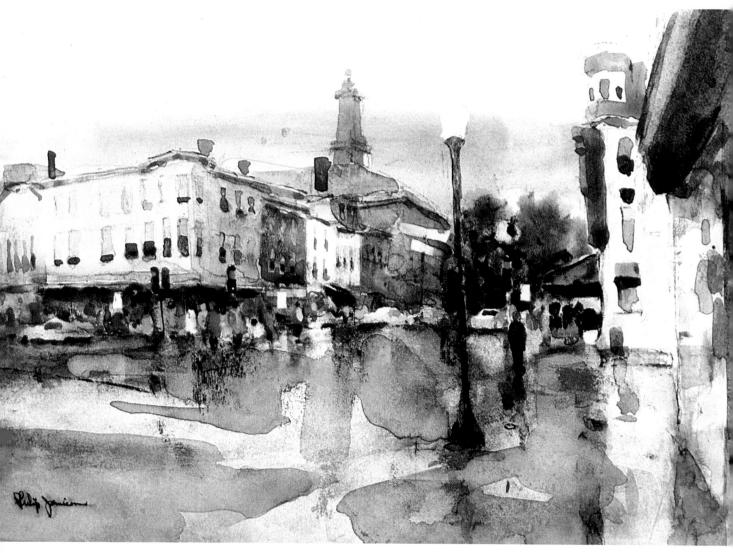

Above '*Market Street' by Philip Jamison, watercolour, 9⅝″×14½″ (24cm×37cm). By combining neutral hues with the merest hints of stronger colour, Jamison expresses the mood of a bleak day. Notice how the red traffic lights sing out strongly against those background greys.*

The most popular watercolour subjects are skies, water and landscapes – all of which contain lots of subtle greys and neutral hues. But people often get stuck when mixing greys, just as they do when mixing greens or fleshtones, and end up with a nondescript colour commonly known as 'mud'.

Remember that greys and neutrals are just as important as bright colours. Areas of neutral hue can be used to capture subtle and expressive effects. They also act as a 'foil' for your brighter colours, giving a painting more vibrancy.

Colourful greys

You can create a varied and luminous assortment of greys and neutrals simply by combining the three primaries; for example, phthalo blue, lemon yellow and alizarin crimson. Alternatively, mix any pair of com-

plementaries – try viridian and alizarin, or cadmium orange and cerulean blue. Combined in equal amounts, these pigments make a totally neutral grey. But varying the proportions of each pigment produces an infinite variety of warm and cool greys. For example, adding just a hint of burnt sienna to ultramarine creates a lovely, granulated grey that's perfect for painting clouds.

The chart opposite shows some examples of greys mixed exclusively from the primary triad.

Tube greys

The ready-mixed greys – Payne's grey, Davy's grey and sepia – are too strong to be used 'neat' in large areas, and should be used only for small details. They are useful, however, for rapid watercolour sketching outdoors, when you've no time to mix colours.

Row A – LIGHT TONES

Greys made with opaque pigments – cerulean, yellow ochre and Indian red. The first sample in the row shows a slight gradation of the hue. In the second, a granulated effect is achieved by gently rocking the board while the wash is still wet. In the last two samples, the colours are fused wet-in-wet. These soft textures are highly effective in landscapes.

Row B – MID-TONES

Because each of the staining pigments actually stains the other, the staining primaries – Winsor blue, Winsor red and Winsor yellow – can be easily mixed to grey. Begin by combining all three primaries in equal amounts and then, for variations in hue and intensity, alter the proportions. Varying the amount of water used in the mixes adds still more variety.

Row C – DARK TONES

A group of strong, dark greys made by mixing the staining pigments with very little water. A predominance of blue produces a grey similar to Payne's grey (first sample). More red makes a grey resembling sepia (third sample). These neutral hues can be lightened by adding more water, but remember that they always dry lighter than when first applied.

ROW A

ROW B

ROW C

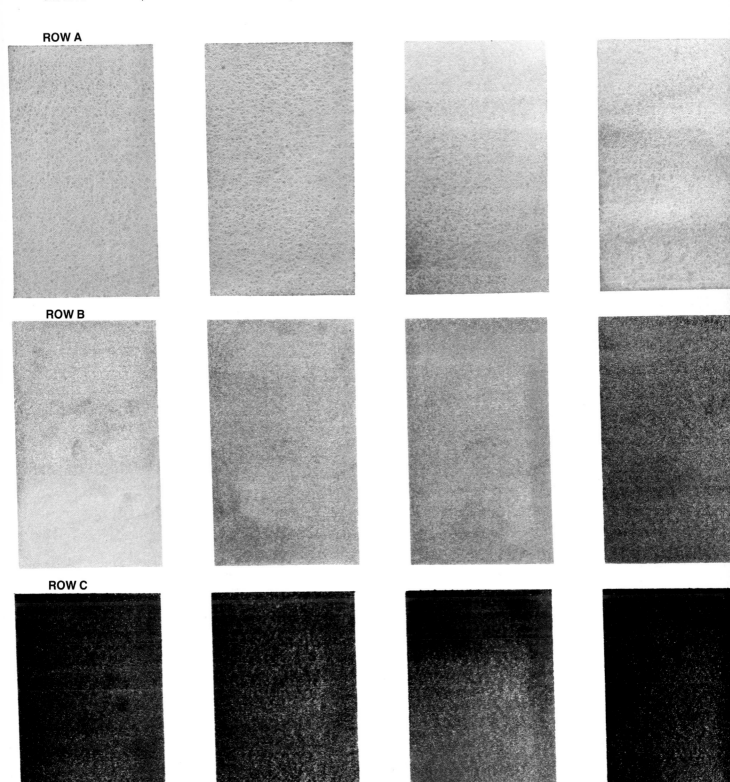

Lakes of Killarney: demonstration

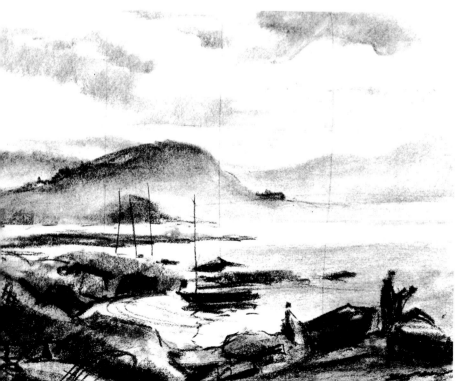

In this demonstration, watercolourist John Pike shows how a variety of warm and cool greys can combine to create a stunning picture, full of mood and atmosphere.

On the left is a charcoal sketch of the scene. A preliminary sketch like this enables you to plan the composition and the tonal pattern of the picture before you start to paint, thus avoiding mistakes later.

1 Define the lightest tone

In this scene, the sparkle of sunlight on the lake provides the lightest tone, so leave this area as white paper.

Using a no.6 flat brush, lay a neutral grey wash over the rest of the paper. It takes practice to determine

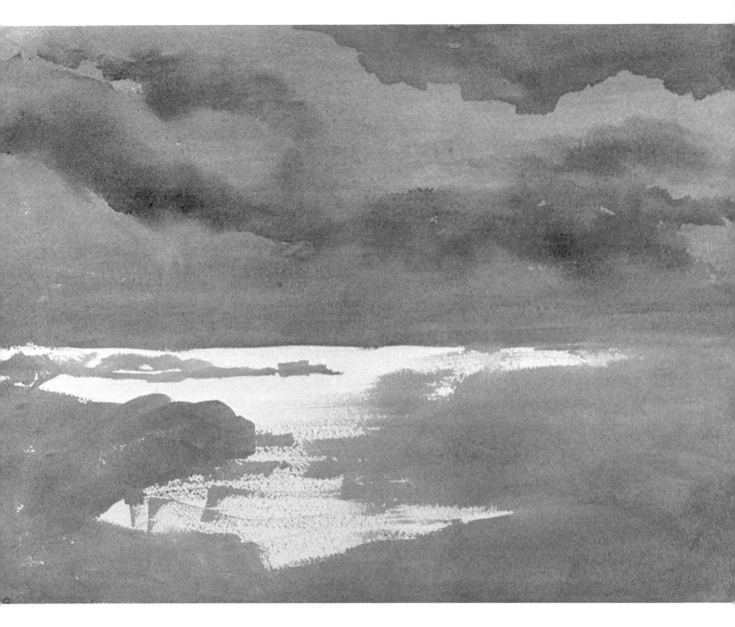

how light or dark this tone should be – the idea is to make it dark enough for the patch of light to sing out strongly, yet light enough to emphasize the strong darks that you will add later.

Before you start painting, practise mixing neutral greys on scrap paper. A good mixture to try is phthalo blue, alizarin crimson and a touch of cadmium lemon. Alternatively, ultramarine and raw umber gives an attractive, muted grey. Or you may prefer to use a favourite mixture of your own.

One thing to watch out for is mixing too much water with your paint. Make the colour stronger and richer than you think it ought to be; it may look too dark at first, but this

is because the white of the paper gives it a false tonal value. Once you've put in the dark areas, the whole thing will fall into place.

Lightly sweep a couple of dry-brush strokes over the lake. This creates a speckled effect that looks like light dancing on the water.

2 Model the clouds

When the first wash is dry, re-wet the sky area, using a round no.5 brush rather than a sponge, so as not to disturb the underlying pigment. Mix a darker grey for the clouds, but keep the mixture loose; adding more red in some areas and more blue in others will give the clouds depth and form. Let the mixtures seep into each other to create a misty effect.

EQUIPMENT USED
□ A sheet of 140-lb Bockingford paper, approximately 12″×8″ (30cm×20cm).
□ Two brushes: a no.6 flat and a no.5 round.
□ A palette of three colours: phthalo blue, alizarin crimson and cadmium lemon.

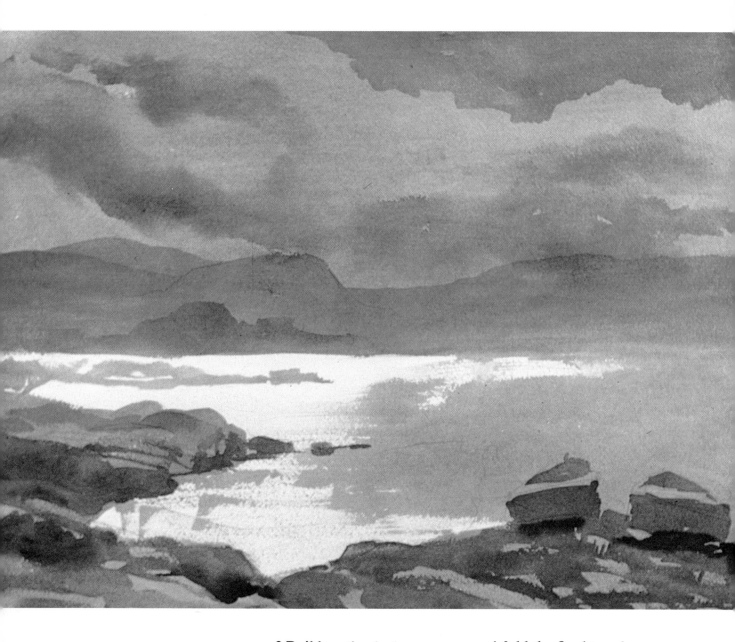

ANIMATE THE SCENE
How often do you include people in your landscapes? A few figures dropped in the right place can give life and movement to an otherwise predictable scene, and they also convey a sense of scale. Think of the vast landscapes of artists like Turner, Fragonard and Claude Lorrain; much of the feeling of vastness comes from the tiny figures placed in the foreground.

In the demonstration, you can see how the group of figures and boats creates a lively centre of interest, as well as providing vertical balance in a largely horizontal composition.

3 Build up the darks

When step 2 is dry, paint the farthest of the distant hills with a predominantly blue grey. It needs to be quite weak to give the impression of distant haze, so add more water to the mixture. Let that dry, then paint the overlapping layers of the nearer hills with a slightly denser tint.

For the darker forms in the middleground and foreground, add still more blue to your grey mixture. Using the paint thicker now, model the rock forms with loose brushstrokes over the original wash. In the foreground, add more red to the mixture, to make it warmer.

Position the two beached boats on the right with a couple of strokes of the flat brush.

4 Add the final touches

With a little dry colour on the tip of a flat brush, add a hint of textural detail to the nearest of the hills to separate it from those in the far distance.

Create a deep, dark grey by mixing your paints almost at full strength, with very little water added. Use this to complete the rocks and the boats in the foreground.

Mix a watery grey-green (yellow and a touch of blue) to paint the reflections of the rocks and the ripples at the edge of the lake. Be economical with these strokes – and resist the temptation to do any more work on the brilliant patch of light on the water. Don't push your luck!

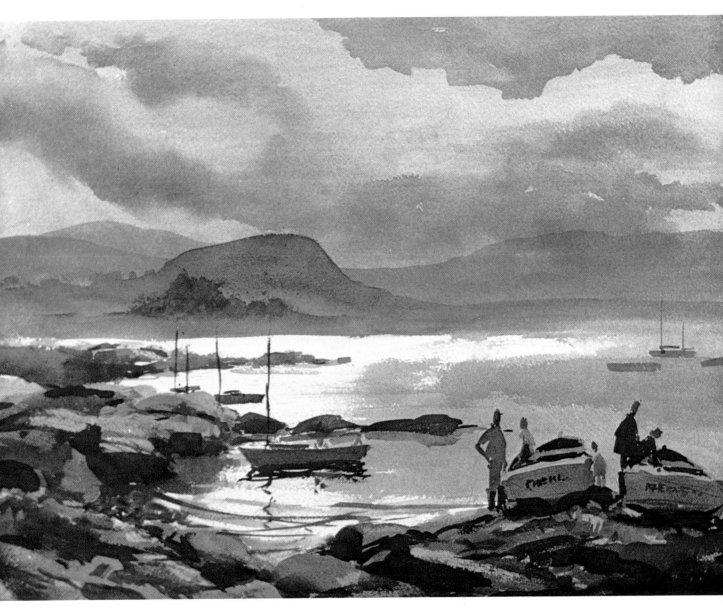

Above *'The Lakes of Killarney' by John Pike, watercolour, 22"×30" (56cm×76cm).*

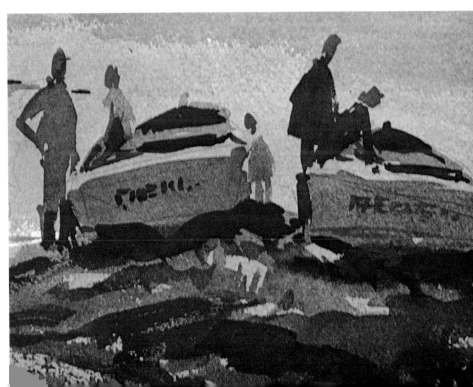

Finally, put in the group of figures. The detail on the right shows how simple it is to create a figure with just three or four strokes of the brush. Stick with your no.5 brush here – anything smaller will only encourage untidy fiddling.

The success of this painting lies in *economy of effort*. A whole range of greys is mixed from just three colours, giving unity to the scene, while brushstrokes are kept to a minimum. The combination captures perfectly the tranquillity of this misty afternoon in Ireland.

Mixing greens

We've all experienced that sense of elation when confronted with the glorious greens of nature, only to be disappointed when things don't work out in paint. More often than not this is the result of using ready-mixed greens straight from the tube. If you want to paint realistic landscapes it's worth learning how to mix your own greens, because tube greens on their own can never capture the subtle nuances that you find in nature.

Analysing landscape greens

The greens found in nature vary enormously, but most contain far more warmth (yellow and red) than many painters realise. For example, the warm glow of reflected sunlight may affect the actual hue you observe. On the other hand, smooth-textured vegetation often reflects the cool, blue-violet cast of the sky. Some foliage is light and transparent in quality, while other greenery is dense and opaque. Lastly, don't forget that green becomes paler and bluer as it recedes into the distance. A rich, dark tree painted on the far horizon will stick out like a sore thumb!

Why mix greens?

With all these variations to contend with, it follows that a quick squirt of sap green or Hooker's green dark on your palette is not going to get you very far. Greens used straight from the tube tend to be rather harsh, and it's no good trying to lighten the colour by adding more water. The result will be weak and lacklustre.

Better by far – and more economical – is to mix your own greens. By using some of the other colours in your palette you can create an impressive range, which does full justice to the subtle hues of nature.

Versatile viridian

The colour swatches opposite show just one method of mixing greens – using viridian as a base.

In its pure state, viridian is an intense, cold green with an unnatural appearance. But when you add red, yellow or orange to it, a whole range of lifelike greens appear – from light to dark, warm to cool, intense to neutral. The chart opposite shows just some of the possibilities.

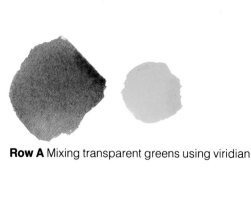

Row A Mixing transparent greens using viridian

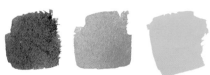

Row B Making more transparent greens using viridian

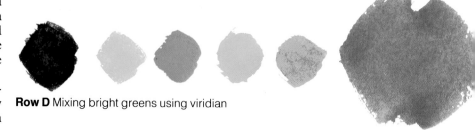

Row C Mixing opaque greens using viridian

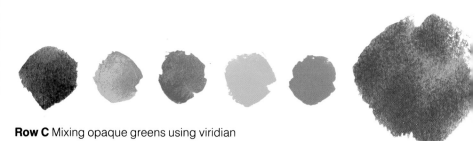

Row D Mixing bright greens using viridian

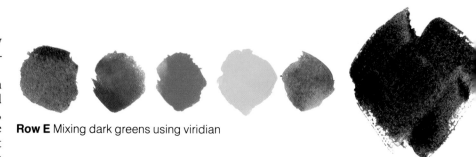

Row E Mixing dark greens using viridian

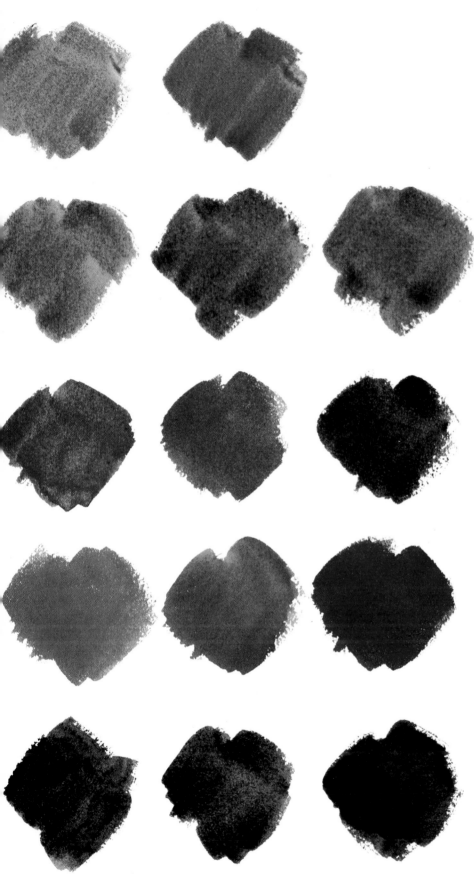

A TRANSPARENT GREENS
The three mixtures in row A are made by combining viridian and aureolin. The first sample is mostly aureolin, the amount of viridian being gradually increased in the following two swatches. All three have a glowing transparency that could be used to suggest fresh vegetation or sunlit foliage.

B MORE TRANSPARENT GREENS
The samples in row B are mixtures of viridian, aureolin, and a small amount of rose madder genuine. By varying the proportions of these pigments, you can produce mixtures that range from a warm orange-green to a cool blue-green – useful for darker vegetation or autumn foliage.

C OPAQUE GREENS
When combined with warm, opaque pigments, viridian produces mixtures of great weight and density. In row C, it is combined with cadmium yellow, yellow ochre, cadmium orange and cadmium red to produce the kind of rich, opaque hues that can describe anything from a lush meadow to an evergreen forest.

D BRIGHT GREENS
In row D, a small amount of viridian is mixed with large amounts of aureolin, cadmium yellow, yellow ochre and cadmium orange respectively. Use these bright, fresh greens to describe the vibrant brilliance of lush spring foliage or a sunlit meadow.

E DARK GREENS
Viridian combines well with orange-reds and reds to produce rich, dark greens. In row E, the first sample is a mixture of viridian and Indian red, with a spot of aureolin added for warmth and intensity. The second swatch is viridian and burnt sienna. The proportions in the last two examples (both viridian and cadmium red) are reversed to create a cool and a warm green. You can use variations of these combinations for darker foliage, trees in shadow, or the interior of a wood.

Verdant Meadow: demonstration

⚠ DULL, COLD GREENS?

If your painting is filled with dull, cold greens – mixtures that looked all right on your palette but then dried to the colour of an old sofa – the explanation is simple; as a colour dries it becomes lighter, less intense and colder. To retain the warmth and intensity of a mixture, try using less water. Alternatively, lighten your greens by adding warm pigments – yellows and oranges.

More green mixtures

Discover for yourself the value of mixing your own greens: take three blues – cerulean, cobalt and ultramarine – and three yellows – lemon, cadmium and ochre. Add each of the yellows to each of the blues, and you instantly have nine different greens, ranging from bright, leafy hues to the deep, sea greens which you find in stormy skies and water.

Colours like Prussian blue and Payne's grey are useful, too. Mixing Prussian blue and yellow ochre produces an olive green; lemon yellow with a touch of Payne's grey results in a really dark green.

Extend the possibilities by adding touches of earth colour (raw sienna and raw umber) for even richer greens. Experimenting in this way, you'll find that the colours you create will themselves suggest the kind of images you see in nature.

Painting nature's greens

The photograph above represents the sort of scene which a beginner might tend to shy away from. All those greens!

In the demonstration that follows, artist Ferdinand Petrie shows how to simplify the scene by breaking it down into broad tonal areas and leaving the finer details of colour and texture till the end.

When painting a scene like this one, it helps to have a strong light source which adds definition. In this picture the low, early morning light comes from behind the subject, silhouetting it and creating a strong pattern of light and dark.

Your picture will be successful if you keep things simple and organized. Decide which green mixtures you want to use for the light, mid-tone and dark areas and arrange them separately on your palette.

1 Lay the first wash

Lightly pencil in the horizon and the shape formed by the spreading branches. Outline the shapes of the shadows in the grass, too – if you're painting a scene like this outdoors, the shadows will have moved before you get around to painting them. It's important to keep the position of the shadows consistent.

With a no.6 brush, lay a wash of new gamboge over the entire paper, except for the shape of the tree and the sunlit spaces, which are left white.

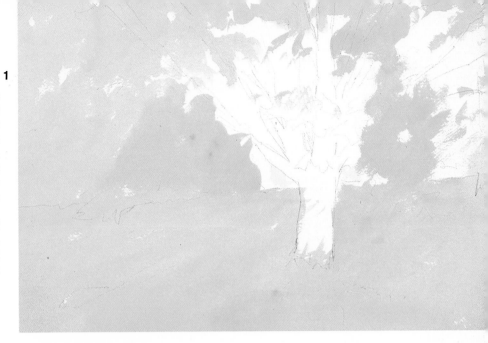

2 Build up the greens

When the yellow wash is dry, apply the mid-tones of green. Mix new gamboge with ultramarine, then darken it with a touch of Payne's grey. By using varying amounts of these three pigments, you can make several harmonizing shades. Begin painting with an intermediate shade, laying down the fairly bright greens; then, using a deeper mixture, develop the darker areas found mostly in the foreground. Leave yellow patches where the brightest sunlight falls.

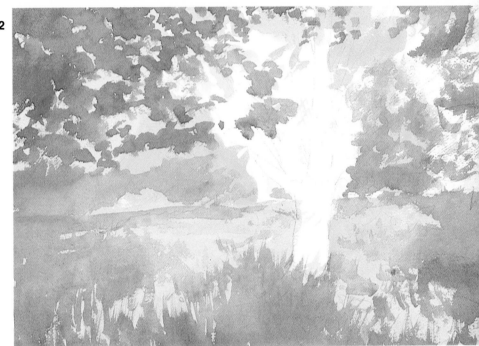

3 Add the darks

Put in the darker tones before you've added too many gradations to the lighter ones. This way, you can judge how the light and mid-tones change when they're put next to the dark ones, and adjust them to suit.

Paint the trunk first. Use burnt sienna, alizarin and ultramarine, adding more ultramarine for the darker shadows.

Paint the darkest masses of leaves with viridian and yellow ochre, and use the same mixture to deepen the shadows in the grass, applying the colour with a fairly dry brush.

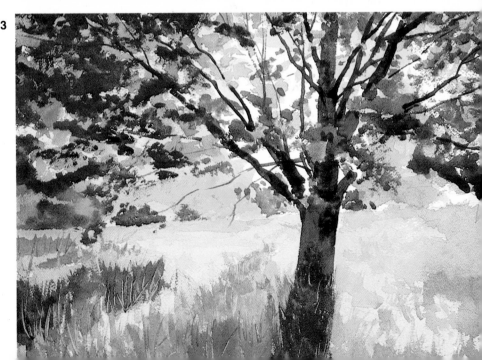

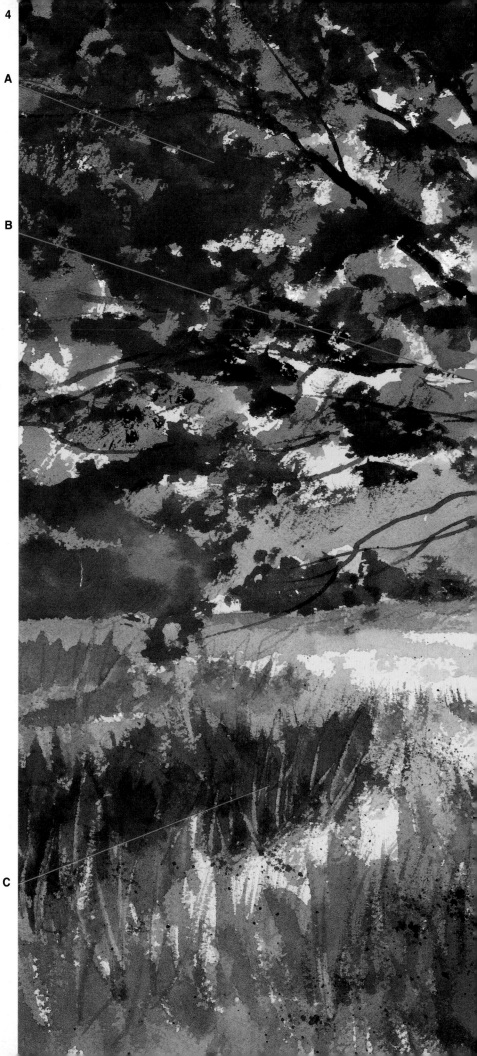

4 Add more detail

This picture has been slightly enlarged so that you can clearly see the variations in texture and tone which give the impression of sunlight darting through the leaves and across the grass.

A The tree Complete the tree trunk and branches, adding dark shadows and lifting out highlights. Suggest the finer branches with loose drybrush strokes, weaving them in and out of the foliage.

Complete the canopy of the tree by adding more dark and mid-tones. To give the leaf masses a lively, irregular quality, use a no.4 brush and vary your brushstrokes. For the dense masses of foliage, load the brush with pigment and drag its side over the paper. In the more open areas, make short, stabbing strokes with the tip of the brush. These broken, irregular marks make us feel that the tree is actually moving in the breeze.

B The sky Don't forget to leave plenty of 'sky holes' amongst the foliage, otherwise the tree will look flat and dull. It's quite all right to leave the sky unpainted – the crisp, white paper conveys the impression of brilliant summer light.

C The grass Notice how the sun's rays pick out some of the taller grasses, even in the shadow areas. Continue to knife out these light grasses, which you started in step 3 (re-wet the paper if necessary, or scratch out the dry paint with a sharp knife or razor blade). This wealth of detail in the foreground, contrasting with the more indistinct background, enhances the feeling of depth.

EQUIPMENT USED
☐ A sheet of 140lb Bockingford paper, approximately 12″×8″ (30cm×20cm).
☐ A palette of seven colours: new gamboge, ultramarine, Payne's grey, burnt sienna, alizarin crimson, viridian and yellow ochre.
☐ Two flat brushes: no.4 and no.6.
☐ A sharp knife or razor blade.

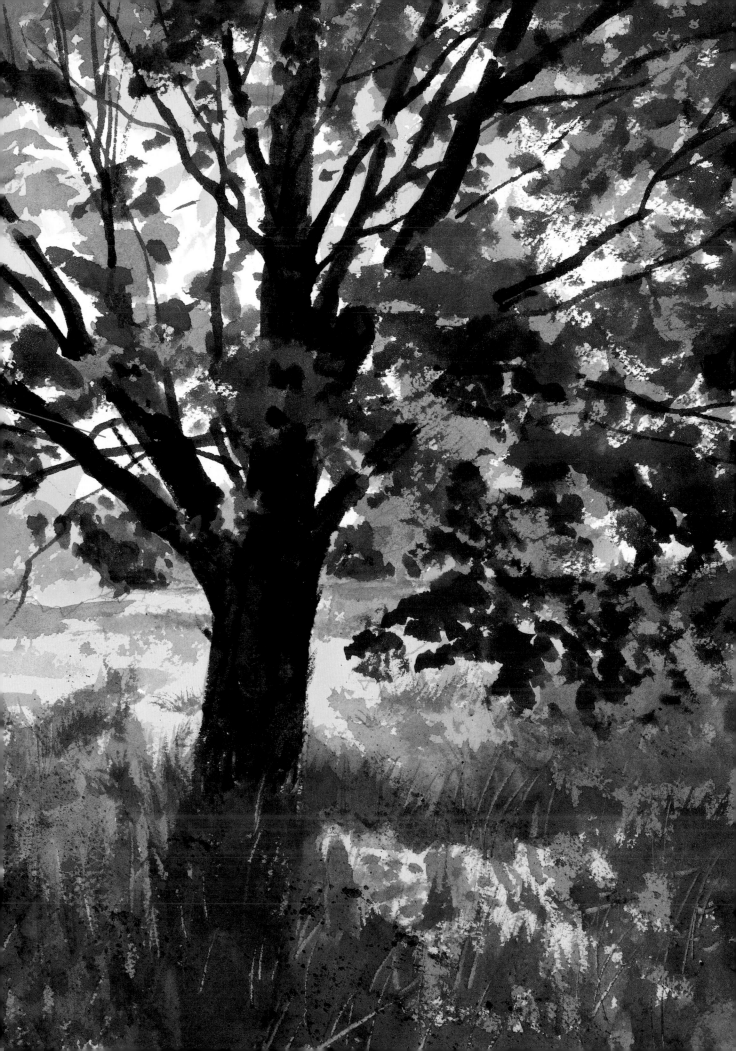

Understanding your pigments

Have you ever ruined a promising painting with an out-of-tune electric blue sky or a floating, weightless barn? It's a common mistake—you reach for a colour that matches the subject, but forget to consider whether that pigment also conveys the *surface quality* of the subject.

Watercolour pigments fall into three groups: transparent, opaque and staining. It's important to know which ones are which, because some work well together in mixes and others don't. Also, the pigments you choose should reflect the 'feel' of

whatever you're painting. For example, a transparent pigment like manganese blue enhances the feeling of light in a sky, whereas a stainer like Winsor blue is too harsh.

Before you start your next painting, take a few minutes to identify the quality or effect you want to convey. Then select the pigment group that will best describe it. For example, if you want to capture the hazy effect of early morning light on the sea, use mostly transparent pigments. But if you want to emphasize the rocky shoreline, select opaque colours.

Below *This colour grid gives you a chance to see how colours behave both under and over other colours. Paint all the colours in one direction and let them dry; then repeat them in the same order going across at right angles. Their relative transparency/opacity and glazing characteristics will quickly be revealed.*

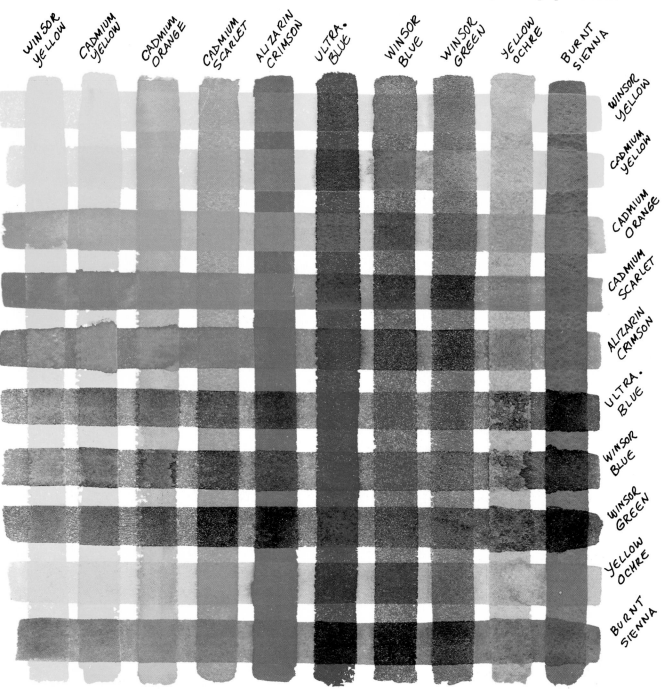

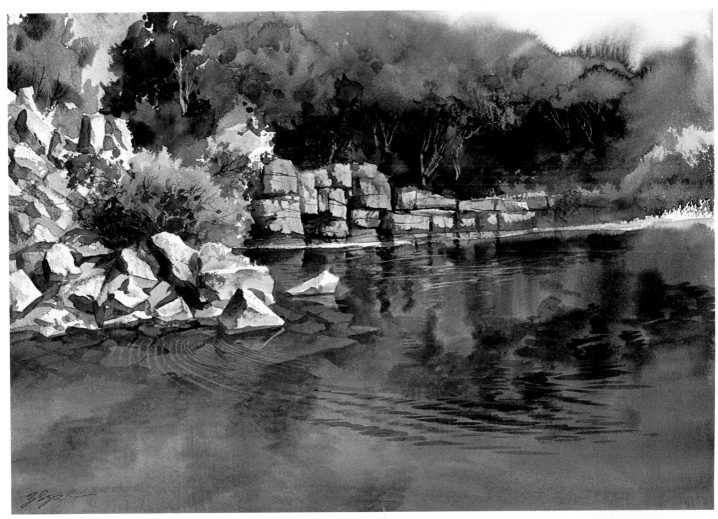

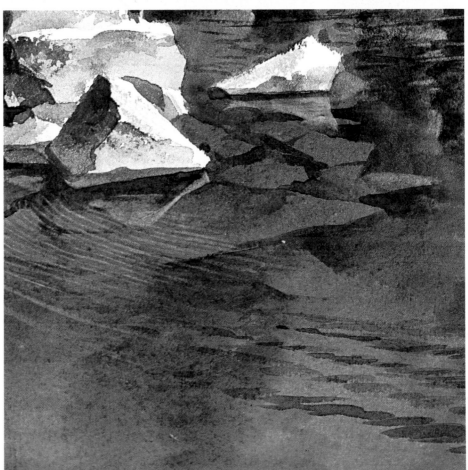

Above *'Wishing Pool' by Zoltan Szabo, watercolour, 15" × 22" (38cm × 56cm). In this painting intense staining pigments (mainly sap green and new gamboge) convey the brilliant, saturated colours of a woodland pool.*
Right *A detail of the pool. The ripples and reflections are lifted out with a wet brush; notice the glow of sap green that remains.*

Staining pigments

Staining pigments have a power and intensity rarely found in nature, so don't use them for delicate subjects. Because they actually stain the paper, they cannot be completely removed, so make sure you avoid them if you're painting a subject like a sky, where you might want to lift out colour for soft effects.

However, stains *are* suited to capturing dramatic effects – the powerful forms of machinery, or the heavy darkness of a night scene.

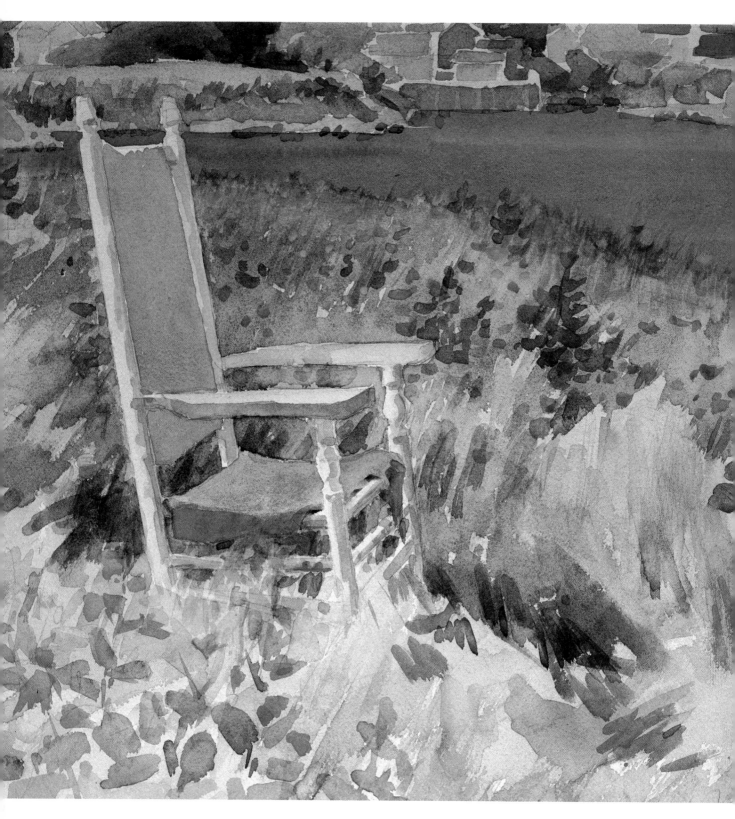

Above 'Last of the Season' by Barbara Osterman, A.W.S., watercolour on Arches 140-lb cold pressed paper, 14" × 21" (36cm × 53cm). Collection of the artist.

A delightful scene that speaks of scented meadows and warm summer breezes. In Barbara Osterman's painting, colour, tone and pigment consistency are perfectly matched to the character of her subject. The result is a sensitive and lyrical description of a simple but engaging subject. Throughout most of the painting, Osterman uses rose madder genuine, aureolin and cobalt blue; these transparent, luminous pigments are perfect for conveying the illusion of atmosphere, space and light. Opaque and staining pigments cannot match this clarity of tone.

Transparent pigments

The transparent pigments have an attractive, airy quality, which makes them perfect for atmospheric subjects such as early morning light on a harbour, or a misty sky and landscape.

Because they don't stain, these pigments can be combined in mixtures or applied in individual glazes without losing any of their freshness.

Opaque pigments

You may think opaque pigments are unattractive, and avoid using them. They *are* heavy and dense, but if they are matched to subjects with similar qualities – an old barn, a gnarled tree trunk, or a ploughed field – they convey a convincing impression of weight and solidity.

Combining pigments

With a little careful planning, you can create an exciting, expressive painting by combining different pigment types. Have you ever noticed how Turner, in his atmospheric watercolours, always placed an opaque boat, cow or tree in the foreground? These small, dense accents make his paintings seem even more vibrant.

Opaque pigments also contrast well with the intensity of stains. For example, you can accentuate the blazing colours of a sky at sunset by including the opaque silhouette of buildings or mountains.

PIGMENT QUALITIES
See p.50 for an at-a-glance list of colours and their properties.

☆ **LABEL YOUR COLOURS**
A helpful way to remember the characteristics of each pigment is to label your tubes or pans of paint (a strip of masking tape marked in pen will do). Label them T for transparent, S for staining and O for opaque. Then, if you're on location and in the heat of inspiration you reach for a dark blue marked S, you'll know in time that it's Winsor blue and you should use it sparingly.

Collection of Hjalmar Breit, III, New Orleans, Louisiana.

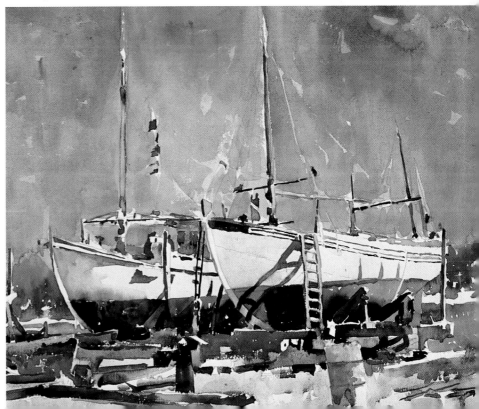

Right *'Double Trouble' by Judi Betts, watercolour, 21" × 27½" (53cm × 70cm). Transparent pigments predominate in this painting of two boats in dry dock, while small accents of opaque pigment accentuate the atmospheric quality of the scene.*

Glazes and graded washes

HOW TO LAY A GRADED WASH

Start with a dry, stretched sheet of paper on a board set at a slight angle so that the brushstrokes will merge into each other (rest the board on a couple of books – you'll need to leave it at the same angle while the wash dries).

Dampen the entire sheet with water, using a no.10 brush. Mix plenty of paint in a small cup, then load your brush to capacity and lay a line of colour at full strength across the top of the paper, taking care not to lift the brush until the stroke is complete.

Now add a little water to the paint and quickly lay a second line of colour under the first, slightly overlapping it. Repeat with increasingly diluted tones until you reach the bottom of the paper, rinsing and drying the brush between each stroke, then leave the wash to dry.

You will notice a bead of paint forming along the bottom of each stroke – don't let this get out of control and run down the paper; come back quickly with your next brushload, picking up the bead so that the strokes melt together.

The completed wash should be fresh and transparent, with no 'seams' showing. It takes practice, but you'll soon learn to guide the brush with your arm rather than your wrist, and to judge how much water to add to each successive stroke.

GET TO KNOW YOUR COLOURS

Make 'test sheets' and keep them for reference. The sheet opposite illustrates what happens to pigments as they are diluted with water – some stay fairly strong, while others weaken rapidly.

The chief characteristic of water colour is its transparency, and in using the glazing technique this is exploited to the full. Glazing your watercolours means applying them in transparent layers over one another, each layer being allowed to dry before the next is added. You are in effect building up thin veils of colour, and because each layer is transparent the light travels through to the white paper underneath and bounces back up again through the paint. The resulting painting reflects the subtle and ephemeral qualities of light. Indeed, the glow and shimmer of some of Turner's works is the direct result of his glazing skill.

Understanding pigments

The glazing technique is a highly satisfying one, but it does demand a knowledge and understanding of the way pigments behave when mixed with water and each other. Basically, pigments fall into three groups – transparent, opaque and staining.

Overleaf is a list of popular colours, divided into these three groups. For glazing you need to work with transparent pigments; they can be applied in repeated layers without obscuring the paper or the underlying layers of paint too much. Another virtue of transparent pigments is that they can be washed out very easily.

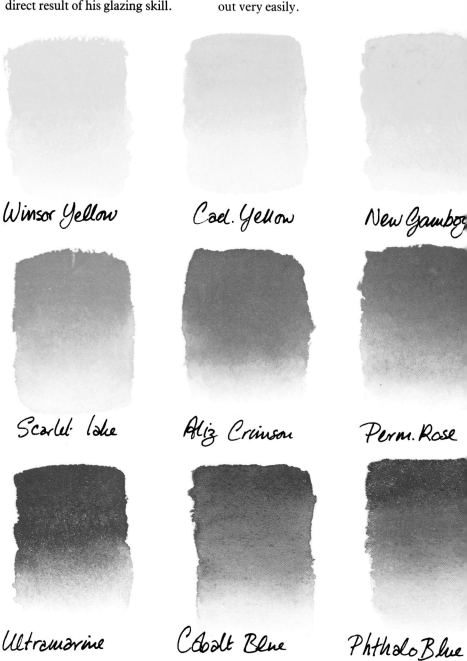

Winsor Yellow

Cad. Yellow

New Gamboge

Scarlet Lake

Aliz Crimson

Perm. Rose

Ultramarine

Cobalt Blue

Phthalo Blue

Desert Scene: demonstration

This painting by Christopher Schink conveys, with the minimum of detail, the atmosphere of a landscape suffused with early morning light. The painting has a subtle luminosity which is achieved by keeping to a simple palette and glazing highly transparent colours one on top of the other. Transparent pigments have a delicacy and clarity of tone that is particularly suited to conveying the illusion of atmosphere, space and light.

1 The first wash

Start by lightly sketching in the basic outlines and any areas you want to leave white or very light.

The general rule in watercolour is **2** 'work from light to dark', and this applies also to glazing. To achieve the greatest transparency, always start with the lightest pigment and leave the darkest one till last. In this painting, cadmium lemon is used for the first wash: yellow is the lightest primary colour and is found in most landscapes.

Graduate the wash by progressively thinning each stroke with water as you move down the paper. Paint around the edges of your planned lights, and pick up any beads of paint which collect at the edges of these shapes with a dry brush.

2 The second wash

When your first wash is completely dry, apply a second graded wash, this time with permanent rose. With practice you'll learn to adjust the strength of these first washes to **3** achieve the desired effect.

Work quickly so you can continue the flow of your horizontal washes. Use a dry brush to pick up any puddles of wash that may have formed at the edge of the paper. If these wet areas run back into your drying wash they will create an unwanted backwash in your glaze.

3 The third wash

To complete the atmospheric grey sky, add a graded wash of cobalt blue – the darkest of the three primaries. This should be slightly less diluted than the first two washes, otherwise the final colour may turn out too grey and neutral.

4 Finishing off

When the final glaze is completed, paint in the details. This particular painting can be finished in three steps. To create a soft-edged effect, paint in the foreground before the last wash has dried: mix together the three primary pigments used for the sky, along with viridian and a little yellow ochre for weight. Apply the paint in bold, sweeping strokes that lead the eye into the painting. A few drybrush strokes here and there convey the texture of the sand.

For the building, mix a transparent grey from the three primaries, dropping in touches of yellow ochre for textural interest. By mixing all your colours from the same basic palette you will create a harmonious picture in keeping with the tranquillity of the scene.

The line of dark, distant hills provides the contrast needed to prevent the picture from becoming too formless. A mixture of burnt sienna and ultramarine will give you a rich, inky blue – a dense, opaque colour which accentuates the transparency of the sky and foreground.

Copying this picture is a useful way of practising the techniques of glazing and graduated washes – but don't end there: use what you've learned and apply it to what *you* want to paint. These techniques are particularly suited to painting skies, fields, rivers and lakes. In still-life and figure painting, too, glazing is the best method of portraying shiny surfaces that reflect highlights.

EQUIPMENT USED
☐ A stretched sheet of medium weight cold-pressed paper, 12″×8″ (30cm×20cm).
☐ One no. 10 wash brush and one no. 3 brush for finer details.
☐ A palette of seven colours: cadmium lemon, permanent rose, cobalt blue, viridian, yellow ochre, ultramarine and burnt sienna.

PIGMENTS EXPLAINED
See p.44 for more information on transparent, opaque and staining pigments.

A GUIDE TO PIGMENT QUALITIES
The colours in the basic palette (p.16) are listed below according to their transparency, opacity and staining power. This is intended only as a rough guide, as paints differ from one manufacturer to another. The way in which the paint is applied can also affect the result; for example, stains can be heavily diluted to achieve a delicate wash effect. Experiment with your own paints before starting a painting, so that you're familiar with how they behave.

TRANSPARENT	OPAQUE	STAINING
Viridian	Burnt umber	Viridian
Sap green	Raw umber	Alizarin crimson
Burnt sienna	Cadmium scarlet	Sap green
Permanent rose	Cadmium orange	
Alizarin crimson	Cadmium yellow deep	
Cadmium lemon	Cerulean blue	
Cobalt blue		
Ultramarine		
Raw sienna		

THINK ABOUT TEXTURE
The graduated brushstrokes opposite show the way in which different earth pigments distribute themselves in a wash, creating different qualities of texture and colour strength. These qualities can be applied imaginatively to express the textural qualities of the scene you're painting. In the painting above the cool, clear sky is expressed by a smooth, transparent wash. By contrast, the earth colours have a granular texture which indicates the grittiness of the sand.

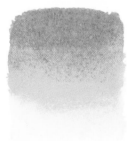

Yellow Ochre Burnt Sienna Raw Umber

2

TONE AND COLOUR

Understanding how to use tone and colour is the essence of good painting. Although artists are always fascinated by colour, it's impossible to paint a successful picture without developing an eye for tone as well.

Tone simply means how light or how dark an area is, irrespective of its colour, and tonal pattern refers to the design of the painting in terms of light and dark shapes that distinguish the elements in the scene.

The aim of an artist is to produce a design as pleasing to the senses as a musical composition. Indeed, the musical analogy is a good one: tone can be likened to the underlying chord structure of a musical piece, while colour is the melody.

This chapter demonstrates ways of using colour and tone to give balance and unity to your paintings.

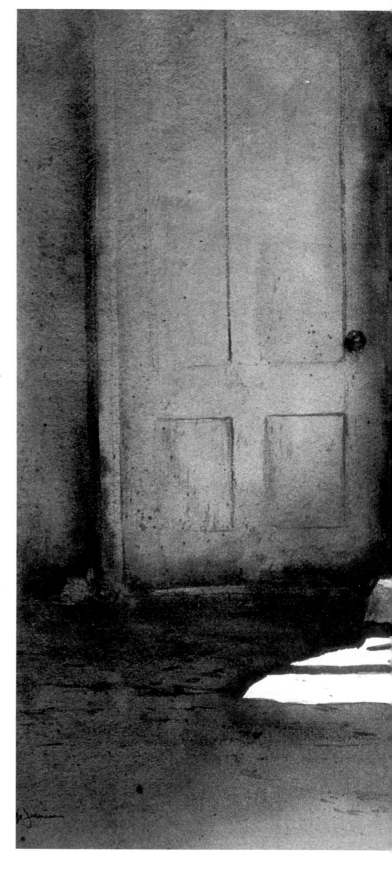

'Bridgeside Porch No 4', Philip Jamison, 18¾"×29½" (48cm×75cm). It is the areas of white space that bring sparkle to this painting.

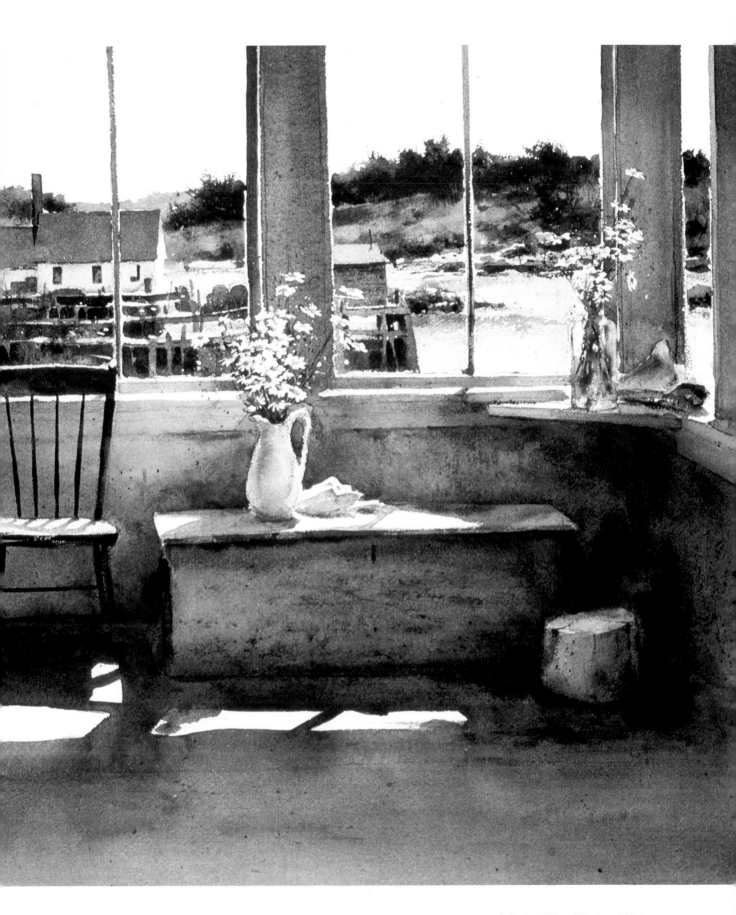

Tone: the interplay of light and dark

Tone – the lightness or darkness of a colour – has a special significance in watercolour painting. Adding water to the paint lightens its tone, building up successive washes of the same colour darkens it. So tones have to be planned with care – right from the time you compose the picture.

Tone in landscape

Tone is a powerful design device in landscapes. It is the interplay of light against dark, dark against light which gives them vitality and sets up rhythms that guide the viewer's eye through the composition.

In the monochrome sketch on this page artist Rowland Hilder uses tone to make his composition 'work'. Notice how the eye is drawn into the picture from the darkened hedgerow in the foreground and then 'swung' from side to side across the road to wander among the branches. The tones gradually become paler towards the horizon, conveying the illusion of deep space.

Seeing tones There's no point in trying to paint the infinite number of tones in nature. No matter how many *colours* you use, your painting will be stronger and more atmospheric if you limit the tones to just three or four – light, dark and one or two mid-tones. Look at a landscape through screwed-up eyes and you'll see the tonal pattern more clearly.

Organizing tones Because of the transparent nature of watercolour, you have to build up your tones systematically, from the lightest to the darkest. A preliminary sketch in pencil will help you to plan the tonal arrangement of your painting. If the sketch shows that there isn't enough tonal contrast in the scene, remember that as an artist you are free to create some!

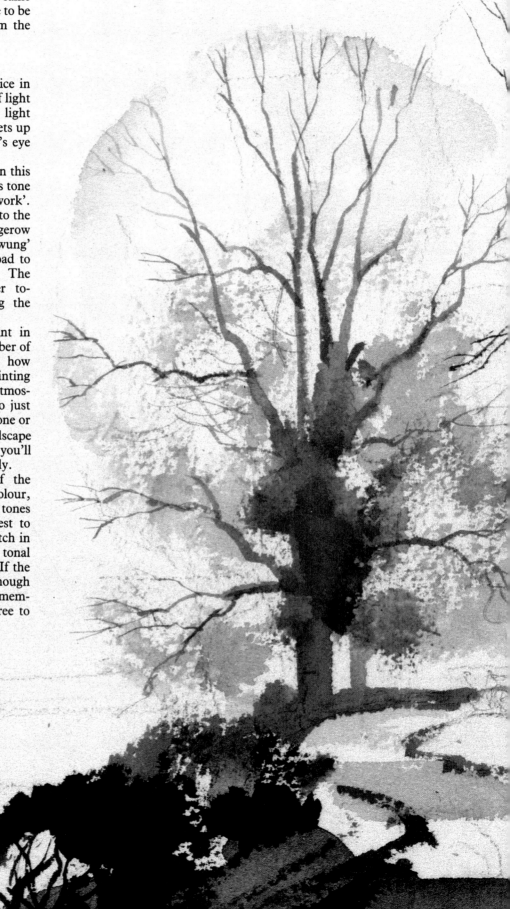

Below *Preliminary sketch in monochrome for 'Tree Lane' by Rowland Hilder, watercolour, 15″×22″ (38cm×56cm).*

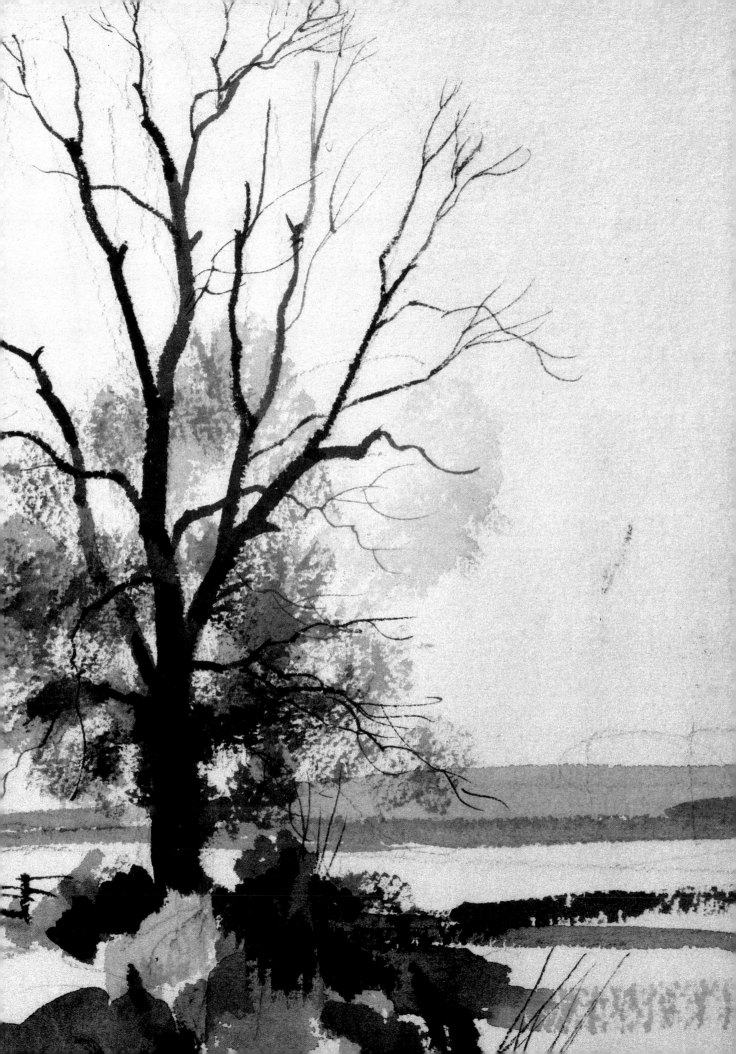

Forest Road: demonstration

Follow this demonstration by Ferdinand Petrie and discover one of the greatest pleasures of watercolour painting: the gradual building up of tones, layer upon layer, to produce a statement of breathtaking clarity.

1 Sketch the scene

Using a 2B pencil, and with very light pressure, sketch the main outlines of the road and the trees.

Now sponge the entire sheet with water. To suggest the sunlight glimpsed at the end of the forest, brush yellow ochre into the centre of the wet sheet. Then lay a pale wash of cerulean blue over the rest of the sheet, letting it fuse wet-in-wet with the edges of the sunlit area to produce a luminous effect.

Before you go any further, it's a good idea to do a monotone sketch of the scene in pencil or charcoal. Limit the tones to just four – dark, two midtones, and the white of the paper for the lightest areas. Ask yourself: does the sketch produce a pleasing and effective tonal pattern? Is there a strong impression of depth? Make any necessary adjustments, even if it means rearranging what you see before you. For example, if the sky and the trees are too similar in tone, lighten the sky or darken the trees.

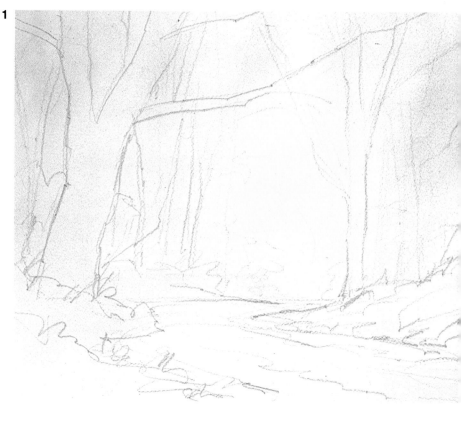

2 Start the background

While the paper is still wet, mix a slightly darker tone of cerulean blue and yellow ochre on your palette. Use a no.4 brush to lay rapid, broad strokes of this mixture across the paper suggesting the silhouettes of pale, distant trees. Like the strokes in step 1, these new strokes blur and blend as they strike the wet paper. However, the paper isn't quite as wet as it was before, so they don't disappear altogether but retain a more distinct shape.

When painting wet-in-wet like this, don't forget that wet paper tends to dilute the colours. Compensate by making your strokes darker than you want them to be – they'll dry lighter.

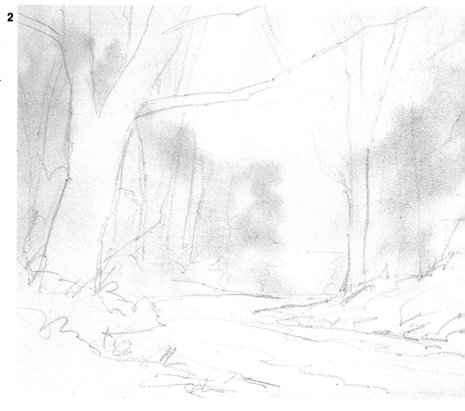

3 Continue the light tones

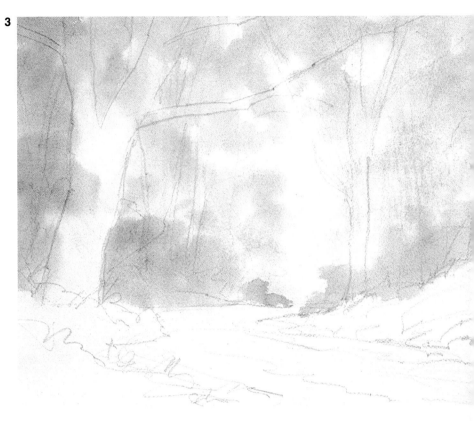

Continue adding broad strokes of light foliage. Then, warming the mixture with a little burnt umber, brush darker strokes along the bases of the trees. You can see now how the tones are building up, starting in the background and moving towards the foreground in over-lapping layers rather like stage scenery.

By the end of this step the paper will have lost its shine, indicating that it's still moist but not wet enough to take strokes of fresh paint without marring the underlying colours. Therefore, wait for the paper to dry thoroughly before moving on to the next step.

4 Introduce the mid-tones

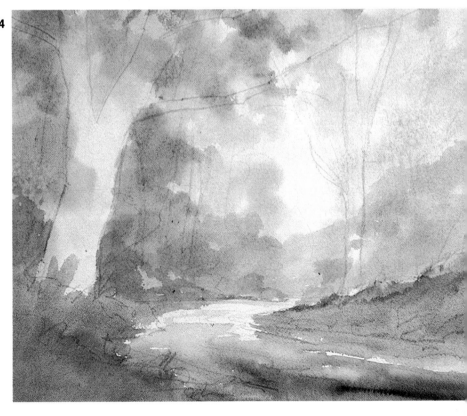

Re-wet the paper with a flat no.6 brush, sweeping quickly over the surface so that you don't disturb the underlying pigment.

Let the water sink in and dry slightly so that your strokes won't be too blurred, then build up the shadowy masses of foliage with darker mixtures of burnt umber, cerulean blue and yellow ochre.

Paint the banks beside the road with burnt sienna and yellow ochre.

For the muddy road, use burnt umber and ultramarine, letting the colours mix wet-in-wet on the paper. Where the road curves away into the distance, leave the paper unpainted to suggest the light reflecting off the wet surface. Allow the painting to dry.

5 Paint the trees

You've laid the groundwork, covering the paper with soft masses of colour. Now it's time to bring the picture 'into focus' with sharp, distinct strokes.

It's also a good idea to add an area of dark tone at this stage: having established the lightest and darkest tones, you can gauge the mid-tones more accurately.

Paint the dark tree with ultramarine and burnt umber, plus a little cadmium orange in the lighter areas. Place the light and dark strokes side by side and let the colours run together.

Adding a little water to your mixture, paint the trees in the middle distance. Then switch to a no.2 brush, add still more water, and touch in the barely-defined trees in the distance.

Because they're painted on dry paper, these strokes are sharper and more distinct than the wet-in-wet mixtures in the previous steps.

5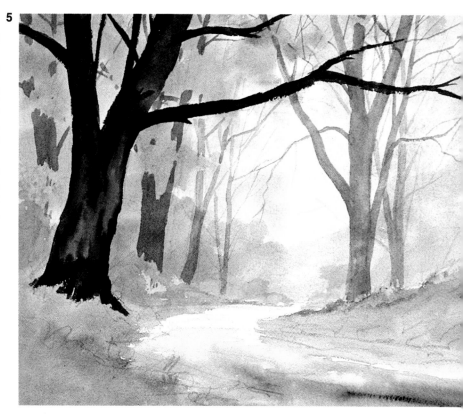

6 Add foreground detail

Still working on the dry paper, develop the tones and textures of the foreground. Using a moist (not wet) brush, indicate the warm grasses on the left with cadmium orange, burnt sienna and ultramarine. The rough texture of the paper should break up the strokes.

Lightening the mixture with more water, paint the opposite side of the road in the same way.

Paint the dark ruts in the road with strokes of burnt umber and ultramarine, allowing the wet strokes to flow together and mix 'accidentally'. Let the painting dry completely.

6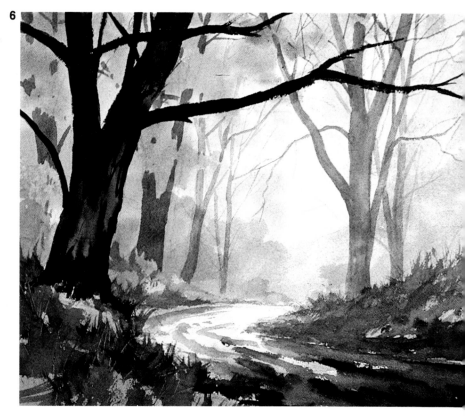

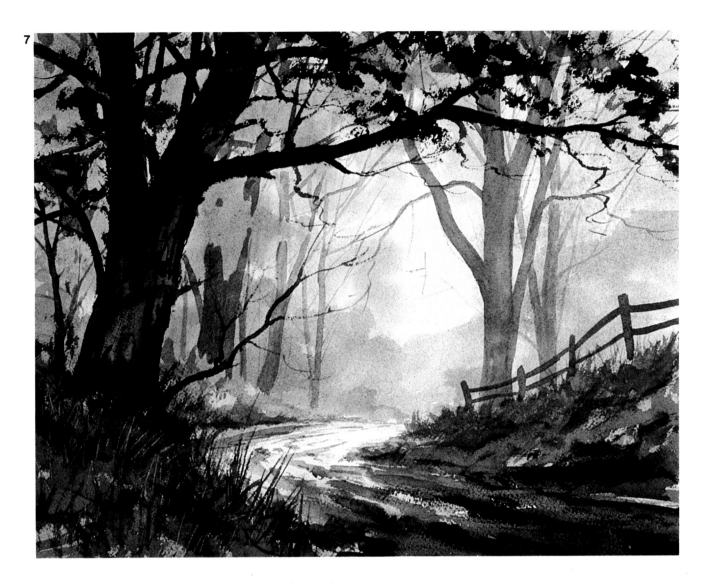

7 Finishing off

Add the blades of dark grass in the lower left with crisp strokes of ultramarine and burnt sienna.

On the opposite side of the road, add more texture to the grass verge with drybrush strokes of burnt umber and ultramarine. Add more water to the mixture to make it flow and paint in the fence, working rapidly so that it looks lively.

Mix a dark, fairly dry mixture of ultramarine and burnt sienna. Turn the brush on its side and dry-brush ragged strokes across the top of the picture to suggest clusters of foliage on the dark tree. Then dilute the mix and swiftly paint in the twigs and branches.

The entire paper is now covered with colour, except for the pale patch at the centre of the road, which is spotlit by the light that filters through the overcast sky.

Why it works

The finished painting doesn't have much colour, but it is made visually exciting by the interplay of dark and light tones. Firstly, the gradation from dark tones in the foreground to pale ones in the distance creates a strong sense of depth. Secondly, the tones have been planned to set up pleasing rhythms that hold the viewer's interest.

When you look at the painting, your eye goes directly to the light reflecting off the road, and then to the pale evening sky. Why? Because here the artist juxtaposes the lightest lights and darkest darks, thereby commanding the viewer's attention.

The lines and rhythms of the composition also lead the eye to the centre of interest. The foreground trees and branches act as a 'frame' which allows the road and fence to draw the eye far into the distance.

EQUIPMENT USED

☐ A sheet of 140lb Bockingford paper, approximately 9″×7″ (23cm×18cm).
☐ A painting sponge
☐ Two round brushes (no.2, no.4) and a flat no.6.
☐ A palette of six colours: yellow ochre, cerulean blue, burnt umber, burnt sienna, ultramarine and cadmium orange.
☐ A 2B pencil.

Mixing darks

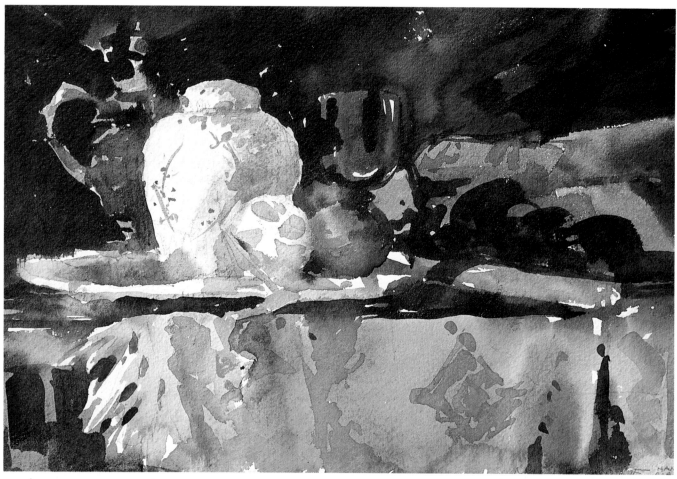

To an untrained eye, all darks will appear flat and neutral. But the darks observed in nature are almost as varied in hue as light or middle tone areas. Here are two simple tricks to help you distinguish the hue and intensity of a dark.

☐ Before trying to judge the colour of an area, rest your eyes. Then look quickly at your subject and note your first impression. The colour rods in your eyes are quickly fatigued, so the longer you stare, the less colour you'll be able to see.

☐ If you're still having trouble identifying the hue of a dark area, hold something perfectly neutral (like the black handle of a brush) against your subject and make a comparison.

It's a sad fact, but the human eye is less efficient at identifying the hue of a dark area than of a light area. This accounts for the difficulty we often have in choosing the right pigments for painting a dark doorway, or the shadow of a tree. Hoping for the best, we stab at the picture with a blob of 'mud' from the mixing area of the palette. Disaster! What should have been a deep, luminous shadow looks flat, muddy and meaningless.

Here are some guidelines to follow to help shed some light on the business of mixing darks.

Give darks their due

All too often, darks are treated simply as inky blue accents to be added at the end of the painting. This can spoil a fresh, delicate watercolour because the darks look like 'holes' in the picture, instead of being an integral part of the overall colour scheme.

You can create a whole range of darks – containing fascinating hints of colour – by blending such colours

Above *In this still life by David Millard, the darks are just as vibrant as the lights. The deep, rich background is a wet-in-wet mixture of sap green and burnt sienna. Mixing darks on the paper in this way creates a feeling of luminosity and atmosphere, because the eye becomes absorbed in the subtle modulations of colour.*

Opposite page *Warm, cool and neutral darks and mid-tones are easily mixed from simple combinations.*

as blue and brown, red and green, orange and blue.

Phthalo blue and phthalo green are the two darkest pigments on the basic palette. Alizarin crimson, burnt sienna, and ultramarine are slightly lighter and cadmium red, viridian and alizarin are all mid-toned hues. Any of these pigments can be intermixed or combined with lighter hues to make a wide variety of middle and 'dark' darks. Try making a colour-mix chart similar to the one shown opposite – then quietly put away your tube of black!

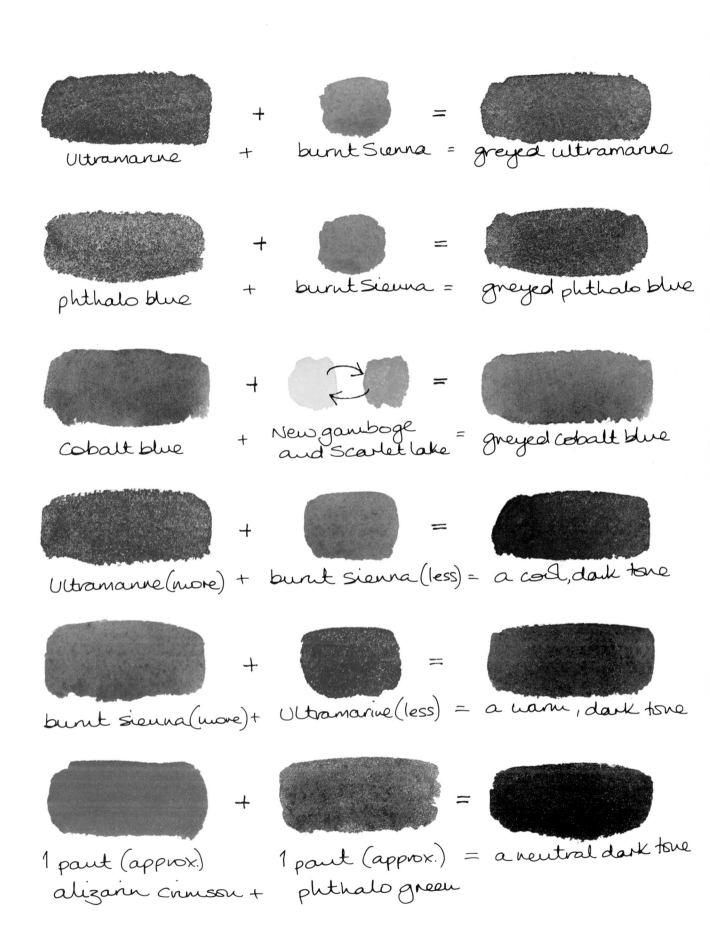

Ultramarine + burnt Sienna = greyed ultramarine

phthalo blue + burnt Sienna = greyed phthalo blue

Cobalt blue + New gamboge and Scarlet lake = greyed cobalt blue

Ultramarine (more) + burnt sienna (less) = a cool, dark tone

burnt sienna (more) + Ultramarine (less) = a warm, dark tone

1 part (approx.) alizarin crimson + 1 part (approx.) phthalo green = a neutral dark tone

Colour in darks

When it comes to handling dark colours, the most common complaint is that they turn out muddy-looking. Take the portrait on the right, for example. It was painted by a very capable student, but there is evidence of some confusion in the dark areas: they are slightly overworked and the colour is too flat.

Below is a sketch of the same subject by artist Charles Reid. Here he suggests the idea of 'dark' darks without being too literal about it: instead of copying the exact colour of the jacket, he paints it with warm-cool contrasts of ultramarine and cadmium red. You might say that he 'pushes' the colour, in order to arrive at a more luminous and vibrant effect.

Notice also how Reid heightens the contrast between the dark subject and the light background so that one intensifies the other. Compare this with the student's sketch, where the muted background is too similar in tone to the subject, resulting in a certain lack of 'punch'.

Right *This student painting displays a realistic interpretation of the dark jacket and hat, but the overall effect is rather bland and predictable.*
Below *The same sitter sketched by Charles Reid. Here, intense colours are mixed wet-in-wet on the paper to create rich, resonant darks, and tonal contrasts are heightened.*

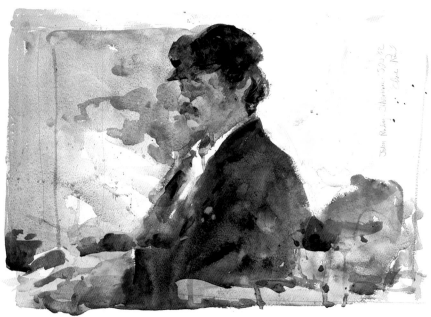

Avoiding muddy darks

Below are examples of some common faults when mixing darks, and how to correct them.

Too many colours Piling up layers of indiscriminate colour will wreck any feeling of freshness in your darks. The fewer colours you mix to arrive at what you want, the cleaner, truer and less muddy your results will be. Try not to use more than three pigments in any dark mixture.

Overworking Indecisive brushwork, rehashed passages, hesitant or picky statements – these are all apt to convey muddiness. To avoid this, you must know beforehand *exactly* what colour mixture you want to use. Test it out for strength first on a piece of scrap paper, then take a deep breath and work quickly and decisively.

Above *'House at Two Lights, 1927'
(after Edward Hopper), watercolour by
Charles Reid. You can learn a lot by
copying the works of master painters.
This painting is typical of Edward
Hopper's fascination with the play of
light and shadow on buildings.*

Composing with darks

The painting above demonstrates
how darks can be used not only as a
compositional element but to cap-
ture a sense of light and atmosphere.

Composition Use shadows and dark
areas to build up or strengthen your
composition and create 'lead-ins'
which direct the eye through the
picture. In 'House at Two Lights'
our attention is held by the pattern of
darks formed by the roofs, windows,
shadows and cast shadows.

Atmosphere Remember, it is the
presence of strong, deep shadows
that creates the impression of bright
light in the rest of the picture.
Imagine 'House at Two Lights' with-
out those colourful darks – it would
lose all its vitality.

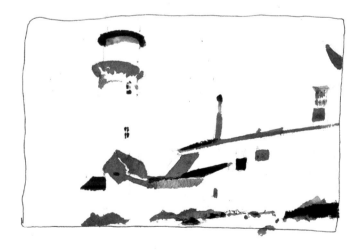

DARKS CREATE RHYTHM
In this sketch the pattern of darks has been 'extracted' from
the painting above. It shows how important the dark areas
are in making the picture flow and hold together. Notice that
most of the darks are connected – they're not scattered
about – and the eye travels from one to the other in a
pleasing, rhythmical way. Note, too, the predominance of warm colours
in the building on the right and the largely cool colours used
for the lighthouse. As well as lending extra variety to the
scene, this helps to back up the impression of depth.

Modelling form with colour

Modelling with colour means rendering the effects of light and shade on coloured objects to make them appear solid and real. Conjuring up a three-dimensional image on a flat piece of paper is one of the greatest challenges in painting, and calls for a knowledge of how colour is affected by light.

Creating shadow tones isn't just a matter of adding black to your colours; light affects colours in infinitely more subtle ways. For example, where an object turns into the light it takes on a warmer hue, and where it turns into shadow the colour becomes cooler.

To illustrate another effect, examine a red apple and an orange under a lamp – you'll see that the shadow side of the apple takes on a greenish tinge, while on the orange it tends more towards blue. This is because the shadows of an object always contain elements of that object's complementary colour.

Highlights, too, are not always white, but often reflect surrounding colours. When the light comes from a sunny, blue sky, the lightest spot on a red apple is likely to be pale blue; under artificial light, it may well change to yellow.

Rounded forms

Rendering the gradations of light and shade on rounded forms takes practice – in contrast to cubes there are no sharp edges neatly defining them. Instead, the light wraps softly around the shape and *gradually* becomes darker until it turns into shadow.

Yet watercolour, with its translucency and fluidity, is perfect for capturing these subtleties. Either work fluidly and let your colours merge, or build up overlapping transparent layers.

Below *Notice in this painting of a group of onions how artist David Millard builds up the rounded forms with transparent layers of colour, blotting the light areas with a tissue to create soft effects.*

☆ **COLOUR OR TONE?**
Do you get confused between colour and tone when painting three-dimensional objects? It helps to sort out the tones first by doing a monochrome sketch in pencil, charcoal or a neutral watercolour pigment like Payne's grey. Then, once you've established the pattern of lights and darks, you can concentrate on converting it into areas of warm and cool colour.

▯ **KEEP SHADOWS TRANSPARENT**
Don't ruin your painting with 'black holes' where shadows should be! Shadows are usually luminous, not opaque, and they often contain subtle areas of reflected light.

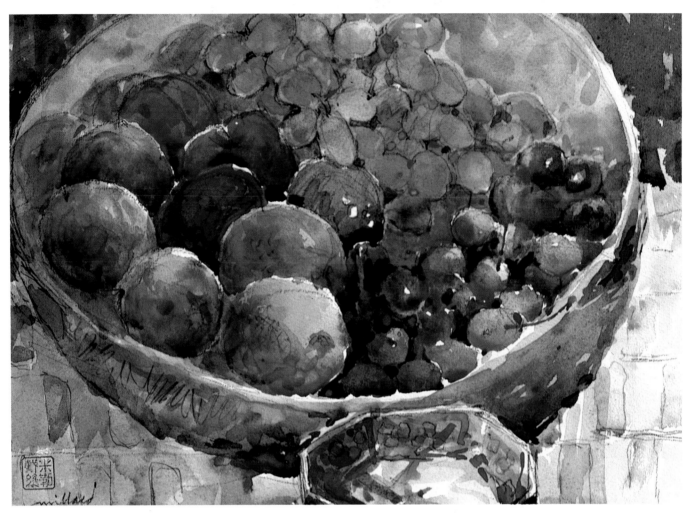

Above *Another still life by David Millard. The pale, luminous grapes contrast well with the deep, luscious darks of the cherries and plums, while tiny dots of white paper are left to indicate the shine on the fruit.*

Set up a still life

Painting fruits and vegetables is a good way to practise modelling form with warm and cool colours.

☐ Set up a simple arrangement on the kitchen table, lit by artificial light so that the shadows and highlights remain constant.

☐ Gather your colours. You'll need two or three to represent local colours, plus some warm and cool complementaries of these.

☐ Begin modelling the forms with colour. Where the shapes bulge, or move into the light, use warm colours. Use cool colours for the shadows and receding planes.

☐ Once you've mastered these simple shapes, try more complex, shinier objects such as bottles.

SPHERES IN LIGHT AND SHADE
This diagram depicts the effect of strong light from a single source on rounded forms. Note the placing of the highlights, mid-tones (local colour), dark tones (shadow areas), reflected light and cast shadows. Notice, too, how reflected light is bounced back onto the spheres from the other surfaces.

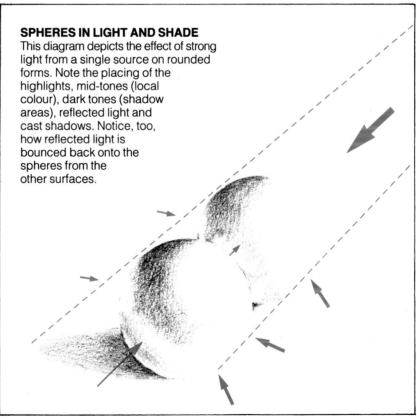

John Berry

Bowl and Fruit: demonstration

The best way to learn how to portray **1**
three-dimensional roundness in col-
our is to try painting some still life
objects from the kitchen, such as this
casual arrangement of apples, plums
and grapefruit by Claude Croney.

1 Outline the composition

Begin with a simple pencil drawing
to indicate the rounded shapes of the
fruit, plus the bowl and the edge of
the table. You needn't be too precise
in drawing these lines – they are only
guidelines and should not restrict the
freedom of your painting.

Dampen the background wall area
and paint it with a very loose mixture
of cerulean blue and yellow ochre.
Let more blue show in some places
and more yellow in others. Use a flat
no.6 brush and big, free strokes.

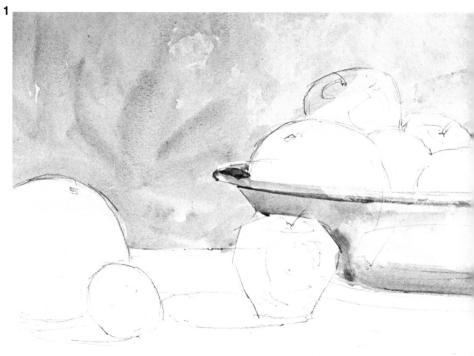

2 The grapefruit **2**

Paint the three grapefruit with a pale
wash of cadmium yellow. Note
where the brightest highlights are
and indicate them by blot-lifting
with a piece of tissue. Add some
yellow ochre to the cadmium yellow
and wash this over the shadow side
of the grapefruit.

To enhance the rounded effect,
add a touch of cerulean blue to the
mixture to create a cool, dark hue.
Use this for the deepest areas of
shade.

Keep the paint nice and fluid and
work the layers wet-in-wet so that
they blur together with no hard
edges. You can either blend your
washes carefully for a smooth effect
or, as the artist does here, let the
brushstrokes curve to follow the
rounded forms.

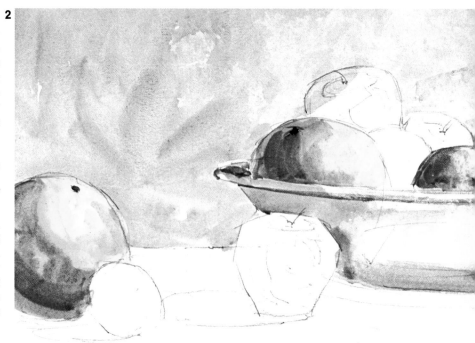

3 Continue modelling

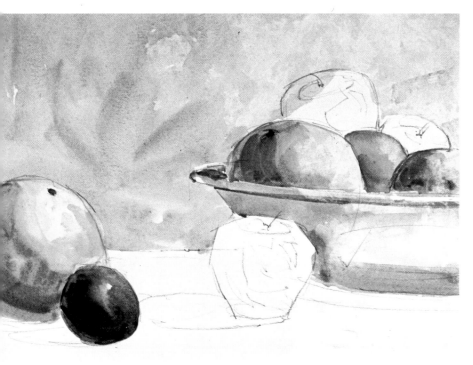

For the orange in the bowl, just behind the two grapefruit, start with a mixture of cadmium yellow and cadmium orange. Add an extra dash of cadmium orange across the top while the first wash is still wet, and a little cerulean blue to suggest a shadow further down. Finally, blot-lift a tiny highlight just above the shadow.

Use a round no.3 brush to model the plum in the foreground with short, curving strokes. This blue-black mixture is mainly ultramarine and alizarin with a hint of yellow ochre. Use more water on the light side and less on the dark side of the plum, and leave a spot of white paper for the brightest highlight. Gently blot-lift the area surrounding this highlight; this leaves a faint trace of colour that evokes the soft, bluish bloom of the plum.

4 The apples

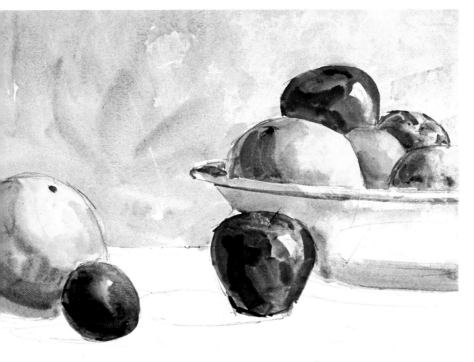

The apples require a more 'angular' treatment because they are not as smooth and rounded as the other fruits. Notice, too, that the highlights are brighter and sharper due to the shinier surface.

Begin the apples with a light wash of cadmium red and a little cadmium yellow, leaving clean white shapes for the highlights. For the shadow side, use cadmium red and alizarin; the darkest touches of shadow include a little Hooker's green. Add these dark strokes while the lighter strokes are still slightly wet.

Paint the apple at the back of the bowl with the same mixtures, but with more water. Making background objects paler and less distinct helps create a sense of depth.

5 Build up texture 5

Now it's time to 'anchor' the fruit to the horizontal surface of the table, which is painted with a flat no.6 brush carrying a fluid mixture of Hooker's green and burnt sienna. Make the brushstrokes irregular, some containing more green and some containing more brown.

Next, build up the texture on the background wall to give it the appearance of rough stone. Use free, erratic strokes carrying mixtures of cerulean blue, yellow ochre and a drop of burnt sienna.

The apparently random composition of this painting is in fact carefully planned. The vigorous brushstrokes in the background relieve monotony without being too 'busy'; they form a visual link between the fruit on the left and the bowl on the right, so creating a path through the picture plane.

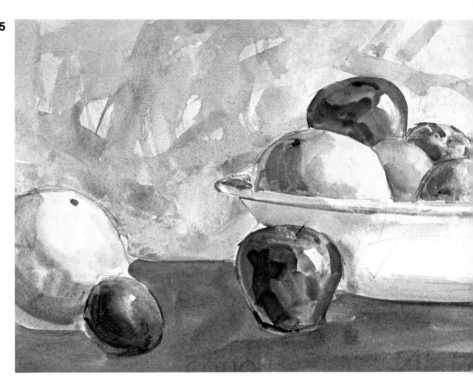

6 Add the shadows 6

Paint the cast shadows on the table and the shadows of the apple stems with a mixture of burnt umber and Hooker's green.

Darken the colour with more burnt umber and use it to paint the stems themselves. Using the same mixture, add more texture to the wall and the tabletop with a technique known as 'spattering', in which small droplets of paint are flung randomly onto the painting surface.

Spattering is a technique that should be used in moderation, but it is effective for giving a hint of texture without being obtrusive. One method of spattering is to tap a brush loaded with paint on the handle of another brush held in your free hand. Tap *gently*, holding the brushes about 4″ (10cm) above the paper.

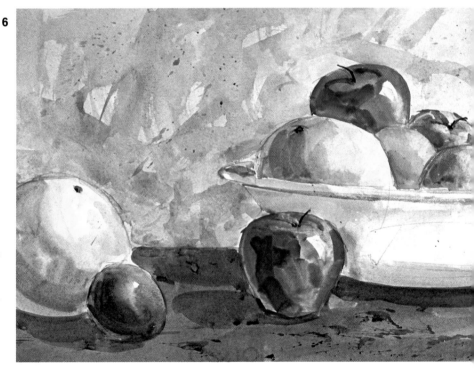

7 Add the final details

At this point the picture seems to need another dark note, so add a second plum at the back of the fruit bowl to balance the one in the foreground. This is an example of what's known as 'artistic licence' – it's perfectly acceptable to alter reality if necessary in the interests of a well balanced picture. When your painting is hung on the wall, nobody is going to know that the plum at the back of the bowl is fictitious!

Add the final details with the tip of a no.3 round brush and a fairly dry mixture of Hooker's green and alizarin. Paint a few broken lines on the tabletop to suggest cracks in the wood. When these are dry, use the corner of a sharp blade to scratch out some highlights on the edges of the cracks. Suggest the rough texture of the wood with drybrush strokes.

Notice, too, how the brushstrokes are left largely unblended to create textural interest. This is the artist's own personal style, but you may prefer to portray the round smoothness of the fruit by building up thin glazes of colour and dabbing with a sponge to create soft highlights.

Finally, darken the shadow on the side of the bowl with a blend of cerulean blue and yellow ochre. Notice the warm reflection of the apple in the shiny side of the bowl, painted with a pale mixture of cadmium red and cadmium yellow.

A question of style

In this painting the artist uses a very simple, gestural style which conveys a fleeting impression, rather than making a finished statement. This air of informality is reinforced by the composition; the grapefruit on the left and the bowl of fruit on the right are cut off at the edges, while background interest is provided by nothing more complicated than lively brushwork. This kind of still life makes a refreshing change from the standard setup of neatly arranged fruit and folded drapery.

EQUIPMENT USED
□ A sheet of 90lb Bockingford paper approximately 9″×7″ (23cm×18cm).
□ Two brushes: a flat no.6 and a round no.3.
□ A palette of ten colours: cerulean blue, ultramarine, yellow ochre, cadmium yellow, cadmium orange, cadmium red, alizarin, Hooker's green, burnt sienna and burnt umber.

Using a limited palette

Above *'Dartmoor Forest' by John Koser, watercolour, 19"×27" (47.5cm×67.5cm). This landscape demonstrates that it is possible to create a full-colour painting using only the three primaries – red, yellow and blue.*

Here the artist uses Indian yellow, alizarin crimson and phthalo blue in small splashes of colour: where these colour-splashes mix and interact they form vivid greens, browns and golds.

Many professional artists shun the use of a lot of colours on their palette at any one time. Though they may vary the palette from painting to painting, they usually retain a somewhat limited colour range, because in this way they can achieve a harmonious painting with a rich and complete 'feel' to it.

Restricting your palette to perhaps two or three pigments is one way really to learn about your colours and how to get the most out of them.

Monochromatic palette

You might like to try a painting using only one colour and see how much variety you can get into it. Use the white paper for the lights and the darkest tone of one colour for the dramatic dark punches. Side-by-side, these two provide the maxi-

mum contrast: it's how you use this contrast, and all the other tones in between the two extremes, that gives you a feeling of colour. You'll do best if you use a warm, dark colour such as burnt umber or sepia.

This exercise teaches you a valuable lesson: that the *arrangement of tones* in a picture is just as important as colour in creating a satisfying design.

Closely related palette

One way to achieve harmony in your paintings is to use an 'analogous' colour scheme; that is, closely related colours on either side of the colour wheel. For example, try combining red with a red-orange and a red-violet. The common component in these three colours is red, and this makes the painting harmonious.

Two's company

When you work with a limited palette, you learn a great deal about how your colours react with each other. Challenge yourself: pick one or two colours at random and see what you can do with them.

Artist David Millard made this delightful painting of spring lilacs using only two colours: mauve and green. Far from being a restriction, this allowed him to explore the full potential of each colour and he was able to use the knowledge gained in his future paintings.

Millard began with a soft, wet-in-wet wash of mauve-green. When this was dry he painted the bouquet of lilacs and leaves, mixing mauve and green for the stems and a few dark accents. Some of the flowers and leaves are heavily pigmented, while others are virtually tinted water, to create a pleasing range of tones.

Above *Don't forget, in watercolour you have the added advantage of being able to use the white of your paper as a third 'colour', without disrupting the overall harmony. In this painting by David Millard the bits of white left in the vase sparkle against the soft background wash, conveying perfectly the effect of shiny glass.*

Boat Yard: demonstration

EQUIPMENT USED
☐ A sheet of 140lb (290gsm) Bockingford paper, approximately 10″×8″ (25cm×20cm).
☐ Three brushes: a round no. 6, a round no. 4 and a size 0.
☐ A palette of eight colours: cobalt blue, light red, Naples yellow, burnt umber, indigo, burnt sienna, ultramarine and cadmium yellow.
☐ Masking fluid.

Boats and their reflections present a rich source of painting material. Their colours and shapes lend themselves easily to a harmonious composition, as they do in this painting by artist Richard Bolton.

In order to make a strong statement in paint, he uses a very limited palette – mainly indigo and light red.

1 Lay the first washes

Start by lightly outlining in pencil the main elements of the composition. The rowing boat in the foreground will be painted last because it is the lightest part of the painting; if you don't feel confident about painting around it, mask out the shape with masking fluid. It's also an idea to mask out such details as ropes and pebbles, as these smaller

forms will be difficult to paint around later.

Dampen the sky area, then paint the sky with broad bands of colour, using a round no. 6 brush. Use cobalt blue, light red and Naples yellow, allowing the colours to blend together on the paper. Paint these washes very thinly, merely tinting the background.

For the mud flats below, paint in a wash of cobalt blue and then burnt umber, tilting the board slightly to encourage the colours to run together. Paint these washes quickly, with a sweeping motion. As you near the bottom of the paper the brush will be drying out: take advantage of this – the drybrush strokes in the bottom left corner subtly suggest pools of water in the mud.

2 Paint the boats

This is the most important stage of the painting, for the broad tones are created by boldly constructing with large brushstrokes the mud flats and background jumble of boats.

The boats and the mud flats are painted in the same colours, to contribute to the overall harmony of the painting. Squeeze plenty of pigment onto your palette so there's no danger of runnng out halfway through the painting. It's a good idea to use a dinner plate as a mixing palette – although you are using the same three colours, you'll be mixing them in various tones from light to dark.

Paint the boats first, using indigo, light red and burnt sienna in varying strengths. Use a fairly dense mixture for the nearest boat; lighten it slightly for the middle boat; then paint the farthest boat with a pale tint. This progression of tones from dark to light conveys recession.

Using the same mixture of colours as for the boats, paint the mud flats with broad, sweeping washes. As in step 1, allow the brush to dry out as you reach the bottom of the paper, creating a broken-textured effect.

While the surface is still wet, paint the dark boat reflections with a mixture of burnt sienna and ultramarine. Use plenty of water, painting the shadows loosely to add a watery look to the mud.

Remove the masking fluid from the foreground boat and small background details. Paint the poles in the background with drybrush strokes.

HIGH AND DRY

Harbour scenes are everyone's favourite subject because they're so picturesque. But why not try painting a harbour when the tide's out? The boats are tilted on their sides, creating interesting shapes, and there's a wealth of pattern and texture to be found on the harbour bottom.

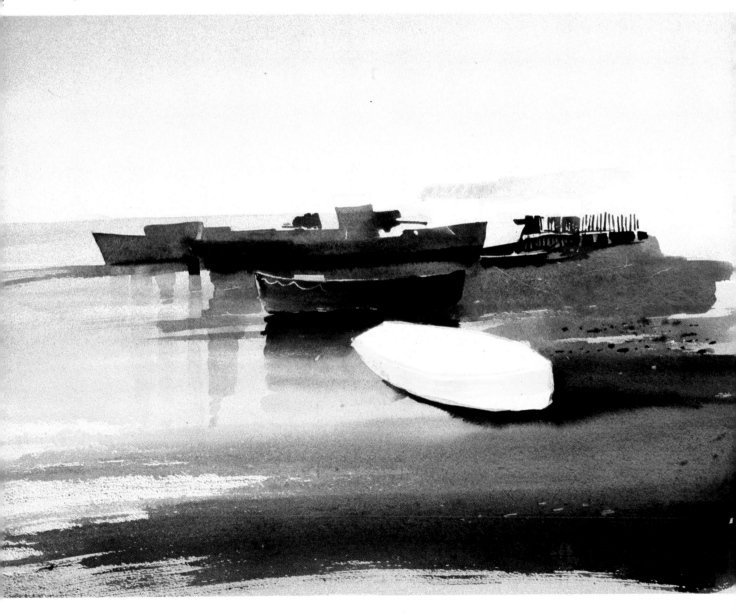

3 The foreground boat

The rowing boat in the foreground is important to the overall success of the painting, as a solid form and as a strong light area. As it forms the focal point of the picture, drawing the viewer's eye, it's important to give it interesting tones and depth.

Let the white of the paper act as the white paint on the boat. Using a round no. 4 brush, start painting the interior sides and seats of the boat a pale grey, created from a wash of cobalt blue with a touch of burnt sienna. For the shadows, darken the wash by adding more pigment to the mixture. Paint the bottom of the boat with a warm burnt sienna. Model the rounded shape of the boat's hull with a very pale wash of cobalt blue and burnt sienna, mak-

ing it darker underneath. Finally, lightly indicate the lines on the hull with a no. 0 brush and the same mixture of colours.

Allow the boat to dry completely, then fill in the details around the seats and oar-locks, again using a dark mixture of cobalt blue and burnt sienna. Take care not to overwork the details on the boat – its main function is to act as a white area against the dark background of mud and boats.

With a dark mixture of indigo, light red and burnt sienna, indicate a few stones and pebbles in the mud. Again, don't overdo it: a light scattering is all that's needed. Keep these details near the centre of interest and away from the edges of the painting.

4 The final details

Paint the row of boat sheds in the background, using a mixture of raw umber, burnt sienna and ultramarine for the roof. Indicate doors and windows with cobalt blue and burnt sienna.

Next, paint the masts and rigging on the boats in the background, using a no. 0 brush. This must be done with care – lack of brush control means that the lines could come out looking thick and clumsy, ruining your painting.

Use the paint quite dry and quickly sketch in the lines rather than labouring over them (it's a bit like using a saw, or an electric sewing machine – the faster you go, the straighter and truer the end result will be!). In painting, an *impression* says far more than a blow-by-blow account.

Although the boat forms in the background are essentially dark, they should be relieved by picking out little highlights with a brush and clean water. Finally, paint the funnel on the large boat in the centre, using cadmium yellow and a touch of burnt sienna.

The simple truth

The artist's main concern in this painting was to capture the clutter of the boat yard and yet retain the easy flow of the watercolour medium, which is all too easily lost when too much attention is paid to detail. And using a limited palette of harmonious colours helps to tie everything together in a unified whole.

Below *This painting has a very harmonious feel, but it is saved from becoming stilted and overcautious by the artist's use of quick, free brushstrokes.*

Extending your palette

Many watercolourists tend to stick to a palette of 'safe' colours – often rather dull ones – which they use again and again. Maybe it's because watercolour is very often associated with those grey, misty English landscapes! If your paintings lack that certain sparkle, perhaps the picture below will inspire you to let your hair down and try out some brighter colours.

In the sunny scene below, there's a lot of reflected light and colour, which the artist accentuates by contrasting cool blues and violets with warm pinks and reds. Where a beginner might only see grey in the shadows and white on the buildings, Tom Hill imbues everything with exotic colour to convey the impression of intense heat and sunshine. Among the colours used are blues (ultramarine, cobalt and manganese), reds (scarlet lake and permanent rose) and warm earths (raw sienna and burnt umber).

Below *'Summer Morning in the Market' (detail) by Tom Hill, 20″×15″ (50cm×37.5cm). Collection of Julia Cote.*
Vibrant yet well controlled colours convey the vitality of this sunny street scene in Mexico.

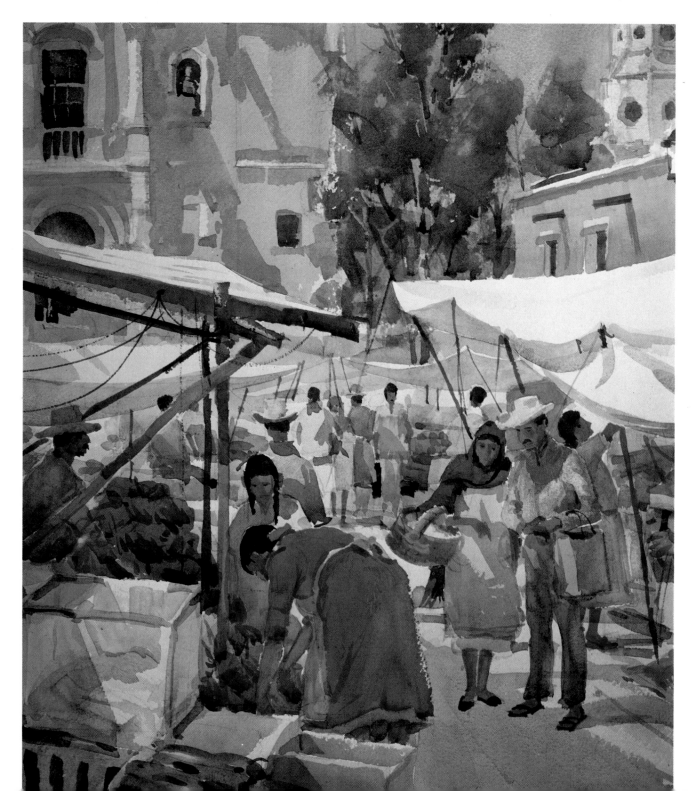

Colour style

Colour gives you an excellent chance to stamp your personality on your paintings. Every great artist develops a favourite palette of colours which becomes part of their individual style – think of Monet's shimmering blues, pinks and mauves; Bonnard's vibrant blues and oranges; or Rembrandt's rich darks.

Try 'borrowing' the colour scheme of a favourite painting and applying it to your own subject. It will increase your skill in mixing colours and using them expressively.

Choosing colours

When choosing colours, stick to variations of the main primaries (from which everything can be mixed) rather than picking them at random. Tom Hill's painting shows how colour can be exaggerated in a creative interpretation of a scene. But notice how well his colours are controlled.

Mix and match

Buy just one tube of colour at a time and try it out alongside your existing ones. The colour samples on the right are taken from artist David Lyle Millard's notebook.

These samples show the rich variety of hues obtainable by intermixing a small selection of colours. Try mixing all your reds with all your yellows to make a variety of oranges and pinks, then mix the blues with the earths to make interesting greys, and so on. This is the key to a more brilliant palette.

Right *Throw your hat in the air and try some new colour combinations. Some of the mixtures in the top section can be found in the painting on the opposite page.*

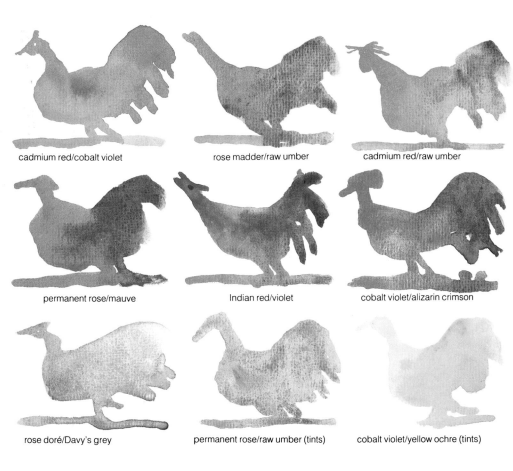

cadmium red/cobalt violet

rose madder/raw umber

cadmium red/raw umber

permanent rose/mauve

Indian red/violet

cobalt violet/alizarin crimson

rose doré/Davy's grey

permanent rose/raw umber (tints)

cobalt violet/yellow ochre (tints)

cerulean blue/light red

cerulean blue/rose madder

manganese blue/permanent rose

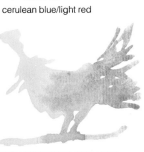

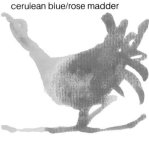

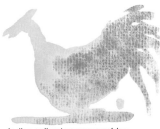

Naples yellow/manganese blue

cadmium yellow deep/cobalt green

Indian yellow/manganese blue

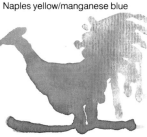

Hooker's green/manganese blue

Naples yellow/olive green

raw sienna/cobalt violet

Painting with pure colour

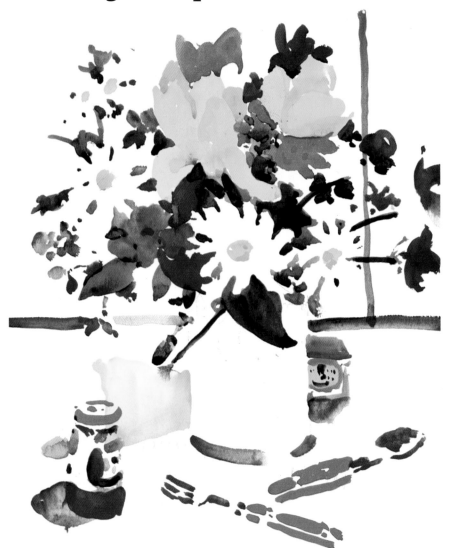

SOME NEW COLOURS

Manganese blue Transparent and non-staining, this cool blue makes wonderful granulated washes. Try it in skies.

Phthalo blue Just as ultramarine is the most useful warm blue, phthalo is the most widely used of the cooler blues. It is very powerful, so just add a touch in mixes. Its high transparency makes it excellent for glazes and atmospheric effects.

Permanent rose A deep, pinkish red – very transparent. It makes beautiful violets when mixed with ultramarine.

Light red A soft brick red. When mixed with ultramarine, it makes a subtle dark which is excellent for warm shadows.

Naples yellow A cool, transparent yellow, ideal for rendering the effect of sunlight. It also lends a soft warmth to other colours.

CHILD'S PLAY

Henri Matisse once said that he wanted to paint as a child of five saw. In other words, he wanted to capture a child's ability to see only the priorities, uncluttered by details.

The charming picture above was painted by Sarah Reid, aged seven. It may not look 'real', but it has that spark of life which says far more than many more finely manicured works.

Next time you paint, set yourself a strict time limit. This will force you to go for the essentials and you won't have time to reach the usual fiddling stage. Be direct and decisive!

Colour confidence

The essence of a good watercolour is freshness and translucency. But all too often, in an effort to make the subject look 'real', we muddle about too much with small details. The result is overmixed colour that looks grey and muddy.

If you've fallen into timid colour habits, here's an exercise designed to breathe some fresh air into your painting. It involves using unmixed paint straight from the tube and concentrating on local colour only.

Set up a simple still life like the one shown above, using flowers, fruits, vegetables, packaged goods from the kitchen cupboard or anything else containing strong colours. Paint the objects using pure, bright tube colour. You may need to add a little water to manipulate the paint, but don't mix any colours, soften edges, or show any form in terms of

Above Just as a monochrome sketch helps you to simplify tones, so a pure colour sketch makes it easier to simplify a scene containing complex colour mixtures.

Right The same still life, painted in the traditional way, retains its freshness and sparkle. Both pictures were painted by master watercolourist Charles Reid.

light and shade. Aim for a flat, poster-like effect.

Painting with pure colour forces you to make clear decisions, rather than relying on careful mixtures to get a colour 'just right'. It also gives you a better appreciation of the power of individual colours, so that when you return to mixing pigments in the normal way you handle them with more confidence. The result is nearly always fresher, more lively paintings.

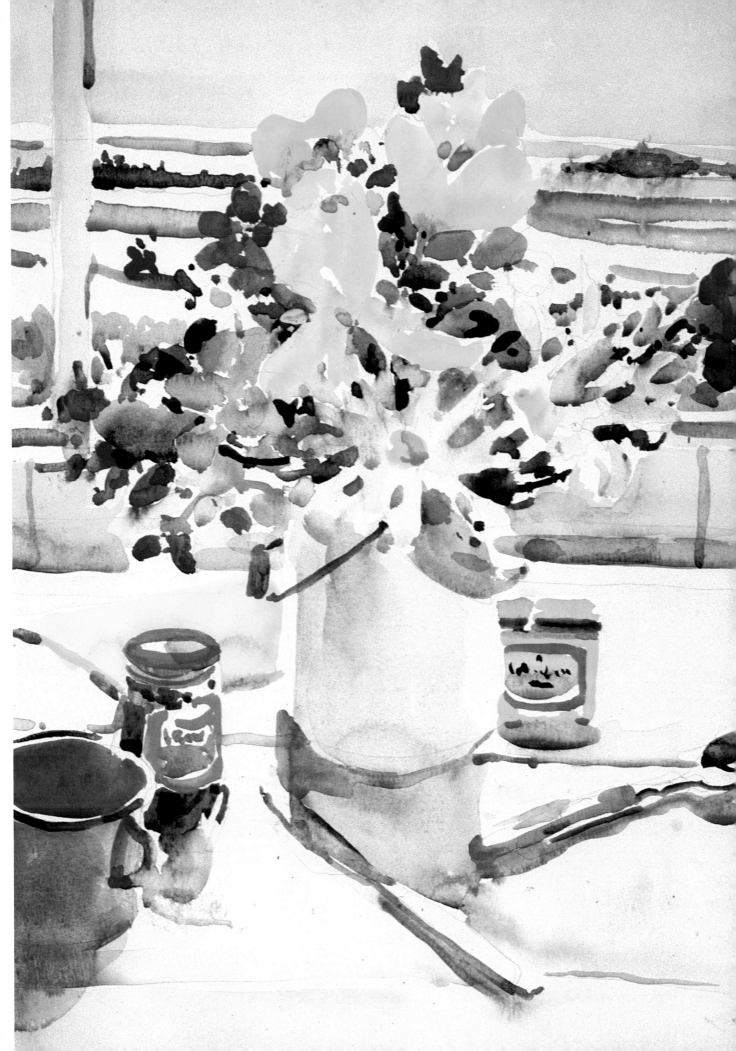

Creating impact with colour

Good paintings don't just happen – they have to be worked at! Often, it isn't enough merely to copy what you see before you – you must be prepared to exaggerate or re-arrange certain elements in order to produce a lively image on paper. Think of a painting as being a *poem*, rather than a news report; you are expressing feelings, not recording facts.

When you paint a picture, it's because something inspired you. What was it that stopped you in your tracks? Colour? Light? Shape? Work out what you want to say, then decide how to go about emphasizing your point so that the viewer feels the same excitement that you felt. Here are some ways that you can use colour to get your message across.

The painting of a vase of flowers on the left shows how you can 'push' bright colours by playing them off against a cool, neutral background. Arrange the cool colours around the warms, and the contrasting colours around the whites. Notice the variety of colour used in the leaves . . . blues, mauves, purples, right through to ochres and olives. The white flower is also significant – cover it up with your hand and see how the colours are diminished. On the following pages you'll find further suggestions for getting the most out of your colours. Try them out next time you paint – you won't look back!

Left *To accentuate the brilliant colours of the flowers, artist David Millard deliberately keeps the background a pale, neutral grey.*

Below *This detail shows how the brilliance of the flowers is emphasized by the deep darks of the foliage. Notice also the colours in the 'white' flower.*

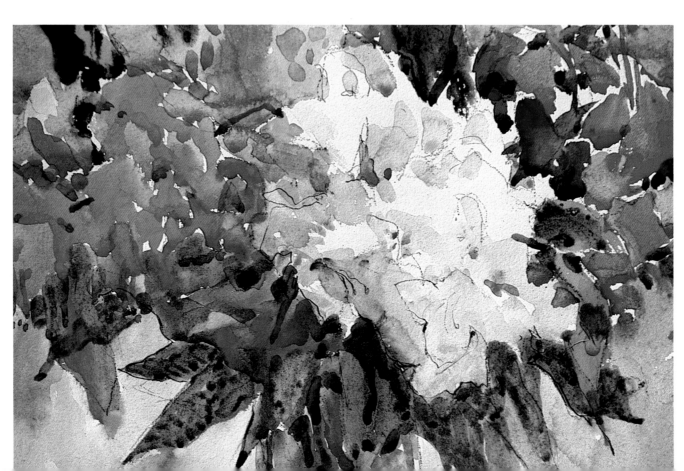

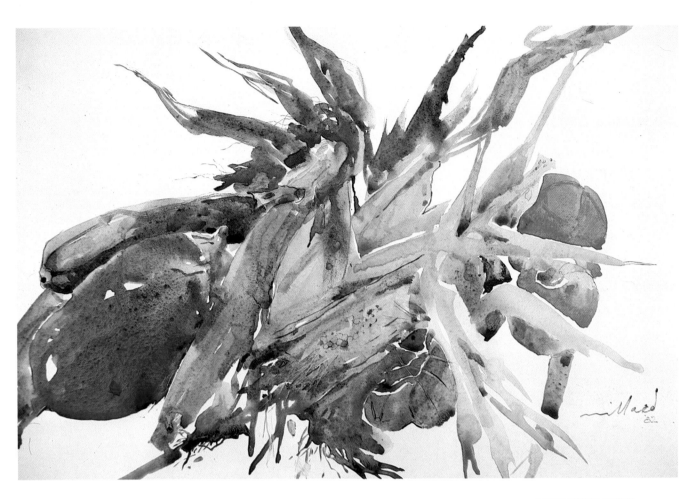

Colour placement

When you're setting up a still life, think about the arrangement of colours as well as the arrangement of objects. The impact of the painting above, for example, lies in the placing of small, bright accents in an overall muted scheme.

Vibrating colours

Experiment with unusual colour combinations which produce vibrating optical effects (you can find inspiration from the works of great colourists like Bonnard, Matisse and Odilon Redon). The painting on the right was inspired by something the artist saw on holiday – a huge basket of aubergines on a restaurant windowsill, with an inky blue sky beyond. The sky is painted with various mixtures of ultramarine, cerulean blue, ivory black and alizarin crimson. The aubergines, meanwhile, are a brilliant collection of deep pinks and violet burgundies (permanent rose, permanent magenta, cadmium scarlet and permanent mauve).

Above *Here, the muted colours of the background and the green vegetables allow the bright purples and reds to sing out strongly.*

Right *Notice how the tiny areas of white paper increase the brilliance of these exotic colours.*

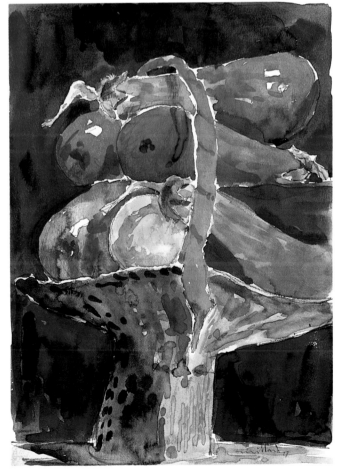

In a painting, every colour is influenced by the colour you place beside it. As the table below shows, a colour can be lightened or darkened, intensified or neutralized, warmed or cooled by its surroundings.

Colour looks	Next to
Darker	A lighter hue
Lighter	A darker hue
Cooler	A warmer hue
Warmer	A cooler hue
More intense	Its complement
Less intense	A similar hue

Use this theory of 'colour contrast' to get the most out of your paintings.

Paint light with colour

How do you express, with colour, the brilliant light of a sunny day? To capture the feeling of light, there are three things you can do: use high-key colours, placing *complementaries* near each other if possible; include strong *shadows* (otherwise the painting will look washed-out); and leave *white shapes* that let the air in.

The painting below is composed mainly of blues and oranges – complementaries that intensify each other and set up a shimmering effect. The contrast between deep shadows in the foreground and light colours on the buildings also spells 'sunshine'.

Invented colour

You don't *always* have to paint realistically. Use colour creatively to express your feelings. Often this can turn a dull painting into something exciting and original.

David Millard painted the harbour scene (opposite, top) on a very hot day. While the other artists around him were busy painting green boats in grey-green water, Millard was using hot pinks and oranges! He painted the scene the way it felt – not the way it looked; this combination of hot colours and sparkling slivers of white convey the impression of blistering summer heat.

In the smaller painting beneath it, a softer, more delicate palette is used to convey an impression of cool, early morning light.

Below *This picture is full of light, achieved through a harmonious blend of complementary colours.*

Top right *Here the artist invents his own colours, to convey what he feels, rather than what he sees.*

Bottom right *This time the colours are less intense, lending a quieter mood.*

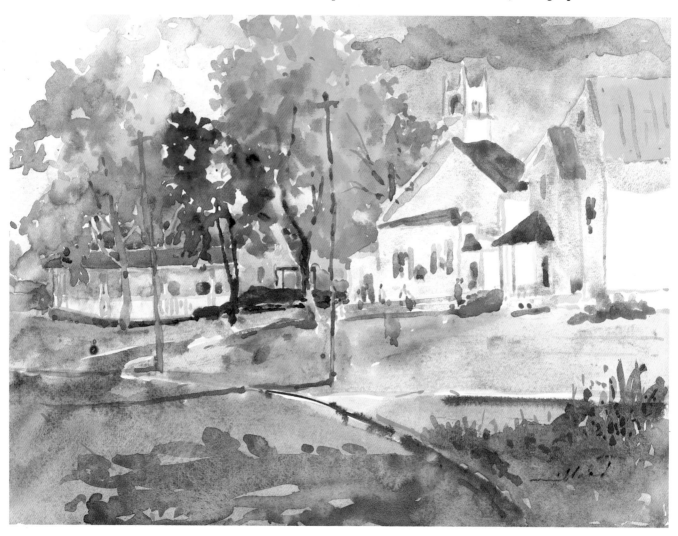

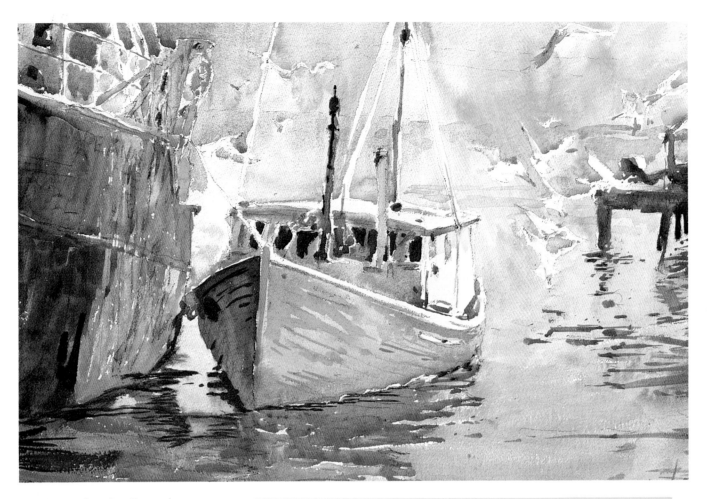

Summing it all up

To produce an expressive painting – one that clearly communicates your thoughts and feelings – you must carefully select and organize your colours to reinforce the qualities you wish to convey. Here is a brief resumé of ways to create impact with colour:

Contrast warm and cool To accentuate bright colours, place them next to cool, neutral ones.

Use complementary colours Complementary colours intensify one another. Use red against green, or orange against blue to create eye-catching effects.

Invent colours Choose colours that convey your emotional response to your subject. For example, express the excitement you feel about a winter snow scene with colours totally unrelated to your subject, such as yellows and oranges.

And finally . . . don't forget that white – the white of unpainted paper – is your most brilliant colour. Use it to breathe light and air into your paintings.

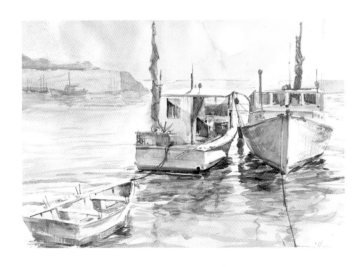

HARMONIOUS COLOURS

A painting that contains too many colours can look spotty and disjointed. Try to simplify the colour scheme; this not only gives greater clarity to your painting, it also establishes the mood you want to convey.

The painting at the top of this page uses a harmonious blend of pinks, reds and ochres to convey the impression of intense heat. In the smaller painting, muted yellows and greys make us think of the cool light of evening.

Planning white areas

With an opaque medium such as acrylic or oil, you can paint dark and light areas in any order. But transparent watercolour must be painted in a systematic way, working from light to dark – once the paper is tinted with colour there's no going back!

In pure watercolour the lightest areas are attained by leaving the paper white, and their forms are described by the contrasting darker areas surrounding them. (Other methods of creating white areas are using opaque white and masking fluid. For more details see p.122 and p.128 respectively.)

White areas, then, are not added but left. So you have to work out how to organize and place them *before* you start painting. The best way to do this is to make a small tonal sketch like the one below, then follow the sketch when you start painting in colour. Copying a holiday snapshot is a good way to practise the technique since the snap is likely to contain strong patterns of light and dark created by brilliant sunlight.

First make a simple contour drawing of the photograph. Don't bother with detailed accuracy, but concentrate instead on mapping out the areas of light and shade. (Remember that squinting at the photo helps to simplify it into tones.) Follow by painting the drawing in black and white, leaving bare paper for the light tones and then filling in around them with dark and medium grey washes.

Strength, clarity and breadth of effect are the aims in watercolour, and your tonal sketch helps you to keep this in mind. Refer to it constantly when painting the picture in colour so that you don't get bogged down in unnecessary detail.

The importance of whites

Whites and light areas have a very positive part to play – they have a visual force equal or superior to darks. While dark areas absorb light and appear to contract, light areas reflect light and seem to expand. Design light areas with care, placing them on or near important areas.

Whites can also inject a sense of mystery into your watercolours; if you leave some things undefined, half suggested, you invite the viewer to participate, and in this way you play on his imagination.

The painting by Charles Reid on the opposite page is a good example of how to 'say more with less'. The artist wanted to make a statement about the brightness of Mediterranean light – how it bleaches out colours and bounces off the surfaces of objects. He does this with great economy, reducing the scene to patterns of light and shadow. He draws a rough outline of the scene, mixes his colours loosely and lets his brush scuttle over the paper, leaving interesting 'breathing spaces' of white which suggest the dappled play of light shining through the trees. Notice how the sky is also left white; if he had painted it blue he would have deadened the effect.

If you're a bit nervous of this free approach, remember that the more you paint the more confident you will become. One day something will click, you'll feel in tune with the medium, and you'll know instinctively how to achieve the effect you want.

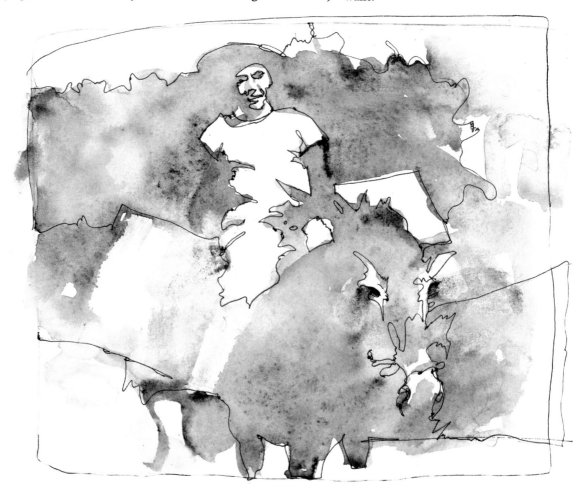

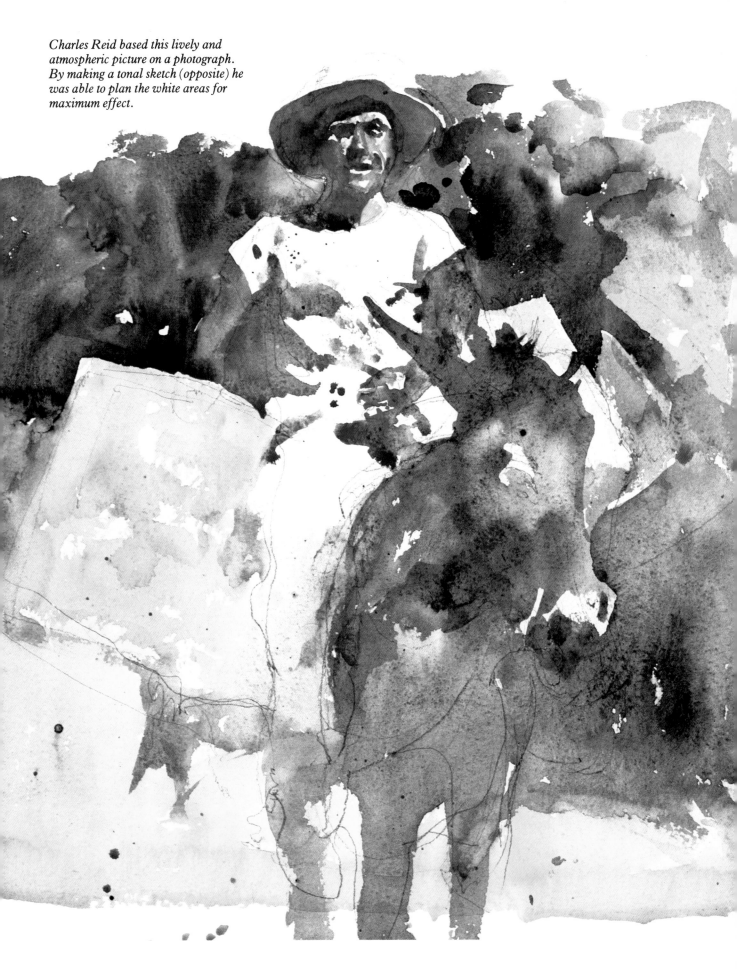

Charles Reid based this lively and atmospheric picture on a photograph. By making a tonal sketch (opposite) he was able to plan the white areas for maximum effect.

Using white space

The essence of a good watercolour is freshness and spontaneity, and this results from knowing what to leave out of a painting, rather than how much to put in. Would-be painters often make the mistake of thinking they must fill every inch of space with colour: in fact, with watercolour this is neither necessary nor desirable.

Think of the white of the paper as being another element in your palette of colours. White has great visual strength, and when it is surrounded by deep tones it takes on a very attractive, glowing quality. In the still life with garlic (below left) the whites seem to 'sing out' because they are surrounded by rich, deep colours.

In the tropical scene (below right) the white of the paper plays a major part in defining the atmosphere of the scene. The whole picture dances with light because the shadow areas are broken up with little patches of white – the highlights on the figures, for instance. These patches also help to relieve the angular shapes of the buildings.

Train your eye to see the various shades of white by making quick tonal studies, keeping the white paper as your lightest tone. Set up a still-life of white objects, or simply observe the patterns of light and shade on a sunny white wall. In '*June Flowers in My Studio*' by Philip Jamison (opposite), the artist begins by leaving the table and much of the background pure white to establish the bright highlights. Then he builds up the shadows layer upon layer – in some places the merest hint of a shadow is suggested by simply brushing on a wash of dirty water. The daisies are painted with opaque white, because their shapes are too complex to paint around.

Because of their brilliance, whites have the power to guide the viewer's eye throughout your composition. In the harbour scene (opposite) the vertical pattern of whites holds the attention: starting with the bright colours of the fishing boat, the eye follows the white pilings to the sail, then back round via the sail's reflection in the water and the white gunwale of the dinghy. Be on the lookout for interesting white patterns like these.

WHITE FRIGHT?

Don't be afraid to leave large areas of white space in your paintings. Watercolour paper provides a unique, translucent white not available in any other medium. It's too valuable to ignore!

☆ LEAVE WHITE LINES

If you want to paint colours next to each other when they're still wet, leave a tiny white line between them. You'll find this adds a sparkle and vivacity to the colours.

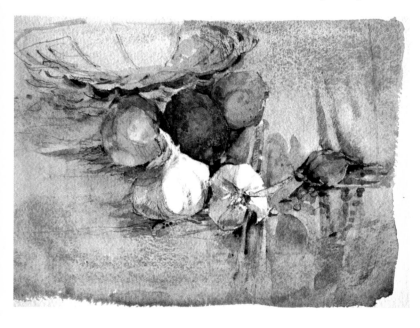

Above *A still life study of garlic and limes, by David Millard. The whites have impact because of the intensity of the surrounding colours, especially where the dark green lime defines the shape of the garlic in a hard edge.*

Right *A tropical scene taken from David Millard's watercolour sketchbook. Almost a third of the picture space consists of white paper, which captures the effect of the intense afternoon sunlight and allows the painting to 'breathe'.*

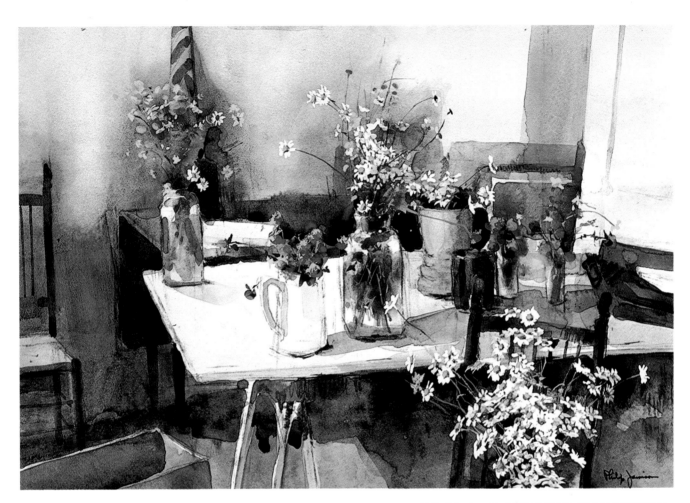

Use your paper wisely

White is the most reflective colour and you can use this quality to good effect in your paintings. When transparent colours are applied straight from the palette, it is the whiteness of the paper that makes them appear bright and clean. But when those same colours are diluted with water, the white paper can lighten and subdue them to add mystery and subtlety to your work.

Think about the texture of the paper too. The surface of a good quality rough paper has a definite tooth and when a colour wash is laid sparingly over the top the pigment may get trapped in the hollows or it may adhere to the peaks.

In either case this leaves tiny dots of white which cause the wash to sparkle with light – the perfect effect if, for example, you want to paint sunlight reflecting off the surface of a river or lake.

Never forget that watercolour paper can produce effects which in other mediums must be painted. All you have to do is use it wisely.

Top *'June Flowers in My Studio', Philip Jamison, watercolour, 12″×18″ (31cm×47cm). In this picture the artist has cleverly turned his white space to two uses – as a colour (for the table top) and as a way of showing the bleaching effect of summer sun.*

Above *Sketch of a harbour scene by David Millard. By using white space to represent sails, their reflections, the boat hull and the harbour wall pilings, Millard sets up a pleasing rhythm which runs right across the sketch and ties it all together.*

Harbour Cottages: demonstration

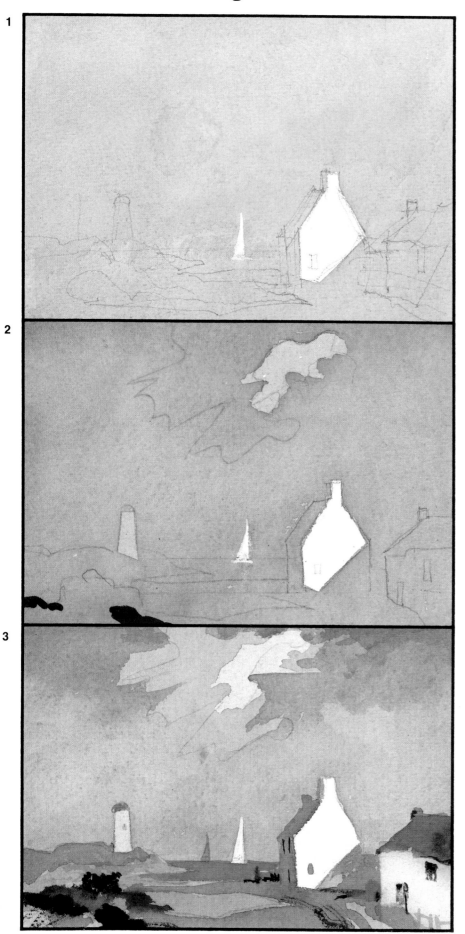

This sketch by famous watercolourist Rowland Hilder captures a fleeting moment when the sun shines brilliantly through a gap in the clouds.

1 Map out the whites

Make a rough contour sketch of the main shapes in the scene, including the patterns of light and shadow. Mix a thin wash of cerulean blue with a touch of raw umber and brush this over the surface of the paper, leaving the whites to stand out.

2 Establish the tones

When the first wash is dry lay a second wash of the same colour over it, except for the small cloud and the lighthouse. Put in the two deep shadows in the foreground rocks (a strong mix of cerulean blue, raw umber and viridian). Now you have established your dark, mid and light tones, and the whites stand out effectively.

3 Complete the sketch

Add a wash of cerulean blue to the sky area, starting at the top of the picture and graduating it from dark to light by adding more water to the paint as you move down to the horizon line. Don't be finicky here – this is a sketch, and all the freshness will be lost if you overwork your brushstrokes. Load the brush with paint and sweep it over the paper, skipping round the outlines of clouds and buildings. Then allow the wash to dry without touching it again.

Using a no.4 brush, add a slightly stronger wash of blue to the patch of sea. Work in some foreground details and shadow areas with a very watery mix of cerulean blue, raw umber and viridian. (For convenience you may prefer to use Davy's grey instead – a useful colour to add to your basic palette.) Note that the lightest cloud appears to be white, although it is a whole tone darker than the house.

EQUIPMENT USED
☐ A sheet of medium textured paper, about 11″×8″ (27cm×20cm).
☐ A round or flat no.10 brush and a round no.4 brush.
☐ An HB pencil.
☐ A limited palette of colours: cerulean blue, raw umber and viridian.

Yacht Race: demonstration

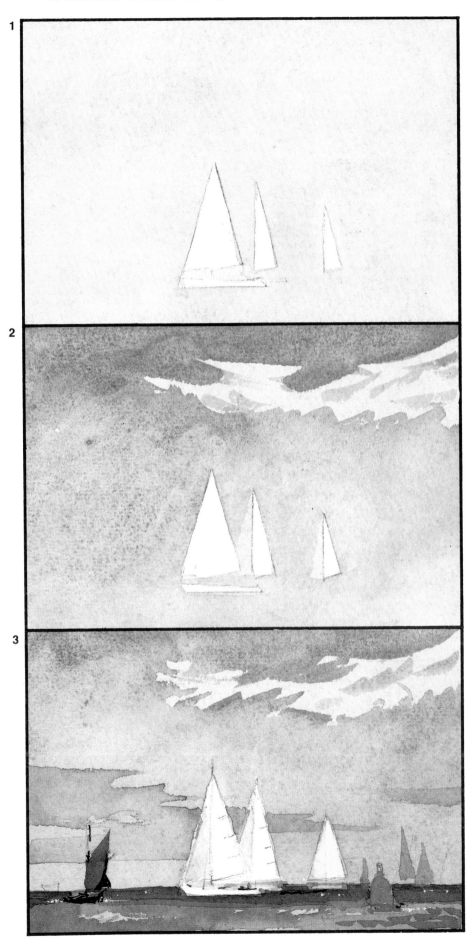

Here's another demonstration by Rowland Hilder, showing that a sketch can often say just as much as a full-blown painting.

1 Map out the whites

Outline in pencil the areas to be left white. Mix a very pale wash of raw umber (mix more than you think you'll need – you don't want to run out halfway!) Lay this in a flat wash over the paper, leaving the white boat sails unpainted.

2 Paint the sky

When the first wash is dry, add a wash of cerulean blue, graduating it downwards from dark to light and leaving just a few hard-edged shapes high in the sky to give the impression of scudding clouds. Here the shadowed areas of the sails have also been left, to be completed in the final stage.

3 Add the final details

Paint the sea with a mix of cerulean blue, burnt umber and ultramarine varying the tones to give the effect of waves. Leave little flecks of the pale undertone here and there for the wave crests. Add the lower strips of dark cloud with a paler version of the sea mixture.

There is barely any linear perspective in this scene, but you can achieve the effect of distance by using colour perspective. Use a pale wash of grey to touch in the background sails, barely discernible in the distance. Bring up the foreground by introducing a note of bright colour – in this case the red buoy (a device often used by the old Masters, Turner in particular). This bright, slightly opaque accent is balanced on the left of the picture by the rich darks of the fishing smack (ultramarine and raw umber).

Finally, use a no.4 brush to touch in the smallest details: the shadows on the sails, and the tiny figures in the nearest boat.

EQUIPMENT USED
☐ A sheet of medium textured paper, 11″×9″ (27cm×20cm).
☐ A no.10 brush and a no.4 brush.
☐ A limited palette of colours: raw umber, cerulean blue and ultramarine.

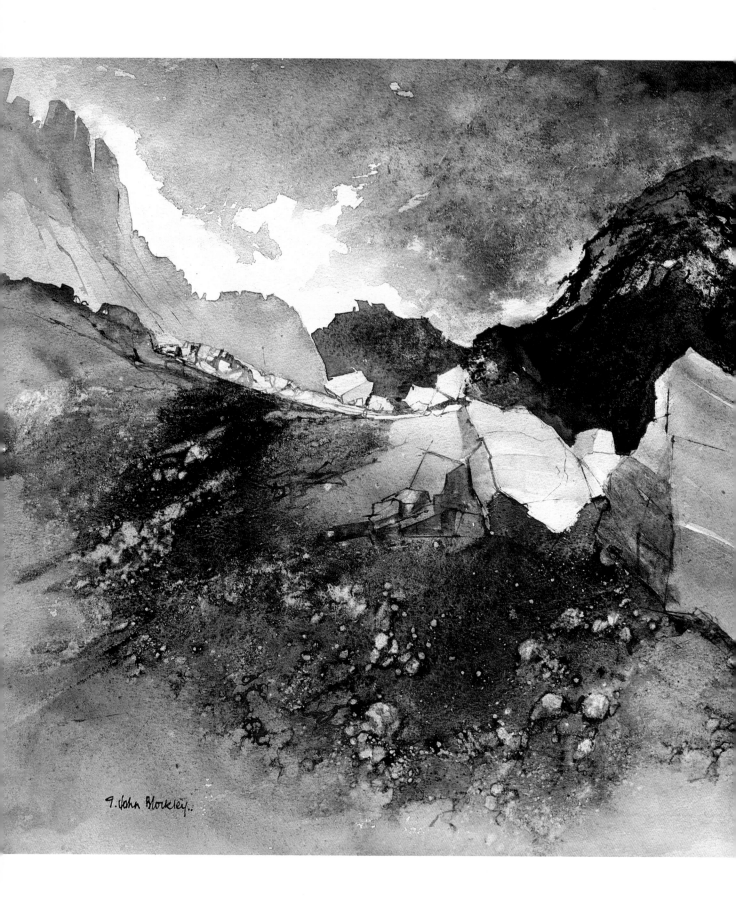

G. John Blockley..

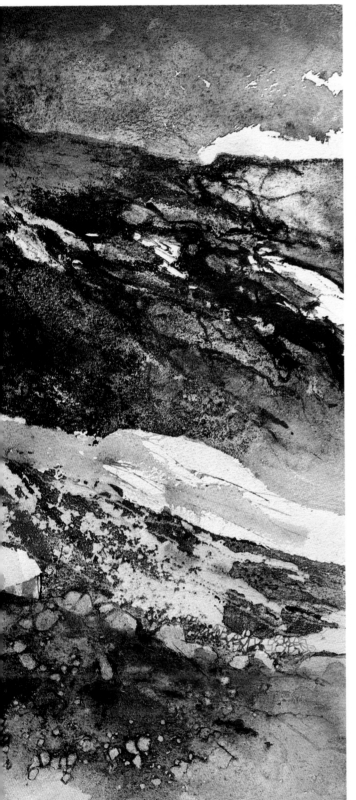

3

SPECIAL TECHNIQUES

Watercolour painting is always exciting because it is never quite predictable; when pigment and water interact with sparkling white paper, unexpected things sometimes happen and the medium takes on a life of its own. The skill of an artist lies in knowing how to take advantage of opportunities that arise, to manipulate the blend of pigment, water and paper and to use them as a means of describing the subject.

In addition, it is possible to *control* the effects you want by using special techniques such as those described in this chapter. A single drybrush stroke, for example, can evoke the sparkle of sunlight on water, while expressive lines and textures can be created by scratching and scraping.

It is this combination of skill and unpredictability that gives watercolour such a wonderfully fresh, lively, spontaneous feeling.

'Llanberis Rocks', John Blockley, 15"×21" (38cm×53.5cm). Some of the foreground colour was blotted with a rag to suggest stones.

Drybrush painting

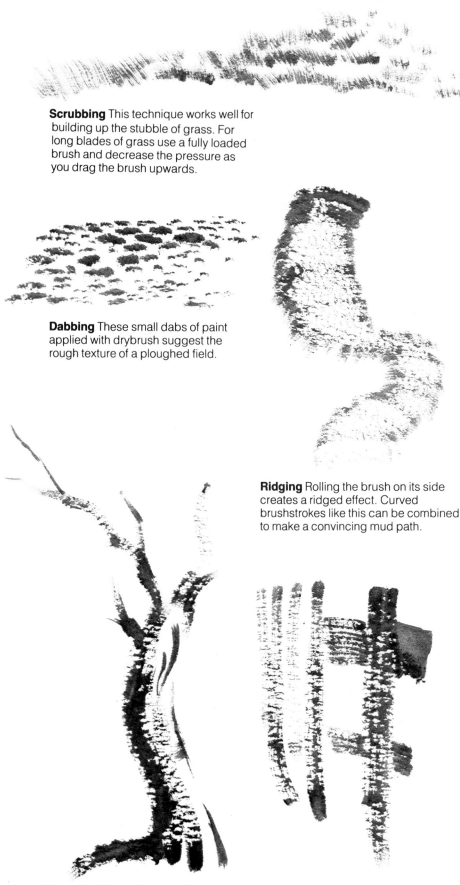

Scrubbing This technique works well for building up the stubble of grass. For long blades of grass use a fully loaded brush and decrease the pressure as you drag the brush upwards.

Dabbing These small dabs of paint applied with drybrush suggest the rough texture of a ploughed field.

Ridging Rolling the brush on its side creates a ridged effect. Curved brushstrokes like this can be combined to make a convincing mud path.

Smearing These almost calligraphic strokes could represent wooden fencing, or some spindly branches in the background.

Drybrush is a technique in which paint straight from the tube is mixed with little or no water and applied to dry, rough-textured paper. The paint is caught by the raised 'tooth' of the paper, leaving some parts still white.

Drybrush strokes have a fascinating ragged quality that is ideal for suggesting textures such as tree bark, grasses, wood, and clusters of foliage. It is particularly useful to the watercolourist, since it allows you to give the impression of detail without actually having to portray it.

In the painting opposite there's an interesting contrast between the loose, drybrushed texture of the door and the detailed rendering of the doorlatch and padlock. The picture has been enlarged so that you can see the important role played by the paper's own texture.

Making marks

Try some experimental brushstrokes like the ones on the left. Use a lightweight rough-textured paper but don't bother to stretch it as you're not going to use much water. When it comes to brushes, the more shapes and sizes you have, the more strokes you can make.

Squeeze a mound of pigment onto your palette. Dip the brush in water, then blot it with a tissue so that it is only damp, not wet. Pick up some paint – not too little, not too much. Hold the brush at an angle of 45° and drag it lightly across the paper in quick, continuous strokes.

Make as many of these marks as you like, from short, stippled ones to long, curving strokes that suggest natural forms. Try using different paper surfaces, and use the side of the brush as well as the tip. In this way you'll soon build up a repertoire of textural effects which you can use in your paintings. Here are some more suggestions:

Foliage Jab the tip of the brush headfirst into the paint, then dab gently on the paper.

Wood grain Use a very dry brush and drag it lightly across the paper, varying the pressure.

Water Use slightly thinner paint and apply it quickly with long, light brush strokes. This leaves a slight speckle that looks like the shimmer of light on the surface of water.

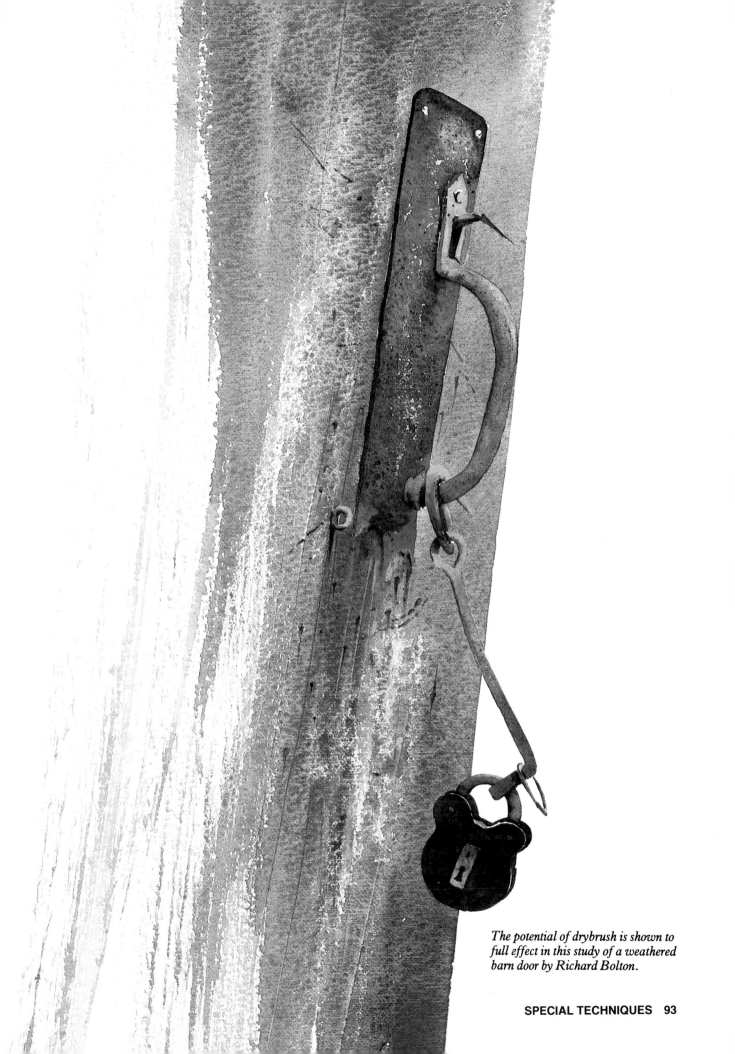

The potential of drybrush is shown to full effect in this study of a weathered barn door by Richard Bolton.

Drybrush in landscapes

Chinese brushes
Some of the major art suppliers stock Chinese brushes which are made from goat or badger hair set in a bamboo handle. As well as being cheaper than normal watercolour brushes, their versatility makes them a good buy. The fairly coarse, strong bristles are perfect for drybrush work, and they are equally as capable of producing fine, delicate lines when the brushes are used in the normal way.

Quick, decisive brushstrokes are a key element in watercolour painting. The more you fiddle around with a watercolour, the more likely you are to lose sparkle and spontaneity; the drybrush technique is valuable, for it can suggest detail without appearing overworked.

Nowhere is this more apparent than in landscape painting, where the versatility of drybrush comes into its own. The strokes are bold, expressive and full of movement, lending themselves perfectly to subjects like a raw, rocky terrain or a turbulent storm. But you can get delicate effects too. Drybrush strokes laid over a wash create an illusion of transparency because you can see the wash through the drybrush marks. Drybrush is often used when painting the veins on a leaf, or the delicate bloom on a petal.

The slightest touch of drybrush can have a dramatic effect on the sense of space in your picture. Apply it right at the end, when your background washes have dried, and the picture will suddenly click into focus. In the painting opposite, the sharply defined drybrushed details in the foreground contrast with the soft background washes to create a feeling of depth.

Drybrush work is in effect 'drawing' with the brush. Don't labour it; use the same quick, confident movements that you would with a pencil sketch. Part of the joy of watercolour is that what seems like a haphazard technique can often produce just as accurate and sensitive a painting as hours of meticulous work in another medium.

Below *Here the artist uses drybrush to capture the movement of the tall grass and the impression of light glinting on the wet, muddy track.*

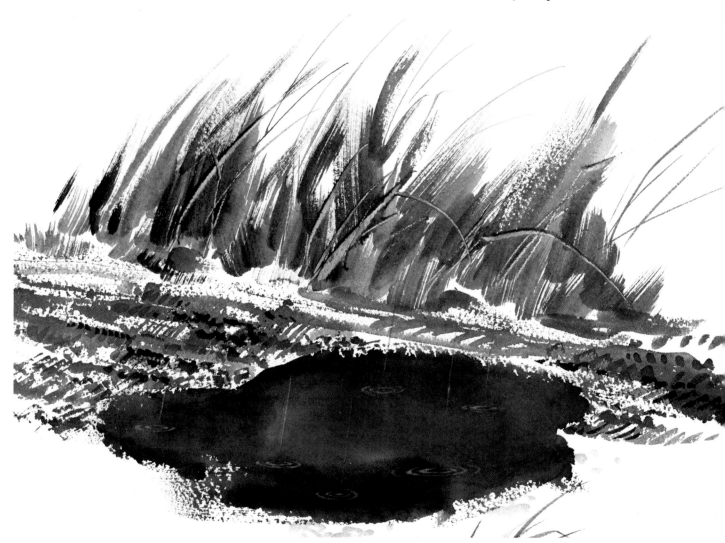

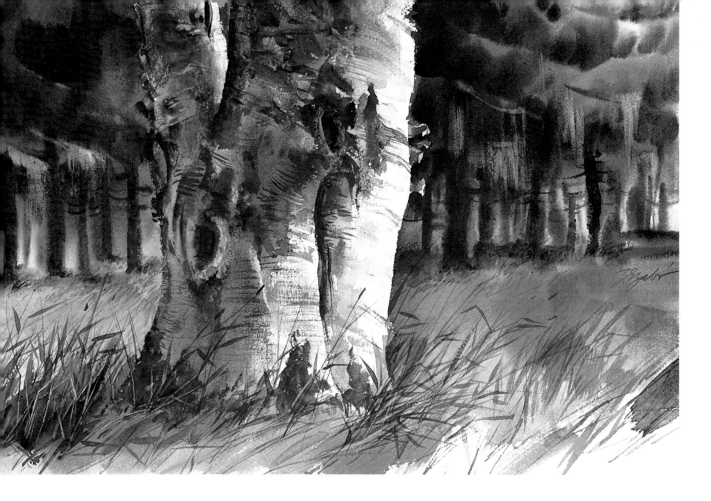

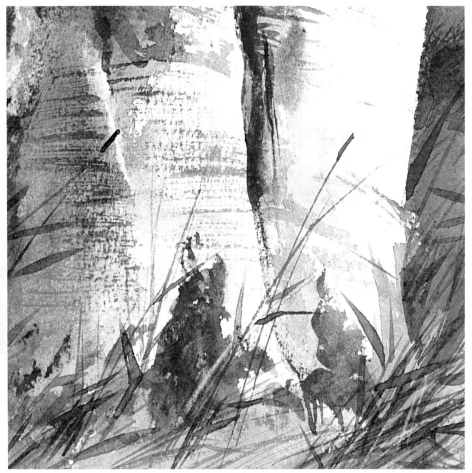

Above *'Lone Performer' by Zoltan Szabo, watercolour, 15"×22" (38cm×56cm). Detail shown left.*

Putting drybrush to work

In the painting above, Zoltan Szabo complements soft lighting with the lively texture of drybrush.

He starts by using cadmium yellow with a little viridian for the lush forest grass, then adds burnt sienna to paint the dark spruce trees. The colours are mixed loosely on the paper wet-on-wet, allowing pure viridian to show through where the light catches the trees.

The birch tree consists of varying blends of burnt sienna, cadmium yellow and viridian, diluted with plenty of water on the lit side. The bark and scar textures are then softly modelled while this wash is still damp.

The final touches are added with drybrush strokes, as shown in the detail left. Short, horizontal dabs of raw umber suggest the texture of the bark, while at the foot of the tree the sharp-bladed grass is defined by long, upward sweeping strokes.

Scratching and knifing out

TRY IT OUT FIRST
Before attempting any technique for the first time, it's worth doing some experiments on a piece of scrap paper. Lay a dark wash over the entire sheet, then scratch and knife out a variety of marks at different stages of wetness to see what effects you get.

TOOLS FOR THE JOB
Raid the tool box or kitchen drawer for suitable sharp instruments. You can use the edge of a coin, ice lolly stick, butter knife or plastic credit card for knifing out, while a mapping pen, cocktail stick, or even your thumbnail will scratch out more delicate shapes.

❗ ONE WAY ONLY
When scratching out with a razor blade for a really sharp, clean white, you can draw the blade over the same area several times. However, don't move the blade back and forth – it will destroy the surface of the paper.

Although brushes are the primary tools of watercolour painting, there are a number of 'technical tricks' that you can perform with other implements. Knives, razor blades and the pointed end of the paintbrush handle can all be used to create lines and textures in a wash. Scratching the surface with a sharp point creates delicate linear effects, while scraping with a blunt edge picks out broader areas.

Scratching wet colour By scratching into a wet surface with the tip of the brush handle, you can make darker lines in the wet pigment. This is because the scratched line soaks up pigment faster than the surrounding wash. Use this method for dark branches, twigs and grasses – it produces a sharper line than you can obtain with a brush.

Scratching dry colour When the paint is bone-dry, use a craft knife or the sharp corner of a razor blade to scratch away the dried colour and reveal the white paper underneath to suggest delicate twigs and grasses, or sunlight on water.

Knifing out of wet colour With a blunt tool such as the rounded blade of a butter knife, you can scrape out some of the colour to create lighter areas in a dark wash while it is still wet. This is useful for rendering muted highlights such as shiny, wet rooftops or the lit side of a tree trunk.

Knifing out of dry colour Lighten the sunlit side of a tree trunk, cloud or rock, by using the flat edge of a knife to gently scrape away *some* of the colour so that the underlying paper begins to show.

Below *In this impression of a heavy downpour, Zoltan Szabo uses the corner of a razor blade to gouge out the rain splashes on the ground.*

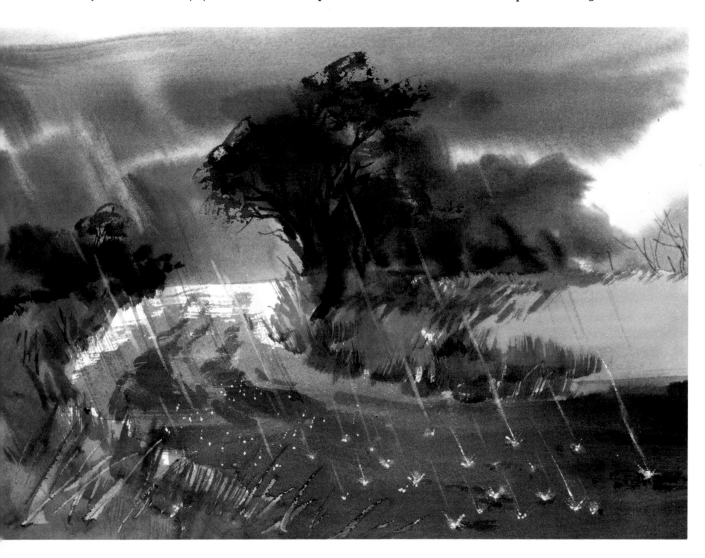

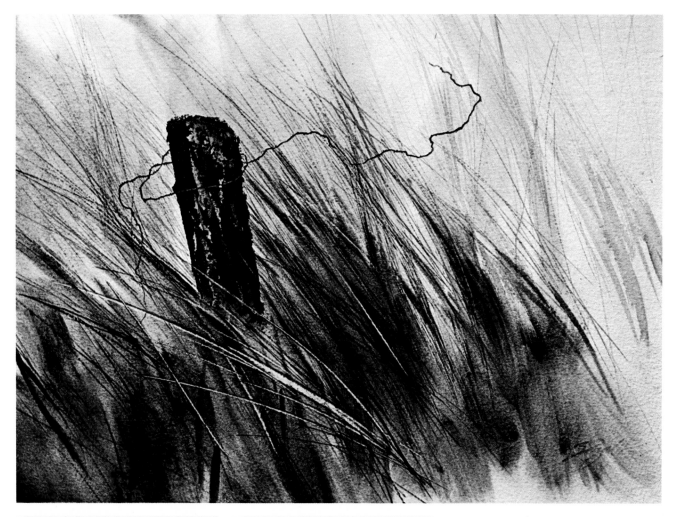

Above *A commonplace subject, delivered with energy and verve. Zoltan Szabo starts with loose washes and then drags the paint with the end of his paintbrush to suggest windblown grass. Finally, he jabs a few sharp knife strokes into the damp paint for the lighter grasses.*

KNIFING OUT

Wet colour Use a blunt tool such as the edge of a coin to create light lines in a dark wash. Press the coin against the paper and push aside the wet colour the way you'd scrape butter off a slice of bread, but don't dig in and create a groove which will fill up with paint.

Dry colour Knifing out of dry colour requires a sharper instrument. Use the broad side of a razor blade – held vertically and with firm pressure – to give a bright, drybrush-like sparkle.

SCRATCHING OUT

Wet colour To make dark lines in a wash, scratch into the wet paint with the tip of your paintbrush handle. This produces a sharp line. For a more ragged line, use the tip of a sharp knife or the pointed corner of a razor blade.

Dry colour For delicate white highlights, use a sharp, pointed tool and lightly scratch away the pigment when it is bone-dry. Use a quick, dashing movement rather than a slow, deliberate one. Working fast will help to develop your sensitivity.

Spider's Web in the Forest: demonstration

How do you capture the delicate form of a spider's web in paint, without it looking clumsy and mechanical? Zoltan Szabo shows how easy it is, using the scratching out technique.

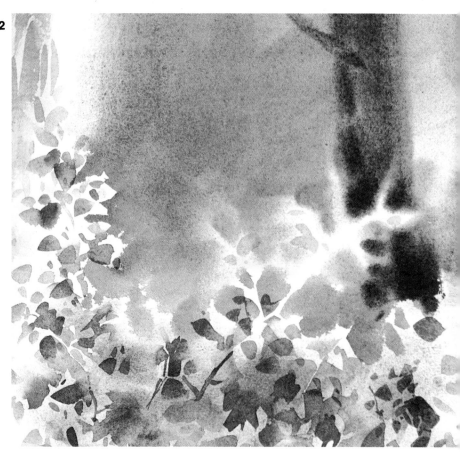

1 Start the background

Very faintly, in pencil, define the broad areas of the composition – the tree trunks and the two clumps of bushes. To create the soft, blurred shapes which form the background, begin by wetting the paper so that the colours can merge wet-in-wet.

Paint the foreground leaves first; it's quite easy to work around their complex outlines with dark colour afterwards, whereas you can't paint light leaves over a dark background. The mixture used here is cerulean blue, new gamboge and ultramarine.

The dark background is pthalo blue, alizarin crimson and a little burnt sienna, with a much paler version of this mixture suggesting the tree trunk on the left.

Before the paper dries, paint in the more distinct shape of the dark tree trunk, using pthalo blue, burnt sienna and alizarin crimson.

2 Add foreground details

Bring the foreground closer by adding some texture. Using the same mixture as in step 1, complete the left-hand tree trunk with a few drybrush strokes to suggest the bark.

Paint the clusters of foliage with various mixtures of ultramarine and new gamboge, adding the hint of a twig here and there. Vary your brushstrokes to suggest the leaves, rather than trying to paint each one individually, and combine crisp, hard edges with softly blended ones to give the feeling of both depth and movement. Remember to allow plenty of gaps between the darker strokes, so creating the impression of light filtering through the leaves.

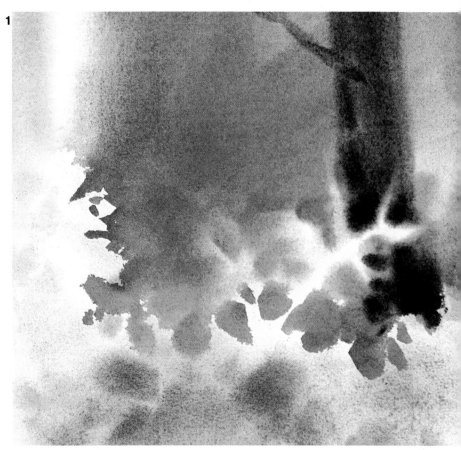

EQUIPMENT USED
☐ A sheet of hot-pressed watercolour paper, approximately 18″×20″ (45cm×50cm).
☐ Two round brushes, a no.2 and a no.6.
☐ A palette of six colours: cerulean blue, new gamboge, ultramarine, phthalo blue, alizarin crimson and burnt sienna.
☐ A sharp craft knife.

3 Add the darks

Paint in the dark bushes in the distance with a mixture of phthalo blue, alizarin crimson and burnt sienna. Keep these shapes simple so that they don't conflict with the brighter, more detailed foreground. Again, leave spaces between the dark strokes to suggest filtering light, and silhouette a few twigs against the sky.

At the centre of the painting, a branch slants upwards into the sunlight. Define its shape by placing dark shapes around it and then lifting out the lacy pattern of twigs with a no.2 brush.

Now the scene is set ready for the final touch – the spider's web.

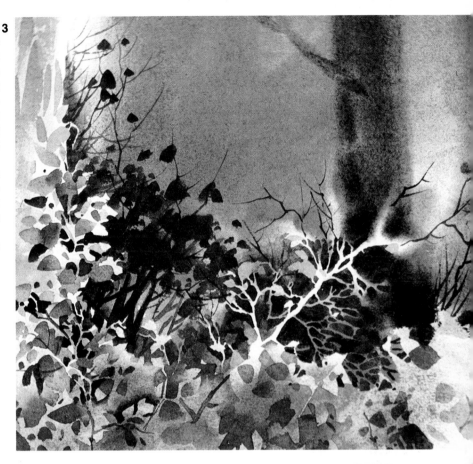

4 The spider's web

When the sheet is bone-dry, use a sharp craft knife to scratch out the white lines of the web with firm, rapid movements. Don't dig deeply into the paper, but press just hard enough to make scratches that you can see from a distance. As the blade of the knife moves over the textured paper, the rough surface breaks up the scratches. This ragged look suggests the flickering light of the forest, or perhaps droplets of moisture.

With a small, wet bristle brush, lift out the tiny leaf caught in the web. Let it dry, then paint it with a bright mixture of new gamboge and alizarin crimson. The centre of the web is silhouetted against the dark bushes in the distance.

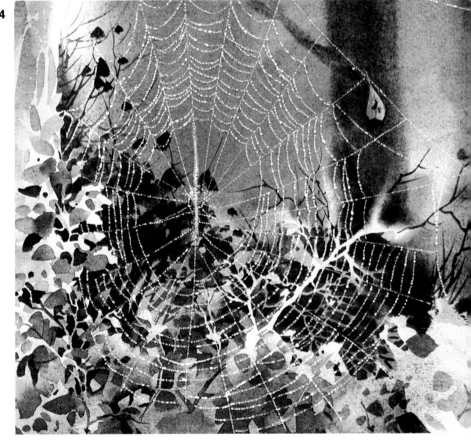

Right *'Homebody' by Zoltan Szabo, watercolour, 11"×14½" (28cm×37cm) (detail).*

Tree Stump and Weeds: demonstration

Zoltan Szabo is an artist who sees beauty everywhere – even in a clump of weeds around a tree stump. Here he uses the knifing out technique to capture the play of light on leaves and grasses.

1 Knife out the weeds

Draw the outline of the tree stump in pencil. Brush clear water over the paper and then vigorously apply random combinations of raw sienna, cerulean blue and phthalo blue. Add just a touch of new gamboge in the brighter greens which frame the tree stump.

When the wet colour has almost lost its shine, use the edge of a knife or a coin to scrape out a few light weeds from the dark background. Because the paint is still slightly wet, the scraping action pushes the pigment to the outer edges of the shapes where it settles, giving definition to these shapes.

2 Paint the stump

Using a fairly thick mixture of raw sienna, burnt sienna and a touch of ultramarine, paint the tree stump with drybrush strokes. For a three-dimensional effect, leave the middle section much paler where the light hits it. Add more burnt sienna to the mixture and use small, rough strokes to suggest the bark. Finally, use the tip of a well pointed no.2 brush to touch in a few knots and scratches.

Add some more pale weeds at the base of the stump. These smaller weeds are too delicate to knife out, so this time use a wet brush to lift out some of the colour. Let it dry, then use the dark background mixture from step 1 to surround and define the lighter shapes.

Paint the tiny leaves at the top of the tree stump with a thin wash of new gamboge.

3 Develop the foreground 3

Continue adding more details around the base of the stump to emphasize the centre of interest. Introduce a feeling of movement, of organic growth rather than static forms, by creating hard and soft edges, particularly in the shadowy areas. In other words, some of the weeds and grasses should have sharp, dark edges, while others have blurred edges, blended wet-in-wet with the background.

Now turn your attention to the plant forms at the edges of the painting. These shapes should remain more blurred than the ones at the centre of interest, with just a few touches of detail such as the dark ferns.

Model the leaves at the top of the stump by adding a few touches of burnt umber.

4 The final touches 4

Let your eye move over the entire design, looking for places that need to be tied together with more darks (here Zoltan Szabo has added more dark touches in the lower right corner, to give that part of the painting more weight).

Above the axe-marks in the stump, knife out the highlights. For a final hint of action, add the falling maple leaf next to, but detached from, the little cluster at the top of the stump.

EQUIPMENT USED
☐ A sheet of hot-pressed paper about 18″×20″ (45cm×50cm).
☐ Two round brushes: a no.2 and a no.6.
☐ A palette of five colours: cerulean blue, phthalo blue, raw sienna, burnt sienna and new gamboge.
☐ A sharp knife or a coin.

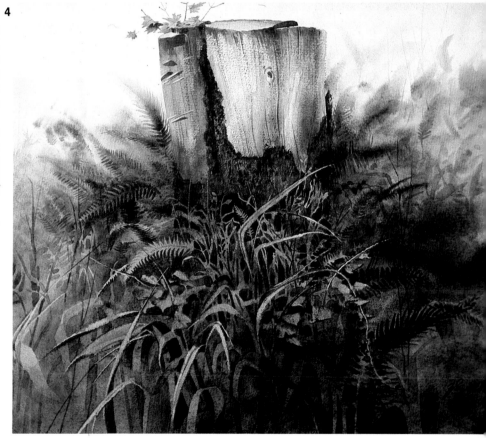

Using broken colour

Expressive brushstrokes add vitality to your paintings. The samples on this page illustrate three types of stroke and how to hold the brush in each case.

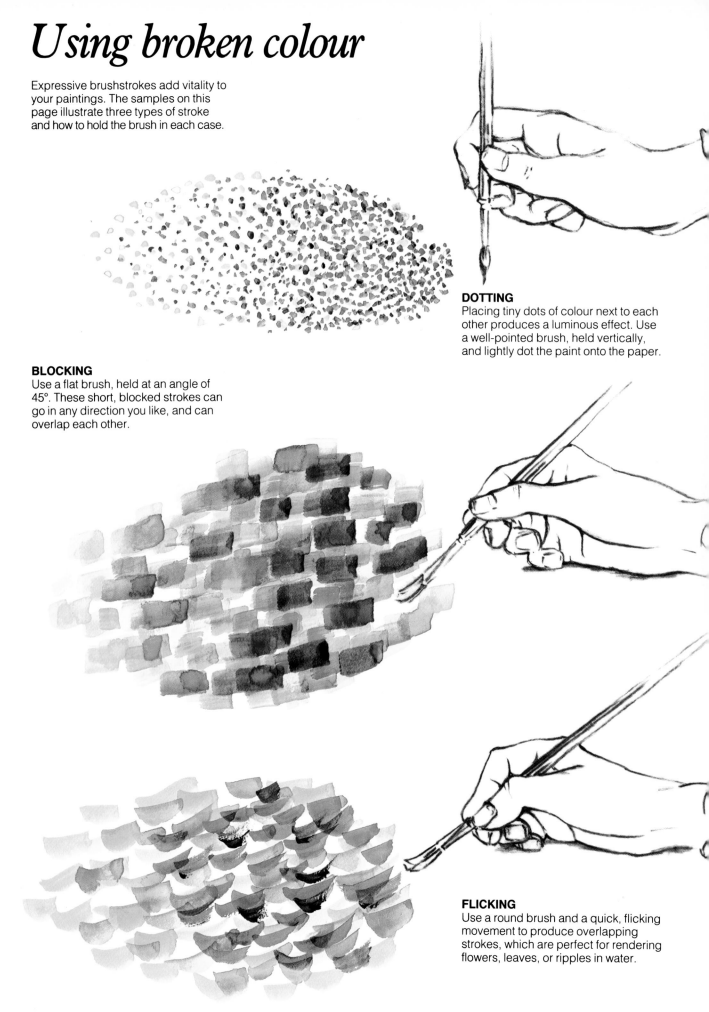

DOTTING
Placing tiny dots of colour next to each other produces a luminous effect. Use a well-pointed brush, held vertically, and lightly dot the paint onto the paper.

BLOCKING
Use a flat brush, held at an angle of 45°. These short, blocked strokes can go in any direction you like, and can overlap each other.

FLICKING
Use a round brush and a quick, flicking movement to produce overlapping strokes, which are perfect for rendering flowers, leaves, or ripples in water.

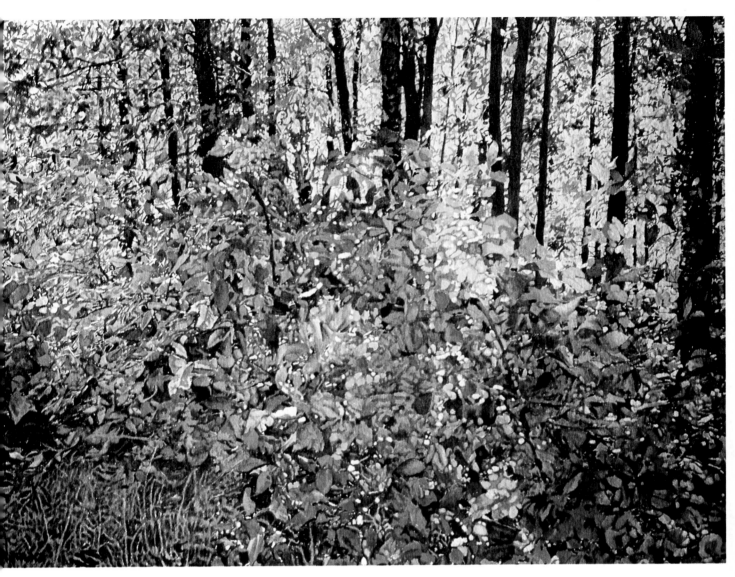

When you brush two hues together on your palette, you're creating a *physical* mixture: the two colours are physically combined to create a third colour. But because watercolour is so transparent and quick-drying, you can also build up a picture with overlapping strokes of colour. These strokes combine in the viewer's eye to create a third colour – an *optical* mixture.

For example, you can create a vivid picture simply by using the three primary colours: overlapping strokes of blue and yellow combine to create green; red and yellow create orange, and so on.

Impressionist technique

The Impressionist and Pointillist painters of the late 19th Century created vibrant optical mixtures. They built up their paintings with small, individual strokes, placed next to *and* over one another, to produce a mosaic of shimmering colour. Although these painters worked mainly in oils, the same technique works equally well in transparent watercolour.

Colour that moves

The stroke technique is particularly suited to portraying things that move: rippling water, foliage, blades of grass and so on. This is partly due to the expressiveness of the strokes themselves and partly because the tiny dots of white paper left between the strokes add such energy and sparkle to the colours.

Experiment with various marks, like the ones on the opposite page, and try out different colour combinations. With a little imagination you can create a whole range of effects.

Above *'Early Autumn' by William McNamara, watercolour, 15"×22" (38cm×59cm). A tangled mass of undergrowth in the middle of a forest is an unusual subject to tackle – but William McNamara delights in exploring the complex patterns to be found in nature. Here he builds up the picture surface with tiny strokes of colour to convey the impression of shimmering light on the leaves.*

Autumn on the Riverbank: demonstration

The stroke technique is perfect for **1**
suggesting the play of sunlight on
grass and trees. In this demon-
stration, artist Ferdinand Petrie
shows you how to use overlapping
strokes of colour – just as the
Impressionists did – to create a
picture that's full of life and move-
ment.

1 The background wash

The stroke technique works best on
a hot-pressed paper; this has a
smooth, unbroken surface with no
tiny pockets of shadow, so the colour
looks brighter and the strokes shar-
per and more distinct.

Begin with a fairly precise outline
drawing of the scene so that you can
plan the placement of the strokes
accurately. Then brush a delicate
wash of phthalo blue, burnt umber
and yellow ochre across the sky,
gradually adding more water and
yellow ochre as you move towards
the horizon. Carry strokes of this
mixture into the water.

2 Begin the foliage **2**

Start building up the warm tones of
the foliage with an underpainting of
new gamboge, yellow ochre and
alizarin crimson. Use bold, clearly
defined strokes with a no. 6 round
brush. Vary the proportions of the
colours in the mixture to make some
strokes brighter and others more
subdued, particularly towards the
horizon.

Add paler strokes of this mixture
to the ground beneath the trees,
leaving plenty of space between the
strokes.

Indicate the trees on the horizon
with strokes of ultramarine, warmed
with a little burnt sienna and yellow
ochre, diluted with lots of water.

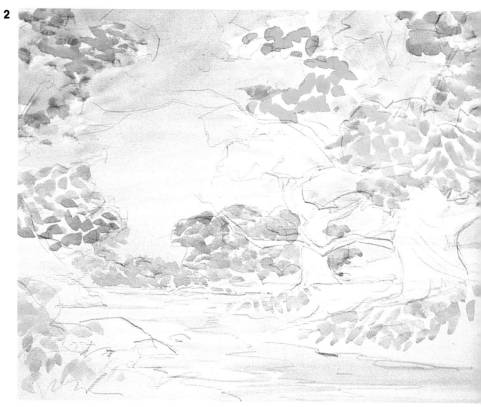

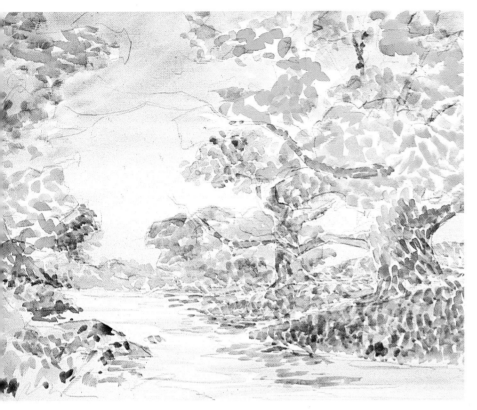

3 Create depth

At this stage it's important to establish foreground, middleground and background, to give the effect of receding space. Mix warm tones for the foreground, gradually cooling them towards the horizon.

With your no. 6 brush, paint the tree trunks on the right with warm strokes of alizarin crimson, burnt sienna and yellow ochre. Add touches of this mixture to the lower branches and the grass beneath the trees.

Render the darker, cooler tones of the tree in the centre of the picture with strokes of ultramarine, burnt umber and yellow ochre. Repeat these colours in the water below to suggest the tree's reflection.

Indicate the cool tones on the left bank and in the distant water with strokes of cerulean with a hint of burnt umber. Add cool strokes to the grass and its reflection on the right with greenish tones of ultramarine and new gamboge.

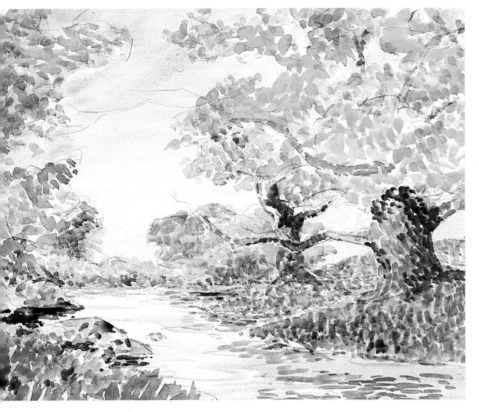

4 Develop the foreground

Continue to darken the thick tree trunk on the right with strokes of alizarin crimson, burnt sienna and a little ultramarine. Add much more ultramarine to the mixture to darken the shadowy trunk in the centre.

With a brighter mixture of alizarin crimson, new gamboge and a touch of burnt sienna, build up the colour in the left foreground. Add more water to this blend for the warm strokes that enrich the foliage of the trees and suggest the warm reflection in the water in the right foreground.

Remember to allow each layer of strokes to dry completely before you add the next layer, otherwise the effect becomes blurred and muddy.

5 The shadows

Having established the main forms with big, bold strokes, you can now start on the smaller details. Switch to a no. 4 round brush and begin making the foliage look more distinct. For the shadows within the foliage, use crisp strokes of ultramarine, warmed with a hint of alizarin crimson. Vary the density of the shadows by making some strokes darker, and some paler by adding more water.

Notice how the artist leaves spaces between the strokes so that each new layer of brushstrokes allows the underlying colours (and white paper) to shine through.

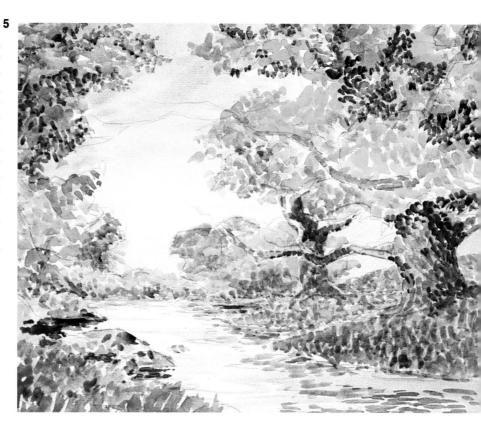

6 Strengthen the darks

Continue to enrich the shadows with darker, denser strokes of ultramarine and alizarin crimson. Now there are strong darks in the foliage, on the shadow sides of the tree trunks and on the ground.

Use the same dark mixture to define the branches in the foreground more precisely and to indicate a few smaller branches among the foliage. Then build up a strong shadow beneath the low mass of trees in the middleground, and darken its reflection in the water.

Begin to place small, distinct strokes of ultramarine over the warm undertone of the foliage. The two colours mix to create the cool colours of the leaves and shadows, while remaining delicate and transparent.

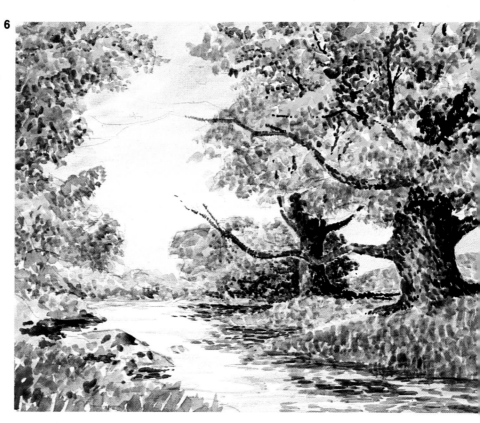

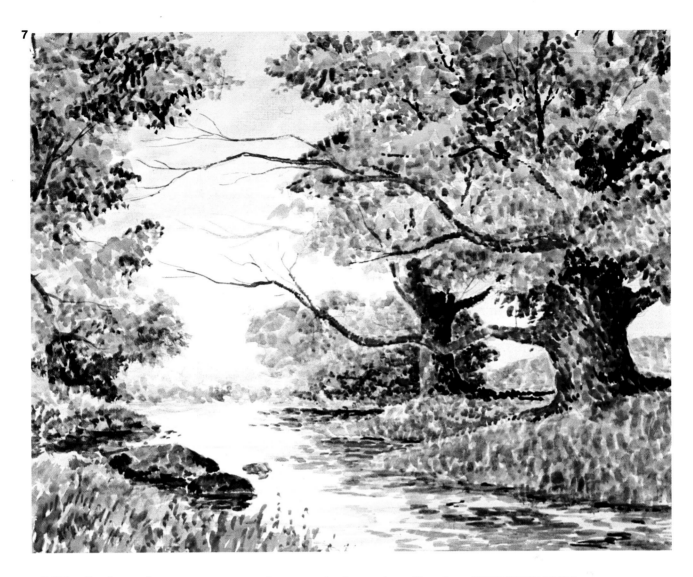

7

7 The final touches

Concentrating on the left side of the picture, strengthen the darks among the foliage with small, precise touches of ultramarine and alizarin crimson. Use the same mixture to strengthen the cool reflections of the trees in the water.

Darken the rocks on the left with strokes of new gamboge, alizarin crimson and burnt sienna. Indicate the watery shadows beneath the rocks with touches of ultramarine and alizarin crimson.

Add shadows in the sunny grass on the lower left, using touches of alizarin crimson and cadmium orange, cooled with a little viridian. Finish off the strong shadows in the trees on the right with ultramarine, alizarin crimson and burnt umber.

Finally, suggest a few branches among the foliage in the left-hand trees, using burnt sienna, alizarin crimson and ultramarine. Use the same mixture to add more detail to the tree on the right, carrying several branches across the open sky with strokes of burnt sienna, alizarin crimson and ultramarine. Use a well-pointed no. 2 brush for these strokes and keep the paint fairly dry for a broken effect.

Points to remember

☐ Remember to let each layer of strokes dry thoroughly before applying the next layer.

☐ Build up your colours gradually, working with pale, transparent hues until the very end, when you can add strong colours and rich darks.

☐ It's important to know when to stop – before you build up so many layers of strokes that the clear colours begin to turn muddy. As soon as you feel the colours are as luminous as you can make them – stop.

EQUIPMENT USED
☐ A sheet of smooth (hot-pressed) watercolour paper, approximately 12″×9″ (30cm×23cm).
☐ Three round brushes: a no. 2, a no. 4 and a no. 6.
☐ A palette of nine colours: phthalo blue, ultramarine, cerulean, yellow ochre, new gamboge, burnt sienna, burnt umber, alizarin crimson and viridian.

The spattering technique

There is no limit to the range of ingenious techniques you can use in watercolour, because it is such a spontaneous medium. One technique favoured by many artists is spattering, in which a paint-filled brush is held above the paper and tapped sharply, causing the paint to fall in a mass of tiny, irregular spots upon the paper.

Spattering is used most widely in landscape painting, as it is an excellent means of suggesting rough textures and foreground detail without looking overdone. Try it next time you're painting mountains and rocks, a pebbly beach, crashing waves, or dappled sunlight.

The method

Start by covering up the surrounding floor and furniture – with spattering, paint tends to fly every-where! The photos on the opposite page demonstrate three different spattering methods; try them all out on scrap paper – it will give you ideas and help you get the hang of controlling the paint. Generally, bristle brushes produce the best results. Borrow some from your supply of oil brushes. An old toothbrush also makes a versatile tool.

When you come to spatter on an actual painting – for example a rocky landscape – determine first where the drops are to fall. You can keep them from roaming over the rest of the painting by placing tissues or rags over the areas you want to keep clean. Test the spatter on a scrap of paper first, to make sure the density is about right. You can also vary the size of the dots by changing the distance between the brush and the paper.

Below '*Anthony Waterer IV*' by *Lawrence C. Goldsmith, watercolour, 18″×24″ (46cm×51cm).*
With a little imagination, spattered patterns can be developed into pleasing images. In this painting, blobs of paint are hurled on to wet paper and then manipulated into a design which suggests a cluster of blossoms of the Anthony Waterer spirea plant.

The possibilities

Spattering is a marvellous way of 'loosening up', because its results are so delightfully unpredictable. The technique can be used on *unpainted* wet areas, to produce diffused wet spots. Alternatively, spatter *painted* areas that are still wet – here you will get soft, blurred spots that are modified both by the colour of the area and the degree of wetness. On *dry* areas, the dots are sharper, brighter and do not run.

Try producing 'strings' of dots by briskly swinging your paintbrush over the paper. Or paint the dots more precisely by holding your loaded brush over the desired spot and squeezing the hairs downward with your thumb and forefinger until a drop falls.

If you really want to go to town, spatter with two or more colours; the effect is similar to the Pointillist technique of placing strokes of colour side by side so that, from a distance, they appear to blend as one and sparkle with fragmented light.

Right *In these studies of rocks and boulders, the rough textures are created through a combination of spattering with a brush and dabbing with a sponge.*

Studies by Zoltan Szabo

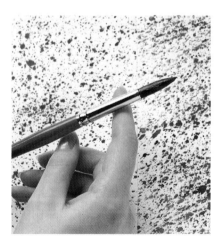

THREE SPATTER EFFECTS

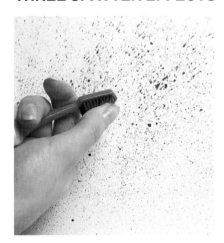

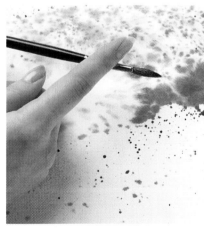

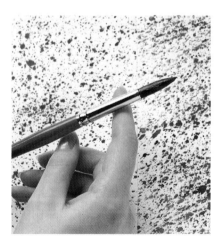

FINE SPATTER
To obtain a very fine spatter, use a toothbrush and fairly thick paint. Dip the toothbrush into the paint, hold it at an angle to the paper, then draw a knife blade, or your thumbnail, across the bristles. This releases the paint in a shower of fine speckles.

DIFFUSED SPATTER
To produce a slightly heavier spatter, take a round brush loaded with paint and tap it at an angle across the finger of the opposite hand. Spattering on wet paper produces highly attractive soft, blurry edges. Try combining two or more colours, as in this example.

RANDOM SPATTER
To make the random spatter above, use a large, round brush held parallel to the paper and about 6″ (15cm) above it. Use the index finger of the opposite hand to hit the brush from below. This method produces an exuberant pattern that resembles sea spray.

Rocky Shoreline: demonstration

When you're painting a flat land-scape or seascape, the only way to create the illusion of distance and space is by simplifying the background and strengthening the foreground. In this demonstration, Claude Croney shows how to create interesting foreground texture without labouring over every little detail. The method he uses is a combination of spattering, drybrush and knifing out.

1 Outline the composition

Sketch in the shape of the distant headland, then carefully outline the shapes of the rocks on the beach. Use a flat no. 6 brush and clear water to dampen the sky area. With the same brush, paint the sky with horizontal strokes of yellow ochre, cerulean blue and burnt sienna. Let the strokes fuse wet-in-wet, and graduate the colour from dark at the top to very pale at the horizon; this gives the illusion of distance.

2 The distant headland

Using a round no. 6 brush, paint the dark shape of the distant headland with a mixture of burnt umber, ultramarine and Hooker's green. Painted in a smooth, even tone, the headland would look like a cardboard cut-out, so indicate its bulk by varying the proportions of pigment in the mixture – sometimes darker and sometimes lighter.

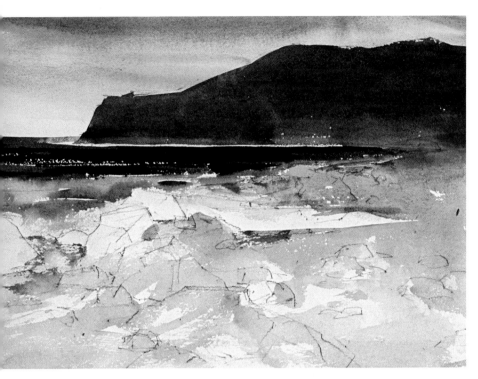

3 The sea and sand

Paint the water with ultramarine, Hooker's green and burnt umber, with more water and a little yellow ochre added closer to the beach. Notice the thin line of white paper left along the base of the headland – a nice little touch that indicates surf breaking on the distant shore. Paint the beach with yellow ochre, burnt sienna and cerulean blue. Brush this over the foreground very loosely, allowing patches of bare paper to show through and create the impression of bright sunlight.

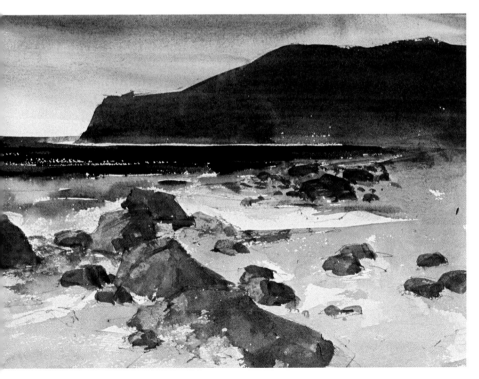

4 Begin the rocks

Paint the lighter tones of the rocks with cadmium orange, burnt sienna and cerulean blue. When these light tones are dry, add the darks with burnt sienna, Hooker's green and cerulean blue. Keep the pattern of shadows and highlights consistent in all the rocks so that you indicate the direction of the light source. Use the side of a round no. 2 brush for the ragged textures of the rocks to the left.

5 The pebbles and stones

With a mixture of burnt sienna, Hooker's green and ultramarine, use the side of a round no. 2 brush to suggest pebbles and seaweed on the beach. Add a little water to the mixture and use it to spatter dark flecks over the beach. This combination of drybrush and spatter creates texture in the foreground, which makes it appear closer.

6 The finishing touches

Employing the same mixture as in step 5, use the tip of your no. 2 brush to suggest cracks, shadows and edges on the rocks. Then use the corner of a razor blade to scratch some light lines along the cracks, as well as flecks of light on the pebbles at the edge of the water. Include some cast shadows to the right of the rocks, using à mixture of cerulean blue and burnt sienna.

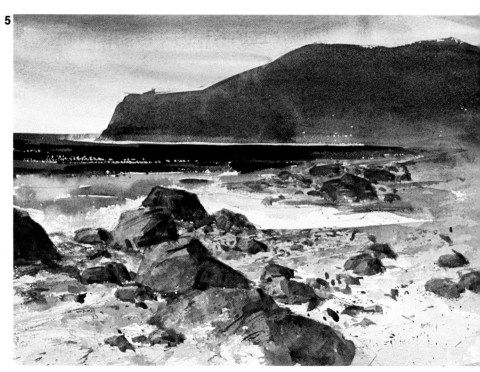

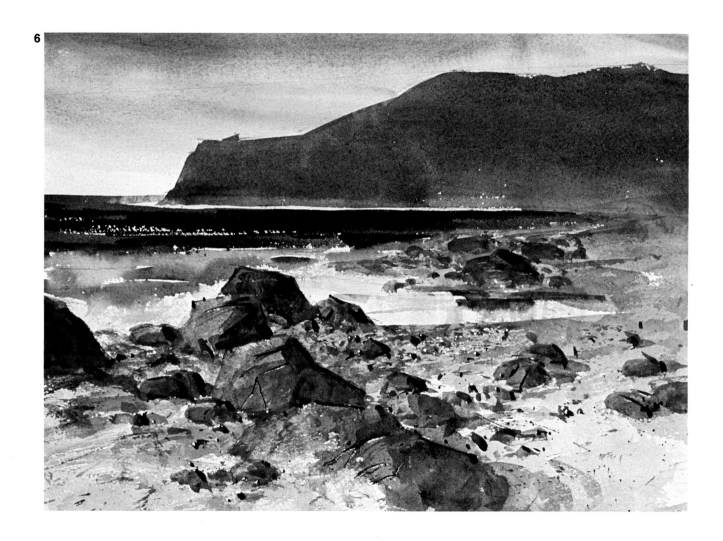

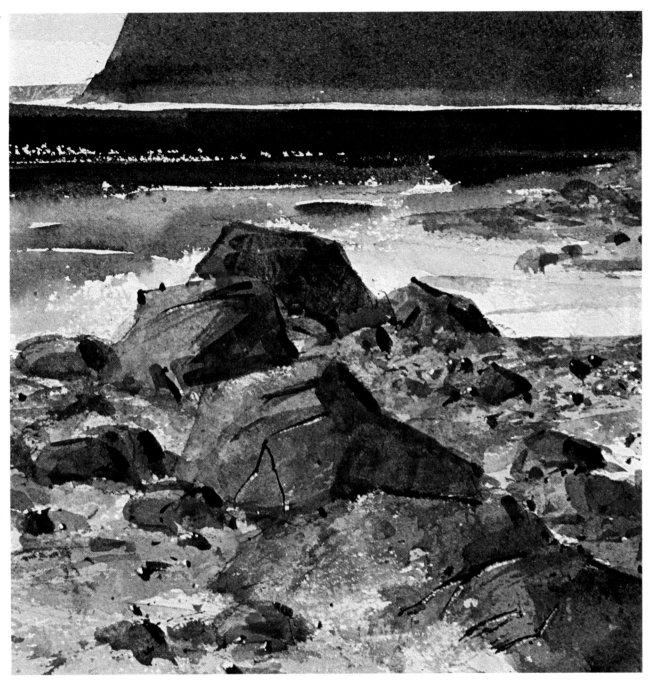

Technique round-up

In this close-up of the rocks, a portion of the beach and a portion of the water, you can see the brushwork in more detail. Notice how a combination of drybrush and very light spattering are used to suggest the sandy, pebbly texture of the beach while still retaining the impression of bright sunlight.

A dark line and a white scratch, side by side, make the cracks in the rocks look very convincing. Tiny flecks of white paper, picked off the tops of the pebbles with the corner of a blade, increase the feeling of sparkling light and shadow.

You can also see how the dark tone of the ocean is gradually lightened with more water toward the shore. If you work quickly, drawing your brush straight across the paper without pressing too hard, you can leave an occasional gap of white paper to suggest the broken strips of light across the dark water. You can also suggest the waves breaking on the shore by pressing down hard with a piece of crumpled tissue while the colour is still quite wet.

EQUIPMENT USED
☐ A sheet of 140-lb Bockingford paper, approximately 10″×7″ (25cm×18cm).
☐ Three watercolour brushes: a flat no. 6, a round no. 6 and a round no. 2.
☐ A palette of seven colours: yellow ochre, cerulean blue. burnt sienna, burnt umber, ultramarine, Hooker's green and cadmium orange.
☐ A craft knife or razor-blade.

Sponging with watercolour

G. John Blockley..

Above *'Iron Gate' by John Blockley,
watercolour on hot-pressed paper,
6½" × 8½" (16.5cm × 21.5cm).
Sponges come in useful for creating
subtle, yet appealing textures in
landscapes. Here the artist hints at
grass, lichen and weathered stone in the
foreground by dabbing on colour and
lifting it out with a sponge.*

Sponges are a handy and versatile
tool for the watercolour painter. In
fact, it's a good idea to keep two
sponges – a large synthetic one for
practical purposes and a small nat-
ural one to paint with.

Synthetic sponges

Always keep a large sponge within
arm's reach so that you can wipe out
an unsuccessful passage of paint
before it dries, mop up spills instant-
ly, and clean palettes as required.

Although natural sponges are pre-
ferable for painting with, synthetic
sponges are useful for laying flat

washes: they can cover a large area
quickly, with less risk of streaking
than you get when using a brush.

Natural sponges

Natural sponges are softer and silkier
than synthetic ones. Use them for
softening passages of wet paint (in
skies, for example), and for lifting
colour from the paper when you
want to lighten an area.

Last, but not least, you can use the
natural texture of these sponges to
apply paint by stamping, twisting or
stroking – as shown in the examples
on the opposite page.

GETTING THE FEEL OF SPONGES

Rich, rough textures and special effects can be achieved when watercolour paint is applied with a sponge. Try it with different consistencies of paint, and with coarse and fine textured sponges. Experiment for half an hour and you'll find endless possibilities.

You can buy small watercolour sponges from art shops, but it's better to buy a bath-size sponge and cut it up into smaller pieces to suit your needs. Synthetic sponges can be cut into wedges and used for painting lines.

MOTTLED PATTERNS

A handy technique for painting foliage and foreground textures is to load a sponge with thick paint and dab it onto the paper.

SOFT AND HAZY

Use a damp, squeezed-out sponge to lighten passages of colour which have become too dark. You can also use it to blend colours when painting flowers, skies or skin tones.

FLOWER FORMS

A soft, silky sponge is perfect for painting flower petals. Start at the centre of the flower and flick outwards; varying the pressure on the sponge creates soft gradations in tone.

Sue Shorvon. Photo John Suett

MAKING WAVES

These wavy lines suggest the rolling waves of the sea. Experimenting with different strokes and colour combinations will give you ideas and inspiration. Try painting with two colours at once – here sap green and ultramarine were used.

Moorland Scene: demonstration

In this study of natural forms, Zoltan **1** Szabo uses sponges to suggest both the roughness of granite rock and the delicacy of leaves and flowers.

1 The first washes

Faintly outline in pencil the shape of the boulder. Mix a very pale tint of cerulean blue and alizarin and apply it in a flat wash, using a sponge, over the entire surface. Allow this to dry.

Re-wet the bottom half of the paper *but not the sky area*. Paint the rock with a pale mixture of Payne's grey and alizarin, using a round no. 6 brush. The bottom edge will be soft where it meets wet paper, and the top edge will be hard where it meets dry paper.

2 The rock

2

While the paper is still damp, paint the dry grass in the foreground with various mixtures of yellow ochre, raw umber and burnt umber. Let the colours blend wet-in-wet.

Just before the paper dries, gently press a damp, clean sponge down on the rock, lifting off some of the paint and creating a mottled effect. Allow this to dry.

When the painting is bone dry, mix a dark, fairly dry wash of Payne's grey and ultramarine – much darker than the first grey wash. Press the sponge into the colour, squeeze it half dry, then dab it over the rock.

Use a small corner of the sponge to indicate the clusters of blue flowers with ultramarine.

3 The tree

Indicate the shape of the tree with strong sponge dabs of burnt sienna and Indian red. Make the dabs less dense on the outer edges. Use raw umber in the shadows of the foliage. With this dark mixture, use the well pointed tip of your no. 6 brush to sketch a few twigs and branches.

Finally, indicate the tall, dry grasses in the foreground with pure raw umber, using the very tip of the brush in light, sweeping strokes.

EQUIPMENT USED

☐ A sheet of 300-lb (500 gms) rough watercolour paper, approximately 8″×6″ (20cm×15cm).
☐ A round no. 6 brush.
☐ A small round natural sponge for texturing and a synthetic sponge for laying the initial wash.
☐ A palette of eight colours: alizarin, cerulean blue, ultramarine, Payne's grey, yellow ochre, raw umber, burnt umber and Indian red.

SPONGES . . . AND OTHER CREATIVE TOOLS

Now that you've discovered the range of effects you can achieve with sponges, why not try out some other ingenious 'tools' to help you create interesting textures? Here are a few suggestions – no doubt you will discover many more of your own.

Cotton buds

Cotton buds are convenient to hold, absorbent, and keep their shape well. They're a boon when it comes to painting small, precise areas such as the petals and stamens of a flower, or for suggesting a distant path in a landscape. Like sponges, cotton buds can also be used to lift off colour and soften edges.

Other objects

Pressing other objects into wet paint and then using them to print patterns can produce exciting results. Choose fairly flat items that are convenient for printing – leaves, feathers or twigs, for example.

To make an impression, mix a large puddle of colour on your palette and dip the object into the paint. Carefully transfer the object onto the paper, cover it with tissue and press gently with the hand. Then carefully remove the object, taking care not to smudge the print.

Fabric scraps

Impressions taken from the woven surface of fabric offer a wonderful variety of patterns. Suitable fabrics include sacking, linen, J-cloth, scraps of lace, and so on.

To make a print, dip your textured material into a pool of colour on your palette. Then press it gently onto the surface of the paper. Fabric impressions are a crafty way of depicting man-made surfaces such as brickwork and fencing.

Lifting out

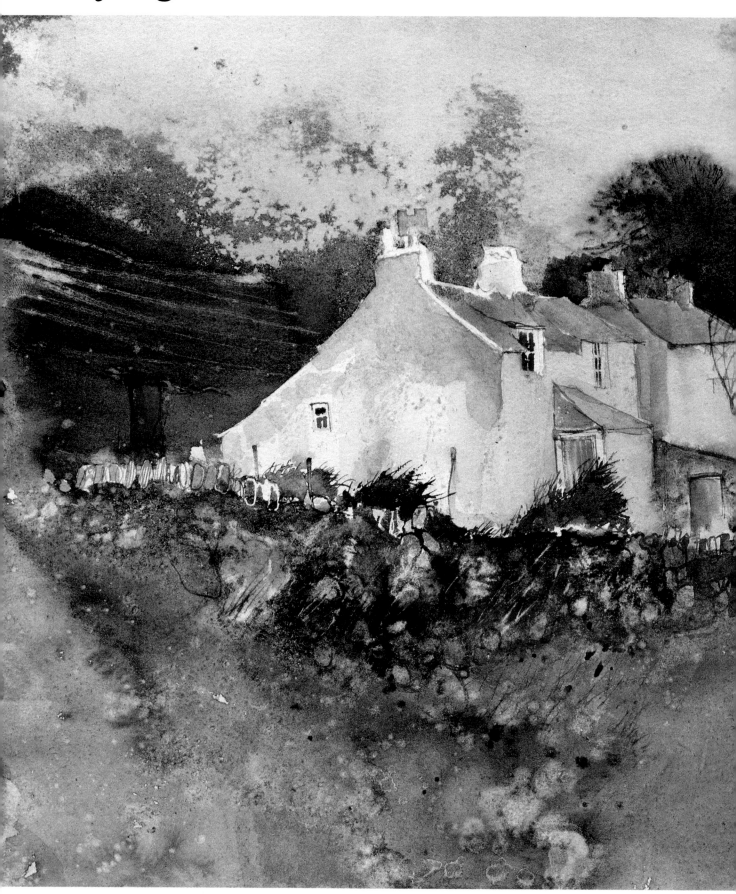

One of the exciting things about working with watercolour is that you can create just as many effects by removing paint from the paper as you can by putting it on. For instance, you can lift out colour with a damp sponge or tissue to produce pale areas in a dark wash.

Another technique is to brush clear water into a damp wash and let it dry. The water creeps into the drying wash, pushing some of the pigment with it, and dries with an uneven, hard edge.

These 'water stains' can be used in various ways, depending on the shape of the brushstroke and on how damp the background wash is. For instance, the group of trees below is produced with linear strokes of water in an almost-dry wash. As each stroke dries it leaves a hard, uneven edge which delineates the forms of the trees while at the same time suggesting the frost which covers them.

In the painting on the left, John Blockley hints at the rocky terrain in the foreground by dropping small spots of water into a damp wash to produce mottled patterns.

Note that water diffuses further on smooth paper than on rough because smooth paper is less absorbent. A hot-pressed paper, such as T H Saunders or Arches, always gives good results.

Left *'After the Rain', John Blockley, watercolour, 12"×16" (31cm×41cm).*
Below *The art of saying more with less. A few strokes of clear water in a dark wash capture the delicacy of frost-covered young trees.*

Frost and Ice: demonstration

In this painting of a winter wood, **1** Zoltan Szabo exploits the fluid potential of watercolour to obtain soft, ethereal effects.

1 Establish the main forms

Wet the paper thoroughly with clear water using an ordinary 2″ (5cm) decorator's paintbrush. This is a handy piece of equipment for laying in large washes; the bristles are soft and springy and capable of holding plenty of water.

Paint the large background shapes with a mixture of ultramarine, cerulean blue and a little raw sienna. Then dilute the wash to a very pale tint and use this for the main bulk of the snow-covered trees, softly blending it with the background wash to avoid any hard edges. The secret is to work quickly, before the paint has time to dry.

As the background wash begins to lose its shine, but before it is completely dry, use a no. 5 round brush and clear water (not too much) to lift out the shapes of the delicate, frosty branches. The water pushes the pigment aside, leaving fuzzy edges.

The ice on the pond has a soft, greenish glow. Start with a very pale **2** wash of raw sienna and cerulean blue. When this is almost dry, make a few quick, vertical drybrush strokes for the shadow effects, using an undiluted mix of these colours. Add raw sienna for the tree trunks.

2 Introduce more detail

When step 1 is completely dry, work along the shoreline with sharp strokes and hard-edged washes to define the frosty foliage. Keep your brush fairly dry for this, otherwise you will lose the crisp edges.

To push the right-hand tree further into the distance, darken the pale tones with a delicate wash of the original sky mixture. Work quickly so as not to disturb the underlying branches.

Add a touch of raw sienna to this pale wash and use it to suggest the branches and twigs within the centres of the trees. They shouldn't stand out too sharply against the pale frosty glow behind. If they do, use a brush and clear water to lift off some of the colour.

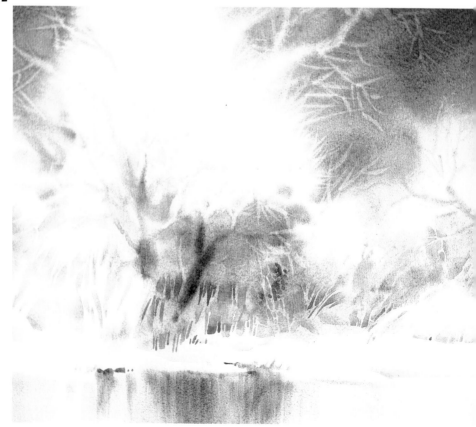

3 The centre of interest

At this stage you can make the picture 'click into focus' by sharpening up the detail in the centre of interest – the area between the trees. With a strong, dryish mixture of sepia, cerulean blue and a little burnt sienna, continue adding more darks along the shoreline to suggest weeds and bushes.

4 The finishing touches

Now all the painting needs is a touch of warm colour to contrast with all those cold, icy blues. Add a sprinkling of leftover dead leaves in the foreground. A mixture of burnt sienna and raw sienna gives you a warm autumnal brown, but vary the tones for a more natural effect. Use the same mixture to paint in a few slender branches amongst the upper boughs of the foreground tree, but keep them inconspicuous so that they don't detract from the focal point of the picture.

Finally use a no. 2 brush and clear water to lift out some horizontal lines across the icy pond.

Don't worry if your picture doesn't come out looking *exactly* like this one. The main thing is that you have gained experience in working at speed with wet washes to create large, soft-edged shapes which seem to glow from within – something which is unique to the watercolour medium.

This loose, fluid style of painting looks more effective done on a larger sheet of paper than you might normally use, which can be an advantage because it encourages you to splash out with big, juicy washes. Most beginners tend to paint tiny pictures in a finicky fashion; don't dip your toe in at the water's edge, dive in!

EQUIPMENT USED
☐ A sheet of 140lb watercolour paper such as T H Saunders or Arches, approximately 20″×14″ (50cm×36cm).
☐ A 2″ (5cm) decorator's painting brush, and two round brushes, nos. 2 and 5.
☐ A palette of five colours; ultramarine, cerulean blue, sepia, burnt sienna and raw sienna.

3
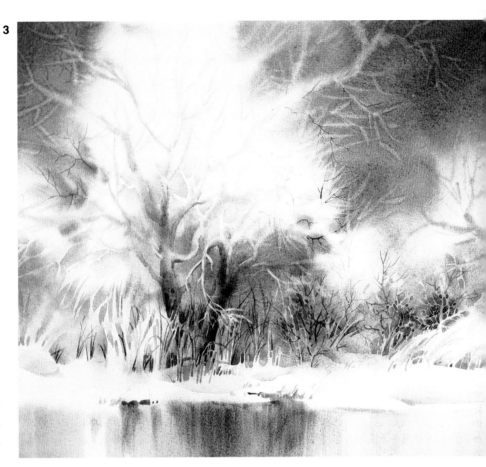

4
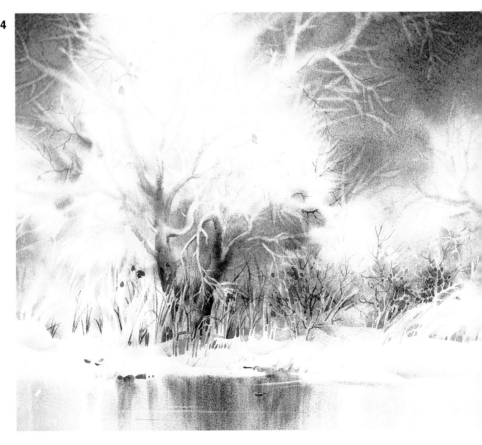

Using opaque white

Normally, the cardinal rule in watercolour painting is to keep it as transparent as possible and avoid using an opaque white (Chinese white), for white areas. But there are times when opaque white comes into its own, as is demonstrated in the magnificent painting on the right, by Stephen Quiller.

Painting snow

A scene like this one would be impossible to paint in the traditional watercolour method of leaving areas of white paper for the snow. But the slight chalkiness of Chinese white not only renders the powdery effect of falling snow, it also partially obscures the background colours, just as snow does in reality.

If the beauty of this painting has inspired you to tackle a snowscape yourself, here is a brief outline of the artist's technique:

☐ The paper is first saturated with water, followed by wet-in-wet washes of alizarin and phthalo green. While the paper is still wet, the artist loads Chinese white onto a toothbrush and drags his thumb over the bristles, spattering paint over the entire surface. The opaque white paint flows at will, blurring into the first washes and producing soft veils of muted colour. The paper is tilted to make the washes flow downwards, creating the effect of a swirling snowstorm.

☐ While this surface is still wet, Quiller uses a deeper mixture of alizarin and phthalo green to hint at the tree and mountain forms near the top of the paper.

☐ When the painting is dry, the foreground trees and figure are painted with controlled brushstrokes, again using alizarin and phthalo green. Chinese white is brushed on to give solidity to the snow in the foreground. Finally, another spatter of Chinese white is applied before leaving the painting to dry.

Right: *'Winter Storm' by Stephen Quiller, watercolour, 19″×24″ (48cm×61cm). Transparent colours and opaque white are combined in this painting to achieve a dramatic interpretation of a winter snowstorm. The placing of the tiny figure enhances the feeling of vastness.*

Canada Goose: demonstration

This very detailed study of a goose, **1** by wildlife artist Graeme Sims, demonstrates another use for opaque white: here the addition of Chinese white gives a soft, pastel-like quality to the colours, which captures perfectly the unique texture of the bird's feathers.

1 Outline the form

Make a fairly detailed contour drawing of the goose: start with the basic outline, then indicate the markings on the head and neck and the shapes of the feathers.

Mix a puddle of Chinese white with the merest fleck of ivory black and use a flat no. 4 brush to wash in the body, head and neck. While the wash is still damp use a no. 2 round brush to apply a weak wash of cerulean blue and Chinese white to the neck and head. Later on this blue highlight will convey the lovely blue-black sheen of the bird's feathers in these areas.

2 Begin the plumage **2**

Using the same brush, this time with a weak solution of raw umber, sketch in the feather shapes. Make sure your brush contains very little water, or precise strokes will not be possible. Leave a white line around each feather.

With a well-pointed no. 0 brush, using a weak solution of lamp black, outline the eye. With short, careful strokes, start to fill in the black plumage on the neck and head. Use cerulean blue with Chinese white and lamp black on the back of the neck as the light catches here and the individual plumage lines can be seen. The neck plumage is fine and short, so use a short, chopping stroke rather than a solid wash. Notice the down extending beyond the outline of the bird's head and neck. With your no. 2 brush, using a mixture of cobalt blue, lamp black and Chinese white (with the cobalt dominant), start to sketch in the tail feathers.

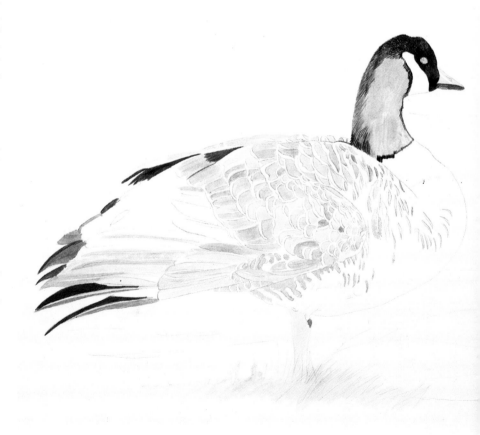

3 Indicate the fine down 3

Continue building up the plumage on the neck and head. With your no. 0 brush, paint the pupil of the eye black, leaving a tiny dot of white where the light catches.

The chest of the bird is an off-white, so mix a little yellow ochre with Chinese white and 'tick in', with short, fine strokes, the whitish plumage between the brown flecks of the chest. You could of course save time and effort with an overall wash, but individual strokes allow the white paper to show through and create the effect of fine down. They also add texture and form to what would otherwise be a fairly bland and uninteresting shape. Finally, darken some of the feathers with a mix of sepia, Chinese white and yellow ochre.

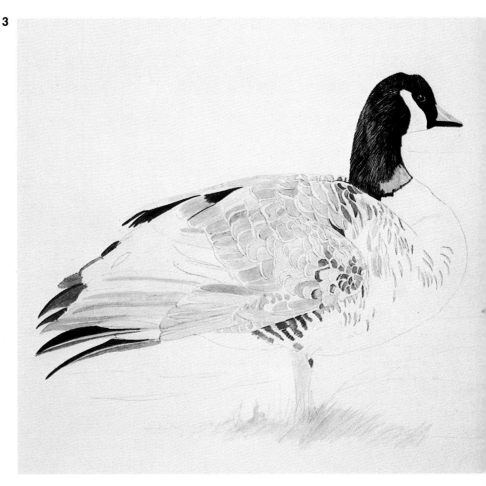

4 Continue the plumage 4

Using a no. 2 round brush and a mix of sepia and Chinese white, paint the remaining tail feathers, leaving white margins here and there. Then complete the body feathers with a mix of sepia, Chinese white and yellow ochre. Achieving a realistic impression of feathers is always difficult, so whatever you do, avoid overpainting – there are so many refining stages to come! Finally, with a weak black, intensify the darker shade of the eye.

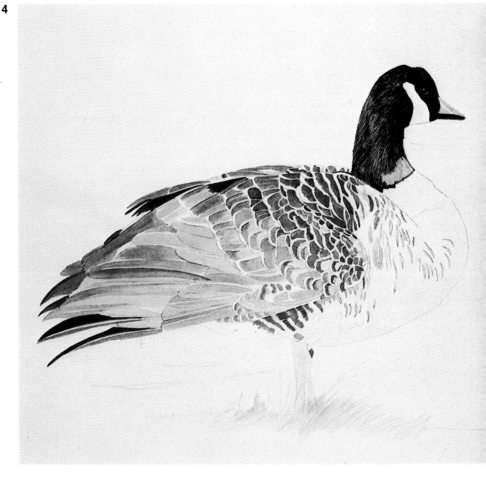

5 Indicate the grass

Add just a touch of grass with a mix of cadmium lemon and Hooker's green dark, and a couple of twigs made from Hooker's green and Payne's grey.

To put a little more life into some of the feathers, mix light red and cadmium yellow pale, and 'warm up' several of the darker feathers.

Indicate the form of the legs with a mix of Chinese white, lamp black and cobalt blue, using a no. 0 brush. For the grey feathers, mix Chinese white and a touch of lamp black.

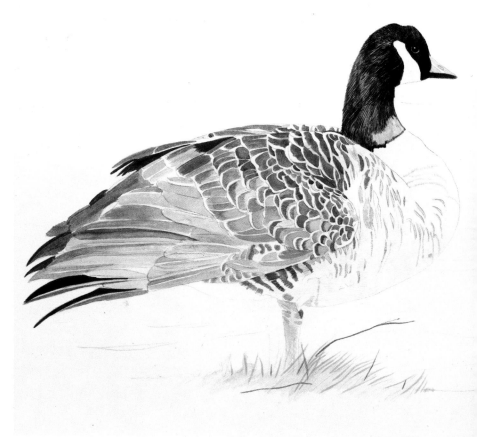

6 Add fine details

Use a round no. 2 brush for the whole of this stage. Darken the tail feathers with a mixture of cobalt blue and lamp black (not in one coat, but in several thin washes, to avoid pure and uninteresting solids). With the same mix, add shadow beneath the bird's wing and strengthen the colour of the leg, neck and beak. When this is dry, add the breathing hole in the beak. Add more lines to the chest area to give it some interest.

Use a mix of sepia and Chinese white to darken the plumage beneath the wing: this increases the feeling of shadow and dimensional effect. Then, with small touches of pure, but fairly watery Naples yellow, add detail to the chest plumage.

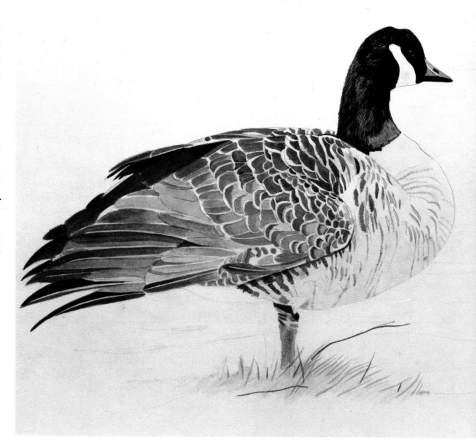

7

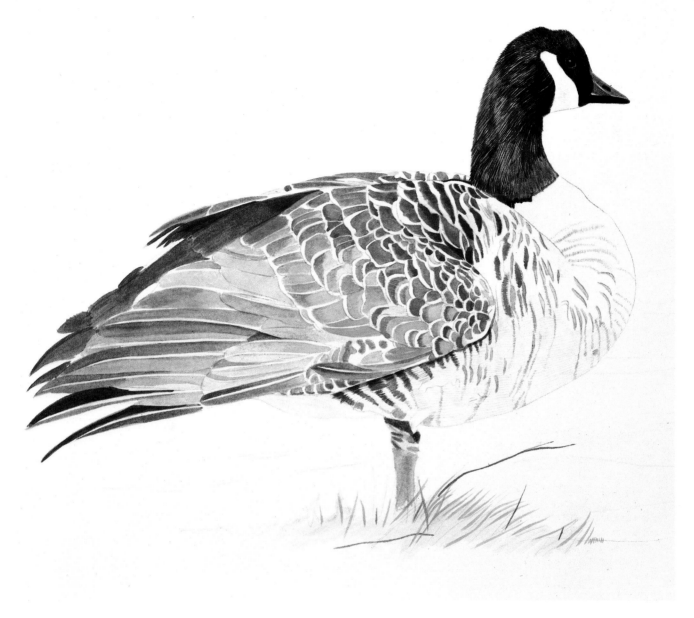

7 The final touches

Using a no. 0 brush and a mix of lamp black with just a little Chinese white and sepia, darken some of the feathers on the back and around the junction of the wing.

With cerulean blue and a touch of lamp black, redefine the top of the beak. Then, with a slightly darker mix of the same two colours, complete the neck and darken the breathing hole.

With a well-pointed brush add a few touches of pure cerulean blue (in a watery solution) to the gaps between the neck feathers and to the beak. Use pure Chinese white to lightly redefine and highlight the tips of the wing feathers and the spines of the tail feathers.

Finally, use Chinese white, a touch of Naples yellow and a speck of lamp black, in a well-mixed solution to paint in the farthest wing, which can just be seen hanging down behind the nearest wing.

Notice how the background is barely hinted at; this focuses attention on the subtle colouring of the bird's plumage while at the same time hinting at the vast frozen wastes of the bird's natural habitat.

EQUIPMENT USED
□ A sheet of smooth (hot-pressed) watercolour paper, approximately 10″×9″ (25cm×23cm).
□ Three brushes: a round no. 2, a flat no. 4 and a no. 0.
□ A palette of 13 colours: Chinese white; lamp black; cerulean blue; cobalt blue; Hooker's green dark; Payne's grey; cadmium yellow pale; yellow ochre; Naples yellow; cadmium lemon; sepia; light red; raw umber.

Using masking fluid

Masking fluid is a useful tool for the watercolour painter because it provides an answer to the thorny problem of painting around small, fiddly shapes in the middle of a sweeping wash.

In watercolour you have to plan in advance where your white areas are going to be and then paint around them. This is fine for large, simple shapes, but how do you paint around a complex shape such as a windmill, or allow space for a tiny white seagull in a dark sky? Having to leave small or detailed areas white can be a nuisance because it inhibits the flow of your wash.

The solution is to use masking fluid to seal off the white areas, allowing the rest of the surface to be freely painted over.

How does it work?

Masking fluid is a suspension of rubber latex in water. It comes in bottles and is slightly tinted so that you can see where you've applied it. When brushed onto the paper it dries quickly to form a water-resistant film, protecting the area underneath while you finish the rest of your painting.

Simply brush the fluid over the areas which are to remain white. Once it is dry, you can ignore the white shapes completely and wash in the sky, sea, or whatever in your normal flowing style.

When the painting is thoroughly dry, gently rub off the mask with the tip of your finger to reveal the details, perfectly preserved.

When to use it

Masking out tends to produce a crisp, sharply defined white area, so it is best suited to 'hard' shapes such as buildings, boat sails, grasses and so on. It is better to paint around soft-edged shapes such as clouds and wave crests, for a more natural look.

The use of masking fluid is a source of some debate among watercolourists. Purists disapprove of it because they regard it as gimmicky, while on the other hand, highly respected artists like Rowland Hilder use it often and to great effect.

It's a matter of personal choice, but it is worth bearing in mind the cardinal rule of any aspect of watercolour painting – don't overdo it! Masking fluid is a convenient way of keeping areas white, but don't let it become a crutch, which might prevent you from learning to develop a steady hand.

Far right *'The Flirt' by Zoltan Szabo, watercolour, 15"×22" (38cm×56cm).*

☆ **PRESERVE BRIGHT COLOURS**
You may want to paint bright colours against a dark background – for example in a night scene or a still life. Paint the bright areas first, allow them to dry thoroughly and then go over them with masking fluid. Brush in the dark background, peel off the mask, and your bright shapes re-appear, perfectly preserved.

▯ **WASH YOUR BRUSH**
▯ Always wash your brush thoroughly in warm soapy water immediately after using masking fluid, to remove all traces of the rubber solution.

If the fluid does dry on your brush, however, it can be removed with a little petrol or lighter fuel.

STEP-BY-STEP TO MASKING OUT

APPLY THE MASKING FLUID
Draw the outline of the shape to be kept white. Fill in the shape with masking fluid, using a soft brush. Wash the brush out immediately and let the fluid dry hard.

COMPLETE THE PAINTING
Apply your coloured washes as normal, sweeping over the fluid and the surrounding areas. The fluid will protect the paper and keep it white. Allow the painting to dry.

REMOVE THE FLUID
Rub off the dried masking fluid with the tip of the finger and peel it away, revealing clean-edged white shapes. These can either be left white or modelled with colour.

Demonstration

In this painting by Zoltan Szabo there's an interesting contrast between the pure lines and brilliant whiteness of the doves and the soft, neutral shadows on the pavement.

1 Mask out the white shapes

The shapes of the doves must be exactly right and must remain unsullied by the surrounding colours. Carefully draw their outline shapes and then fill them in with masking fluid to protect them.

1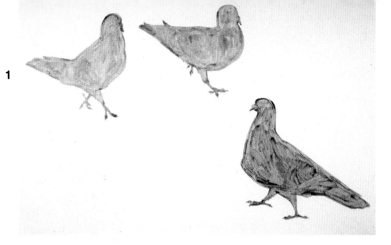

2 Add shadows and texture

Paint a light wash of raw sienna over the whole painting. While this is still wet, add a wash of cerulean blue, ultramarine and burnt sienna. Allow the work to dry, then darken the mixture by adding more burnt sienna and use it to create the gritty texture of the pavement. This is done by spattering the paint: tap the brush, loaded with fairly dry paint, across the outstretched index finger of your other hand, causing a shower of spots to fall onto the paper. When this is dry, use the same mixture to paint the shadows of the doves.

2

3 Rub off the masking fluid

Using a damp bristle brush, lift off some blurred shapes in the foreground to reveal the shadow pattern of the leaves. Using your dark spatter mixture and a no. 2 brush, paint the cracks in the pavement. Wait until the painting is bone dry and then rub off the masking fluid to reveal the pristine white shapes of the birds.

3

4 Model the white forms

To model the soft, rounded forms of the doves, use a mixture of ultramarine, burnt sienna and a little cobalt blue. Test the mixture on a piece of scrap paper first, adding more water if it looks too strong. The white of the paper should dominate, emphasizing the brilliant sunlight falling on the white doves. Paint the feet and beaks with alizarin crimson, using just the tip of a no. 2 brush to 'draw' in the scaly lines of the feet. Add a drop of cobalt blue to the alizarin for the eyes.

4

EQUIPMENT USED
☐ A sheet of watercolour paper approximately 12″×9″ (30cm×23cm).
☐ A no. 6 brush for washes, a no. 2 brush for details and a bristle brush for lifting out colour.
☐ A palette of six colours: raw sienna, cerulean blue, ultramarine, burnt sienna, cobalt blue and alizarin crimson.
☐ Masking fluid.

Vignetting

Another way to place emphasis on a particularly interesting subject is, quite simply, to omit the background altogether. This technique is known as 'vignetting', and is derived from the photographic technique of the same name. The Victorians were particularly fond of vignetted portraits, in which the edges of the subject were softly 'faded out'.

In watercolour, though, the effect is achieved by leaving plenty of white paper around *and also within* the subject. This creates a 'lost and found' pattern whose effect lies in its power of suggestion – the viewer fills in the 'lost' areas from his imagination.

But beware. Vignetting is not simply an easy way out if you don't like painting backgrounds! There's skill in knowing just how much to put in and to leave out of the painting – and how to create a dynamic shape on the page, as Charles Reid has done in this portrait.

Right '*Judith in San Antonio*' *by Charles Reid, watercolour, 22¼″ × 30″ (57cm × 76cm). In a vignette, you must allow white paper to appear within the subject as well as around it, to make a comfortable transition from the painted areas to the unpainted ones.*

'Calla lilies': demonstration

Vignetting works just as well for still life subjects as it does for portraits. In this painting of lilies in a vase, artist Charles Reid accentuates the shapes of the exotic flowers by vignetting them against a plain white background.

1 The first flower

Begin with a simple contour drawing to establish the overall composition, paying particular attention to the shapes of the flowers.

Load a round no. 8 brush with a juicy wash of cadmium yellow and paint the lily on the left. Starting at the tip of the petal, press the brush down to make a broad stroke. Follow by gradually lessening the pressure on the stroke as you approach the narrow base of the flower. Paint the other lily in the same way, all in one stroke, then add a drop of cadmium orange wet-in-wet at the base of the flower.

While this is still wet, paint the flower stem with cadmium yellow and a touch of cerulean.

2 Connecting shadows

With a loose mixture of cerulean, cadmium yellow and a touch of alizarin, brush a light shadow wash down the side of the vase. Darken the mixture with more cerulean and alizarin, and suggest the shadowed underside of the bowl.

The shadow to the right of the bowl is cooler and darker, so add a touch of ultramarine for this area.

Work to the right and downwards to show the shadow on the side of the block, using alizarin, cerulean, ultramarine and cadmium yellow. Add each colour directly wet-in-wet – this gives a far more interesting effect than a flat wash mixed on the palette.

Switching back to the left side of the vase, use the same mixture to paint the dark cast shadow under the leaves with a no. 6 brush.

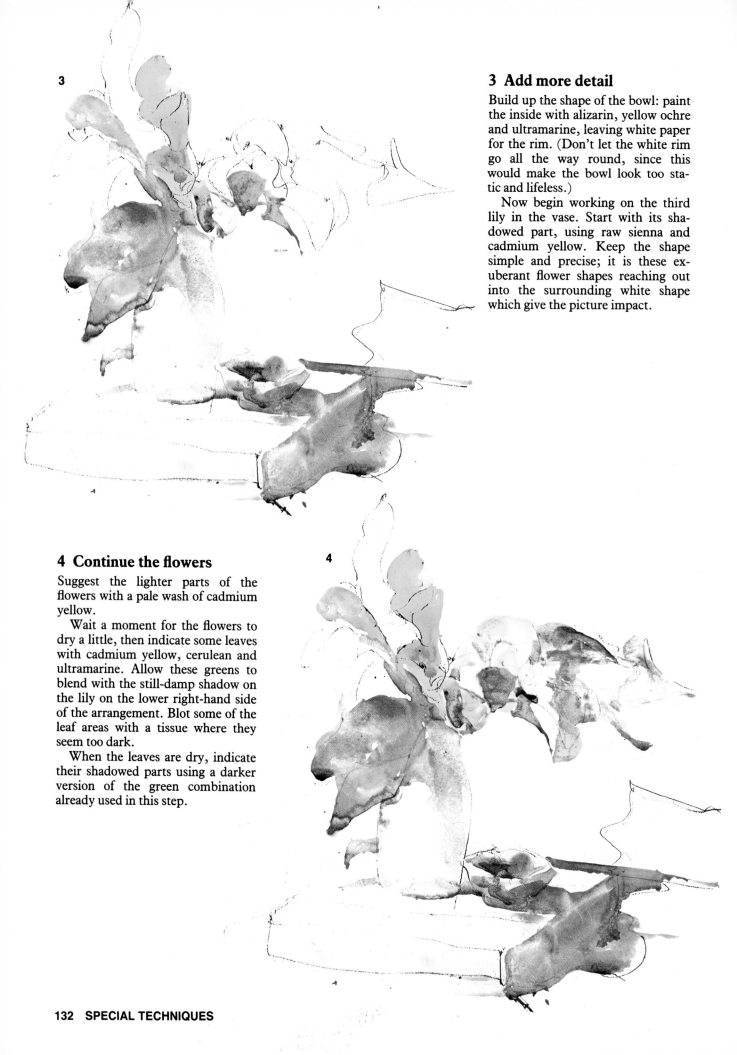

3

3 Add more detail

Build up the shape of the bowl: paint the inside with alizarin, yellow ochre and ultramarine, leaving white paper for the rim. (Don't let the white rim go all the way round, since this would make the bowl look too static and lifeless.)

Now begin working on the third lily in the vase. Start with its shadowed part, using raw sienna and cadmium yellow. Keep the shape simple and precise; it is these exuberant flower shapes reaching out into the surrounding white shape which give the picture impact.

4 Continue the flowers

Suggest the lighter parts of the flowers with a pale wash of cadmium yellow.

Wait a moment for the flowers to dry a little, then indicate some leaves with cadmium yellow, cerulean and ultramarine. Allow these greens to blend with the still-damp shadow on the lily on the lower right-hand side of the arrangement. Blot some of the leaf areas with a tissue where they seem too dark.

When the leaves are dry, indicate their shadowed parts using a darker version of the green combination already used in this step.

4

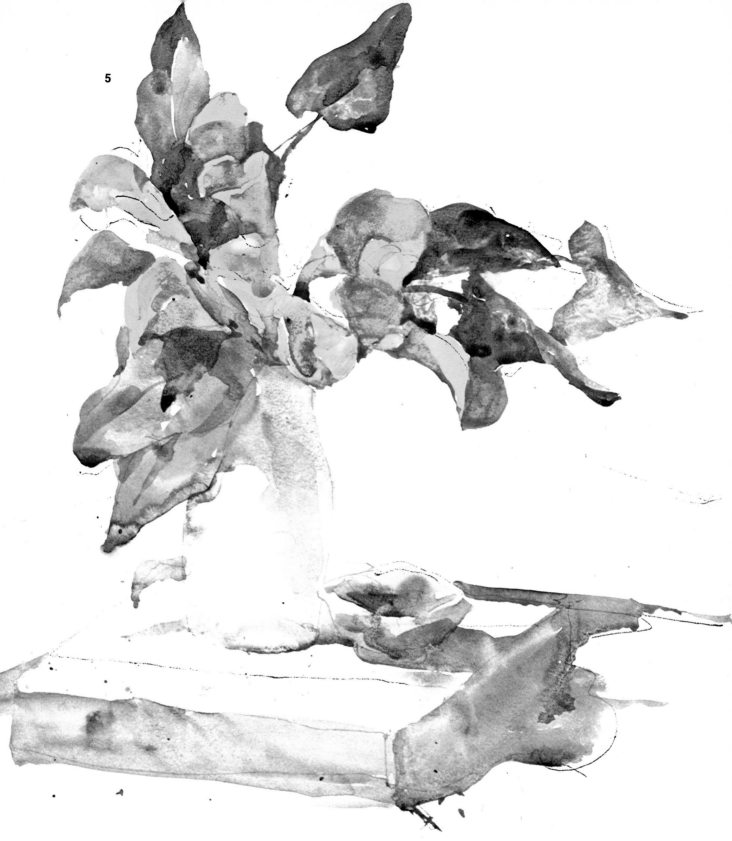

5

5 Complete the picture

Paint the top-most leaves, starting at the tips and working down the left side with one stroke. Then work along the right side with a lighter green wash, leaving a thin strip of white paper down the middle.

Returning to the flowers, paint the dark one on the left with one wash of cadmium yellow, raw sienna and cadmium orange. Then paint the flower just below it with one wash of cadmium yellow and allow it to dry before adding shadows.

Finally, add more shadows and dark accents to all the flowers, using cadmium yellow and cadmium orange mixed with raw sienna.

EQUIPMENT USED
☐ A sheet of 140-lb (290gsm) cold-pressed paper, approximately 16″×13″ (44cm×31cm).
☐ Two round brushes: a no. 6 and a no. 8.
☐ A palette of seven colours: cadmium yellow, cadmium orange, cerulean blue, alizarin crimson, ultramarine, yellow ochre and raw sienna.

Weathered textures

The textures and patterns produced by age and natural weathering in wood, plants, stone and metal make exciting subject material for watercolour paintings, and offer you an opportunity to develop your skill in handling paint. Complex textures may look difficult, but in watercolour you can *suggest* them quite easily with just a little dextrous brushwork. You might also find the following ideas useful:

Textured paper Take advantage of the surface of rough paper, together with the drybrush technique, to represent crumbling stonework and pitted metal surfaces.

Brushes Hog's hair brushes, normally used in oil painting, work perfectly with watercolour to produce streaky textures. Try them when painting tree trunks or weathered wooden doors.

Colour mixes You may have noticed how certain colours, when mixed

Left *These samples show in close-up detail some of the brushstrokes and colour mixes used in the still life opposite.*

Right *A collection of old jars, bottles and brushes makes an exciting 'still life', rich in textural detail, in this painting by Richard Bolton.*

together, tend to 'separate' and form granulated effects; examples of this are ultramarine and burnt sienna, and manganese blue and scarlet lake. Use such granulated washes to suggest the effects of age and weathering on stone and metal.

Contrasting effects

In the still life shown on this page, artist Richard Bolton brings together objects of different forms, textures and sizes to make an interesting set of contrasts.

To suggest the texture of glazed pottery in the gravy boat, jar and bowl, the colours are blended while still very wet; as they melt and run into each other they form soft shapes that indicate the roundness of the forms, and at the same time reflect the effects of ageing. When these washes are dry, the pattern on the gravy boat is lightly indicated using cobalt blue.

Paul Osborne

DESCRIPTIVE STROKES
Use a bamboo brush to make descriptive strokes. Here, a zig-zag of burnt umber is applied first, then ultramarine is swept across the bottom edge. Notice the effect created by the rough surface of the paper.

WET-IN-WET
Brushed into wet paper, a heavily loaded flat brush produces this attractive effect. Here, cobalt blue and burnt sienna are softly blended together and the lower edge is washed away with clean water.

RAPID BRUSHWORK
Rapid brushwork adds sparkle to a painting – it looks quick and unlaboured on the paper. Here, intense washes of burnt sienna and Prussian blue are briskly swept into wet paper.

The weathered texture palette

Although the possibilities for colour combinations are almost endless, most artists tend to rely on certain mixes that suit their particular painting style. The samples below, however, are colour mixtures that always work well for weathered texture effects.

A Burnt sienna and rose madder
Use small patches of this mixture for painting rusty metal.

B Burnt sienna and cobalt blue
Makes an interesting range of greys; useful for painting metal.

A

B

C Yellow ochre and burnt umber
These two colours can be mixed in varying proportions to suggest almost any weathered texture, from rust to decaying wood. They're also perfect for autumn landscapes, especially in ploughed fields and stubble.

D Burnt sienna
A true 'workhorse', this colour mixes well with blues to create a huge variety of greys. You can also use it instead of black to tone down colours that are too bright.

C

D

E Naples yellow and burnt sienna
Another useful mixture for autumn landscapes and for painting freshly-cut logs. A pale wash of Naples yellow on its own is good for pale, wintry skies.

F Naples yellow and burnt umber
When painting weathered wood, use these colours for the highlights and shadows.

E

F

G Vermilion and ultramarine
These colours are useful when painting buildings – tiles, slates, bricks, and rusty corrugated roofs.

H Burnt sienna and cadmium yellow
Blended wet-in-wet, these colours make a good base for painting rusty metal.

G

H

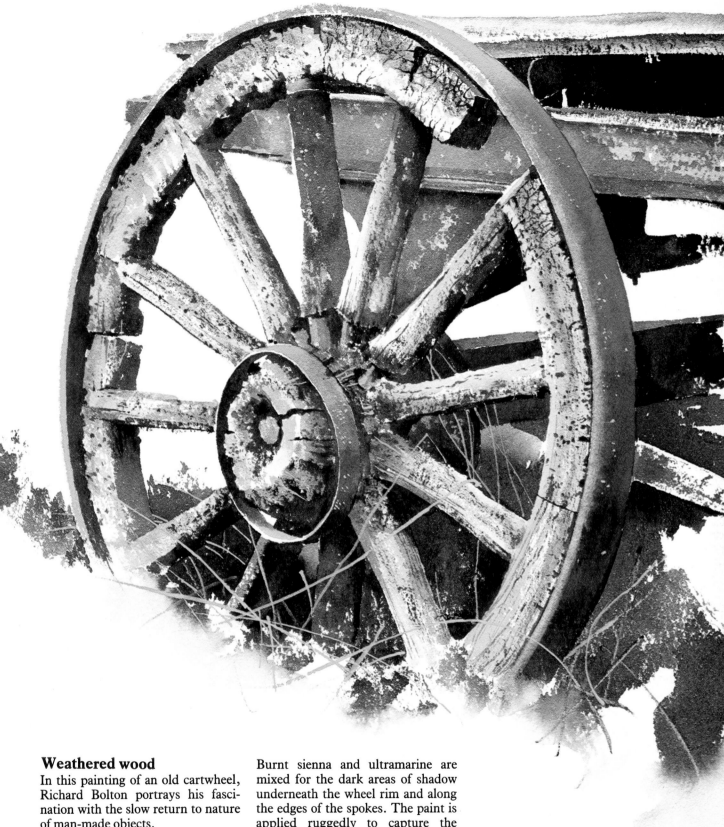

Weathered wood

In this painting of an old cartwheel, Richard Bolton portrays his fascination with the slow return to nature of man-made objects.

The artist begins by painting the entire wheel with a wash of Naples yellow, adding a pale wash of ultramarine for the shadowed areas.

Burnt sienna and ultramarine are mixed for the dark areas of shadow underneath the wheel rim and along the edges of the spokes. The paint is applied ruggedly to capture the effect of disintegration.

Finally, the crumbling surface texture of the wood is achieved with fine lines and drybrush.

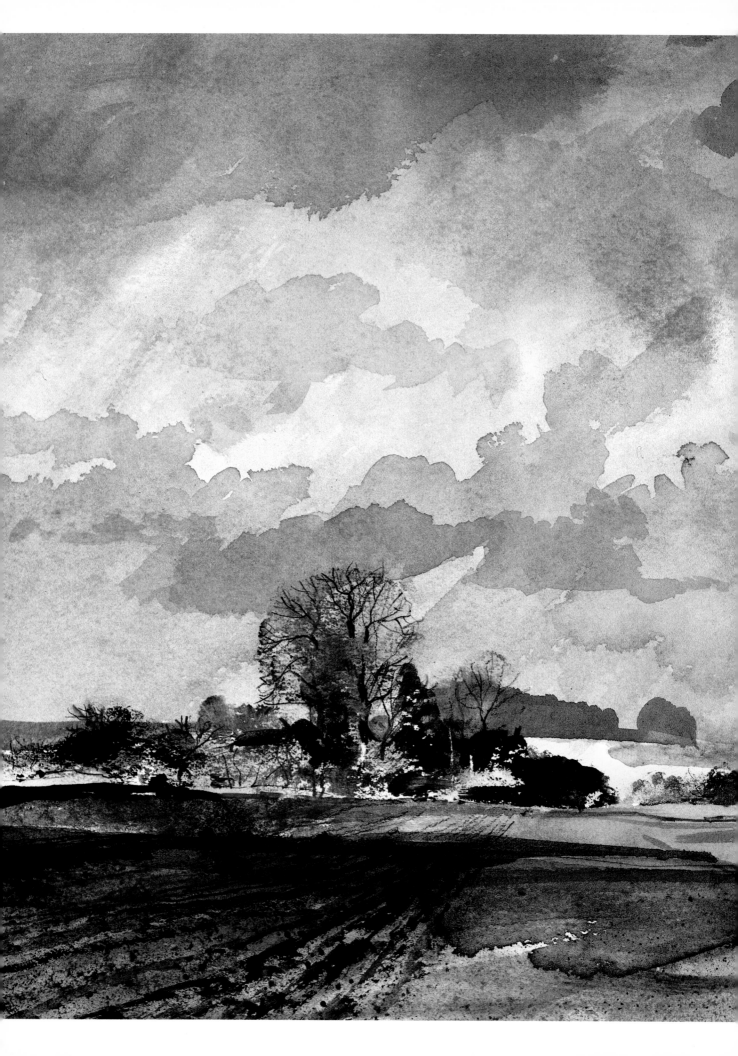

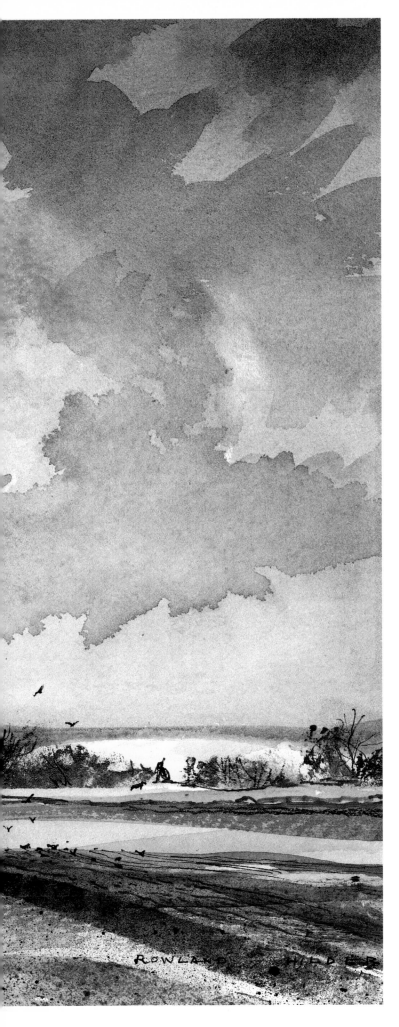

PAINTING OUTDOORS

Watercolourists paint more landscapes than any other subject. The transparency of watercolour makes it ideal for capturing luminous skies, the flicker of sunlight on a mass of leaves, or the crystalline shadows on a snowbank. The speed of watercolour is also a great advantage in painting outdoor subjects. As the clouds race by, as the sun moves across the sky and changes the pattern of light and shadow on trees and snowbanks, you can capture these fleeting effects with a few bold washes and rapid brushstrokes.

This chapter explores the delights of painting sky, land and water, and demonstrates how to combine these elements into vivid paintings that capture the magic of nature.

'Ploughing in the Fall', Rowland Hilder, 11"×15" (28cm×38cm). Light tones in the distance, with darker tones in the foreground and middle distance, give this painting a sense of depth.

Planning an outdoor painting

Watercolour painting in the great outdoors does have its problems – but these are far outweighed by the pleasures. You may have to contend with insects, a sudden downpour, or the idle comments of passers-by, but these are a small price to pay for the pleasure of being close to nature. When you are out painting your senses play an important part in helping you capture the mood of the scene; if you can smell the grass and feel the warmth of the sun, you will paint with more conviction.

Establish the view

When you find a spot that's highly 'paintable' your main difficulty is likely to be in selecting a good composition – literally, you may not be able to 'see the wood for the trees'. This is where a viewing grid comes to the rescue. You can make one quite simply out of cardboard and acetate. The grid frames your subject and helps to separate it from all the confusing material that surrounds it. Stand on one spot and move the grid until you find a satisfying composition.

If you're a beginner, it is wise to start off close to home – in your own garden or a local park. This will give you an idea of the problems to be encountered – and how to solve them – before you go trekking off to the wilds of the countryside.

Basic equipment

First and foremost, keep your equipment simple. This has the psychological effect of keeping your mind clear for producing fresh, spontaneous work. The illustration below shows a good outdoor painting setup.

Easel Choose a lightweight aluminium folding easel for easy carrying.

Paper Take either pre-stretched paper taped to a lightweight board, or a block of heavier paper which doesn't need stretching.

Water A plastic soft drinks bottle is ideal for carrying that essential supply of clean water.

Hold-all A plastic tool box or fisherman's tackle box have useful divided trays that fold back when you lift the lid, making it easy to keep your painting equipment in order.

Extras Whatever the season, it is sensible to take along an extra pullover and something to eat and drink. If you're using a sketchpad, use a bulldog clip to secure the pages so they don't flap about.

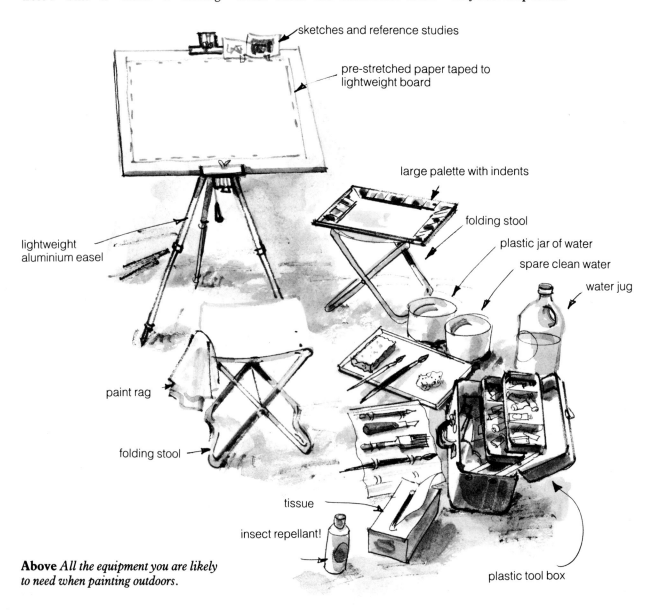

sketches and reference studies

pre-stretched paper taped to lightweight board

large palette with indents

lightweight aluminium easel

folding stool

plastic jar of water

spare clean water

water jug

paint rag

folding stool

tissue

insect repellant!

plastic tool box

Above *All the equipment you are likely to need when painting outdoors.*

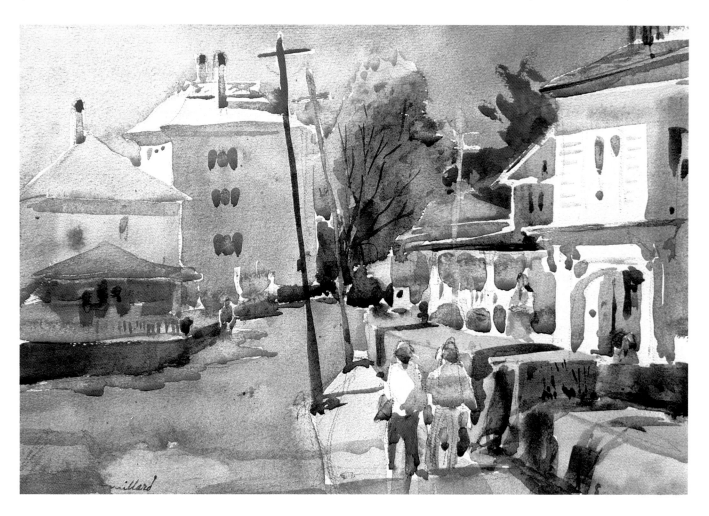

Above and right *The secret of a successful outdoor painting is to plan your lights and shadows before you start. A rapid sketch shows what the overall pattern will look like.*

About town

A townscape drenched in sunlight makes a fascinating subject, because buildings create lively or dramatic shadows which can be used to great effect in your paintings.

The street scene above is bathed in rich, warm afternoon sunlight, which creates luminous shadows and crisp white shapes.

Analyse the scene

A complex composition like this needs to be simplified in order to retain the feeling of light and air. Half close your eyes and you will see the main outlines more clearly. Then make a contour diagram of the scene, blocking in the darks and outlining the highlights, as David Millard has done on the right.

Note the variety in all these white shapes

The shadows reflect the cool blue of the sky

This dark path helps the eye to move back into the distance

The white shirt helps draw attention to the centre of interest

Summer Garden: demonstration

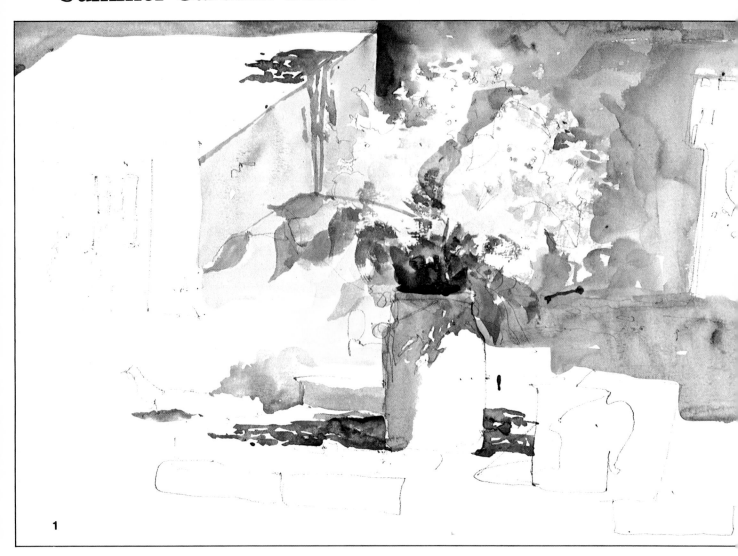

1

EQUIPMENT USED
☐ A sheet of hot-pressed watercolour paper approximately 12″×8″ (30cm×20cm)
☐ 3 brushes: a no.6 round, a no.6 flat and a no.4 round.
☐ A palette of nine colours: sap green, cadmium yellow, ultramarine, cerulean, alizarin, cadmium orange, cadmium red, burnt umber, ivory black.
☐ An HB pencil.

The big problem when painting outdoors on a sunny day is how to cope with the changing light: if you work from light to dark with successive washes – the normal procedure in watercolour – everything may look different by the time you get the shadows in.

The answer is to reverse the procedure and start by indicating the darks and the cast shadows first, so that they are consistent. In this demonstration, Charles Reid shows you how to convey the impression of a bright summer's day by carefully planning your lights and darks.

1 Begin the shadows

Start by roughly outlining the elements of the scene in pencil. Then outline the shapes of the shadows and cast shadows; since you are painting outside, these will change a lot before you complete the painting so it's important to get them consistent at the beginning.

The background Dampen the paper, then mix a puddle of sap green, cadmium yellow and ultramarine on your palette. Using a no.6 flat brush, paint the area behind the vase of flowers. Leave a ragged, indented outline to create the shape of the lilacs.

The leaves Using the same colours, block in the shapes of the leaves in the vase.

The vase Let the paper dry, then paint the shadow on the white vase using a mixture of cerulean, ultramarine and alizarin. (Notice how Charles Reid creates the impression of reflected light in the shadow by varying its density and leaving little patches of sunlight). Work the shadow wash down the left side of the vase. Soften the nearest edge of the shadow with a round no.6 brush and clear water. This indicates the roundness of the vase.

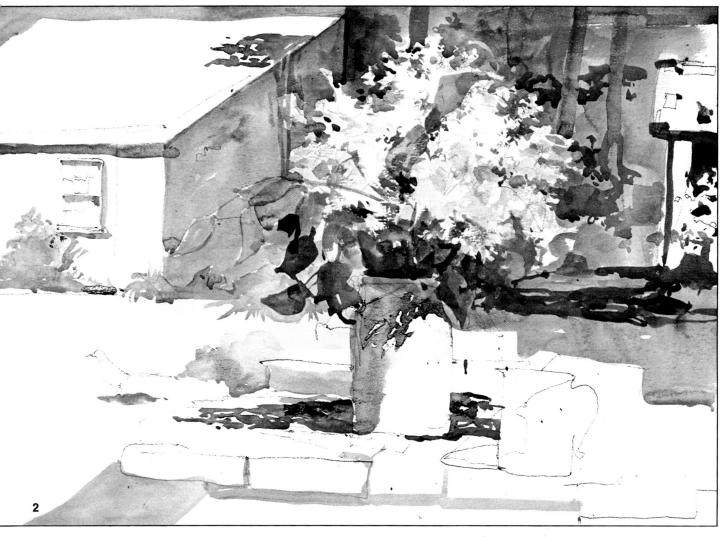

2

The **cast shadow** Using the same shadow mixture, but with less water, indicate the cast shadow of the vase on the table.

The **building** Paint the shadow side of the building on the left with a very light wash of cadmium orange, cerulean and alizarin.

The **flowers** For the pale tints in the lilacs, mix cerulean, alizarin and a little cadmium yellow and apply it lightly with drybrush strokes.

2 Add more darks

The hard part of working from dark to light is to get the darks just right. If they are too light, all the other tones keyed to them will also be light, and the result is a rather washed-out painting. If they are too dark, they will make the painting look spotty. The problem arises because you are painting darks on pure white paper, which makes them look darker than they actually are.

The best solution is to paint the shadows darker than you want them to be; when the mid-tones are added later, the darks will fall into place.

The **background** Mix a dark wash of ultramarine, sap green and cadmium yellow and build up the darks around the flowers and in the background. Keep your brushstrokes loose.

The **vase** Make sure that the shadow washes on the vase and table are completely dry, then apply a thin glaze of cerulean over them to make them appear cooler. Shadows are often more interesting than they appear at first glance; in this picture there is a lovely pool of blue reflected light within the shadow of the vase, just at the base.

The **flowers** Add a touch of warmth in the lilacs, using alizarin. Mix the paint with plenty of water on the palette to get a very pale tint and apply with drybrush strokes.

☆ **CHOOSING A VIEW**

As well as recording scenes, a camera can be a valuable tool in helping you decide on the structure of your final picture. Looking through the view finder you can concentrate on a narrow field of vision and get a good idea of how your final painting might look – the camera cuts out surrounding detail and so acts like a viewing grid.

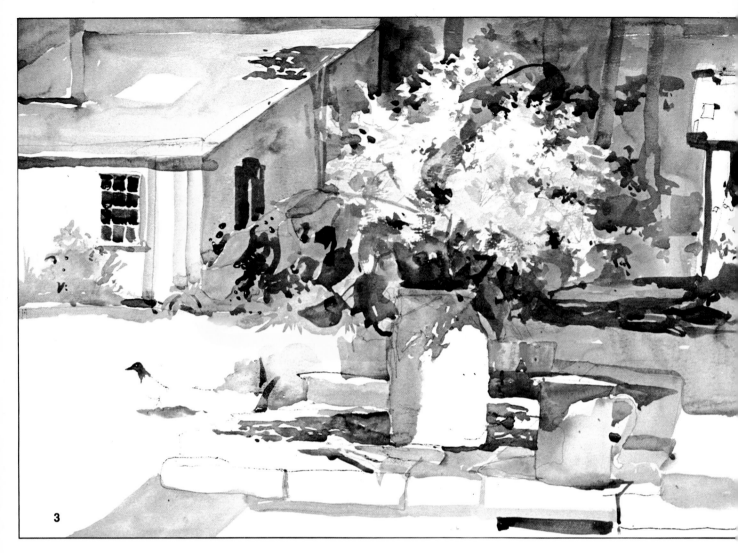

3

EXTRA WEIGHT
When painting outdoors, even a slight breeze can upset your easel or tripod. To counter this, suspend a weight from the centre point of the structure – using a length of nylon cord and a bag filled with, say, rocks or sand.

3 Paint the surroundings

Now that the broadest areas of light and dark are established, you can begin to bring in some of the smaller details.

The roof Paint the roof of the building with a light wash of ultramarine, alizarin and cadmium yellow, leaving a patch of white paper for the skylight. Notice how the artist has painted around the shape of the shadow of the tree on the roof. This is done to avoid disturbing the first wash. Interestingly, the tiny sliver of white which he leaves around the shape effectively conveys an impression of light, air and movement. It is little touches like this – whether by accident or design – that breathe life into a painting.

The window Similarly, the window at the front of the building is painted in an effortless manner. Paint the window panes with burnt umber. Use single strokes with a flat no.6 brush for each pane, leaving lines of white paper between them. Don't be too precise – the window should look old and weatherbeaten, not pristine and new!

The jug Paint the dark shadow on the jug with a mixture of ultramarine, alizarin and cadmium orange. Use the same colours, but with more water, to paint the rest of the jug. Leave patches of white paper around the rim and the handle for the bright highlights.

The table On your palette, mix a puddle of alizarin, cadmium orange and a touch of ultramarine. Load the brush well and sweep it around the shapes on the table. Leave plenty of white space to indicate sunlight.

At this stage of the painting it's a good idea to take a break for half an hour. When you return you will look at the painting with a fresh eye and spot any weaknesses there may be. For example, in this painting there's

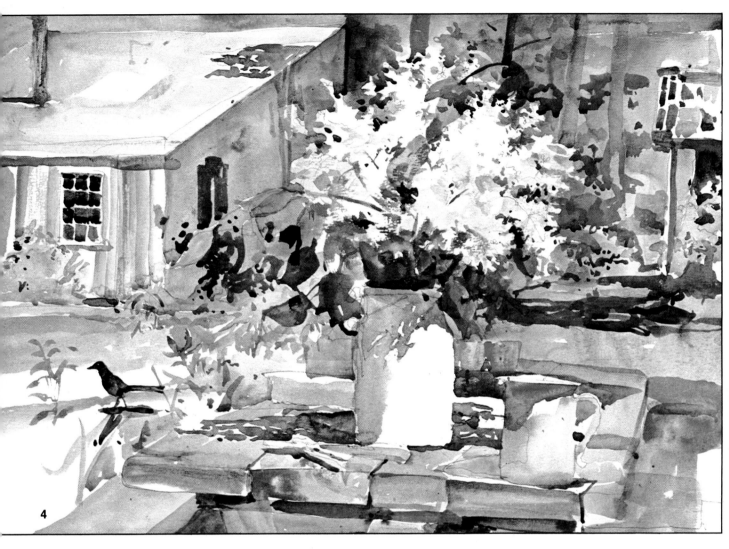

4

a danger that the greens in the foreground will 'disappear' into the background greens. To get round this, Charles Reid introduces one or two accents of colour which help to separate foreground and background. He adds a dark doorway on the side of the building, which makes the leaves in the jug stand out more. Then he uses cadmium orange and cadmium red to make a splash of colour just behind the jug. This juxtaposition of complementary colours – red and green – gives the picture an added lift. Don't be afraid to use such artistic licence if it improves your painting. The result is far more lively than a literal approach.

4 The final touches

The table Paint each slat of the table separately, using various mixtures of alizarin, ultramarine, cadmium yellow and cadmium orange. Again, be sure to leave little patches of white for a sunny effect.

The bird Using a no.4 brush, jot in the shape of the bird. Use ivory black for the head and tail and ultramarine mixed with a tiny dot of ivory black for the breast.

One of the joys of working outdoors is that things happen unexpectedly. This little bird appeared while the artist was painting, so he was included as part of the scene!

The final painting gives a delightful impression of a sunny day, conveyed with great economy of effort. With a subject like this there is a danger of overworking it and losing the freshness and spontaneity. Look carefully at your work when you come to a moment of indecision. Perhaps you have already accomplished what you set out to do. Does your painting look bright, crisp and sunny? Then you have done a successful job of capturing a sunny day.

SUN ON PAPER
Try to avoid painting with the sun directly on your paper. The glare makes it difficult to judge colours and tones, your own shadow on the paper is distracting, and the washes.dry too quickly. Whenever possible, set up your easel in a doorway or in the shade of a tree.

Using artistic licence

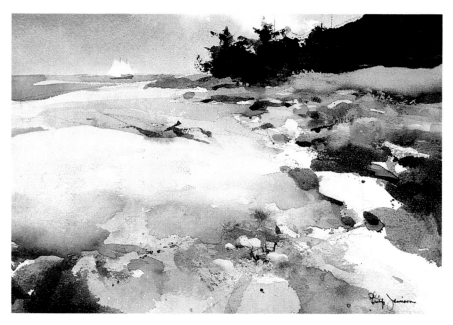

Many people are apprehensive about watercolour painting, believing that it requires a lot of technical skill and know-how. Of course it helps to understand the capabilities of your materials, but don't always paint strictly by the rules – paint according to what you *see* and *feel*.

Jackson Pollock, one of America's pioneer Abstract Expressionists, believed that concentrating on technique is not a good way to go about being a painter: 'You can't learn techniques and then try to be a painter. Techniques are a result.'

Learn to relax

The mystique that surrounds painting disguises the fact that learning to handle watercolour really can be fun. The early stages mark the ideal time to experiment and to learn by your mistakes. But later on, when the basic techniques start to come as second nature, you may try to avoid these mistakes when in fact you can often take advantage of them. So have fun before you're hemmed in, and don't worry if things work out differently to your original plans.

The fascination of watercolour painting lies in its unpredictability. There's a degree of tension and excitement as you apply the paint to the paper and ask yourself: *'will I produce a masterpiece or a mess?'* Learn to enjoy this uncertainty – if you're afraid of spoiling that pristine white paper, your inhibition will show in your work.

Artistic licence

Equally, it's important to be flexible when you come to translate what you see before you into a painting. Don't be too concerned with making an exact reproduction of what you see – a camera can do it much better. Being an artist allows you to control the composition.

The paintings on these pages are the work of Philip Jamison, an accomplished watercolourist who believes that a painting can be modified, re-worked or even completely changed if you're not happy with it.

In these two landscapes he has created two entirely different moods from the same scene. 'Summer Day' (above) sees the area on the left scrubbed out to open up the composition and lend emphasis to the highly foreshortened viewpoint.

In 'Vinalhaven Shoreline' (right) the mood is softer, due to the more horizontal composition. Notice how the rocks on the shore are suggested rather than laboriously copied. The sailing boat is imaginary, put in to provide a focal point and give the painting a sense of scale.

Most of the great artists had a favourite theme which they painted again and again: think of Constable and the Vale of Dedham, or Monet's water lilies. It's always a good idea to do a series of studies of your favourite scene, rather than just one painting: you'll find that new ideas suggest themselves each time you paint.

Top left *'Summer Day' by Philip Jamison, watercolour, 9½"×13½" (24cm×34cm).*
Above *'Vinalhaven Shoreline' by Philip Jamison, watercolour, 10½"×14½" (27cm×37cm).*

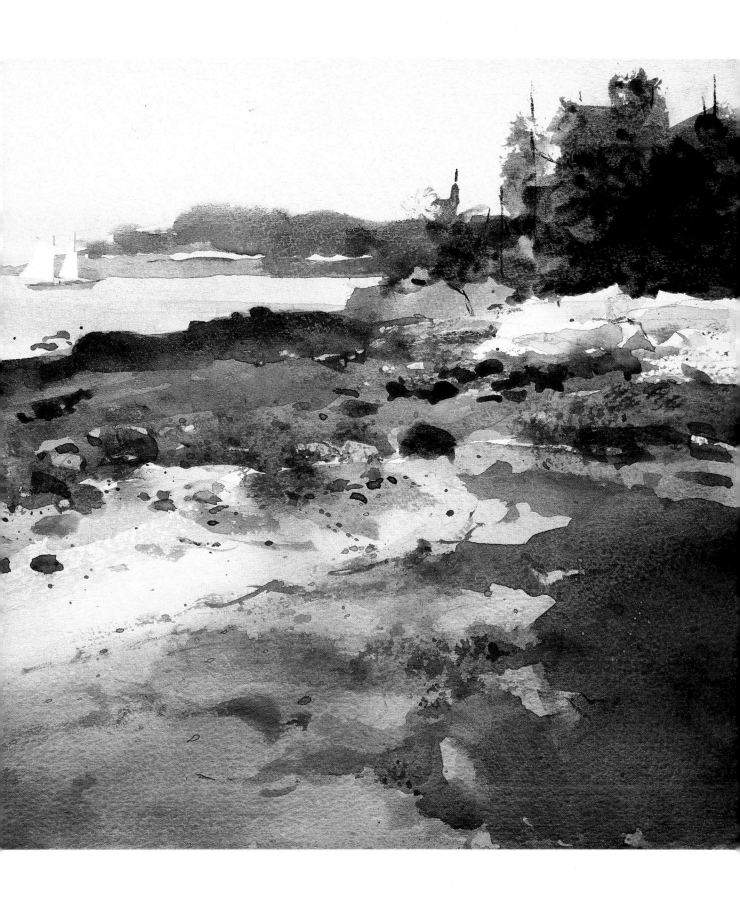

Making the composition work

When you first start painting, you may be happy simply to make the picture come out looking reasonably like its subject. But as you gain more experience, you'll come to realize that there is more to painting than a good eye and sound technique.

What counts is not what you paint, but how you interpret it. Try to absorb the basic feeling of your subject and then produce a strong image of it in paint, even if it means altering reality in order to strengthen that statement.

For instance, you may be struck by the quality of the light in a landscape, but the scene is too complex for you to cope with. In this case decide which elements in the scene will support your statement about the light, and discard the rest.

Similarly, you should have no qualms about moving things about,

introducing new elements, or even combining different scenes into one painting. Philip Jamison's watercolour sketches of 'Moore's Farm' (below) demonstrate how you can rearrange reality, if necessary.

The sketch bottom right is the one most faithful to the actual scene, but it looks confused and muddy. The artist makes several more sketches, using coloured paper shapes to try out compositional ideas, and the top picture is the final result. Compare it to the lower four and you'll see that it looks fresher and more direct. Jamison has simply added more snow to the scene than was actually there, so that the farm buildings are emphasized dark against light.

Next time you paint a landscape, follow Jamison's example and consider what is important and what can be left out altogether.

REARRANGING REALITY

'Nature contains the elements, in colour and form, of all pictures, as the keyboard contains the notes of all music. But the artist is born to pick, to choose, and group . . . these elements, that the result may be beautiful.'
James McNeill Whistler 1834–1903

☆ PAPER OVERLAYS

If you want to alter your composition, you can minimize the number of mistakes and changes made on the painting by using pieces of coloured paper to approximate areas you want to add or subtract. Cut out the shape of the desired change from paper similar to the colour intended and place it on the painting to see if it works.

'VIEW-FINDER'

Many artists these days use a camera as an aid to establishing a composition that works. Find a scene that interests you and take snapshots of it at intervals during the day, looking for the most interesting patterns of light and shade.

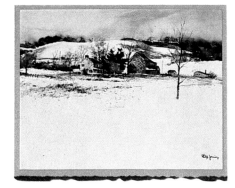

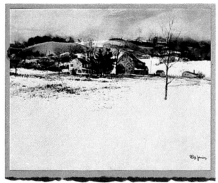 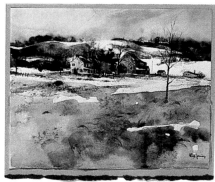

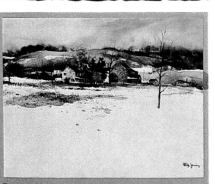

Right *'Moore's Farm' by Philip Jamison, watercolour, printed card 5½"×7½" (14cm×18cm).*

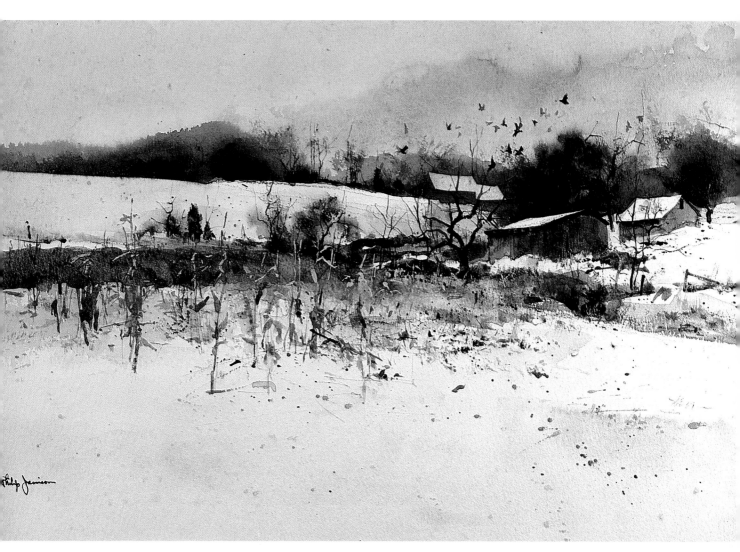

Above '*A Flock of Crows*' *by Philip Jamison, watercolour, 11¾"×19¼" (30cm×49cm).*
Left '*March Thaw*' *by Philip Jamison, watercolour, 14"×21¼" (36cm×54cm), private collection.*

A seemingly complex picture often has a simple structure. 'A Flock of Crows' (above) is made up of four triangular shapes, each leading the eye to the centre of interest.

In 'March Thaw' (left) the artist used paper shapes in white, tan and black to help him plan the abstract patterns of the composition before painting them in. Notice how the interplay of lights and darks sets up a satisfying rhythm and invites the viewer into the painting.

Jamison simplifies the colour scheme too, sticking to one warm and one cool colour, plus white to evoke the stark winter light.

Rescuing a failure

If you paint a failure, don't just discard it – you can use it to experiment with or rework it to your heart's content. Either way, knowing that you've nothing to lose you will be more relaxed and ready to try out those loose, free washes that you were so afraid of before!

The happy accident

Remember, a mistake is never a disaster, there is always something to be learned from it. Accidental 'mistakes' can give an extra quality or dimension to a painting, sometimes making it more successful than you had realized it could be. Capitalize on the 'happy accident': a darker shadow than intended could give a scene more depth; likewise, too much green in a sea might bring it nearer the true colour.

If the mistake really is bad then by learning to react quickly and make judgements you can often sponge or wash it away before it dries into the paper. In fact, your efforts to remove mistakes can lead to other interesting discoveries, such as which pigments leave a stain when you try to lift them off. Sometimes lifting and blotting out colour leaves a misty, evocative impression which you might otherwise have found difficult to obtain.

All change

Philip Jamison's painting 'Daisies' (right) underwent several transitions before the artist was satisfied with it. Believe it or not, the picture began as a snow scene! It didn't work, but Jamison was undeterred:

'I threw a yellow-green wash over the entire snow area, changing the season from winter to spring. I added some scattered daisies, using opaque white . . . still nothing, though I liked the daisies. It was then that I gave up on using the painting as a whole and decided to concentrate on just the daisies in the foreground. I worked and reworked them by scrubbing out and painting back, and finally painted in the very dark central strip to suggest a background of pine trees.'

It's worth bearing in mind that if a picture doesn't work as a whole, you can always cut it up and save individual areas that *are* successful. 'Daisies' is shown both in progress (below) and in its revised, cropped state (top).

The initial response

Always give careful thought to *what* you are going to paint and *why*. The artist whose goal is merely to paint a pretty picture to hang on the wall is more likely to fail than the artist who sets out to make a statement about his feelings for the subject.

Decide what it is about a given scene that strikes a response in you; is it the quality of the light? The juxtaposition of colours? Aim to project that particular quality with force and clarity in your painting.

Learn to trust your instincts and you'll find that 'technique' will develop of its own accord.

A GOOD ALL-ROUNDER
There's a bewildering array of watercolour papers around, but 140lb Bockingford is suitable for beginners and experienced artists alike. It is reasonably priced, its surface is pleasant to work on, and it has the strength to stand up to repeated wettings without tearing.

BRUSH HYGIENE
A muddy-looking water jar means a muddy painting! Change the water frequently, and remember to wash your brush out thoroughly between each application of paint. This may seem time-consuming, but it soon becomes second nature and it will prevent your colours from becoming sullied.

TAKE YOUR TIME
Most watercolour pictures are spoilt by overworking – beavering away at the paper while paying less and less attention to the actual subject. Remember, spend more time looking and preparing than painting.

CORRECTING WATERCOLOURS

Sponging out Use a small, natural sponge to lighten a large, dried area such as a sky. The sponge should be damp, but not dripping. Work gently over the surface of the paper (don't rub).

Alternatively, start by brushing a wash of clear water over the offending passage, let the water soak in so that the colour loosens, then mop it up with the sponge.

Scrubbing and lifting out To remove colour from a smaller area, you can try scrubbing with a bristle brush – the kind used for oil painting. Work with the brush in one hand and a tissue in the other. Dip the brush in water, scrub gently, and blot away the loosened colour with the tissue.

Washing out If the whole painting looks hopeless, submerge it in a sink full of cold water and soak out as much colour as you can. Some colours will come out by themselves. Others will need to be 'tickled' with a soft brush or a sponge. Some pigments, such as alizarin crimson and phthalo blue, will always leave a stain.

Tape the paper to a board afterwards so it dries flat. You'll be left with a 'ghost' of your original painting, over which you can apply fresh paint either while the paper is still wet or after it has dried.

Top *'Daisies' by Philip Jamison,*
watercolour, 16⅜″×14⅜″ (41.5cm×37cm).

Below *'Daisies' (in progress) by Philip*
Jamison, original size 11¼″×15″
(29cm×38cm).

NOTE THE LIGHT SOURCE
Notice where the light source –
the sun – is in relation to your
subject. This photograph of a
tree was taken in mid-afternoon
and the sun is at an angle of
about 45° to the ground, on the
left of the picture. By viewing
the tree from this position
(left) you can take advantage
of the side lighting which
helps to separate the tones
more clearly.

SUCCESSFUL COMPOSITION
The traditional way to get a
balanced, satisfying composition
is to use the 'intersection of
thirds' (right). Imagine that
the scene is divided into thirds
both horizontally and vertically.
Any one of the four points
where the lines intersect is a
'satisfying' position for the main
subject – in this case the tree.
The composition becomes dull
if the tree is centred.

Composing a landscape picture

When painting an inspiring landscape, it's all too easy to get carried away by your enthusiasm and not think constructively about what you're doing. It may sound like anathema to an artist, but the watchword with any painting is *organization*. This applies particularly to watercolour, since you must build up your tones from light to dark, and mistakes cannot be painted over.

When planning your painting you need to think carefully about defining the individual elements – composition, light and shadow, scale and colours.

The photograph on the left represents a typical landscape which you might find when you go out with your easel and camp stool – a young tree silhouetted against a vibrant summer sky. In this scene you can see that the light is good, the colours clear and the composition fairly straightforward. The feature requiring the most attention is the cloud-filled sky.

Looking at the foreground

You will notice when you look around you that colours are usually a little stronger and warmer when they are closer to you, in the foreground. In the photograph you can see this by comparing the colour of the foreground tree with the softer appearance of the distant trees. Looking at the sky, the colour is strongest at the top, getting paler towards the horizon. Note also how the cloud cover builds up nearer the horizon.

The treatment of the foreground presents challenges for all painters. Foreground should not be too full of

Left *Even apparently simple landscape subjects benefit from good organization. Here, the tree's position, horizon line and light source are all critical.*

distracting detail, but neither should it be ignored or overlooked – you need to balance a picture carefully and pay attention to the scale of the foreground features and texture.

A good idea is to keep a sketchbook of 'foreground ideas', adding sketches of plants and other interesting details every time you go out painting or sketching. Then, if you paint a landscape picture such as this, you can use ideas from your sketchbook to make the foreground of your painting more interesting.

Creating a sense of distance

Differences in scale provide a sense of distance. This is clearly shown in the photograph, where the foreground tree is much larger than the trees in the background, and the clouds appear smaller and denser as they approach the horizon.

The eye-level (horizon) is another aspect of the picture that you should think about. Notice in this example that the artist has composed the scene from a low viewpoint; this emphasizes the sky and frees the tree from what would otherwise be a cluttered background. When deciding on a composition, move around and look at your subject from various view-points, with different eye-levels.

Once you have selected your view it is worth giving some thought to the general mood of the scene before you start work – this is much more the product of the light, the sky and time of day than the actual details of the landscape. As the light will change considerably during the painting of the picture, it may be helpful to make brief notes about the play of light and dark at a given point so that you can refer back to them as the light changes. This lends a consistency to the picture which can otherwise be difficult to achieve.

THE FINER POINTS

blue tinge of hills gives illusion of depth

foreground details bright and clearly defined

low horizon line lends dramatic intensity

1

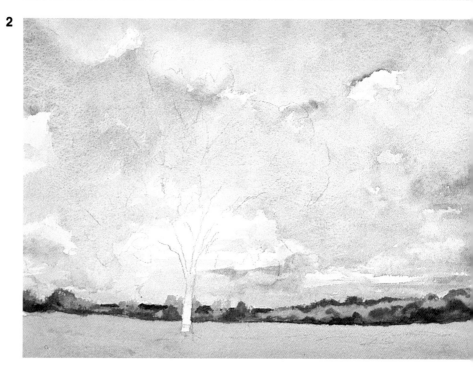

EQUIPMENT USED
Sable blend brushes in sizes no.2, no.6 and no.10.
A sheet of NOT paper, such as Saunders, 10"×7" (25cm×17.5cm).
A palette of four colours: cobalt blue, raw sienna, burnt umber, Hooker's green dark.
Blotting paper and tissues or a small sponge for lifting out colour.

KEEPING COMFORTABLE
A lightweight folding canvas stool is essential for painting outdoor scenes. Nothing is more likely to disturb your concentration than physical discomfort.

2

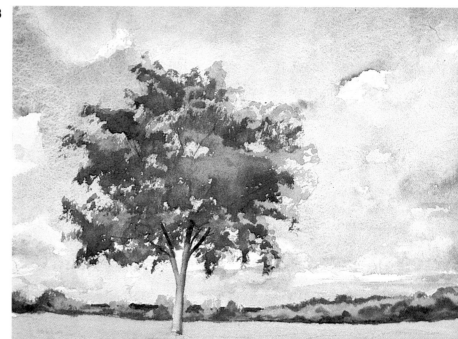

PREPARE YOUR PAPER
You can buy blocks of pre-stretched paper for outdoor painting, but it is cheaper to prepare your own: soak and stretch a large sheet of paper, allow it to dry, then cut it into smaller pieces which can be taped to a clipboard with masking tape.

KEEP IT CLEAN
A vital part of your outdoor painting kit is a good supply of clean water so that you can renew your painting water from time to time. Lightweight plastic soft-drinks bottles are ideal for this.

⚠ DON'T DESPAIR
You are quite likely to find that you paint a sky like this more than once before you are happy with it. Complete the sky to your satisfaction before you go on to paint the trees and foreground.

3

If you paint blue over some of the sky areas where you intended to have cloud, you can lift out colour while it's still wet with clean paper tissues or blotting paper.

Summer Landscape: demonstration

This demonstration by artist Ferdinand Petrie shows how effective a simple composition can be. There's no easier way to become discouraged than to start with an overly ambitious scene!

1 Preliminary sketch

Concentrate on the large areas first – you can think about details later. Lightly sketch in the horizon line and the outline of the tree. Indicate the white areas of the sky too – these will be left unpainted to provide sparkling highlights.

The key to handling a strong sky like this is to keep it fresh and unstudied – be loose and free in your approach, let your colours melt into each other and don't overwork them.

Thoroughly dampen the sky area and use a well loaded no.10 brush to lay in a wash of cobalt blue, skipping round the areas you want to leave white. The sky always looks paler towards the horizon; to achieve this effect, add more and more water to your wash as you work down to your horizon line.

Just before the wash dries, 'lift out' patches of colour here and there for the lighter areas of cloud. Lifting out is done by gently dabbing out the colour with a ball of tissue, a sponge or a dry brush.

Now block in the darker clouds using burnt umber, with touches of cobalt blue and raw sienna to give them form and warmth. Lay the colours in wet washes over one another so that they bleed together to create the effect of soft-edged, moving clouds. Make the edges darker than the centre for a three-dimensional effect.

To finish off the sky, paint in horizontal strokes with a no.2 brush to suggest the distant cloud formations just above the horizon.

2 Creating the middle ground

Keep the middle ground fairly light so that it contrasts with the darker line of the distant trees. A suitable mixture might be raw sienna and Hooker's green dark, or olive green with burnt sienna – experiment until you find the combination you prefer.

When the sky and field washes are dry, paint in the band of distant trees with raw sienna to represent the areas where the sunlight catches the

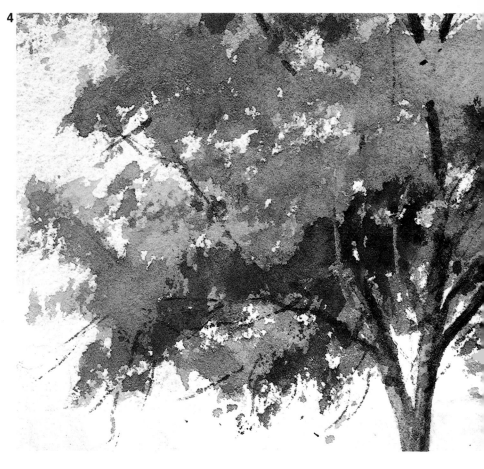

4

treetops. Then touch in the darker trees with a loose mixture of burnt umber and cobalt blue. Some trees are much darker, suggesting the shadows of a passing cloud, so add a hint of Hooker's green dark to the mixture.

3 Starting the foreground tree

The foliage of the foreground tree is painted freely at this stage. Take care to balance the overall shape of the canopy and leave plenty of light showing through from the sky beyond.

Notice the shadow on the right of the trunk, and the dappled shadows cast by the foliage. The trunk is painted in a grey mixture of cobalt blue with a little burnt umber, the colour being softened carefully until the trunk is just tinted.

4 Working up the canopy

The aim here is to suggest the tree's foliage without paying too much attention to every leaf and branch. Work swiftly with deft brushstrokes and use a variety of greens mixed from your blue and yellow pigments.

You'll be able to control the colours more easily than if you use pigments straight from the tube.

The light catching the central foliage is heightened by the application of darker greens underneath. Create some of the lighter areas by lifting the paint while it's still wet. Flick on the outermost leaves with the tip of the brush to suggest movement.

Don't overwork the branches – they should support and balance the foliage, but paint them in light, broken lines, lifting out colour here and there to suggest sunlight.

Overleaf *The finished landscape (shown one and a half times actual size so you can see the details clearly) shows how the essence of the scene is captured without portraying every little detail. The foreground is completed by painting the tree shadow, thereby emphasizing the light source.*

A few strokes indicate grass – another way of creating a sense of depth by giving more detail and texture in the foreground, less in the distance.

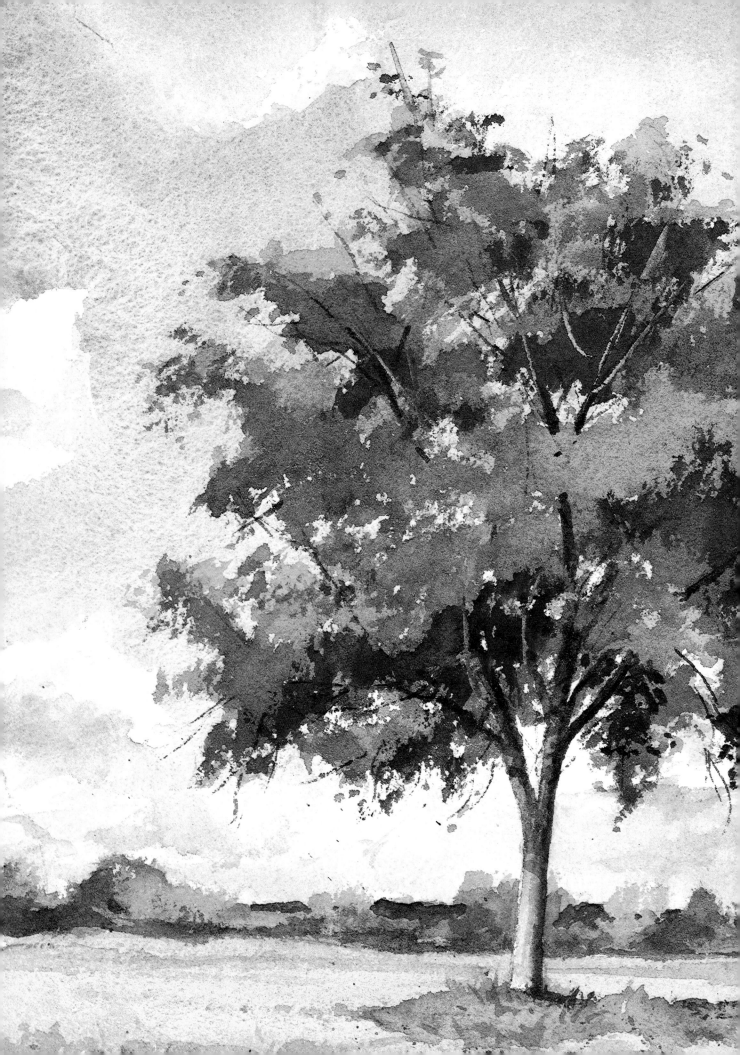

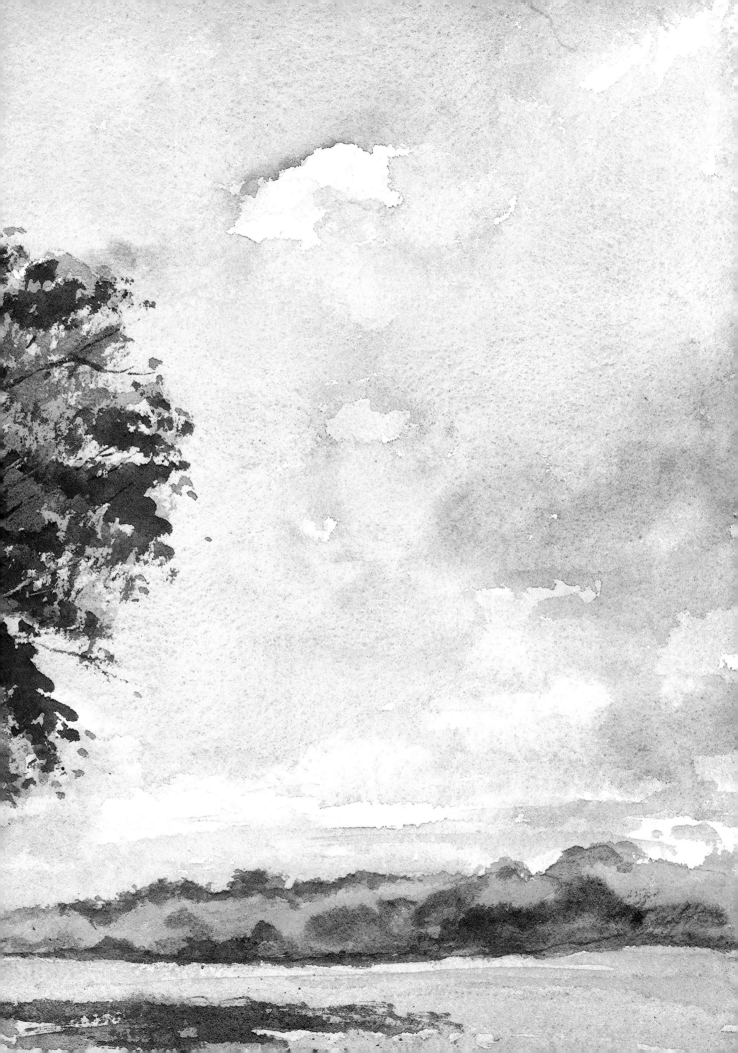

Winter landscapes

In painting the purity of white snow, watercolourists have a special advantage – the white is already supplied by the paper. However, it would be a mistake to accept snow simply as a vague, colourless area. Snow, like water, is a great reflector of colour and light. Depending on the quality of the daylight, you might see delicate tints of yellow and pink or blue and violet in the highlights and shadows.

Bright sunlit snow

You'll need two sets of colours, warm and cool, for modelling snow. Even in bright sunlight, you will find the purest white only in small areas. The shadows are surprisingly colourful; paint them with ultramarine, cerulean or manganese blue. These colours granulate when applied in a wash, and give the appearance of powdery, sparkling snow. For the warm areas, add touches of light red, raw sienna or burnt sienna to the blues. The shadows are darkest at their outside edge, because the inner areas pick up some reflected light from the sky.

Snow on an overcast day

On an overcast day there are no sharp shadows, only soft shading. To

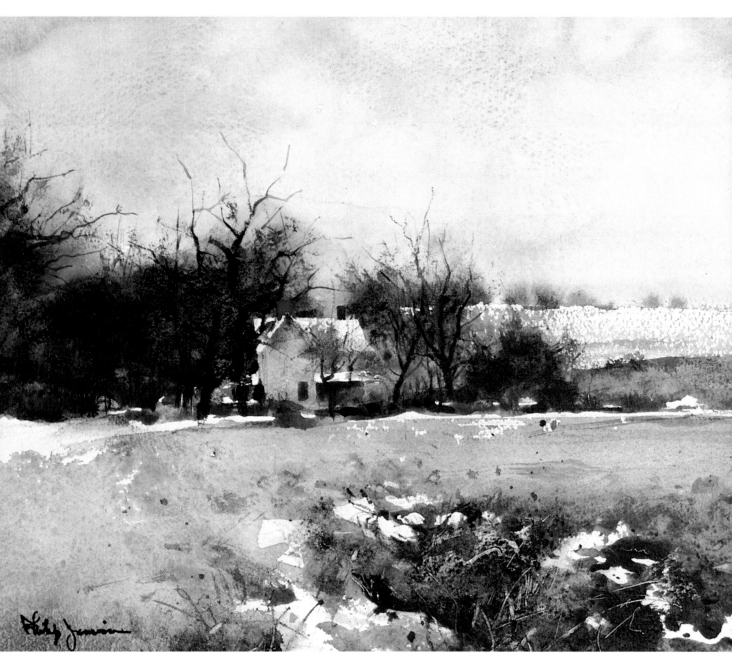

Below *'Along Hillsdale Road' by Philip Jamison, watercolour, 8½" × 11¾" (21.6cm × 29.9cm). In the distant field, where snow only partly covers the ground, Jamison applies the paint with a dry brush.*

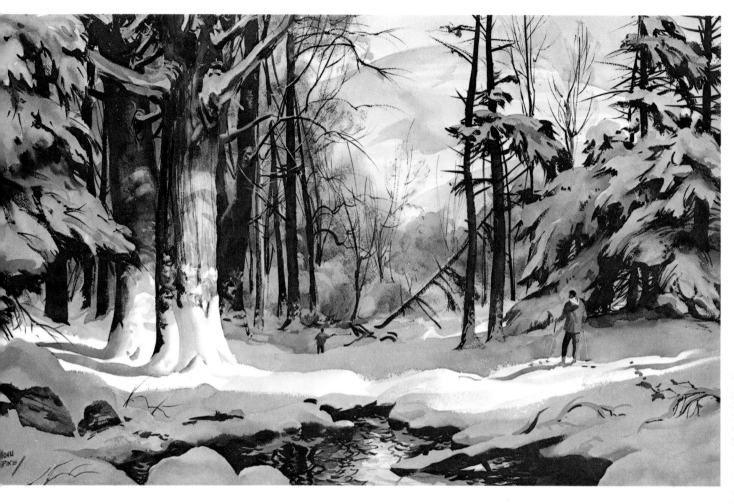

suggest the soft contours of the snow, apply your colours wet-in-wet as one continuous wash, so that they blend as they touch, without hard overlaps.

Where the ground isn't completely covered – perhaps the snow has started to thaw – use scumbling or drybrush in the surrounding areas.

Highpoints of colour

There's always a danger that snow scenes may become monotonous. Avoid this by introducing highpoints of colour: Conifers are still green; deciduous trees may have a few orange leaves left on their branches, and sometimes you'll see a bush covered by gorgeous red berries. Take advantage of these to introduce a new colour to your palette.

Another source of bright colour is the light. Often in winter, early afternoon light acquires a rosy glow that can be dramatic when reflected in the snow. Intensify the pinks and golds on the snow with equally colourful shadows – don't be afraid

to use deep blues and violets for an atmospheric treatment.

Tonal contrasts

Snowscenes give you a chance to play around with strong tonal contrasts. Dry stone walls, hedgerows, trees and buildings will form dramatic silhouettes against the white snow, but do bear in mind *composition* and *balance*: if dark and light areas hold equal importance, the picture will look dull, so always let one or the other dominate.

Wintry skies

To evoke the bleak atmosphere of a winter day, keep the sky fairly simple. The sky does play an important role, however, in establishing the overall mood: for example, the warm greys and browns of an overcast sky make the chilly blues and whites of a snow-covered landscape look brighter by contrast. Be on the lookout for contrasts like these – they lend drama and atmosphere to an ordinary scene.

Above '*Overlook Mountain' by John Pike, watercolour, 24″×40″ (61cm×102cm). Notice the colour variety in this wintry snowscene: the blues and violets in the snow, the warm browns and yellows of the sunlight, and the dark brown silhouettes of the tree trunks and rocks.*

Snow on the hills: demonstration

Ferdinand Petrie demonstrates how **1**
to capture the chill of a wintry day
using just two colours: ultramarine
and burnt sienna. These colours
must be mixed carefully to achieve a
delicate balance between warm and
cool tones.

1 Paint the sky

Make a simple drawing of the main
shapes in the landscape: the outline
of the hills, the trees and the fore-
ground shadows. Since the sky is
part of the background, it's best to
do this first. Wet the sky area only
and then, starting at the top, brush
in ultramarine softened with a mere
hint of burnt sienna. (The burnt
sienna will give the sky a slightly
warm hue.) As you move towards the
horizon, add more water to the
colour, but suggest low lying clouds
with a few dark, wavy strokes.
Suggest the light clouds by lifting
out; hold a just-damp brush flat
against the paper and 'roll' it slightly
as you make the strokes.

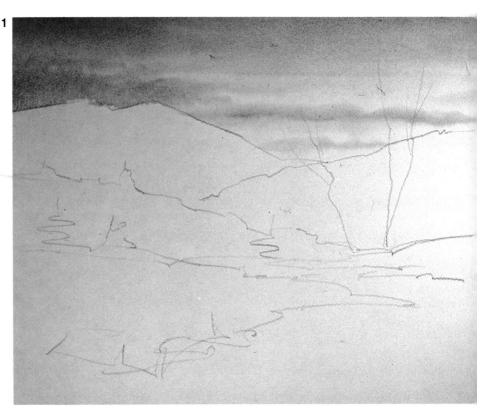

2 The distant hills **2**

When the sky is completely dry, mix
a pale wash of burnt sienna and
ultramarine (still using more blue
than brown), and paint the most
distant hills. Turn your board upside
down so the pigments run to the top
of the mountain, creating a misty
effect. (Alternatively sponge off
some colour at the mountain base.)

Let this dry, and then prepare a
darker mix by using more burnt
sienna. Block in the darker moun-
tain, creating a misty effect as be-
fore. For the trees on the right-hand
slope, add even more burnt sienna to
create a strong, warm colour. Make
the paint thick, and apply it with a
dry brush so that the tooth of the
paper shows through, giving an im-
pression of snow patches among the
trees.

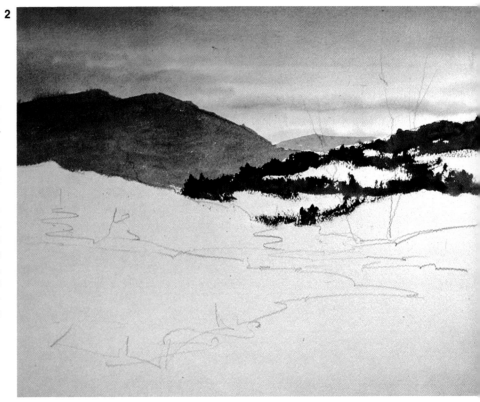

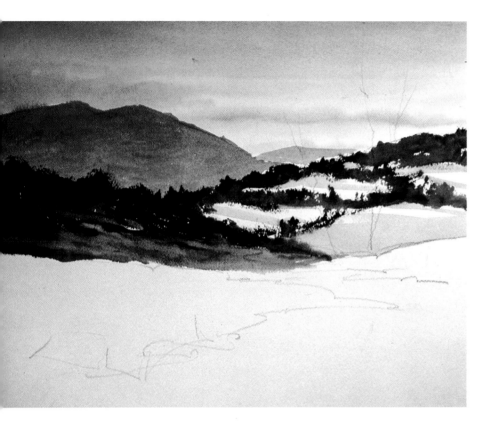

3 The middle ground

Mix a paler version of the wash you used on the dark mountain for the delicate shadows on the hillside below the trees. This wash must be very pale. When the dark mountain is dry, paint the hill in front with thick strokes of burnt sienna darkened with ultramarine and mixed with only a little water. As you work down the mountain, add more blue and more water to make a distinction between the trees on the crest and the cooler tones of the snow lying in shadow.

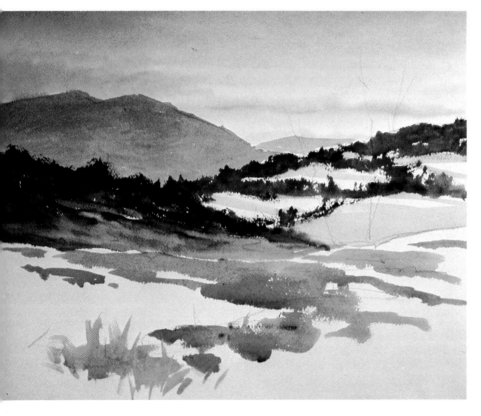

4 The foreground

In the foreground, the snow only partly covers the field. Paint the exposed weeds and soil with almost pure burnt sienna softened with the slightest hint of ultramarine. Dilute this with varying quantities of water, so that some strokes are darker than others.

Now, lighten the shadowy slope you painted in the last step, to indicate ice and slush: wet your brush with clean water and gently scrub the dark area, then blot away some of the wet colour with a tissue. When this is dry, cover it with a pale wash of ultramarine, subdued with a little burnt sienna, to cool it slightly.

5 The background trees

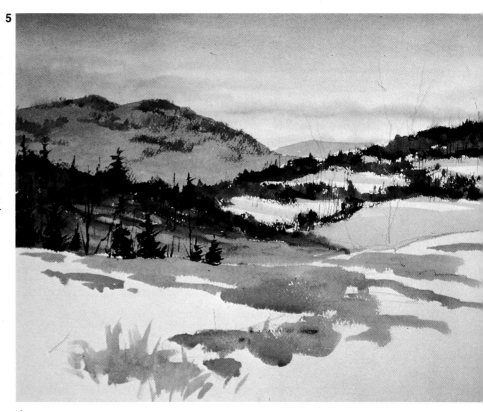

Mix a very dark wash, using ultramarine and burnt sienna almost straight from the tube, diluted with just enough water to make the paint flow smoothly. Load your no.2 brush and paint the conifers and bare trees on the shadowy slope. Apply rough strokes of the same mixture where the shadows fall in the warm-coloured shrubs on the right-hand slope. Then add a little more water and burnt sienna and, on the big mountain beyond, paint clusters of trees among the snow.

6 The foreground trees

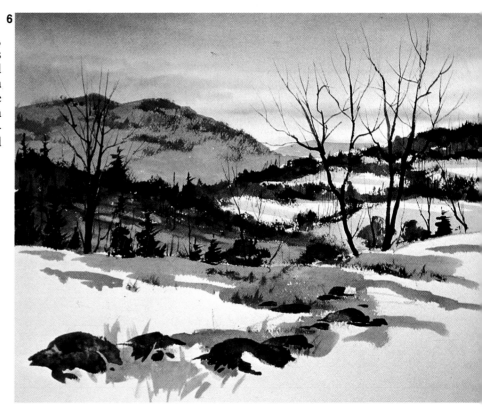

Still working with your dark mix, paint the slender lines of the leafless trees and their wispy branches. Add a little more water and burnt sienna before you paint the rocks in the foreground field. Then dilute it even more and, with rough strokes, suggest the scrubby weeds at the far end of the field and the trees beyond.

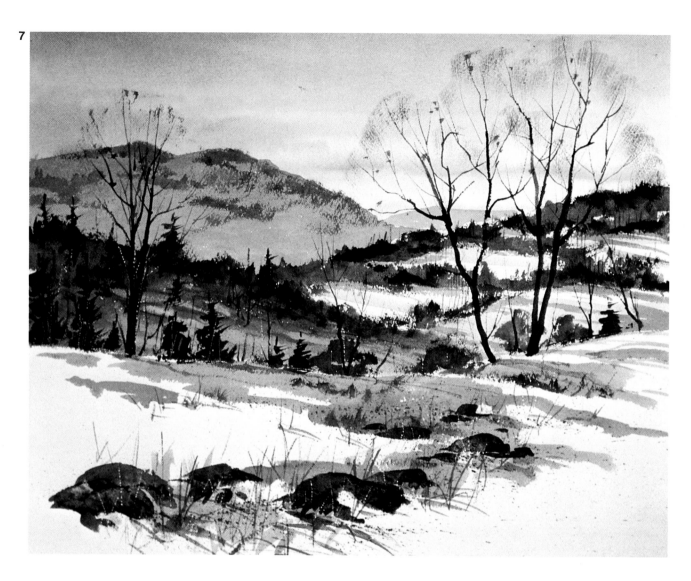

7 The final details

As always, save the detail and texture for the final stage. Load the tip of your no.2 brush with the dark mixture you used for the leafless trees and paint the cracks in the foreground rocks. Add a little burnt sienna and more water to the mixture and dip the no.10 brush in it.

Using your fingers, squeeze out some of the moisture and then press the bristles gently against the palm of your hand so they separate slightly. With the brush like this, apply small 'blurs of colour' to suggest dead leaves on the tree branches against the sky.

Add more water to the mixture so it flows smoothly, wet the brush thoroughly, and re-shape the bristles by rolling them gently in your hand. Paint the warm blades of grass in the foreground.

Darkening this mixture with more ultramarine, paint the shadow lines of grass in the lower half of the painting. Draw similar lines across the slopes in the middle ground to suggest tree shadows on the snow.

Looking at the finished painting, it's hard to believe that it was painted with only two colours. Notice how effectively the slight changes in the proportions of a mixture – just a little more warm colour, or a little more cool colour – reflect the subtle colours of a wintry day. Phthalo blue and burnt umber are another good mix.

EQUIPMENT USED
☐ A sheet of 140-lb (290gsm) NOT paper, approximately 12″×8″ (30cm×20cm).
☐ A palette of two colours: ultramarine and burnt sienna. You can substitute burnt umber for burnt sienna, and use Winsor blue instead of ultramarine.
☐ Two brushes: a round no. 10 and a no. 2.
☐ Some paper tissue.

Snow, ice and frost effects

When those cold winter days arrive, don't be tempted to put away your palette and paints and retire to the fireside! Dramatic snow-filled skies and crisp frosty mornings have their own special atmosphere, which you can readily capture in watercolour. Ice and snow may prevent you from setting up your easel outside, but this need not be a drawback; you can always take photographs or make sketches while out walking, and then work from these.

Departing from the literal

A winter landscape can either be painted realistically – or you can aim instead to capture the *spirit* of winter by emphasizing the strange, unearthly beauty of trees heaped with snow or dusted with sparkling frost. Zoltan Szabo, the artist who painted these winter scenes, aims always to *suggest* his subject, rather than being too literal in his representation.

Use a soft paper such as Arches, which allows the paint to spread softly with no hard edges. But remember to offset your soft colour washes with some precise, recognizable objects, otherwise the effect becomes too contrived.

Above *The sky is a wet-in-wet wash of ultramarine and burnt sienna. The frosty trees are suggested by brushing clear water into the still-wet wash.*
Below *The soft foliage of the trees is achieved by painting them just before the misty background dries.*

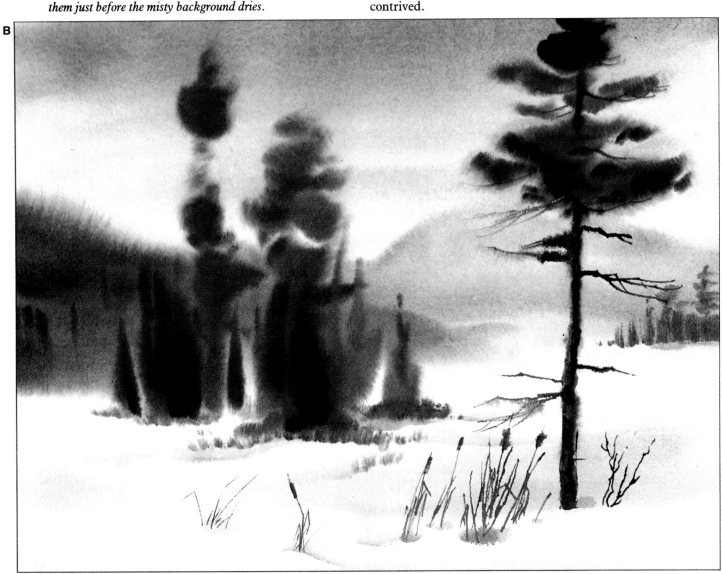

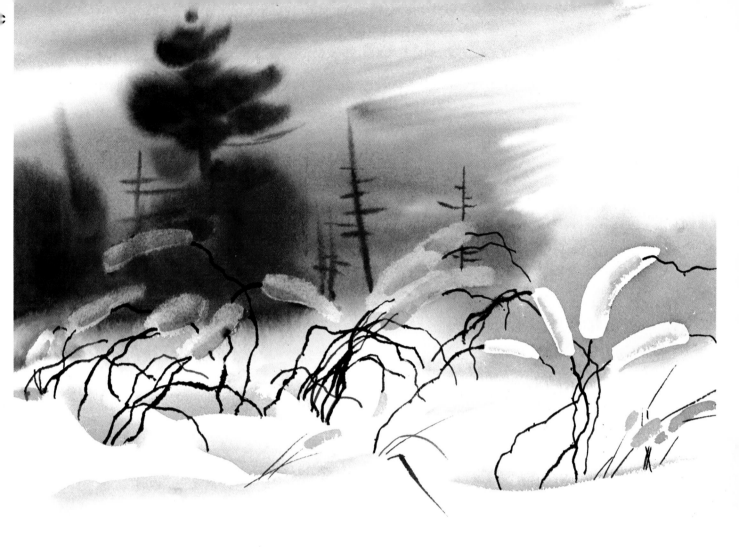

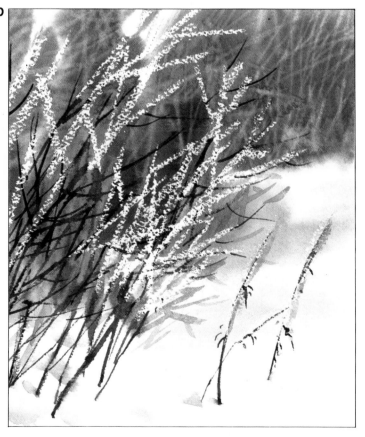

Above *The patch of white paper in the top right corner suggests cold winter sunlight.*
Below *A stick of candle wax is used to 'draw' the frost-covered twigs before painting the background.*

Special effects

Below, watercolourist Zoltan Szabo explains how to apply some of the classic watercolour techniques to capture the magic of landscapes in winter.

A Hoarfrost An exciting way to suggest hoarfrost on trees is by 'lifting out' their shapes with clear water. Just as your background wash is about to lose its shine, quickly paint in the shapes of the frost covered trees with water, using a small, pointed brush.

B Misty pines On a grey, misty day, pine trees seen at a distance appear as soft, blurred silhouettes. Begin with the background hills and sky, painting them wet-in-wet so that they appear shrouded in mist. Just before this wash dries, paint the pine trees, letting their edges blur into the surrounding wash.

C Objects in snow Objects sticking out of snow, like tree trunks, rocks and twigs, cause little drifts and reflect heat, making little nest-like dimples in the snow next to them. Paint these hollows with light washes, making the nearest edge hard and the furthest edge soft.

D Sunlit frost To capture the sparkle of sunlight on frost-covered twigs, simply 'draw' the twigs with a sharp piece of wax before painting the background. Then scratch off the wax to reveal the white paper underneath.

Creating snowflakes with salt

In watercolour, achieving a 'snowing' effect in a landscape is difficult, because you can't leave hundreds of tiny flecks of white paper in your painting; you have to resort to 'technical tricks' which give the impression of snow.

One method is to spatter the painting with opaque white. But for a more delicate effect, some artists prefer to use a few crystals of salt sprinkled into a wet wash. A little star forms around each crystal as the salt soaks up the paint and when dry, these forms have a delightful resemblance of snowflakes.

Timing it right

The timing of salt application is crucial, so practise the technique several times on scrap paper before attempting to use it in a painting.

If you apply salt when the wash is very wet, much of it will melt; this results in over-large 'snowflakes' which tend to run into one another. If you wait too long and the paint does not have enough water in it to melt the salt, the effect won't work.

Once the salt is applied, you normally leave the surface flat to prevent the water from flowing in any direction, since the melting salt shapes would run with the water. However, you can create the effect of a blowing blizzard by tilting the paper a fraction so that the water and salt flow across it and smear slightly (see Zoltan Szabo's painting at the top of the opposite page).

The little star shapes take several minutes to become legible; they don't form immediately. Try not to disturb the paper during this time – apply the principle of the 'watched kettle' and walk away from it. When you're sure the paint is dry, simply brush off the salt.

Points to note

☐ Ordinary table salt works quite well for this technique, but better results are obtained with crushed rock salt or sea salt.

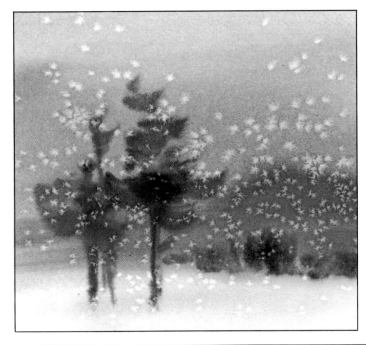

Left *Salt 'snowflakes' harmonize well with a landscape because they are not pure white but show some of the underlying colour.*

THE SALT TECHNIQUE STEP-BY-STEP

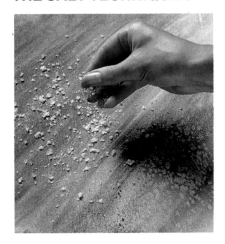

APPLY THE SALT
Paint a brushstroke of any colour on your paper with a medium wet brush. Just before the wash loses its shine, drop one or two salt crystals into it and watch a little 'star' form around each grain as the salt soaks up the paint solution.

LET IT DRY
Keep the paper in a horizontal position while you wait for the salt and the paint to dry (this stage requires patience – it can take up to 20 minutes). When it's dry, brush off the salt and you're left with tiny, crystal-like shapes that resemble snowflakes.

OTHER EFFECTS
Experiment with the salt technique – sometimes the patterns created will suggest other images. In the photo above, a tiny pinch of fine salt was applied to a dark wash of ultramarine just before it dried. The result looks like a starry night sky.

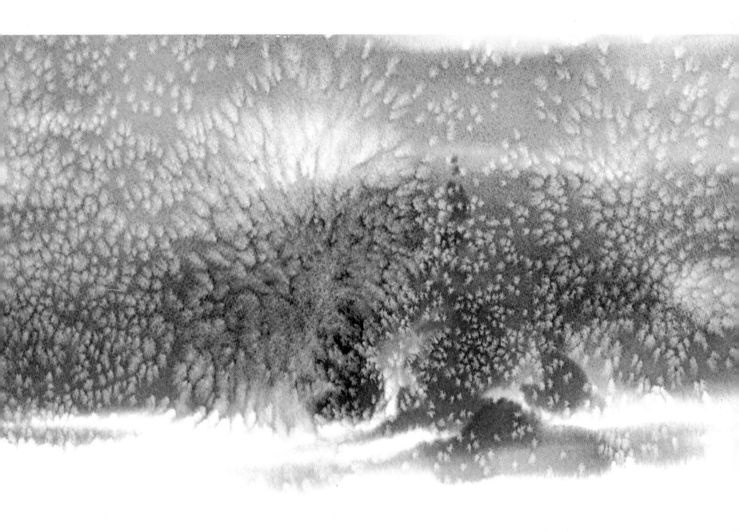

Above *A dramatic snowstorm effect, produced by tilting the paper so that the salt shapes run together.*
Right *Smaller snowflakes are made by sprinkling salt into a wash that's slightly drier.*

☐ Be careful not to use too much salt because it will look artificial if the technique is overdone. Sprinkle only a few granules, and don't try to aim them – let them fall haphazardly, just like real snowflakes.

☐ Salt won't react on pigment that has dried and been rewetted. For best results the salt must flow freely in a freshly painted wash.

☐ An interesting variation on the technique is to mix a little salt into the pigment on the palette; as you sweep the brush across the paper, the salt grains are deposited in the wash. This creates a particularly delicate textured effect.

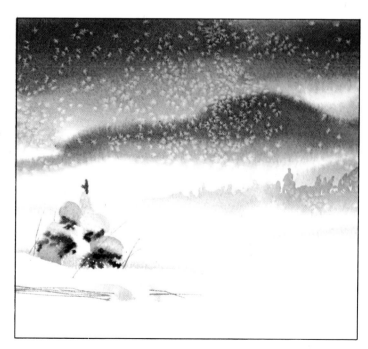

Aerial perspective

As a landscape painter in watercolour, many are the times you'll be faced with the problem of how to make the land and sky in your pictures appear to recede far into the distance. The classic way of overcoming the problem is to apply the rules of aerial perspective – an atmospheric effect which causes our eye to perceive distant objects as less distinct and cooler in hue than those in the foreground. By reproducing this effect in your paintings, you automatically imply to the viewer a sense of distance.

Four key points

In practical terms there are four things to remember when painting the effects of aerial perspective:

Hues grow cooler and become progressively more blue as they near the horizon.

Intensities of colours weaken to the point where, in the far distance, the various different hues are barely discernible.

Tonal contrasts become less pronounced: eventually, only the overall shape remains visible.

Details grow indistinct, and disappear somewhere between the foreground and middle ground.

The seascape below shows these ideas put into practice.

For the foreground boat, artist Christopher Schink employs a full range of tones and warm, intense colour. Towards the middle ground, the mid-tones start to predominate and the colours become cooler and more muted. Compare this with the farthest boat, which is a uniform blue grey in colour and contains no detail.

Notice, too, how Schink aids the illusion with brushstrokes that become steadily less distinct towards the horizon.

Below *Christopher Schink demonstrates how skilful paint handling can create the illusion of deep space.*

COLOUR CREATES SPACE

The effects of aerial perspective are part of the reason why we associate cool, less intense colours with recession while warm, bright colours appear to advance towards us. Always be ready to exploit this tried and tested colour 'rule' when painting deep, spacious landscapes.

☆ RAISE YOUR VOICE

When painting a landscape, start from the furthest distance and move gradually forward. Begin with a 'whisper' of cool, bluish tones and hazy, wet-in-wet effects. Then 'raise your voice' with stronger colours in the middleground. Finally, end with a 'shout' of rich, warm hues and well defined detail in the foreground.

Scottish Farm: demonstration

When artist John Blockley climbed a hillside on the west coast of Scotland and looked down on the farm below him, he felt 'a sense of endless space, as though the ocean continued for ever'. This demonstration shows you how he recreated the dramatic scene in paint.

1 The first wash

With a soft pencil, outline the main elements of the scene – the line of the clifftop, the shapes of the cottages and the forms of the distant islands. Notice how the barn and the cottages are positioned so as to lead the eye through the painting.

Using a round no. 6 brush, paint the sky with a thin wash of cobalt blue to represent the cool, misty atmosphere. Gradually lighten the wash with more water as you bring it down over the sea, whose reflective surface is lighter than the sky. When this is dry, paint the distant islands with a single, slightly stronger, wash of cobalt blue.

2 Start the foreground

Begin suggesting the busy foreground with its softly blurred vegetation by brushing in a wash of Hooker's green. Use the wet-in-wet technique to add darker shades of green mixed with burnt umber. Let loose, curving strokes suggest organic growth, but be careful to leave the shapes of the buildings white.

Already you can see how the contrast between the warm colours of the foreground and the cool blues of the background creates the illusion of depth and space.

3 Continue the foreground

While the foreground is still wet, work more colours into it: use ultramarine, Hooker's green, Payne's grey and burnt umber to suggest the rich, dramatic colours of the coastal farmland. Don't overdo the mixing, or you'll end up with mud. But do work the brush in a sweeping motion to give energy and interest to the foreground and force the eye upward.

If you find the foreground is becoming too dark and heavy, lift off some of the colour with a soft, damp brush. Notice where John Blockley creates some areas of bright green: when the painting is finished, these will suggest sunlit patches of grass.

4 Paint the barn

To paint the rough stone wall of the foreground barn, start by lifting off dots of colour with the end of a brush handle wrapped in a damp rag. Then, using a no. 0 brush dipped in a mixture of burnt umber and ultramarine, define some of the stones in the wall. Wash in the smoother wall at the side with Payne's grey.

Lift out more dots of colour in the immediate foreground: in the next stage this patch of dots will be further developed to suggest an old, crumbling stone wall.

Darken the upper edge of the cliff with burnt umber and ultramarine and drag out several thin diagonal strokes with a no. 0 brush to suggest long grass blowing in the wind.

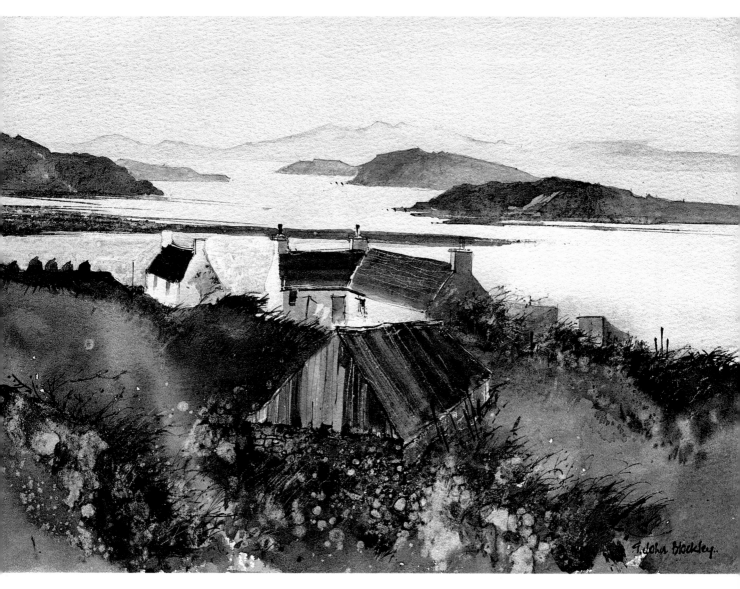

5 Complete the picture

The islands Indicate the far distant isle with a very pale wash of cobalt blue. Gently blot the colour here and there with a piece of tissue – this gives the impression of an island shrouded in mist, and adds a little mystery and romance to the paintings.

Paint the middle range of islands with cobalt blue and a tiny drop of burnt umber. Add more burnt umber to the mixture for the nearest islands.

The buildings Using a round no. 4 brush, paint the shadowed walls of the cottages with a very thin wash of raw umber. For the grey slate roofs, use various mixtures of Payne's grey and cobalt blue.

Paint the roof of the barn with downward strokes of muted colours:

Above *'Coastal Farm, Erbusaig' by John Blockley, watercolour, 7"×10" (17.5cm×25.5cm). When the rules of aerial perspective are applied, as here, even a small painting can give the impression of vast distances.*

Payne's grey, burnt and raw umber, ultramarine and burnt sienna. Use the corner of a razor blade to scratch out a few lines to suggest the weather-beaten roofs.

The foreground To suggest the tumbled vegetation and weathered stones in the foreground, lift out more spots of colour, then outline some of them with a no. 0 brush and a dark mix of burnt umber and ultramarine. Using the same mixture, finish off by indicating the windswept bracken.

EQUIPMENT USED
☐ A sheet of 140lb (290gsm) Bockingford paper, approximately 7"×10" (17.5cm×25.5cm).
☐ A palette of seven colours: cobalt blue, ultramarine, Hooker's green, burnt umber, raw umber, burnt sienna and Payne's grey.
☐ Three brushes: a round no. 4, a round no. 6 and a no. 0
☐ A razor blade or craft knife.

Painting waterscapes

Water holds a particular fascination for artists: a stretch of calm water has a tranquillity that we all yearn to capture in paint. And yet it is one of the most baffling and mysterious subjects to portray effectively. Claude Monet, the great Impressionist famed for his exquisite paintings of ponds and rivers, once wrote to a friend: 'I have started again to paint the impossible: water, with waving grass in the foreground. It is wonderful to look at, but it drives me mad trying to paint it'. So, if you find painting water difficult, take heart – you're in good company!

Keep it simple

The problem with water is that it just won't stay still. Even the slightest breeze disturbs the surface, breaking it up into ever-changing pools and ripples and distorted reflections. When this happens, it's all too easy to make the classic mistake – that of *over-elaborating*.

Don't try to paint every ripple and streak of light you see – it's frustrating, very hard, and in the end looks bitty and amateurish. It's easy, too, let your eyes move with the flow of the water so that patterns and reflec-

tions keep changing. The secret is to fix your gaze on one spot – after a while you'll suddenly find the reflections don't move that much after all!

The most appealing watercolour paintings are those which look as if they were done without too much effort. By capitalizing on watercolour's speed, transparency and ease of flow, you can make a stretch of water look authentic with just a few washes. Water is a clear substance and, if you overwork your washes, that clarity will be lost forever. Think carefully before committing brush to paper, apply your wash boldly and with conviction – then leave it alone!

Below *'Early Riser' by John Pike, watercolour, 24"×40" (61cm×102cm). A simple, yet powerful watercolour, in which the light areas are sharply contrasted with dark tones to give them more impact.*
Opposite, top *'Evening Sky, Lock 44, on the Ohio River' by John Pike, watercolour, 22"×30" (56cm×75cm) Here the mood is very different: the water is calm and still, reflecting the soft glow of the evening sky.*

VARIED BRUSHMARKS
Many artists make the mistake of thinking that, because water lies flat and horizontal, that's how their brushmarks should be. This makes for a monotonous painting and the viewer's attention 'slips off' either side. Try to vary your brushmarks, angles and widths: this adds interest and animation – and is just as effective in rendering a watery scene!

☆ LIGHT ON WATER
How do you capture the glare of bright sunlight reflecting off water? The white of your white paper is a far cry in intensity from the real light bouncing off the water, but it's all you have. Therefore you must surround that light area with dark tones, making the white paper seem brighter by contrast and increasing the feeling of light. You can see how effectively this works in John Pike's river scene below.

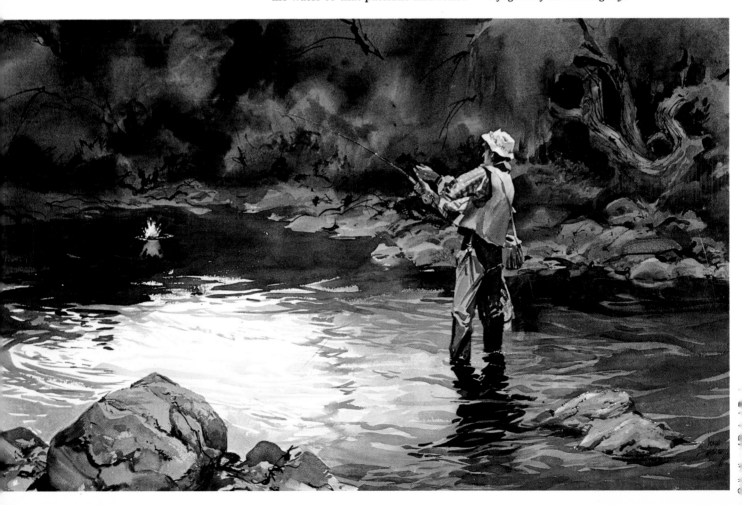

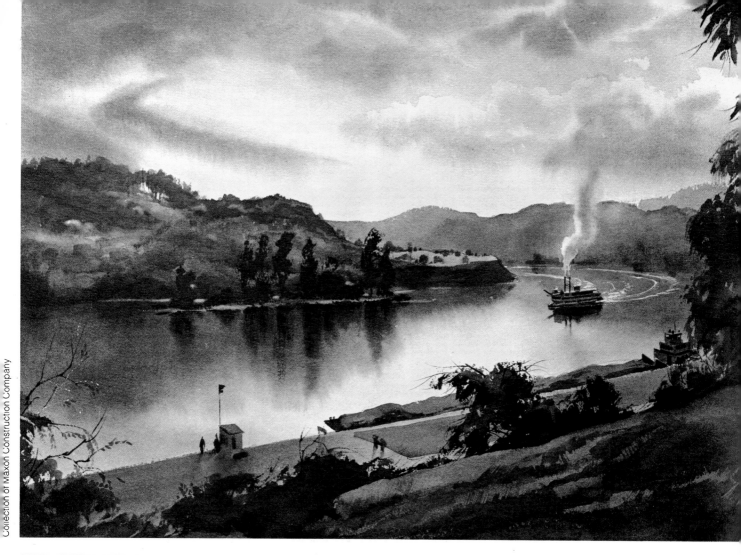

Reflections in water

When painting a still lake or river, think of it as a soft mirror, reflecting the colour of the sky and also any trees, grass, buildings around the water's edge. In the painting above, the sky and landscape are complemented by their upside-down image in the water. This pictorial arrangement is satisfying to look at and creates a feeling of tranquillity.

By contrast, the watercolour sketch on the left shows how a strong current can distort reflections and create fascinating patterns that lend movement to your painting. Here, Zoltan Szabo paints the water with sap green, sepia and burnt sienna. Just before the paint dries, he knifes out the wiggly reflections with a palette knife.

Left *In this sketch, Zoltan Szabo uses minimal brushwork to portray trees reflected in a deep, fast-flowing river.*

When you're going out on location to paint a water-side scene you'll probably be working with a rather restricted palette, so try to plan ahead as much as you can. Time of day or weather conditions will both make quite a difference to the colours you decide to select, and the following suggestions may help.

Sunset
☐ Burnt sienna, cadmium yellow, New gamboge, cadmium red, ultramarine.

Sunrise
☐ Yellow ochre, cadmium yellow, raw sienna, cobalt, ultramarine.

Stormy day
☐ Raw umber, yellow ochre, Winsor blue, viridian, alizarin crimson.

Bright day
☐ Cadmium yellow, raw sienna, cadmium red, ultramarine, cerulean blue.

OBSERVE AND SIMPLIFY
Before you start painting, you should always spend a few minutes just looking at the colours around you and sorting out the appropriate hues from your palette. You can then study the general movement of the water and plan out the details of your chosen scene.

When you work, paint in the simple masses first, then move on to the details and deal with all parts of the scene at once. This way, you can avoid the trap of concentrating on small, fussy areas in the hope of getting them 'just right' and ending up with a painting that looks disjointed and disappointing.

Lakes

The moving surface of a large lake is rather like a small-scale ocean, with choppy little waves breaking across it. When the wind is too weak to create such waves, but strong enough to roughen up the water, it produces patterns that make wonderful design elements and can produce a striking composition.

To paint these breeze patterns effectively, work quickly with a soft loaded brush over dry paper. Before the freshly applied paint can dry, work in the darker shapes of the still reflections with rich, wet strokes of contrasting tones. (If you find it difficult to 'see' the reflections – half close your eyes and they will look much more clearly defined.)

On calm days, details such as distant islands, rocks and trees reflect perfectly in the dark washes and capture the serenity of the scene. But, when there's even a slight breeze, the reflections disappear and the waves are broken up into tiny ripples that blend into a single, solid light shape with only the slightest hint of colour from the sky.

Rivers and creeks

The shallow edges of flowing creeks and rivers encapsulate the trans-parent qualities of moving water, though their deeper regions are more like lakes. To paint underwater details beneath churning, transparent water demands a keen eye: below the surface, the forms are only gently defined and it's best to paint impressions rather than solid shapes.

Shallows

Small, puddly areas of water can be quite a challenge to the artist, especially when viewed from a steep angle: the bottom appears dark and solid yet the surface is clear and fragile. The texture and tone of the water also contrasts strikingly with its solid surrounds.

To paint a shallow puddle, draw its outline in perspective, keeping the surface flat. At the outer rim, look for a light, sparkling line reflecting the sky above. If the puddle is on hard ground, this line is thin and sharp, but in soft, muddy conditions its white edge widens. The drybrush technique is an excellent way of capturing this.

Finally, whether you're painting a tranquil lake-side scene or a rain-spattered puddle, remember the key words *observe* and *simplify* – and all your time and effort should prove a good investment!

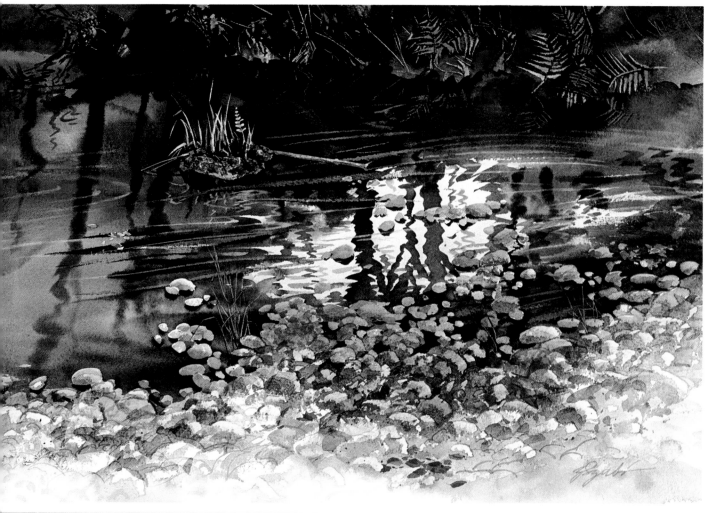

Above '*Jewel Case*' *by Zoltan Szabo,
15"×22" (38cm×56cm). When Szabo
saw this shallow river bed, he was
fascinated by its rich green colour,
bright reflections and delightful
shoreline of rounded pebbles.*

Left *The artist painted the tree
reflection with Winsor blue and burnt
sienna applied horizontally over the
masked-out rocks and leaves. He then
added similarly reflected wiggles of sap
green and burnt sienna to give stronger
tonal contrasts.*

Far left *This detail was created by
masking out the islet of leaves. The mud
is a drybrush glaze of burnt sienna and
ultramarine, modelled with a knife
while still damp. With the masking
removed, Szabo then painted the ferns
and grass so that their shapes would
stand out sharply against the
background.*

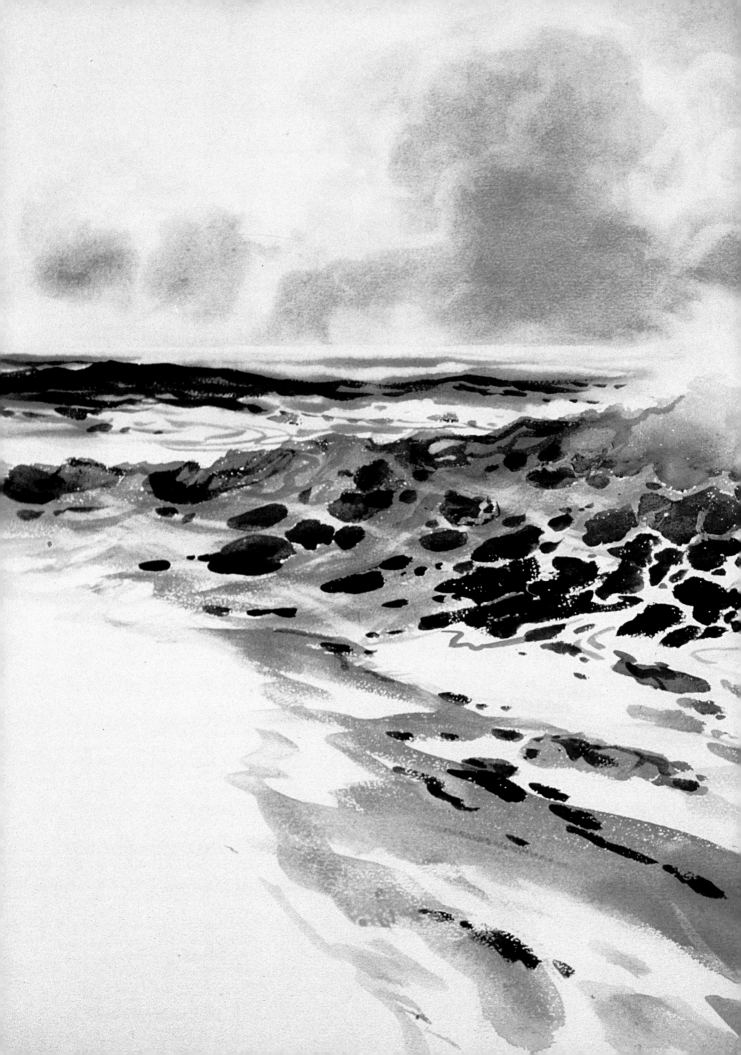

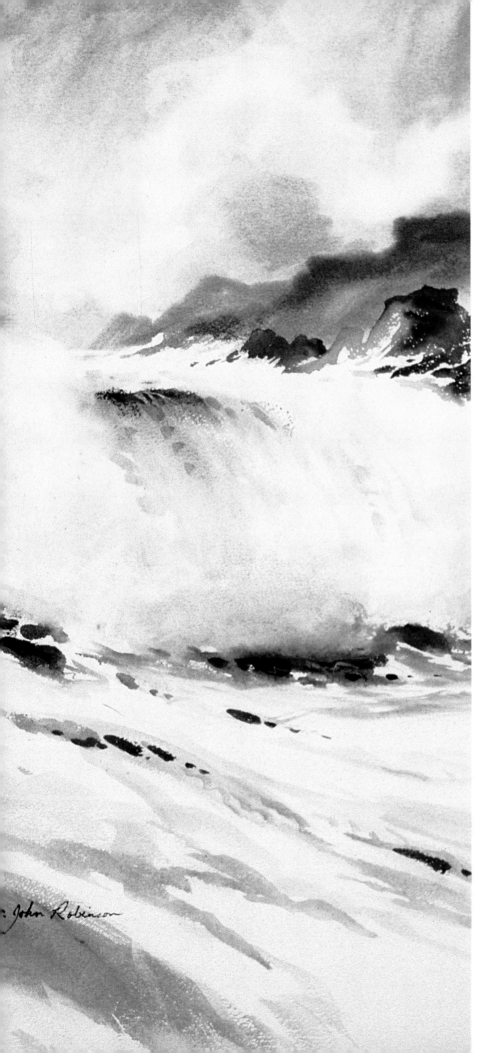

Painting the sea

The seascape painter faces the unique challenge of depicting a constantly moving subject. Furling waves, crashing surf and flying foam are all split-second effects that can appear to change before your eyes. But what seems like a complex subject is much easier to paint if you remember one basic rule: always aim to have one focal point supported by, and not competing with, the rest of the picture.

Centre of interest

A centre of interest is just as important in a seascape as in a landscape: the eye must have somewhere to 'rest'. If you're painting a seascape with no obvious centre of interest then you must create one by 'twiddling' with your tones or colours. It's just like adjusting the 'bass' and 'treble' knobs on your hi-fi to get the best out of a piece of music.

Remember that the eye always heads for the area with the strongest contrast, so try to place the lightest light and the darkest dark at the focal point. Tone down all other contrasting areas except those at which you want the viewer to look.

Colour schemes

Seascapes are best painted with a limited palette. Use one colour to set the dominant note of the painting and include some closely related colours for harmony. For example, in a painting that is mostly blue, add small touches of green or purple. These colours add interest, but because they are close to blue on the colour wheel they don't have a jarring effect.

Finally, enliven the colour scheme by adding a small touch of a complementary colour – for example some yellow/orange-coloured rocks or sand, orange being the complement of blue.

Left *'Winter Waves' by E. John Robinson, watercolour, 22"×30" (56cm×76cm). In this painting the breaker is the main attraction – note how the sky and foreground are textured to lead the eye to it.*

Crashing Surf: demonstration

There is nothing like a wave bursting against a rock for pure drama. In this demonstration, Claude Croney shows you how to capture the impression of crashing surf and flying foam.

1 Outline the composition

Using a sharp pencil, carefully outline the shapes of the rocks in the foreground and the waves to the right. Next outline the shape of the burst of foam – very lightly and casually, since this will have soft, wet edges. Then draw the horizon line near the top of the picture.

Using a no. 6 round brush, dampen the sky and distant sea areas with clear water, followed by strokes of Payne's grey and well-diluted yellow ochre. Carry these strokes right up to the edge of the foam, where they melt softly away, leaving bare white paper in the centre.

2 Darken the sea

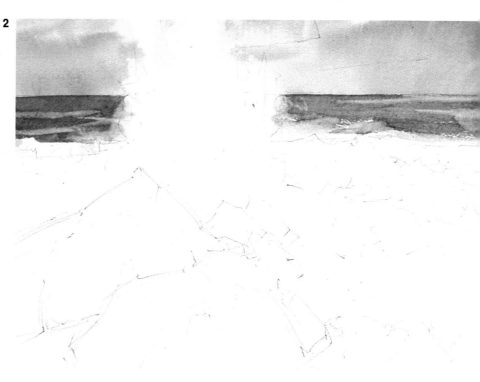

When the sky and distant sea are dry, darken the water with a wash of Payne's grey and yellow ochre. Let this dry thoroughly, then use a round no. 4 brush to apply darker strokes of the same mixture over the underlying colour, leaving lighter strips between them. Don't forget to keep the edges soft around the foam burst.

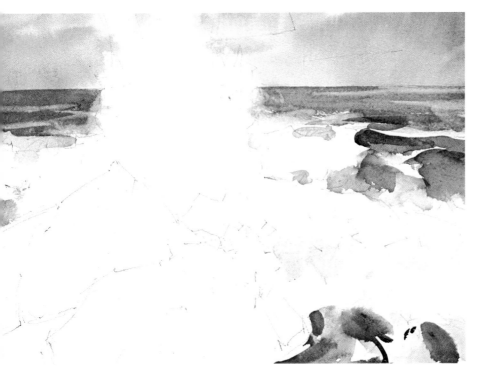

3 Model the foam burst

Add some pale shadows to the foamy shapes surrounding the big burst in the centre: it is these shadows that create the impression of bright whiteness in the highlights. Use a round no. 6 brush and various mixtures of yellow ochre, Payne's grey and ultramarine diluted with plenty of water. Capture the upward movement of the foam by pressing the side of the brush against the paper and pulling it upwards, leaving a ragged broken stroke.

Use these same mixtures, this time containing much less water, to paint the darks of the waves in the middle distance and in the right foreground.

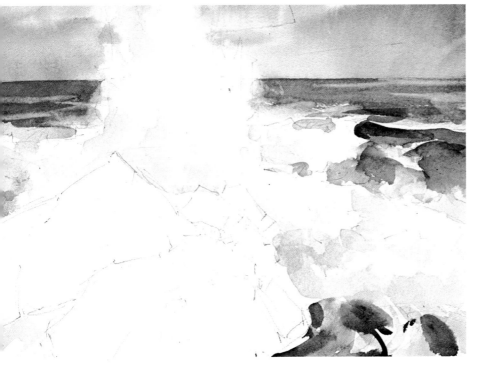

4 Add more shadows

With a very pale mixture of yellow ochre and Payne's grey, complete the shadow modelling on the foam burst. Make the strokes short and ragged, often applied with the side of the brush, to reflect the movement of the foam.

Create variety of tone in these shadows by softening the edges of some of the strokes with clear water (you can see an example of this in the shadow to the left of the big burst of foam).

Don't be tempted to overdo the shadows or you'll lose the impression of brilliant whiteness. If you can, practise on a piece of scrap paper first.

5 Begin the rocks

Paint the dark shapes of the rocks with rough, rapid strokes of burnt umber, Hooker's green and ultramarine. Vary the tones of these strokes, with some containing more burnt umber and others more blue or green.

To indicate the light reflecting off the shiny wet surface of the rocks, use a knife blade to scratch irregular lines and patches in the still-damp paint. Allow the painting to dry.

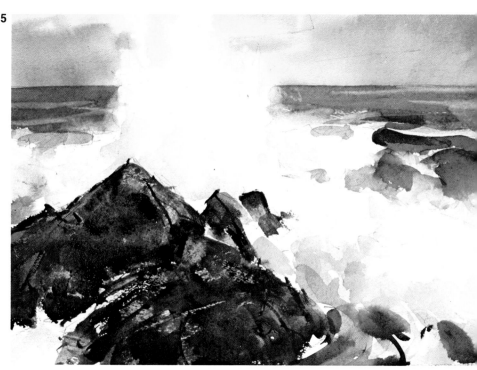

6 Add more texture

Use the tip of a round no. 2 brush to add dark lines and dots to the rocks – a mixture of alizarin crimson and Hooker's green. Vary the tones of these marks, making each one only slightly darker than the area it rests on. In other words, the texture lines in the light areas should be much lighter than those in the shadowed areas.

Use the same brush to add some thin strokes of Payne's grey and ultramarine in the upper right section to define the distant waves more clearly. Allow the painting to dry thoroughly.

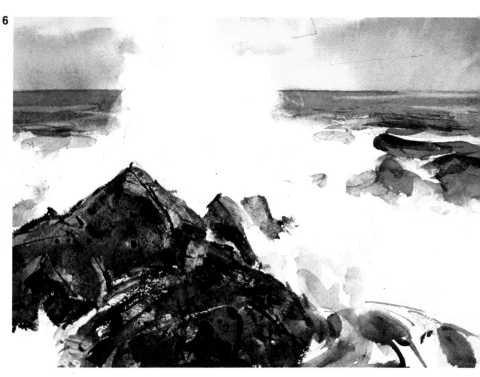

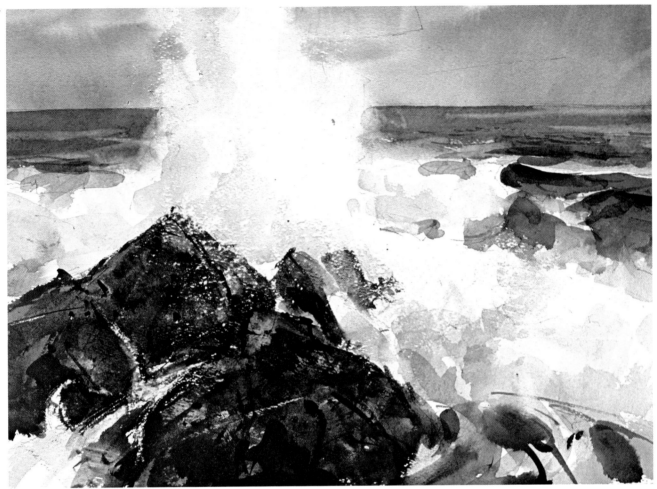

7 The final touches

As the waves crash against the shore the foam is flung upwards and outwards, showering the rocks. To capture this effect, use a sharp knife blade (the edge, not the tip) to scrape away tiny flecks of colour. Carry the blade lightly over the surface of the rocks and the foam in the foreground, gradually lifting away streaks of colour from the high points of the paper. Where these flecks of paint are removed, dots of bare paper begin to show through. This technique is preferable to using opaque white to depict the flecks of foam, because it harnesses the brilliance of the pure white paper.

Now use the *tip* of the blade to scratch white lines next to some of the dark cracks in the rocks. This makes the cracks seem deeper and more three-dimensional.

When you work with a knife, it's important to know when to stop. You can get carried away and scrape off too much; in fact, just a few scrapes are enough to do the job.

The drama of the sea

This painting demonstrates that an exciting seascape does not have to be a vast, panoramic view. Here the artist creates a tremendous sense of power by giving us a close-up view of a wave crashing against the rocks. To enhance the drama, he deliberately darkens the sky, the sea and the rocks so that the foam appears more distinct.

Painting surf

Resist the temptation to paint surf as if it's a mass of snow-white whipped cream. Remember that surf is simply water in another form, and that it still reflects the colours of its surroundings: in bright sunlight, 'white' surf may take on a slightly golden hue; on an overcast day it is more likely to be a delicate grey. And don't forget that surf has a shadow side, just as a cloud does. That shadow isn't necessarily grey, but might be gold, green, blue, or even violet – you've got to look carefully to make sure.

EQUIPMENT USED

☐ A sheet of 140-lb (290gsm) Bockingford paper, approximately 10″×8″ (22.5cm×17.5cm).
☐ Three round brushes: a no. 2, a no. 4 and a no. 6.
☐ A palette of six colours: yellow ochre, burnt umber, Hooker's green, ultramarine, alizarin crimson and Payne's grey.
☐ A razor blade or craft knife.

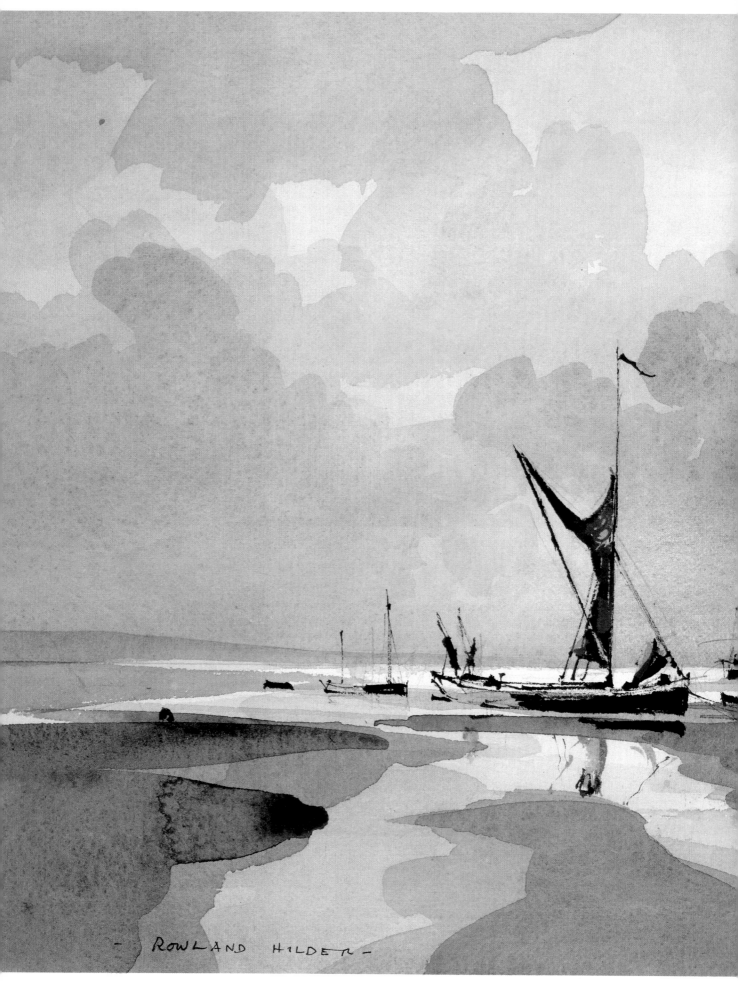

— ROWLAND HILDER —

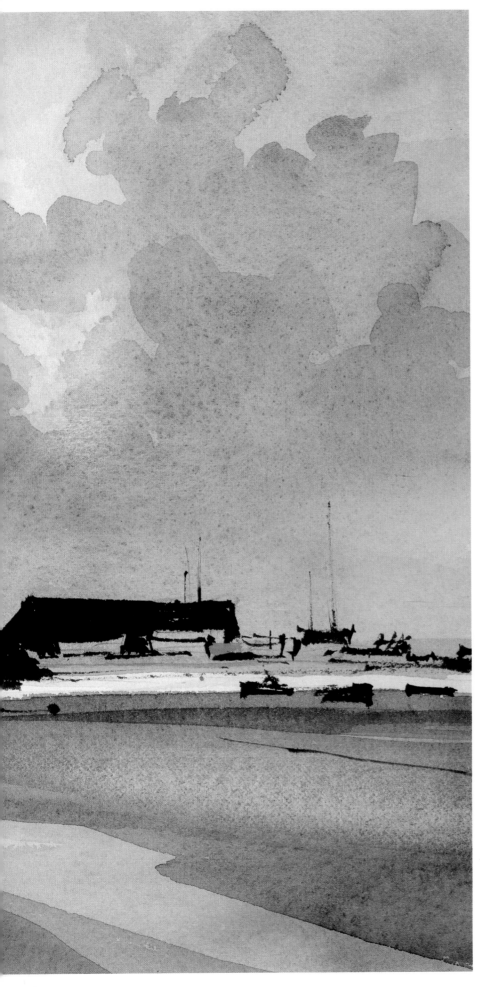

Painting skyscapes

'Paint a sky a day'. That was the advice given by one of the great masters of watercolour, Alfred East. Make it a routine to paint or sketch a sky every day: there is no better way of learning about how watercolour behaves. Wet-in-wet blending, hard-edged effects, controlling a wash, gauging drying times – all these skills will quickly become second nature.

Compositional harmony

Once you've gained confidence in the basic techniques, you should begin to think about the relationship between sky and land in your paintings: the balance of colours, tones and shapes between the two is all-important. Here are some guidelines to help you arrive at a pleasing composition.

□ Decide which you want to emphasize – sky or land. Place the horizon line low down to emphasize the sky, and high up to emphasize the land.

□ Sky and ground should not vie for attention. Balance complex landscapes with simple skies, and vice versa.

□ Don't put the largest cloud in the middle or at the edges of the picture.

□ A group of trees or something similar to the shape of the clouds creates visual harmony and balance.

Some of these points are illustrated in Rowland Hilder's magnificent painting, left: notice how the horizon line is placed low down to lend emphasis to the panoramic sky, and how the rounded shapes in the foreground echo the soft shapes in the sky. The dark shapes of the boats, meanwhile, add contrast and prevent the picture from becoming 'wishy-washy'. The vertical masts provide a link between water and sky, and help to balance the horizontal composition.

Left *'Sailing Craft at Low Tide, Morning Light' by Rowland Hilder, watercolour, 11"×15" (28cm×38cm). Here, a simple composition and harmonious colour scheme express perfectly the early morning calm.*

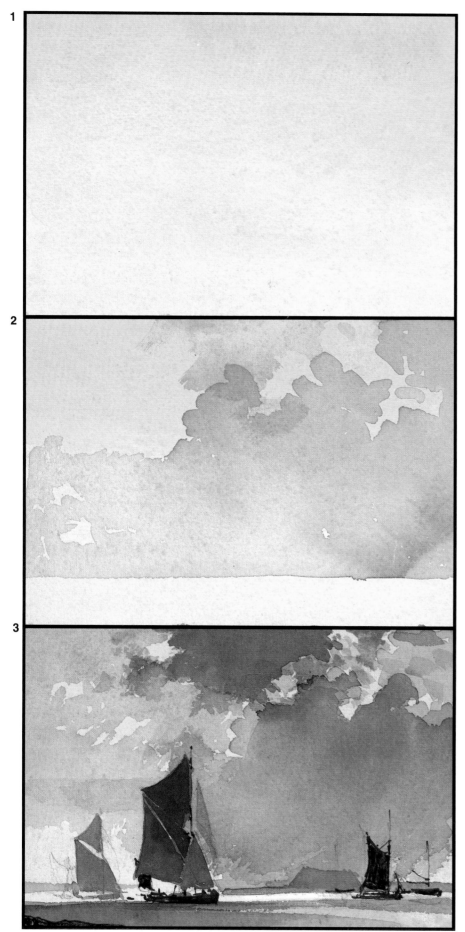

Painting a windy sky

The sky offers countless moods for you to capture in watercolour. On this page, artist Rowland Hilder demonstrates how he paints one of his favourite sky 'types' – billowing, sunlit clouds scudding over the sea.

1 Lay an underwash

Dampen the paper all over. Using a round no. 6 brush, lay a wash of raw sienna over the whole paper and let it dry thoroughly. Then overlay a graduated wash of cadmium orange from top to bottom, and leave this to dry too (note that both pigments should be well diluted, otherwise the colour will be far too strong).

2 Begin the clouds

Using a round no. 6 brush, paint the shapes of the dark cumulus clouds with a thin wash of neutral tint (or use a mixture of alizarin crimson, phthalo blue and lamp black). Bring these clouds right down to the horizon line, and vary their tones by letting the pigment overlap in places.

The clouds are mostly hard-edged, but soften some of the edges with water for a more natural effect. Allow the painting to dry.

3 Add the darks

Intensify the darks with further washes of neutral tint, making the top cloud darkest to bring it forward. Add patches of cerulean blue here and there for the background sky. Keep the colour more intense at the top and leave small areas of orange to indicate warm clouds.

With a round no. 2 brush and burnt umber, paint the boats; use a paler tone for those in the distance. Finally, scratch out the sunlight on the water with a sharp knife.

EQUIPMENT USED
☐ A sheet of 140-lb (290gsm) Bockingford paper, approximately 10″×8″ (25cm×20cm).
☐ Two round brushes: a no. 2 and a no. 6.
☐ A palette of five colours: raw sienna, cadmium orange, neutral tint (or a mixture of alizarin, phthalo blue and lamp black), cerulean blue and burnt umber.
☐ A sponge and a sharp knife.

Painting a stormy sky

Phthalo blue is a colour not normally used in sky painting, because it is a powerful stainer. However, it is highly effective for portraying the kind of intense, almost metallic blue to be found in clouds when there's a thunderstorm brewing.

1 Lay a graduated wash

Dampen the paper, then use a round no. 6 brush to lay an initial wash of yellow ochre, well diluted, over the whole paper. When it is dry, lay a graduated wash of lamp black over it, from the top downwards. Allow the painting to dry.

2 Create cloud forms

Add a pale wash of phthalo blue from the top, leaving patches of the first wash to indicate high clouds in shadow. Let the lower part of the wash expose some patches of yellow ochre (vary the hard and soft edges) to indicate clouds in sunlight.

3 Add more clouds

Use a ball of tissue to blot-lift some patches of colour from the phthalo blue wash, to give the clouds a rounded appearance. Finally, add some pale touches of neutral tint to indicate the shadow sides of the lower clouds.

EQUIPMENT USED
☐ A sheet of 140-lb (290gsm) Bockingford paper, approximately 10″×8″ (25cm×20cm).
☐ A round no. 6 brush
☐ A palette of four colours: yellow ochre, lamp black, phthalo blue and neutral tint.
☐ Tissue or a sponge.

Storm Brewing: demonstration

1

2

In this demonstration, artist E. John Robinson shows you how to create a subtle yet dramatic sky.

1 The background sky

Lightly pencil in the bulging outlines of the cumulus clouds and indicate the shape of the rocks on the left.

Dampen the paper. With a mixture of cerulean and a bit of yellow ochre, make sweeping strokes diagonally from the top left corner down to the edges of the main cloud form. Add more cerulean to the mixture to darken the sky just above these clouds. Gently blot the edges of the clouds with a clean, barely-damp sponge to create soft effects.

Above the cumulus clouds, lift out some thin, streaky wind clouds, this time with the edge of the sponge. Paint a horizontal line for the sea, using a round no. 4 brush and a mixture of cerulean and ultramarine.

3

THE LINK BETWEEN SKY AND LAND

More than any other single factor, the sky sets the mood of a landscape painting. So don't think of it as merely a backdrop; aim to design the sky to complement or enhance your landscape. Learn to look for connections between the sky and the land – colours, shapes and tones – that will pull the painting together. Below are some suggestions to help you achieve this.

UNITE SKY AND GROUND
As your painting of the landscape progresses, bring along the sky as well so that they complement and harmonize with each other. A good way to achieve this is to mix small amounts of your sky colours into the ground colours, and at the same time accent the sky with a little of the strongest, most influential colours from the ground.

SKY PATTERNS
The shape and movement of clouds can do a great deal to enhance your composition. For example, if your centre of interest is a group of dark trees in the left-hand corner,

balance it with a line of pale cloud running from the top right corner down towards the left so that the viewer's eye is led to the trees.

SUBTLE COLOURS
The sky isn't just blue, and clouds aren't always white – both are made up of a wealth of colours. Experiment with touches of unexpected colour: for example, when you confront a cloudy sky use violet and burnt umber for the shadows in the clouds. Or, on a sunny day, warm the sky with a touch of cadmium red. You'll find that while your skies still look natural, they have a new excitement to them.

2 The cumulus clouds

Since the towering mass of cumulus cloud takes up so much of the picture space, it must be broken up into interesting textures and forms. Be careful not to overdo the shadows in the clouds; if they're not handled with a light touch, the sky will look much too heavy.

Start by re-wetting the main cloud mass with a sponge. Then, with a round no. 6 brush and a mixture of cerulean and yellow ochre, paint the shadow in the upper cloud mass. With a paler wash of the same mixture, model the lower mass of clouds. Use a brush and clean water to soften and blur the shadow edges. The result is a two-part cloud mass, both parts with light, billowy clouds, slightly shadowed.

Finally, add more ochre to the mixture and paint the low-lying horizontal clouds near the horizon.

3 The stratus clouds

Adding a line of low stratus clouds gives the sky more depth and helps form an important link between the sky and the sea.

Make sure the painting is thoroughly dry, then paint the stratus clouds with ultramarine and a touch of yellow ochre. Use the side of a round no. 4 brush and paint the clouds with straight, horizontal strokes. Make clouds a different length and thickness and lighten the tones with water as they disappear up into the mass of cumulus cloud.

Finally, paint in the distant headland with raw sienna and a touch of ultramarine. Again, vary the tones with water, and leave a ragged edge along the bottom to give the impression of chalk cliffs. Paint the two foreground rocks with a denser version of the same mixture, to make them appear nearer.

EQUIPMENT USED
☐ A sheet of 140-lb (290gsm) Bockingford paper, approximately 10″×6″ (25cm×15cm).
☐ Two round brushes: a no. 4 and a no. 6
☐ A palette of four colours: cerulean, yellow ochre, ultramarine and raw sienna.
☐ A small soft sponge.

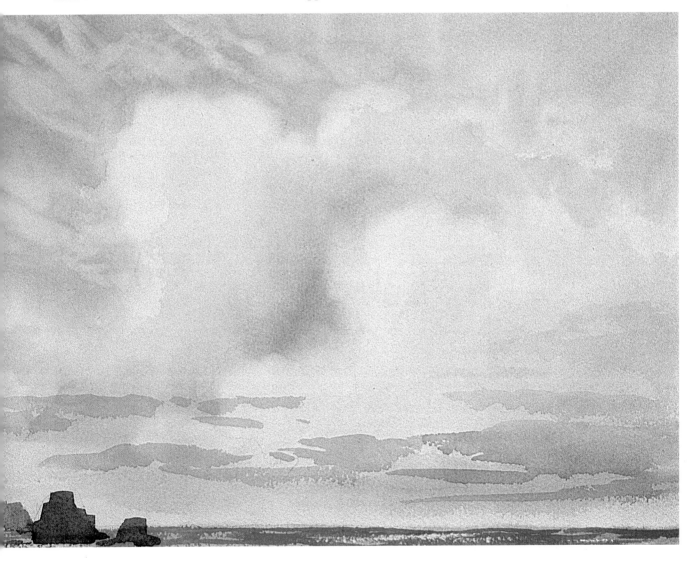

Painting clouds

Watercolour is the perfect medium when it comes to painting skies and clouds. After all, transparent washes of colour over white paper bear a close resemblance to the glow of sunlight filtering through wispy layers of cloud.

The beauty of clouds is that they are ever-changing. This strikes such terror into some people that they try to evade the issue by ignoring the sky altogether in their paintings! This is a pity, because watercolour has a speed and freshness that's perfectly suited to capturing fleeting effects. The idea is not to be too literal in your approach; try to catch the overall pattern of the cloud shapes rather than painting each individual cloud. In sky painting the main thing is to capture a mood.

Improvisation

Clouds are fickle by nature, so use spontaneous methods to portray them. Here is a wonderful opportunity to improvise; experiment with washes, let your colours run together, or direct their flow by tipping the paper. As long as the paint remains wet you have a chance to 'play' with it. For example, you can lighten areas of cloud and soften the edges by soaking up colour from the paper with a damp sponge or a ball of tissue. Capitalize on those

'happy accidents' that often occur with such a fluid medium – they all contribute to the range of effects you can achieve.

Wet-in-wet

Because they fuse and flow with such ease, colour washes on wet paper lend themselves especially well to portraying misty or rainy skies. You can get a soft, vaporous effect by dropping wet paint onto damp paper or into wet colour. Don't be afraid to use fairly thick paint, because the wet surface automatically dilutes the colour. Also, resist the temptation to 'twiddle' – let the paint spread and diffuse of its own accord; overactive brushwork results in loss of transparency.

Tools of the trade

While there is no substitute for skilled brushwork, the use of improvised 'tools' can sometimes add to the spontaneity of your work – and you can find many suitable items around the house. In the painting opposite, for example, the artist used a soft eraser to lift out the shafts of sunlight breaking through the clouds. (Do this very gently, and only when the paint is bone dry.) The photographs below illustrate some other materials and techniques in a similar vein.

COLOURS FOR CLOUDS

If you've never painted clouds before here are a few suggested colours to start you off. Experiment with different variations of warm and cool, and keep a note of successful mixtures for future reference. Always start with the lightest colour and build up layers of stronger ones, but don't use more than three colours on top of each other.

Dark clouds Ultramarine, burnt sienna, cerulean, yellow ochre, lamp black, light red, neutral tint.

Light clouds Ultramarine, cerulean, rose madder and yellow ochre.

Clouds at sunset New gamboge, rose madder, cadmium orange, cadmium red, mauve, cerulean and ultramarine.

CHOOSING YOUR PAPER

There are two things to consider when buying paper: weight and texture. Painting skies usually involves a lot of water, so use a heavy grade paper – between 140 lb and 300 lb – that won't buckle as you paint. The ideal texture is a semi-rough or 'Not' surface, which is good for large, smooth washes and bears up well under a lot of sponging and scraping. There are lots of papers to choose from, but Saunders and Bockingford represent particularly good value for money.

TECHNIQUES FOR CLOUD PAINTING

John Suett

HAZY EFFECTS
Use the wet-in-wet technique for soft, vaporous clouds. Dampen the paper with water, then drop in fairly thick colour (remember it will dry lighter). Allow the paint to dry untouched.

LIGHTENING COLOURS
To create a light area in a dark cloud, gently press into the wet colour with a small, barely damp sponge. You'll find that a natural sponge is much more gentle than a synthetic one.

SOFTENING EDGES
You'll be surprised at how many watercolour 'tools' you can find lying around! A moistened cotton bud is perfect for softening the edge of a cloud or the line of the horizon.

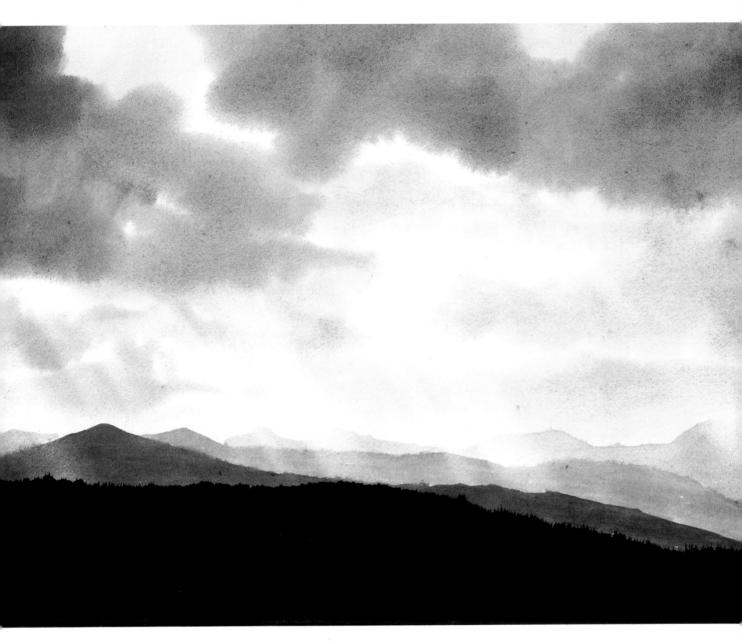

Cloud perspective

Many a promising landscape has been ruined by a sky that looks like a limp curtain hanging down behind the scene. To get a feeling of depth and space into your painting, think of the sky as a dome-like structure in which clouds appear smaller, closer together and less distinct as they recede towards the horizon.

Remember, too, the film of atmosphere that alters the colours of distant objects. Towards the horizon, clouds often take on subtle shades of dusty grey or pale lavender.

The painting above by artist Ferdinand Petrie conveys a strong feeling of receding space. The mountains are paler and less distinct as

they near the horizon, and this is echoed in the tonal arrangement of the clouds.

For the sky, Petrie begins with various mixtures of cerulean, burnt sienna, Payne's grey and ultramarine, worked wet-in-wet on the damp paper. Notice that the darkest clouds are grouped together in the foreground (near the top of the paper). Bear this in mind when painting dramatic skies – a centre of interest is just as important in a cloudscape as it is in a landscape.

The lightest clouds are gently sponged out, and when the painting is completely dry, a few shafts of sunlight are lifted out with a soft putty eraser.

Above *Study of a rain-filled afternoon sky by Ferdinand Petrie. Notice how the arrangement of dark and light tones in the mountains is echoed in the sky to encourage a feeling of receding space.*

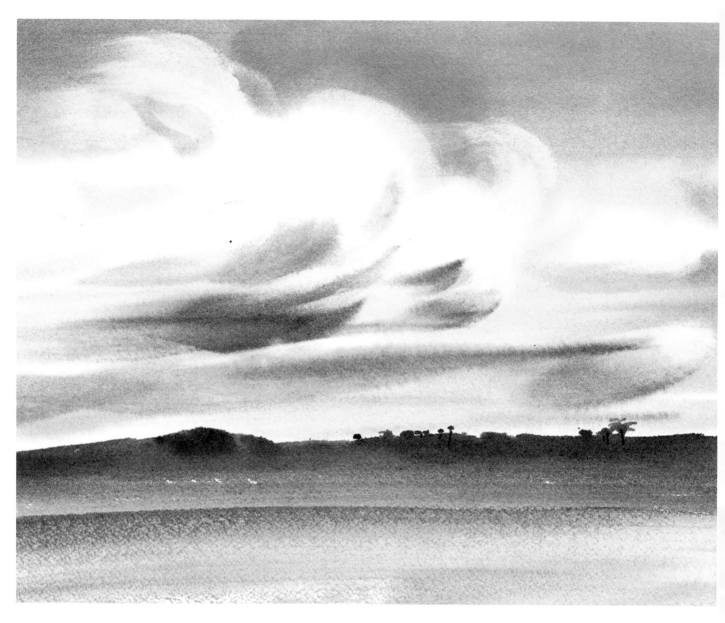

▲ CUMULUS CLOUDS

The best way to render windswept clouds like these is with a few fast strokes. In this study, the sky is painted with a mixture of ultramarine and cobalt blue, leaving white paper for the fluffy tops of the clouds. In the lower part of the sky, a touch of raw sienna is added to denote the distant haze. The dark bottoms of the clouds are a mixture of burnt sienna and ultramarine. Finally, the wispy cloud tails are lifted out with a slightly damp sponge.

Cloud types

The secret of painting moving clouds is to watch for the general pattern of their movement. If you half-close your eyes you will see the cloud pattern more clearly. The studies on these pages, by Zoltan Szabo, show how to simplify the four main cloud types.

Cumulus clouds are large, turbulent shapes, billowing and white on top and darker and flatter on the base. Although they look white at a casual glance, they actually contain lots of subtle colour; the tops of the clouds can range from pure white to shades of cream or pale pink, and their shadows contain hints of blue, red and yellow. Emphasize the roundness of cumulus clouds by contrasting warm and cool tones and partially blending the edges into the sky.

Cirrus clouds are thin, feathery streaks of cloud which have been tossed around in all directions by high winds. If they are white, render them with the lifting-out method; just before the sky wash dries, create streaks in the paint with a clean, barely damp brush. Drag and twist the brush on the surface, imitating the rolling wisps of cloud.

Storm clouds are the most dramatic of all. Mix warm and cool greys from burnt sienna, yellow ochre, ultramarine and alizarin and use vigorous brushstrokes to create variations in the cloud masses.

Strato-cumulus clouds are long, ribbon-like clouds arranged in almost parallel rows across the sky. Paint them paler and narrower towards the horizon – never forget about cloud perspective!

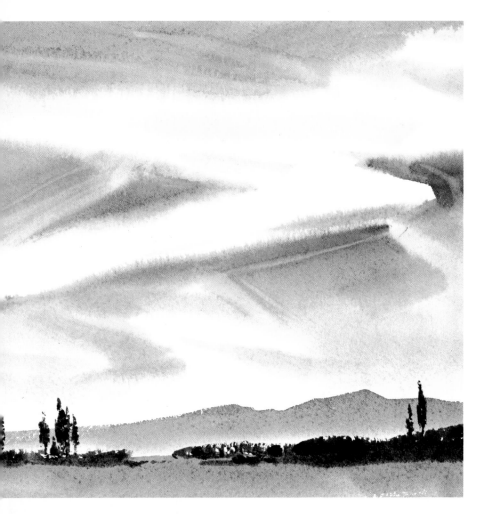

◀ CIRRUS CLOUDS
These layered cirrus clouds are painted with raw sienna, burnt sienna and cobalt blue, applied in sweeping strokes on slightly damp paper.

▲ STRATO-CUMULUS CLOUDS
To paint these clouds, wet the paper and quickly brush on varied strokes of cerulean, ultramarine, and a touch of raw sienna. Use a flat no. 6 brush and space the brushstrokes so that they don't blend completely.

◀ STORM CLOUDS
These dramatic clouds are painted with ultramarine, burnt sienna and raw sienna on wet paper, leaving a few clear white shapes. Some pure cerulean blue is dropped in underneath the dark clouds to indicate clearer skies in the distance.

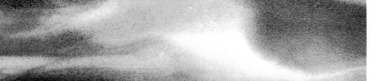

Painting sunsets

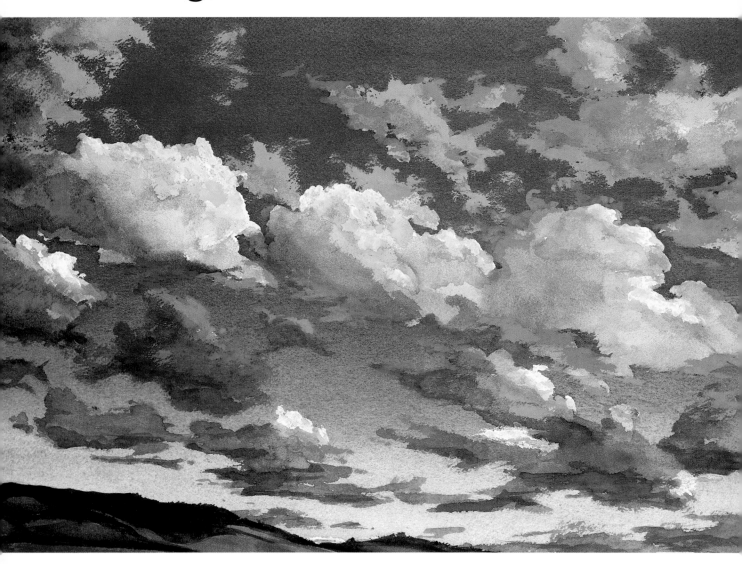

Few of us can resist the temptation to go completely overboard when painting sunsets – only to end up with a corny 'chocolate-box' picture. Here are some of the problems and pitfalls of painting the evening sky, and suggestions for different ways of dealing with them.

Glowing colours

The first thing to remember is that whereas a sunset has overwhelming colour, and luminosity, our pigments don't have the same energy range. The answer is *not* to pile on layers of hot colour. You don't want brightness; you want luminosity. And the way to achieve this is by inter-twining your reds, oranges and violets with much cooler tones of blue and blue-green.

In addition, you can enhance the warmth in the sky by using cool, dark tones in the landscape.

Above *Not all good sunset paintings include the sun itself. Ferdinand Petrie painted these soft clouds to reflect the brilliant pink and gold tones of the setting sun.*

Transparent pigments

Only pure, well-diluted, transparent pigments can get close to the brilliant luminosity of the sky at sunset. Be sparing with opaque colours such as the cadmiums and ochres – keep in the main to hues like vermilion, alizarin crimson, light red and lemon yellow, and for patches of blue sky use cobalt blue with touches of ultramarine. All of these colours can be intermixed without going muddy; for example, a hint of alizarin added to cobalt blue produces a glowing violet hue, while light red dropped into cobalt is perfect for the shadowed areas of clouds.

☆ **SOAK IT UP**
Many watercolourists find that a sheet of blotting paper is an indispensable aid when painting wet-in-wet. When flooding in a large wash, for instance, you can soak up any ridges of excess paint with the edge of the blotting paper. Unlike tissue, it will soak up the moisture while leaving the colour intact – and once it's dried you can use it again and again.

Sunset in the Mountain: demonstration

Not all sunsets are dramatic displays of brilliant colour. In a misty or overcast sky, subtle lavender tints blend into blues and greys to create a quieter mood.

In this watercolour sketch, artist Ferdinand Petrie captures the impression of soft, hazy light filtering through a screen of dark clouds onto the mountains below.

1 The sky wash

Quickly sketch in the main lines of the composition. The light that falls over the entire scene unifies the composition, making the sky harmonize with the mountains. To capture this harmony, start your graded sky wash at the distant mountain range. Begin with alizarin crimson, then, working upwards, drop in some lemon yellow to create a glowing orange. Finally, near the top of the picture, add a thin wash of cobalt blue.

Now take a brush loaded with water and pull some of the alizarin down over the mountain ranges.

2 The clouds

When the sky wash is dry, paint the upper cloud formations. Start with the darkest ones near the top of the painting, rendering them with cobalt blue plus touches of alizarin and burnt sienna. As you move down towards the mountains, lighten the tone of the clouds with more water.

3 The mountains

Paint the mountain ranges, starting at the back, with washes of ultramarine and alizarin. As you work forward, make each range slightly deeper in tone than the one behind it. Allow each section to dry before painting the next, so that hard edges form along the tops of the mountain ridges.

EQUIPMENT USED
☐ A sheet of 140-lb (290gsm) Not paper, approximately 7″×8″ (17.5cm×20cm).
☐ Two brushes: a flat no. 4 and a round no. 4.
☐ A palette of five colours: alizarin crimson, lemon yellow, cobalt blue, burnt sienna and ultramarine.
☐ Blotting paper or tissues.

1

2

3
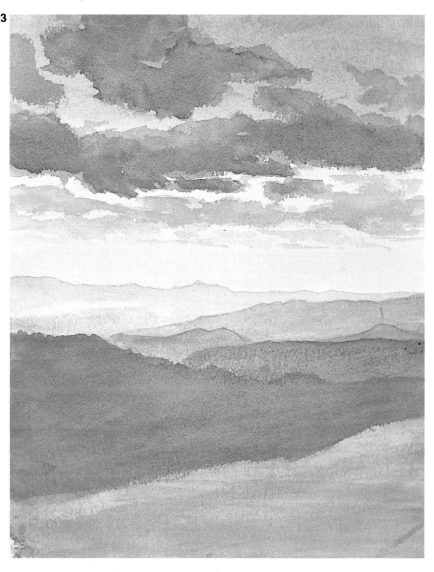

Painting fog and mist

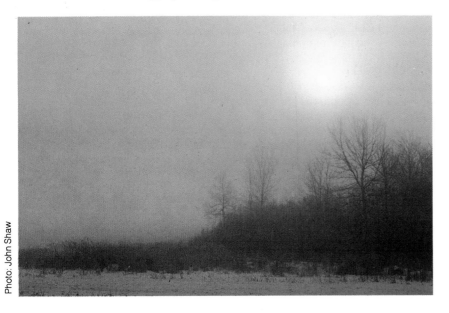

Photo: John Shaw

There can be few atmospheric conditions more fascinating and mysterious than fog and mist; shapes seem to appear and disappear, edges fade softly away, and the whole scene is bathed in a watery light. In short, a misty landscape just cries out to be painted in watercolour.

However, the very softness of a misty day presents the artist with potential hazards – you don't want a picture that looks limp and insipid. Your skill will be in finding details and passages of colour and tone that give the viewer *some* definition with which to appreciate the softness of the rest of the work. Sources can be found in nature, like the ripe berries that look even brighter on a grey day. By paying attention to these accents and handling your washes gently, you should arrive at the essence of the weather.

Before planning your painting, think about the characteristics of a foggy day that set it apart from other days. Below are some suggestions of what to look for and how to capture the effects you see.

Light

On a foggy day the light is soft; there is no direct sunlight to separate light from shadow, so everything is bathed in a relatively constant mid-tone. To get the softness of the light, keep your tonal range rather narrow. Light-to-middle tones are most effective, but remember to accent them with some touches of dark tone for contrast.

Shapes

Fog blurs edges and reduces forms to simple silhouettes. There are no cast shadows, and textural detail is lost, except in those subjects closest to you. Keep your impressions simple: too much detail destroys the illusion of mist.

Colour

You might expect a painting of a foggy day to be all grey. But you can go beyond greys and still produce a convincing impression of fog. Try mixing a lavender-grey, a blue-grey, or even a yellow-grey; brighter hues used in very light washes will give you magical atmospheric effects, as in the painting opposite by Ferdinand Petrie. Here, Indian yellow is the dominant colour. Compare this with the actual colour seen in the photograph above; Petrie's version is somewhat brighter, but it gives the impression of the early morning sun breaking through the mist.

Mood

The mood on a foggy day is quiet and hushed. Let your brushes move softly, creating gradual changes in colour and tone. You can create a hazy look by applying colour to damp paper and allowing shapes and forms to blur. Or you can paint the scene in the normal way, let it dry completely, then immerse the whole painting in water and blot-lift the colour with a tissue. Later, you can add sharper details such as tree trunks and branches on top of the blurred shapes.

Above *With a medium as fluid and unpredictable as watercolour, painting atmospheric conditions in landscapes can be exciting and fun. Here Ferdinand Petrie uses wet-in-wet washes to capture the hazy, lyrical feeling of a foggy morning in winter.*

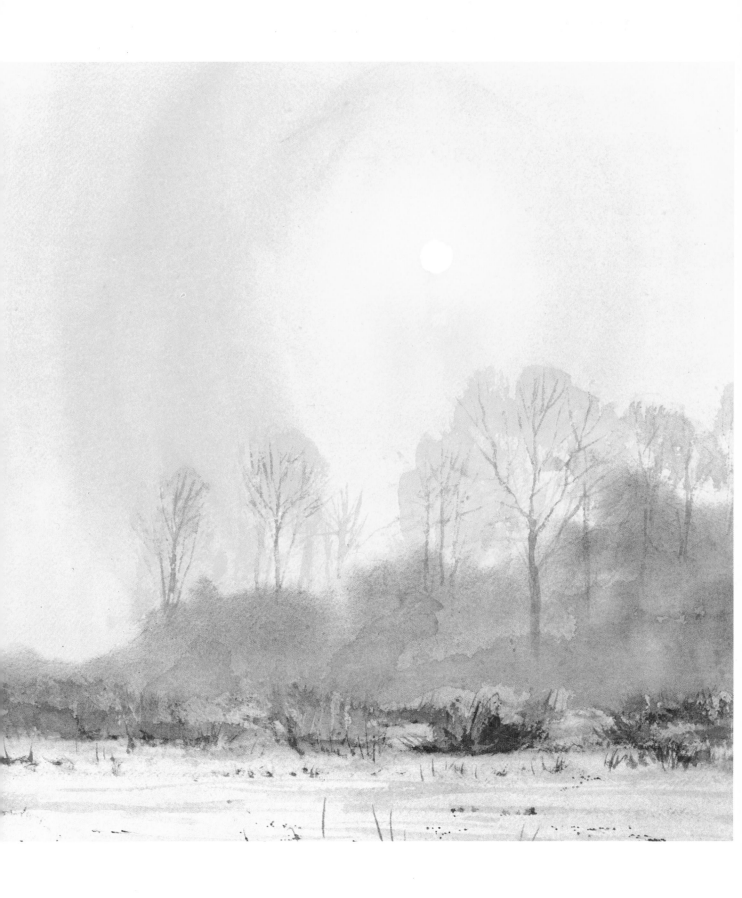

Early Morning Mist: demonstration

The beauty of misty landscapes is that shapes and tones become softened and blurred, creating an air of mystery, of something indefinable. This phenomenon has enormous appeal to the artist; but in order to render it successfully in paint, you can't afford to be hazy in your thinking. You have to work systematically, building up your tones from the lightest to the darkest.

In this demonstration of a fog-covered hillside, artist Ferdinand Petrie defines the vague shapes of the trees using successive layers of very light wash. In contrast, the foreground is sharply defined so as to accentuate the mistiness of the distant trees.

1

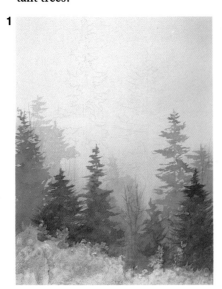

2

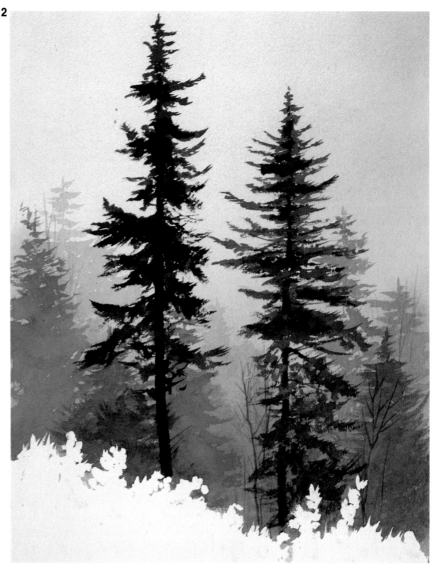

EQUIPMENT USED
☐ A sheet of 200lb (400grms) Not watercolour paper, approximately 8″×11″ (20cm×27.5cm).
☐ Two round brushes: a no. 6 and a no. 8.
☐ A palette of five colours: yellow ochre, Davy's grey, Payne's grey, ultramarine and cerulean blue.
☐ Masking fluid (optional).

1 Lay a graded wash

Lightly sketch the outline of the trees and foreground. Mask out the shape of the flowers and grass in the foreground, or simply leave it as bare paper, as this is painted last. Mix a large puddle of yellow ochre tinged with Davy's grey and well diluted with water; wet the entire paper, then use a round no. 8 brush to lay in a graded wash of this colour. Start lighter at the top, then, as you approach the foreground, intensify the wash with Payne's grey and ultramarine.

2 Begin the trees

When the background has dried, prepare a pale wash of Davy's grey, cerulean blue and yellow ochre and use a round no. 6 brush to paint the lightest trees in the background. Don't add texture or detail; just show their silhouettes. When they're dry, add a little more blue to the mixture and paint the trees in the middle distance. Then add another layer of trees in front of this one. Each layer should be only slightly darker than the previous one.

3 Paint the foreground

Add more Davy's grey to the mixture and paint the tall trees in the foreground, varying the density of colour to break up the heavy mass of foliage. Work from the trunk outward; the brush becomes drier towards the ends of the branches and conveys their feathery texture.

Finally, paint the foreground grass with a varied mixture of ultramarine and yellow ochre. Leave small patches of white paper along the upper edge to indicate the light reflecting off the wet foliage.

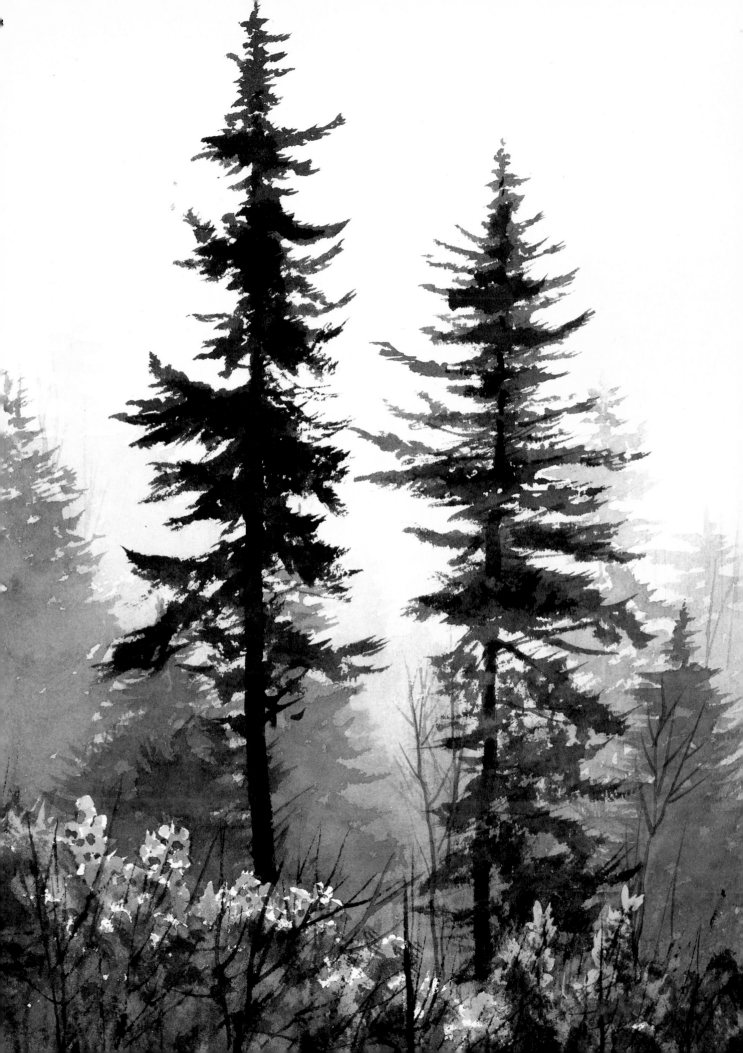

5

PAINTING THE FIGURE

The fluid, spontaneous, often unpredictable medium of watercolour is always a challenge – and, for the watercolourist, the human form is the most challenging subject of all. Contrary to popular belief, figure painting in watercolour is not *difficult* – it's just *different* from figure painting in oils. Whereas the oil painter builds up the form slowly by 'pushing the paint around' on the canvas, the watercolourist works swiftly, aiming to capture the all-important first impression.

This chapter shows you how to harness the quicksilver nature of watercolour, so perfectly adapted to expressing the fleeting, transient effects of light that lend character and atmosphere to a portrait.

'John at Silvermine', Charles Reid, 22½" × 26" (57cm × 66cm). Concentrating on the man's colourful clothes, instead of fine facial details, gives a feeling of spontaneity.

Private collection

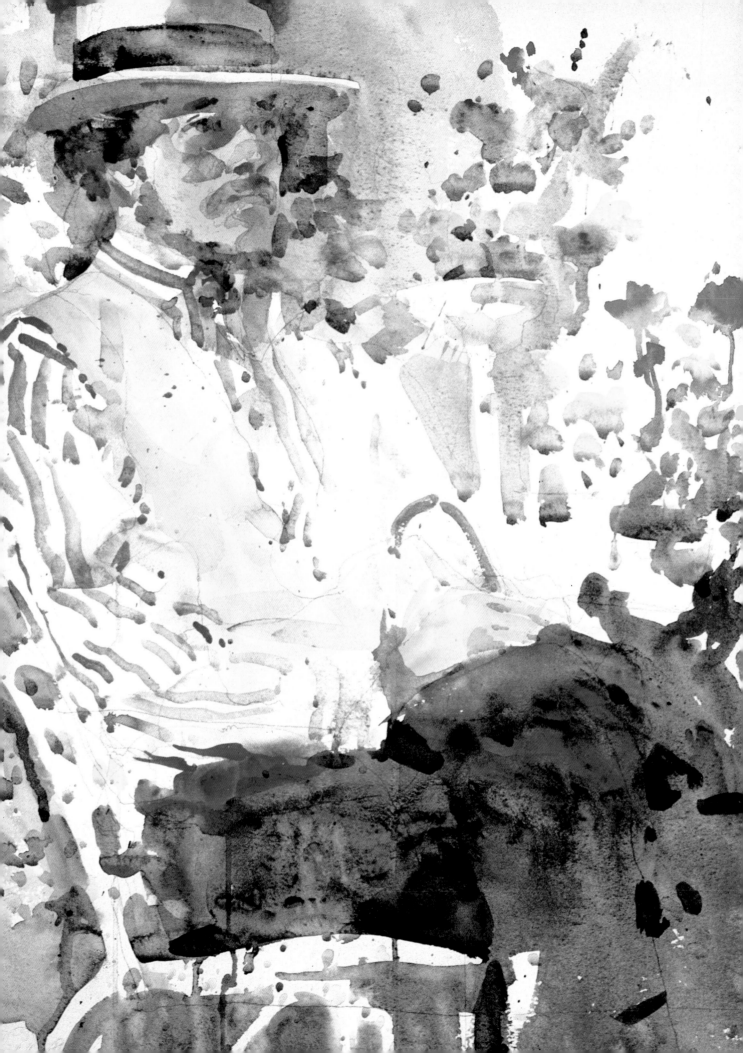

Painting the nude

RHYTHM AND MOVEMENT
Your model may be standing still, but she is not a statue! Bring your figures to life by emphasizing the *key* line, or rhythm, within the pose. Whether it is an S curve, a C curve, or any other line, there is one line in each position that is important – usually the longest unbroken line in the body. In the figure on the opposite page, for example, the key line sweeps down from the head to the back, then diagonally down to the feet, creating a satisfying rhythm.

There's a popular myth that it's difficult to paint figures with watercolour. But that's because many beginners try to use watercolour as they would oils, aiming for a highly 'finished' effect. Watercolour is anything but an exact science – learn to relax and enjoy the spontaneous, informal qualities of this medium.

Animation

Animation is much more important than anatomy, so learn to identify the gestures that convey the most about your subject. Look at the painting by Charles Reid on the opposite page – see where he emphasizes the upward thrust of the hip, the graceful curve of the waist and the relaxed pose of the legs.

Be bold

Don't be over-cautious when working with watercolour: timid, fearful strokes and washed-out colours result in disappointment. Before you start figure painting 'proper', make plenty of practice sketches; *because* they're practice sketches, you'll be bolder in your approach. First, lay down large pools of colour to establish the general shapes, then break down the shapes with smaller patches of colour. Work wet-in-wet, wet-on-dry, blend and lift off with a sponge – indulge yourself!

Fleshtones

There is no set formula for mixing fleshtones: complexions differ from one person to another, and they are also affected by the colour of the prevailing light and reflections from nearby objects. But it is possible to generalize to some extent, and the colour samples at the top of the opposite page will start you off well. The colours used are cadmium red, yellow ochre, cadmium lemon and cerulean blue. In addition, you might add the following colours. Cadmium orange is useful for pepping up an area that looks too pale. For cool fleshtones, try adding Hooker's green instead of cerulean blue. Raw sienna is useful in the shadow areas, and burnt umber is a must in the darkest areas. Mixing fleshtones takes a lot of practice, so don't despair if your first attempts end in failure!

Above *A simple colour silhouette using warm and cool washes. Before you attempt to paint from the model, do lots of practice sketches like these, using as few strokes as possible. It's important to get used to moving the brush freely.*

Concentrate on colour and don't worry about careful boundaries. The colours used here are cadmium red, cadmium yellow and cerulean blue. When adding blue to cool the colour, add it wet-in-wet on the paper. Don't work it in with the brush – you'll only disturb the wash. Just leave it to settle.

Right *'Jennifer' by Charles Reid, watercolour on Fabriano paper, 15"×20" (38cm×50cm). Economy of effort is the keynote here. The shadow shapes sweep down across the body, animating the form while expressing the languorous pose. Notice how the dark background enhances the lightness of the skin.*

FLESHTONES: STEP 1

Squeeze cadmium red and yellow ochre onto your palette. On the paper, paint a square of red and a square of ochre, about 1″ (2.5cm) apart. With your brush, draw some ochre across the bottom of the red swatch and carry the mixture down a couple of inches, zigzag fashion. Both colours should be wet enough to flood together and create a soft, delicate effect.

FLESHTONES: STEP 2

Now repeat the same procedure, this time adding blue to give you the cool tint found in shadowy areas. While the red and ochre are still wet, make a swatch of cerulean blue 1″ (2.5cm) below and to the right of the ochre (or the red if you're left handed). Clean your brush and shake it, then take a *little* blue into the centre of the red-ochre mixture and blend wet-in-wet.

FLESHTONES: STEP 3

Repeat the same procedure, this time using cadmium red, cadmium lemon and cadmium orange; dilute the yellow a little with water to cut its strength. Cadmium orange can pep up a dull, washed-out, light area but it's a strong colour so use very little and make sure the red-yellow mixture is wet so that the orange can be absorbed. Don't work the mixture with your brush.

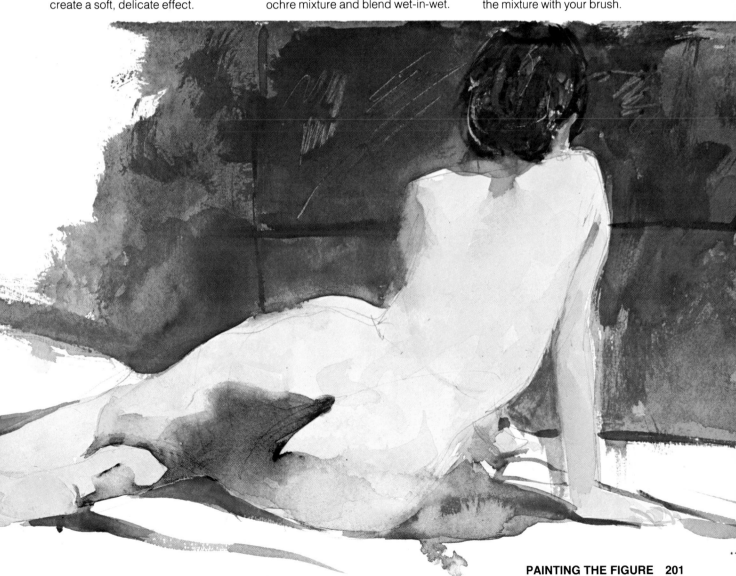

Figures in light and shade

The silhouette sketches below show how to simplify shadows and highlights on the skin. Place your model so that he or she is lit from the side and you can see the shadows more clearly. Remember, you are not aiming for a likeness – you are practising brushstrokes and colour control.

Step 1

Starting with a warm wash of cadmium red and yellow ochre, brush in the figure freely. While this wash is still wet, add a touch of cerulean in the torso area and let it blend in wet-in-wet. Leave this to dry, then mix a darker skin tone, using cadmium red, raw sienna and a touch of cerulean. Use this to block in the warm shadows on the head, arms and shoulders.

Step 2

The shadow on the torso is much cooler, so add more blue to the mixture; use strong colour, but not too much pigment. Notice how freely these shadows are indicated. Enjoy yourself and revel in the colour without worrying about careful drawing.

Step 3

Starting from the lower torso, sweep the colour right down to the feet. Try to do each leg in one stroke if you can, or two at most.

WHICH PAPER?
A fairly absorbent medium-rough paper such as Bockingford 140-lb is ideal for figure painting. Avoid non-absorbent paper as it tends to repel the paint and form puddles.

Use a fairly large sheet – 12″×14″ (30cm×35cm) is a good size and will encourage you to work boldly.

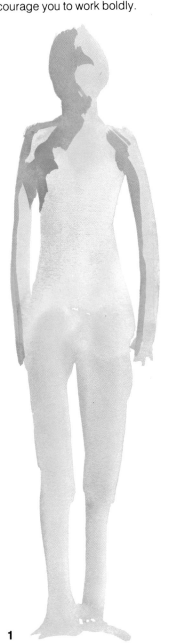

1

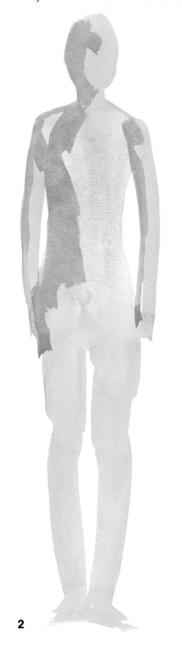

2

3

Seated Nude: demonstration

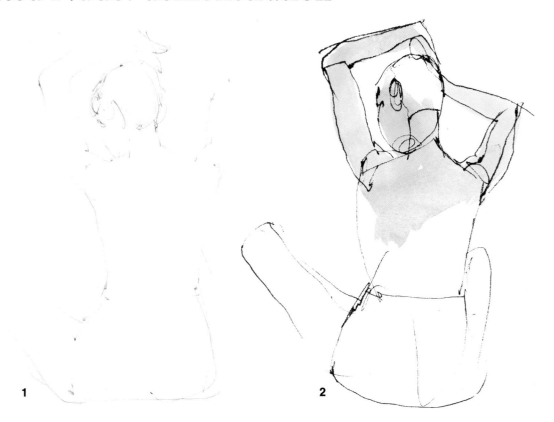

1

2

In this demonstration, Charles Reid chooses a direct back view of the model. This is a good choice of pose for a beginner because it is relatively simple, and the angular forms of the arms contrast nicely with the rounded forms of the body.

In order to make the painting techniques as clear as possible, the artist did a different piece of artwork for each step instead of showing one painting from start to finish. So don't worry about any inconsistencies in the illustrations.

It's a good idea to have all your colours ready on the palette before you start the project. You can't do expressive, spontaneous brushstrokes if you have to stop and squeeze out colour as you paint!

1 Sketch the figure

Draw a light sketch of the figure, not a careful rendering. Make your drawing about 10″ (25cm) high. This is a good average size, big enough to allow freedom in your brushwork. Remember, the sketch should only be a guide for your wash – the lines you make need not be carefully filled in. If the drawing goes badly, it's better to start afresh; washes won't sit nicely over a heavily erased area with a spoiled paper surface.

2 The upper torso

Make a warm puddle of cadmium red and cadmium yellow with just a touch of cerulean blue or Hooker's green. Fill your brush from this puddle, give it a good shake, and wash in the upper section of the figure. Block in the head, then the neck, and continue into the shoulders and arms. Don't worry unduly about filling in the pencil outline.

3 The lower torso

Cover the whole torso area with cool tones; use mainly cerulean blue or Hooker's green and a small amount of the warmer mixture. Work fairly quickly to get a good wet-in-wet blend between the warm and cool areas. Gently blot the colour with a tissue if it becomes too dark.

3

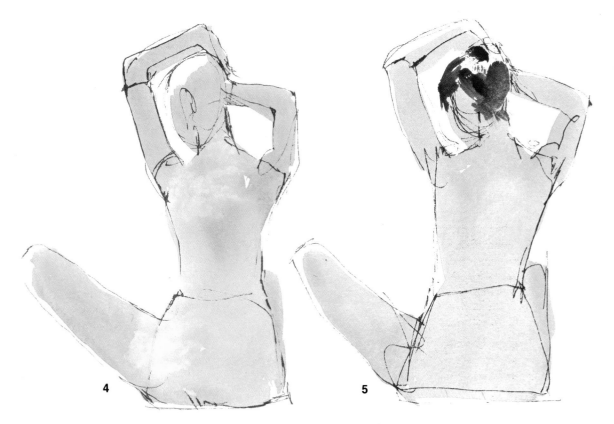

4

5

EQUIPMENT USED
☐ A sheet of 140-lb cold-pressed paper, approximately 15″×10″ (38cm×25cm).
☐ A soft, round no. 6 brush that points well.
☐ A 2B pencil.
☐ A palette of seven colours: cadmium red, cadmium yellow, yellow ochre, cerulean blue, Hooker's green, ultramarine and burnt sienna.

BEAUTY IS SKIN DEEP

Many beginners tend to stick to a single 'formula' for all fleshtones – and then wonder why their figures look like cardboard cut-outs. Train yourself to see the beautiful colours that actually exist in fleshtones and exploit them to the full. If a shadow looks green, include some green in your mixture. Study the model to see if colours are reflected onto the skin from clothing or nearby objects.

4 The legs

Now it's back to the warm colours, because the legs face into the light. Start with the left knee and brush towards the torso. Indicate the right leg, which is mostly hidden from view. While the wash is still damp, lightly blot the hip and upper torso with a tissue to indicate soft highlights. Allow this to dry.

5 The hair

For the dark hair, mix a combination of burnt sienna and ultramarine, or try alizarin and Hooker's green. Experiment! Don't always use the same two colours. Mix the colours on the palette, start blocking in the area, then add some pure colour wet-in-wet. Let some pure blue, green or red show. Don't feel that everything must be blended.

6 Model the arms

Model the warm shadow areas on the arms with a combination of cadmium red, raw sienna and cerulean blue or Hooker's green. Starting at the wrist, carefully articulate the thumb; a graceful little touch. Allow the warm, dark colour to blend with the hair. Finish both arms, then model the ear and the chin. (Notice the patch of light left at front of the ear.)

7 Model the back

Returning to the cool shadow mixture, use sweeping strokes to define the structure of the back. Notice, for instance, the shadow that indicates the underplane of the left shoulder blade, made with one deft stroke. Make the shadow shapes simple; isolated islands of shadow look unnatural.

8 Create depth

Now the figure is almost finished, with only a few loose ends to tie up. For instance, the right arm and leg won't recede enough if they are of the same tone as the rest of the shadows. Add a darker wash here, using the same mixture used in step 6. Allow the picture to dry before going on to the next step.

9 Soften the shapes

Now that you have defined the broad areas of light and shade, it's time to soften the shadow edges for a more natural effect. Mix a thin wash of colour, midway between the warm and cool tints used so far. Add this mid-tone across the shoulders and in the lower torso so that it overlaps the shadows and highlights. This subtle transition from light to dark stresses the roundness of form.

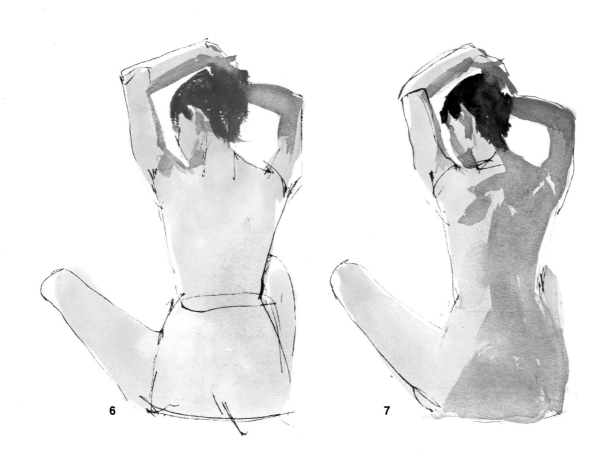

6

7

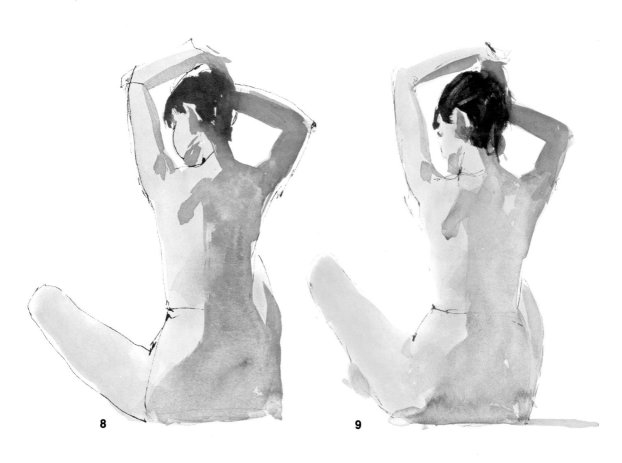

8

9

Relating figure to background

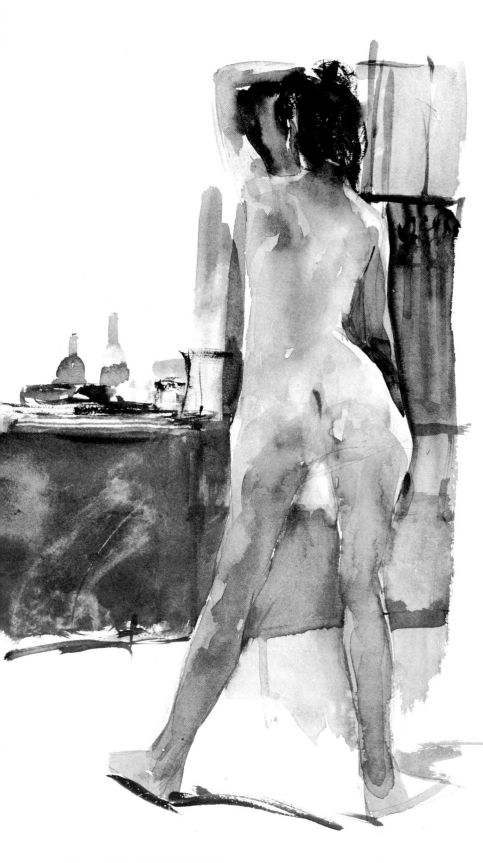

When you're painting portraits or figures, don't make the mistake of treating the subject and his or her surroundings as separate entities: the result will be an unhappy, disjointed painting in which the sitter appears merely to have been 'pasted on' to the background.

The way to achieve an integrated, harmonious painting is by learning to treat the subject and background as two closely related elements that have to be knitted together so that the seams don't show!

To help you create those all-important tie-ins, here are some points to watch out for.

Left *'Back View I' by Charles Reid, watercolour, 16″×20″ (37cm×47.5cm). Here the background is simple but well thought out: the dark tones and hard, geometric shapes lend emphasis to the model's rounded forms and pale skin.*

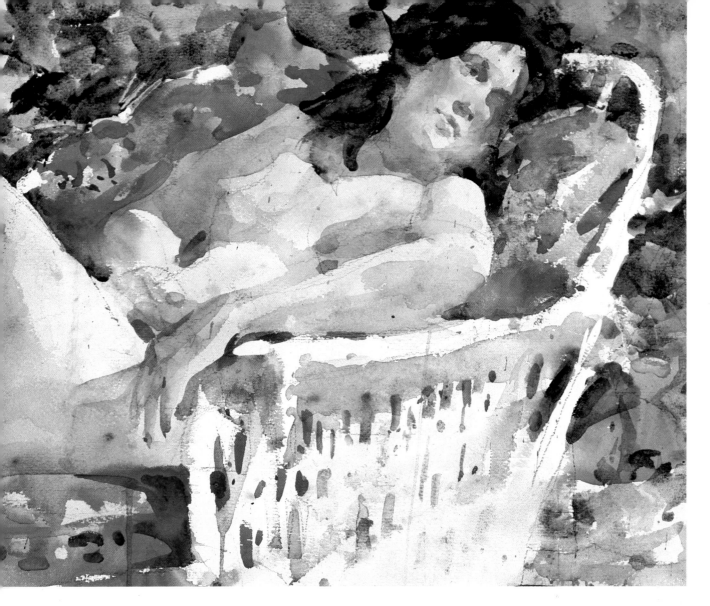

Establish connections

One way to achieve a feeling of 'wholeness' is to alternate your brushwork constantly between the figure and the background. Doing this forces you to see colours, shapes and tonal arrangements as a whole, so helping you to make the most of connections such as reflected colour and common shadow patterns.

Edge control

When painting figures, learn to vary the edges of the form from hard to soft. Generally, edges in shadow are soft and indistinct while edges facing the light are hard and well defined. In 'Keri by the Pool' (above) Charles Reid emphasizes the light-struck areas such as the top of the thigh and the stomach with hard edges. But the shadowed parts – the left cheek and the right arm – are softly blurred into the surrounding areas. This rhythmic flow of hard and soft helps to place the sitter firmly in the chair: if all the edges were hard, she would look like a cardboard cut-out!

Harmonize colours

There are two ways in which colour choice can strengthen a figure composition. First, choose a colour for the background which complements the subject so that the two are played off against each other. Second, introduce elements of reflected colour from nearby objects into the skin tones to connect the figure with their *immediate* surroundings.

In Charles Reid's painting above, the cool green background offsets the warmth of the figure and creates a sense of distance. In the foreground, meanwhile, the warm red of the cushions is reflected onto the figure – the model appears to be sinking into her chair very comfortably! Note, too, how the white chair provides a 'frame' for the model.

Above *'Keri by the Pool' by Charles Reid, watercolour, 21″×28″ (53cm×71cm). In this painting the artist uses several ploys to connect the model with her surroundings: hard and soft edges, similar tones between adjoining areas, and colour tie-ins.*

Background shapes

A cluttered or intrusive background can ruin a perfectly good painting because it draws the viewer's eye away from the main subject. Before you begin the picture, look carefully at your chosen setup through a viewfinder: is there a bright curtain in the background which threatens to overwhelm the subject? Is there too much clutter on that table?

Always keep the background simple – paint general shapes rather than specific details, just as photographers often create out-of-focus backgrounds to accentuate the subject.

Creating mood

When painting a portrait, there's more to consider than just getting a likeness. As an artist, you want to convey the character and mood of your sitter – and you can achieve this by giving careful thought to the composition and overall colour scheme of the painting.

For example in the painting below the artist seeks to focus attention on the sitter's thoughtful gaze. This he does by concentrating most of the colour and modelling in the face; the rest of the picture is kept low-key.

Below *'Light and Shadow' by Charles Reid, watercolour, 10"×14" (25cm×35cm). In this portrait of a young girl, pale fleshtones are teamed with a suitably simple and subdued background to create a reflective mood.*

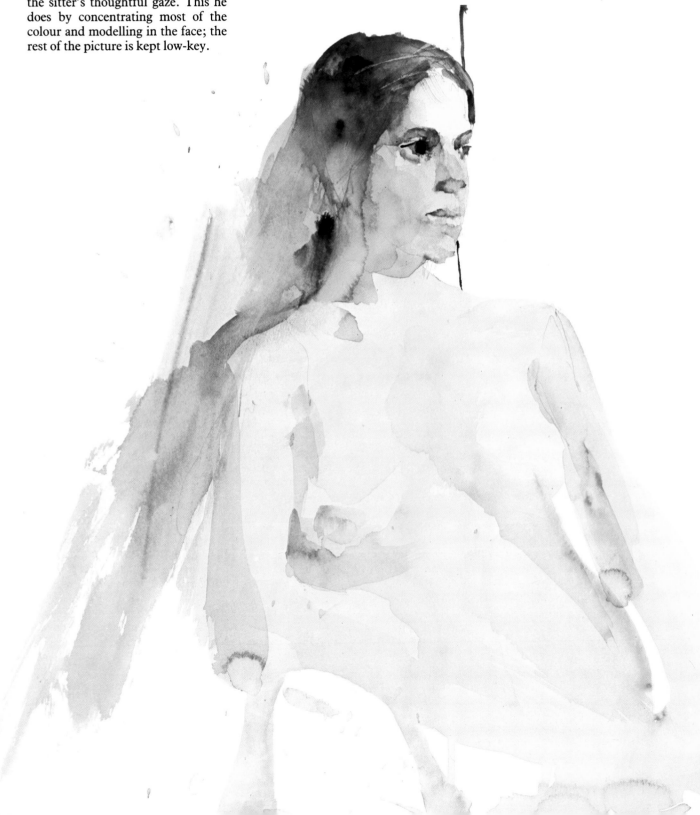

Figure in Sunlight: demonstration

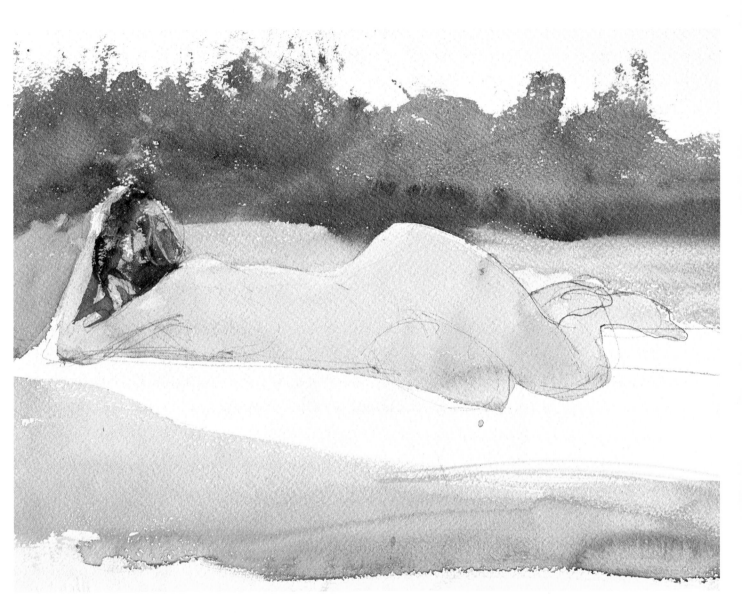

Sunlight brings out colour possibilities which you don't find under artificial light. In this demonstration, artist Charles Reid shows you how to convey the effect of bright sunlight on the skin tones. Notice, too, how he moves continually back and forth from model to background, so ensuring that the two relate to each other convincingly.

1 Lay the first washes

The figure Lightly draw the outline of the figure and briefly indicate the background. Mix a puddle of cadmium red light, cadmium yellow lemon and cerulean on your palette and use this to wash in the figure with a round no. 4 brush. The figure should appear to be 'swimming' in sunlight, so keep this first wash quite light, but rich in colour.

The background The model is lying on a white cloth; leave this as untouched white paper for the time being. Using a round no. 6 brush, wash in the light grass around the figure with cadmium yellow lemon, adding a touch of cerulean here and there for variety.

Paint the distant trees with a mixture of cerulean, cadmium yellow lemon and a touch of raw sienna. Start at the bottom of this band of dark green and work upwards; as the brush dries out near the top, use a scrubbing action with the side of the brush to indicate movement in the tops of the trees.

Back to the figure Check that the light fleshtone wash is dry, then indicate the shadow shapes in the area around the head and forearms. For this, use a round no. 2 brush and a mixture of cadmium red light, raw sienna plus a touch of cerulean. Next paint the model's hair with burnt sienna, adding a touch of cerulean for the shadowed parts. Scratch out a few hair strands with your fingernail.

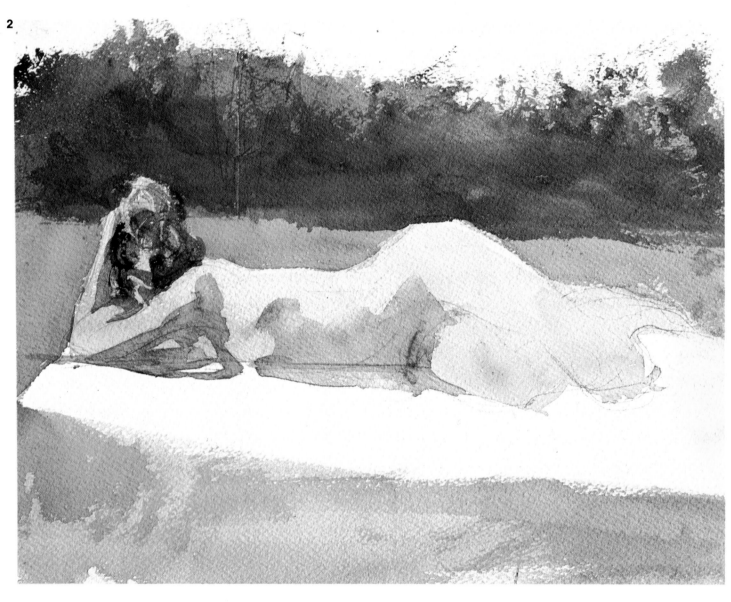

2

EQUIPMENT USED
☐ A sheet of rough Arches watercolour paper, approximately 11″×15″ (27cm×35cm).
☐ Three round brushes: a no. 2, a no. 4 and a no. 6.
☐ A palette of five colours: cadmium red light, cadmium yellow lemon, cerulean, raw sienna and burnt sienna.

2 Model the shadows
The figure On your palette, mix puddles of cerulean, cadmium red light and cadmium yellow, well diluted with water. Dip into each of these colours with the same brush – a round no. 4 – and quickly paint the cool blue shadows that describe the form of the upper arm and torso. These shadows should be light and transparent, allowing the underlying wash to shine through.

In the picture above, you can see interesting variations of colour within the shadows, where red, yellow and blue are allowed to mix on the paper instead of being blended on the palette. This not only helps to describe the form of the figure, but it also creates the feeling of *light* – the hallmark of good watercolour painting. We can sense that sunlight is being bounced up onto the figure from the white cloth. To indicate the roundness of the figure, soften the upper edge of the torso shadow with water.

The cloth Using an identical colour mixture, paint the cast shadow on the white cloth at the same time as you paint the shadows on the figure. Allow them to blend together so that the figure appears 'anchored' to the cloth, not floating above it.

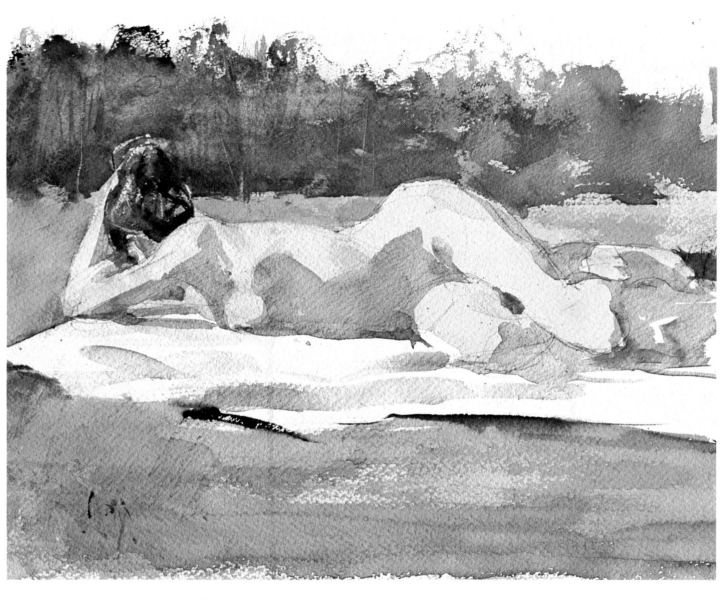

3 Complete the modelling

The figure Using a round no. 2 brush and a mixture of cadmium red light, raw sienna and a touch of cerulean, complete the shadows in the legs and feet. These shadows are warmer than the shadows on the torso because the legs are facing into the sun. The arrangement of the legs is rather complicated, so keep the shadow shapes simple and link them together to avoid a spotty, confused effect.

While this wash is still wet, indicate the cast shadow around the legs with a light wash of cerulean. Rinse your brush, then gently blur the edge between the legs and the shadow with water. Let some of the flesh colour run into the shadow to create a 'lost' edge.

The cloth Using a round no. 4 brush and a loose mixture of cerulean and cadmium red light, indicate a few folds in the cloth with loose, spontaneous brushstrokes.

The figure With a *very* pale mixture of cerulean and cadmium yellow pale, add a few mid tones on the figure – on the shoulder, ribcage and legs. Keep these areas very subtle, since you don't want to disturb the simple light-shadow relationship that gives the figure a feeling of light.

Above *'Figure in Sunlight' by Charles Reid, watercolour, 11″×15″ (27.5cm×37.5cm). This painting demonstrates how even the simplest background can be used to accentuate your subject. Here the yellow-green grass and trees act as a complement to the pinks and blues of the figure and contribute to the feeling of sun and light that permeates this painting.*

Painting portraits

Although portrait painting is more often associated with oils, watercolour is the perfect medium for spontaneous, informal portrait studies. Its qualities are beautifully matched to the subject: glazed washes and soft, wet-in-wet effects bring out the bloom of flesh, while more fluid paint is ideal for capturing those fleeting facial expressions that make a portrait come alive.

But before you can paint a success-ful portrait, it's important to know how to render the individual features of the face. Practise drawing eyes, noses and mouths until you under-stand their shapes. Then try painting them in monochrome washes of ivory black or Payne's grey, as in the demonstrations that follow, so that you can master three-dimensional modelling using washes and glazes, without the added complication of having to think about colour.

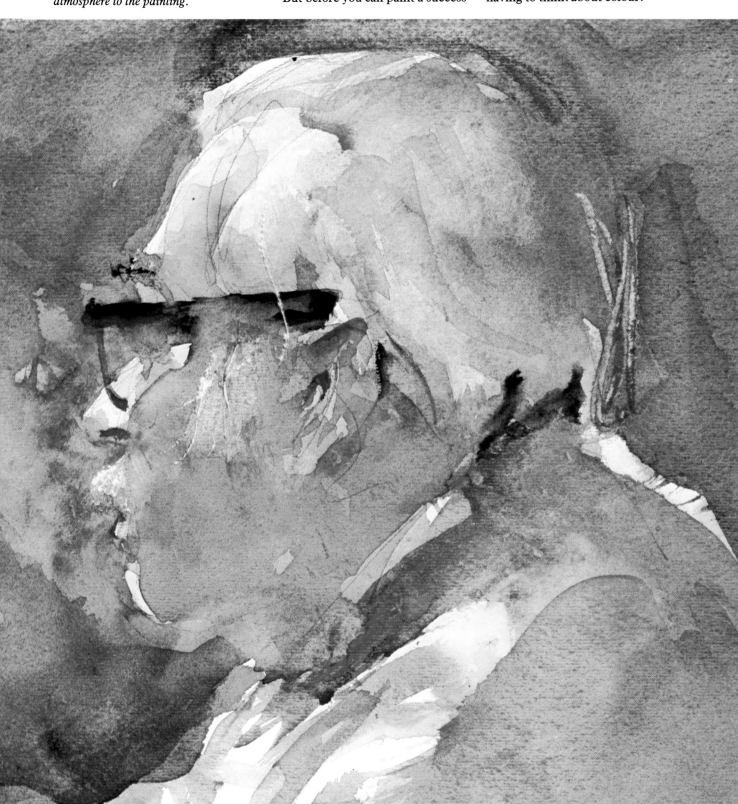

Below *'Eddie' (detail) by Charles Reid, watercolour, 10″×10″ (25cm×25cm). When painting a head in profile, use a strong light source from one side: this creates a fascinating contrast of highlights and shadows and adds atmosphere to the painting.*

Basic head form: demonstration

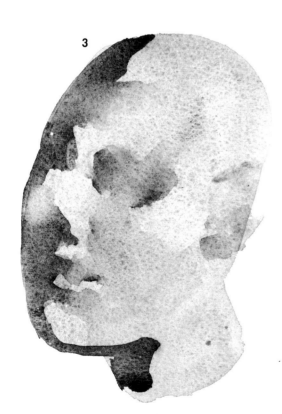

In this short demonstration, Charles Reid shows how simple light and dark washes can describe the basic head form. The only equipment you'll need is a round no. 8 brush, a tube of ivory black, a sheet of hot-pressed paper, plenty of clean water and some tissues. Start by mixing two washes on your palette – a light one for the overall skin tone and a dark one for the shadows.

1 Define the shape of the head

Use the light wash to paint an oval for the head, and the dark wash to paint the shadow down the left side of the face and neck. Use more dark wash to indicate the eye socket and the bottom plane of the nose.

2 Paint the mouth

Indicate the shape of the upper lip and the shadow under the lower lip. Connect the shadow areas with the light areas by creating a middle tone: rinse your brush, give it a shake, and place it in the shadow just above the eye; then draw the brush outwards into the light area and soften the edges with a tissue to create a smooth gradation from light to shadow. Use the same method for the shadows of the cheek and the top of the nose.

3 Model the right side of the face

Lighten and soften the nearest edge of the lips with clear water, blotting with a tissue. Now make an oval shape for the right eye, using your shadow wash. Lighten the middle section of the eye to show its rounded form; then continue this light area up to the forehead and down to the top of the cheek. Model the lower cheek with a second layer of light tone, working the wash down into the shadow below the lower lip. Finally, indicate the right ear very simply.

Painting eyes: exercise

In this exercise you'll be painting an eye as seen from a three-quarter view. The materials used are the same as in the previous demonstration.
1 Lightly sketch in the shape of the eye, then pass a light wash over the whole area of your drawing. When this is dry, use the shadow wash to paint the shadow in the corner of the eye, letting it flow out into the eyeball and under the lower lid.

2 Continue to draw out the shadow along the top of the eye, indicating the shadow on the upper lid. Blot and lighten the inside corner of the eyeball. At the outer edge of the eye, create a simple, oval-shaped shadow. Blot the top edge of this stroke to lighten it and show that the upper lid 'comes out' at this point. You should now have the feeling of the contour of the eyeball.

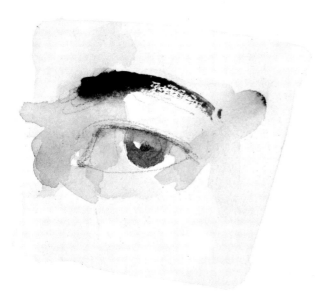

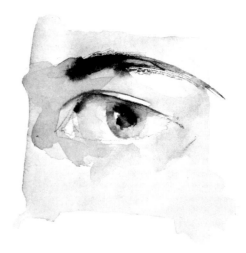

3 Now for the eyebrow. Using almost pure pigment, start at the thicker end, letting the edges blend into the still-damp shadow area. As the eyebrow curves round, your stroke should become thinner and lighter (a touch of drybrush here will suggest the texture of the hairs). Finally, paint a simple oval for the iris, using the dark wash. Leave a small dot untouched, as a highlight.

4 The iris should still be damp. Using a touch of pure pigment, 'drop' in the dark pupil, still leaving the highlight untouched. Next, paint a dark strip along the upper lid (the upper lid is always darker than the lower lid). Just above this, paint a curving line to indicate the fold in the eyelid. In final sketch, there should be both 'hard' and 'soft' edges, so that the eye has definition without looking static.

Painting mouths: exercise

Mouths are difficult to paint, and often end up looking stiff and flat. This demonstration shows you how to use hard and soft edges to model the mouth and give it a feeling of roundness.
1 Sketch a rough outline of the mouth. Using your light wash, cover the entire mouth and surrounding area, leaving a small patch of untouched paper on the lower lip to indicate a highlight.

2 Using your dark wash, begin by painting the upper lip. Usually there is a crease in the skin at the mouth corner, so start your stroke off wider here and then narrow it at the beginning of the lips. Widen the stroke again as you approach the middle of the mouth. Repeat this procedure on the other side, leaving an untouched middle section to indicate the rounded form of the mouth.

3 With a clean, damp brush, draw some tone from the two sides of the mouth into the middle. Next, draw the shadow down into the lower lip from either corner of the mouth, and repeat the process you used for the upper lip. Allow some of the pigment in the lips to 'bleed' into the surrounding skin areas, creating soft edges: this is what prevents the mouth from looking 'pasted on'.

4 Allow the painting to dry before working on any areas that need re-emphasizing. To darken the upper lip, repeat the process used in steps 2 and 3. On the right side, bring some of this shadow tone down into the lower lip to avoid leaving a rigid division between the upper and lower lips. Remember to keep the feeling of softness and mobility in the mouth by using hard and soft edges.

'Laurel': demonstration

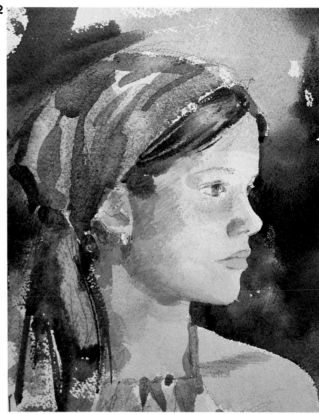

Having practised painting individual facial features, you should now feel confident enough to try a full-colour portrait. In this painting of a young girl, artist Tom Hill demonstrates how to build up a convincing, three-dimensional head by glazing with delicate washes.

1 The first washes

Begin by making a careful, though not too detailed, pencil drawing of the model. Wet the face and neck areas, then flood them with a light-toned wash of lemon yellow tinged with a bit of alizarin crimson, using a flat no. 8 brush. This constitutes the basic skin colour.

While the first wash is still damp, add some slightly darker tones to the cheek, forehead and neck, using lemon yellow, alizarin and a touch of raw umber. Rinse your brush, then apply a pale wash of cobalt violet to the dress and the bandana.

When the face and neck areas are dry, dampen the background and apply a wash of lemon yellow. Charge mixes of Hooker's green, burnt sienna, cobalt violet and ultramarine into the wet background, cutting carefully around the profile of the face, neck and shoulders.

2 Add the darks

When the face is dry, add dark tones (lemon yellow, alizarin and raw umber) to the nostril, under the eye, the cheek, ear, neck and shoulder, using a round no. 4 brush. With a darker tone of cobalt violet (modified with ultramarine and a touch of burnt sienna), quickly indicate the folds of the bandana.

Using raw umber and a round no. 8 brush, paint the hair. Let this dry, then paint the darker strands using raw umber mixed with a little ultramarine and burnt sienna. Paint the iris of the eye with lemon yellow and a dab of raw umber.

3 The finishing touches

Paint the cheek, the lips and the area just under the eye with light washes of alizarin. Finally, paint the eyelashes, eyebrow and pupil of the eye with mixes of raw umber and burnt sienna.

Right *'Laurel' by Tom Hill, watercolour, 12″×9″ (30cm×22.5cm). For this portrait of his daughter, the artist chooses a near-profile pose which is more descriptive and interesting than a straight profile.*

3

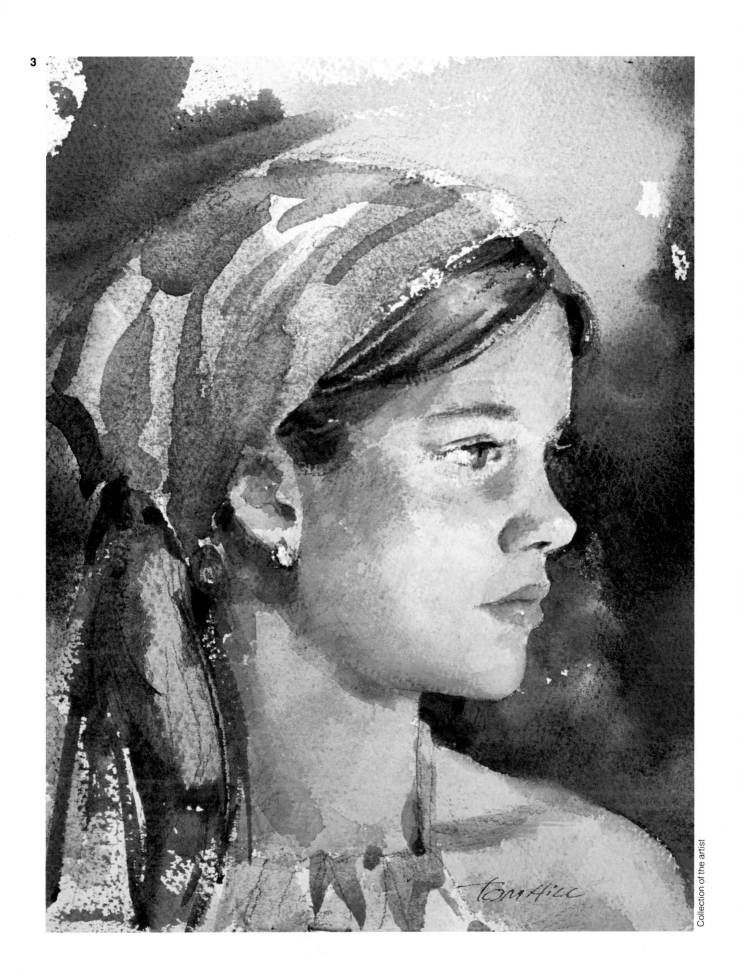

Painting young people

Children, with their sensitive faces, offbeat poses and delicate colouring, are fascinating to paint. Their only drawback, of course, is their inability to keep still long enough for you to paint them! For the water-colourist, this is not a problem; the fluid nature of watercolour allows you to use your intuitive response – to capture a fleeting smile, or the soft bloom of a young child's skin.

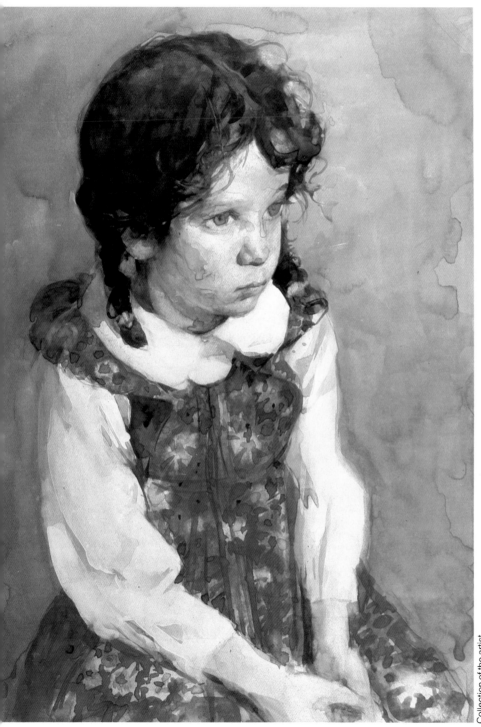

Below *'Karen' by Burt Silverman, watercolour on plate bristol, 15"×10" (38cm×25cm). The loose handling of paint adds to the charm of this informal portrait of a five-year-old.*

The approach

The key words to remember when painting children are *speed* and *simplicity*. You don't have to be absolutely precise in rendering the features – a light, sketchy approach will lend a suitably fresh and youthful air to your portrait.

Skin tones The smooth surface of young skin reflects a lot of light and has fewer and broader shadows than the skin of an older person. Use a limited palette of light, fresh colours – complicated colour mixes will only cloud the issue. Look at Charles Reid's portrait (opposite page) for example: in the face he uses washes and glazes of vermilion, lifting out the light-struck areas with a clean, damp brush and adding a mere hint of ultramarine for the shadows. The colour is quite strong, but it looks luminous because the white of the paper is glowing through it.

The pose

Try to use a natural, relaxed pose. If you know your sitter well, you will be familiar with the gestures and expressions which they use most often; try to incorporate these into the pose and you are well on the way to expressing personality as well as a good likeness.

It's a good idea to provide some sort of entertainment to keep your sitter from getting bored and fidgety. A teenager might appreciate some music to listen to, while the most effective device for immobilizing a very young sitter is television. Engrossed in a favourite show, the child will remain still but his face will be mobile and expressive. Before you actually begin painting, work out the lighting you want, make some pencil sketches and chat with your sitter to both relax him and learn something about his personality and interests.

Finally, be sure to interrupt the pose with frequent rest periods: every 20 minutes for a teenager, and more often for a young child who is liable to become restless.

Right *'Sarah at High Hampton' by Charles Reid, watercolour, 22½"×30" (57cm×76cm). Try to express the gestures and attitudes that typify a young person. Here, the girl's relaxed pose and coltish legs spell 'youth'.*

Collection of the artist

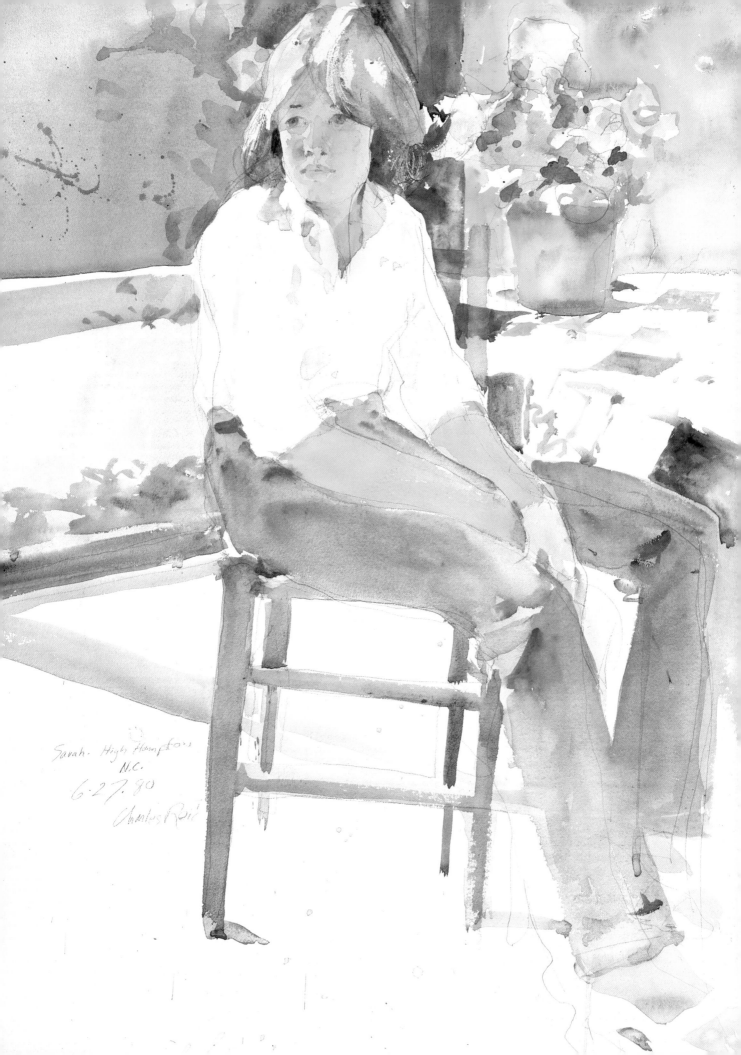

Sarah. High Hampton
N.C.
6.27.80
Charles Reid

Oriental Child: demonstration

In this portrait of a young Japanese boy, Charles Reid chooses a frontal pose, lit by a strong side light which casts a shadow on one side of the face.

1

1 The basic skin tone

Lightly indicate the basic shape of the head in pencil. Paint the face and neck with a rich wash of vermilion, raw sienna, and a touch of cerulean blue and Hooker's green, applied with a round no. 8 brush. Let the red dominate the mixture, to keep an overall feeling of warmth, but add more cerulean blue on the left, shadow side of the face. Work quickly, blending the colours wet-in-wet on the paper so that the skin tone doesn't become too flat.

Here the light is coming from the upper left so, before the wash dries, blot the upper left side of the face lightly with a tissue or a damp brush. Allow the painting to dry.

2 Paint the darks

2

Mass in the hair, using burnt sienna and Payne's grey, with a little cerulean blue. Because the face has dried, a hard edge will form along the hair line; leave this edge hard on the left side, but soften it on the shadow side by 'tickling' it with a soft, damp brush.

Indicate the dark shadows on the face, using the same flesh mixture as in step 1, with a little Hooker's green added to darken it. Working down the middle of the face, wash in the shadows broadly, developing the shapes of the eyes, nose, mouth and chin.

Now add more cerulean blue to the shadow mixture and wash in the right side of the face. Reflected light makes this area a bit lighter than the centre of the face, but still darker than the highlighted areas.

While the shadow wash is still very wet, run a clean, damp brush down the right side plane to soften the division between the shadow and the areas of reflected light.

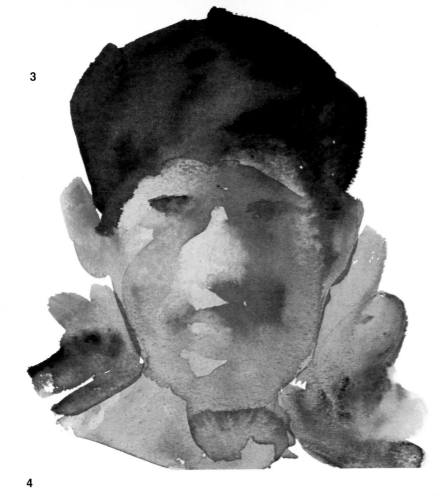

3 Model the forms

Starting at the left eye, soften the edge of the shadow across the eye form, leaving a hard edge at the bridge of the nose. Draw the brush down into the cheek and continue all the way down to the chin. Go back to the nose and soften the edge between light and shadow, leaving the hard edge of the cast shadow under it.

Soften and lighten the inside area of the lips, but leave a hard edge along the top edge of the upper lip that's more in the light.

Paint the background, using Hooker's green, raw sienna and burnt sienna. Mix the colours wet-in-wet on the paper, with loose, vigorous brushstrokes; this lends a sense of atmosphere and air around the subject.

Before the eye areas are dry – when they're just damp – add the suggestion of eyelids and irises, using the shadow colour mix used in step 2.

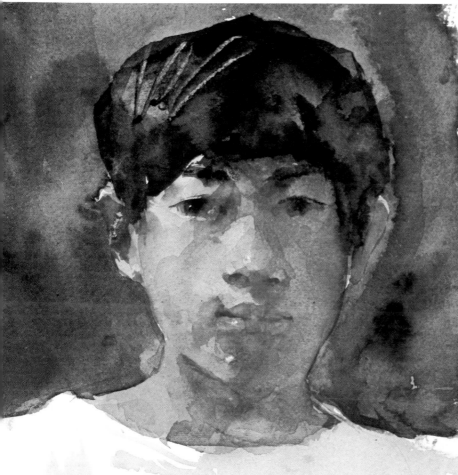

4 Define the features

In this final stage, give more definition to some features, while retaining the soft, 'lost' quality in other areas. Dot in the nostrils, using burnt sienna and burnt umber (black makes the nostrils look like two holes in the face).

Develop the mouth, leaving the darkest area at the left corner and using a broken line to indicate the division between the lips. Define the chin and the shadow below the lip, putting in darks and blotting them with a tissue until the form is right. Lift out a light strip where the lower eyelid is catching some light.

Use a touch of fleshtone colour, watered down to a pale tint, to paint the shadows in the boy's white T-shirt. Finally re-state the hair, adding darker tones in some areas and scratching out a few strands with the point of the brush handle.

EQUIPMENT USED
☐ A sheet of 140-lb (290gsm) NOT paper, approximately 8″×8″ (20cm×20cm).
☐ A round no. 8 brush.
☐ A palette of six colours: vermilion, raw sienna, cerulean blue, Hooker's green, burnt sienna and Payne's grey.

GLOSSARY

Aerial perspective Grading tones and colours to suggest recession and distance. An atmospheric effect which causes the eye to perceive distant objects as less distinct and cooler in hue than those in the foreground.

Binder A medium mixed with powder pigments to make the colour suitable for painting or drawing. Gum arabic, for example, is used for making watercolour paint.

Blocking in Roughly laying out the main forms and overall composition of a drawing or painting, indicating mass and tone.

Body colour Paint, such as gouache, which is opaque and therefore has good covering power. In watercolour this is achieved by adding white to eliminate transparency.

Broken colour Effect achieved by dragging stiff paint unmixed across the paper so that previous layers can be seen through the new application.

Charcoal Wood burnt to produce charred black sticks which can then be used for drawing, producing a rich velvety black mark.

Cold-pressed paper see **Not.**

Complementary colours There are three basic pairs of complementary colours, each consisting of one primary and one secondary colour. These are opposite colours in that the primary is not used in mixing the secondary. Thus, blue and orange (red mixed with yellow) are complementary colours. On an extended colour wheel a warm red-orange is opposite green-blue.

Composition The arrangement of the various elements in a painting – mass, colour, tone and form for example.

Dotting Placing tiny dots of colour, with the point of the brush, next to each other to produce a luminous effect.

Drybrush Paint straight from the tube or pan mixed with little or no water and applied with a brush to dry, rough-textured paper.

Earth colours Such pigments as ochres, siennas and umbers which are derived from inert metal oxides.

Ferrule The metal section of a paint brush which holds the hairs in place.

Figurative Paintings and drawings in which there is a representational approach to a particular subject, as distinct from abstract art.

Foreshortening The effect of perspective on an object or figure in which a form appears to be considerably altered from its normal proportions as it recedes from view.

Fugitive Paint in which the colour is inherently impermanent – one in which the full intensity of colour may fade.

Glaze The application of watercolours in transparent layers, one over another, leaving each layer to dry before applying the next.

Gouache A water-based paint made opaque by mixing white with the pigments.

Graded wash A wash of colour which starts at full strength and is progressively diluted with water as it covers the surface, becoming paler and paler.

Graphite A form of carbon which is compressed with fine clay to form the substance usually known as 'lead' in pencils.

Ground The surface preparation of paper (or canvas) for painting or drawing. The brilliant white of paper may be toned down, for example, with a tinted ground.

Gum arabic A water-soluble gum made from the sap of acacia trees and used to bind watercolours.

Half tones A range of tones or colours between extremes of light and dark.

Hot-pressed paper Paper with a smooth, hard surface for detailed, precise painting.

Hue Pure colour, ranging through the spectrum (red, orange, yellow, green, blue, indigo and violet).

Lifting out Removing colour with a damp brush, sponge or tissue to lighten areas, create highlights or correct mistakes.

Linear perspective The principle that receding parallel lines appear to converge at a point on the horizon.

Local colour The inherent colour of an object or surface; its intrinsic hue unmodified by light, atmospheric conditions or colours surrounding it. For example, a yellow ball.

Masking A way of retaining the ground colour in parts of a painting by protecting it with tape or masking fluid while paint is applied over and around the masked areas. When the painting is dry, the mask can be peeled off or rubbed away. This makes it possible to work over the whole surface without losing shapes or areas of highlight.

Medium In art this term has two distinct meanings. It refers to the actual material with which a painting or drawing is done – for example gouache, watercolour or pencil. It also refers to liquids used to extend or alter the viscosity of paint, such as gum or oil.

Modelling Using tone or colour to create an impression of three-dimensional form by depicting areas of light and shade on an object or figure.

Monochrome A painting or drawing done in black, white and grey only, or with one colour mixed with white and black.

Not (or cold-pressed) paper A finish in watercolour paper which falls between the smooth surface of hot-pressed paper and the heavy texture of rough paper.

Ochres Earth colours derived from oxide of iron, ranging from yellow to orange-red.

Opacity The quality of paint which covers or obscures the paper or previous layers of applied colour.

Palette The tray or dish on which an artist lays out paint for thinning and mixing. Also the range of colours used in making a particular image or colour scheme. A limited palette is one in which only two or three colours are used: an extended palette is one in which a wide range of colours are used.

Perspective A system of representation in painting and drawing which creates the impression of depth, solidity and recession on a flat, two-dimensional surface. See also **Aerial perspective** and **Linear perspective.**

Pigment A substance which provides colour and is mixed with a binder to produce paint or a drawing material.

Primary colours In painting, these are red, blue and yellow; they cannot be formed by mixtures of any other colours, but in theory they can be used in varying proportions to create all other hues.

Resist A method of combining drawing and watercolour painting. A wash of water-based paint laid over marks drawn with wax crayon or oil pastel cannot settle in the drawing, so the marks remain visible in their original colour while areas of bare paper accept the wash.

Rough paper Paper with a very pronounced tooth. The brush drags over the surface, producing a sparkling effect because the paint settles mainly in the crevices, leaving the rest white.

Sable The hair of a small weasel-like animal, used in making soft brushes of fine quality.

Scumbling Opaque paint dragged or lightly scrubbed across a surface to form areas of broken colour which modify the tones underneath.

Secondary colours The three colours formed by mixing pairs of primary colours – orange (red and yellow), green (yellow and blue) and purple (red and blue).

Sized paper Paper coated with gelatin or a glue solution to control its absorbency.

Spattering Spreading paint by drawing the thumb across the bristles of a stiff brush loaded with wet paint so that the colour is flicked on to the surface of the painting, creating a loose, mottled texture.

Sponging Lifting out colour with a damp sponge. Also applying colour with a sponge to achieve interesting textural effects.

Staining pigments Powerful pigments which stain the paper. Unlike transparent pigments, they cannot be completely removed.

Stretching Paper tends to buckle when it is wet; in order to avoid this, watercolour paper must be stretched before it is used. This is done by wetting the paper to make it expand, then fixing it down firmly so that it dries taut. Pre-stretched paper is available in blocks.

Study A drawing or painting often made as a preparation for a larger work – for example, a monochrome study for a painting in full colour.

Tone The measure of light and dark in a painting or drawing, on a scale of gradations between black and white. Every colour has an inherent tone, for example yellow is light.

Tooth The texture of paper. Paper may have a fine or coarse tooth, and some heavy watercolour papers have a pronounced tooth which can be used to achieve effects of highlights and broken colour.

Transparency A quality of paint in which the paint modifies the colour of the surface on to which it is applied, rather than obliterates it. Watercolour is a transparent medium and colour mixtures gain intensity through layers of thinly washed paint.

Value The character of a colour, assessed on a tonal scale from dark to light.

Vignetting A technique in which the background to a painting is omitted altogether, leaving plenty of white space around and within the subject.

Wash Paint heavily diluted with water to make the colour spread quickly and evenly.

Watercolour Paint consisting of pigment bound in gum arabic and requiring only water as the medium. A painting executed in this medium.

Watermark The symbol or name of the manufacturer incorporated in sheets of watercolour paper. The watermark is visible when the paper is held up to the light.

Wet-in-wet Application of fresh paint to a surface which is still wet, so achieving subtle blending of colours.

INDEX

A

A Flock of Crows (Jamison) 149
aerial perspective 168-71
After the Rain (Blockley) 118-19
ageing (weathered) effects 93,
 134-7
anemones demonstration (Reid)
 24-7
animation, human figures 200, 201
Anthony Waterer IV (Goldsmith) 108
artistic licence 146
attitudes, keeping an open mind
 146-51

B

Back View I (Reid) 206
background
 nude figures 206-11
 tone and colour 56-7
beaches, painting hints 74
Betts, Judi, *Double Trouble* 47
blocking brushstroke technique 102
Blockley, John
 After the Rain 118-19
 Coastal Farm, Erbusaig
 demonstration 169-71
 Iron Gate 114
 Llanberis Rocks 90-1
Blue and White Iris (Reid) 29
Boat Yard demonstration (Bolton)
 72-5
Bolton, Richard
 Boat Yard demonstration 72-5
 old cartwheel 137
 weathered textures 93, 134-7
Bowl and Fruit demonstration
 (Croney) 66-9
Bridgeside Porch No.4 (Jamison)
 52-3
brushes 10-11, 134
 care of 15, 150
 Chinese 94
 holding methods 19, 102
brushstrokes 19-21, 102-7
 drybrush painting 92
 weathered textures 134

C

Calla lilies demonstration (Reid) 131-3
Canada goose demonstration (Sims)
 124-7
children, portraits 216-7, 218-21
Chinese (opaque) white 122-7
cirrus clouds 190, 191
Cley Mill, Norfolk (Hilder) 8-9
clouds 188-91
 grey tones 34-7
 skyscapes 182-7
 sunsets 192-3
 white effects 88, 89
Coastal Farm, Erbusaig
 demonstration (Blockley) 169-71
colour wheels 28, 30
colours
 adding and removing 18
 contrast effects 82, 83
 darks 60-3
 extended palette 76-9
 greens 38-43
 greys and neutrals 32-7
 impact effect 80-3
 labelling 17, 47
 limited palette 70-5
 mixing 16-18, 30
 modelling form 64-9
 pigments grid 44
 quality 10
 warm and cool 28-31
 white 83, 84-9, 122-7
contrast colours 82, 83

cool colours 28-31
correcting errors 150
cotton buds 117, 188
Crashing Surf demonstration
 (Croney) 178-81
crisp edges 12
Croney, Claude
 Bowl and Fruit demonstration 66-9
 Crashing Surf demonstration: 178-81
 Rocky Shoreline demonstration
 110-13
cumulus clouds 187, 190

D

dabbing technique 92
Daisies (Jamison) 150, 151
darks, mixing 60-3
Dartmoor Forest (Koser) 70
Desert Scene demonstration
 (Schink) 49-51
dotting brushstroke technique 102
Double Trouble (Judi Betts) 47
drybrush techniques 20, 92-5

E

Early Autumn (McNamara) 103
Early Morning Mist (Petrie) 196-7
Early Riser (Pike) 172
easel, lightweight aluminium 140
Eddie (Reid) 212
edges, soft and hard 12,13
equipment 10-11
 cloud painting 188
 outdoors 140
 sponges and other materials 114,
 117
erasers 11
errors, correcting 150-1
*Evening Sky, Lock 44 on the Ohio
 River* (Pike) 172, 173
eyes, painting exercise 214

F

faces 212-17
failure, rescuing 150-1
Figure in Sunlight demonstration
 (Reid) 209-11
figures 198-21
fleshtones 200-1
flicking brushstroke technique 102
flowers 22-7
 Blue and White Iris (Reid) 29
 extended palette 78, 79
 limited palette 71
 outdoors 142-5
 Paper Flowers, Rhea's Studio
 (Reid) 31
 spattering technique 108
 sponging 115
 using white space 87
 vignetting 131-3
fog and mist 194-7
foliage effects 20, 23, 40-3, 92,
 104-7
foreground, tone and colour 58-9
Forest Road demonstration (Petrie)
 56-9
form, modelling with colour 64-9
Frost and Ice demonstration (Szabo)
 120-1
frost effects 120-1, 164-7
fruit 23, 65, 66-9, 86

G

Garlic and Limes (Millard) 86
glazes 44, 48-51
Goldsmith, L.C., *Anthony Waterer IV*
 108
graded washes 48-51
granulation 33
grass 58-9, 92, 94-5, 97

greens, mixing 38-43
greys and neutrals 32-7
gum arabic 10

H

Harbour Cottages (Hilder) 88
Harbour Scene (Millard) 87
hard edges 13
head, basic form demonstration 213
Hilder, Rowland
 Cley Mill, Norfolk 8-9
 Harbour Cottages demonstration
 88
 *Sailing Craft at Low Tide, Morning
 Light* 182-3
 stormy sky demonstration 185
 Tree Lane monochrome sketch
 54-5
 windy sky demonstration 184
 Yacht Race demonstration 89
Hill, Tom
 Laurel demonstration 216-17
 Summer Morning in the Market 76
holding brushes 19, 102
Homebody (Szabo) 99
House at Two Lights, 1927 (Reid) 63
human figures 198-221

I

ice effects 120-1, 164-7
Impressionist technique 103
Iron Gate (Blockley) 114

J

Jamison, Philip
 A Flock of Crows 149
 Bridgeside Porch No. 4 52-3
 Daisies 150, 151
 June Flowers in My Studio 87
 March Thaw 149
 Market Street 32
 Moore's Farm 148
 Summer Day 146
 Vinalhaven Shoreline 146-7
Japanese child demonstration
 (Reid) 220-1
Jar of Anemones demonstration
 (Reid) 24-7
Jennifer (Reid) 200, 201
Jewel Case (Szabo) 175
John at Silvermine (Reid) 198-9
Judith in San Antonio (Reid) 130
June Flowers in My Studio (Jamison)
 87

K

Karen (Silverman) 218
Keri by the Pool (Reid) 206-7
knifing out technique 96-101
Koser, John, *Dartmoor Forest* 70

L

Lakes of Killarney demonstration
 (Pike) 34-7
land and sky, linking 186
landscapes 70, 138-63
 aerial perspective 168-71
 drybrush technique 94-5
 fog and mist 194-7
 organizing 152-7
 sky 182-93
 snow, ice and frost effects 164-7
 tones 40-3, 54-9
 water and sea 172-81
Last of the Season (Osterman) 46-7
Laurel demonstration (Hill) 216-17
leaves 20, 23
lifting out techniques 18, 118-21
light
 artistic licence 148

colour 56-9, 82
human figures 202-3, 208, 209-11
landscapes 40-3
water scenes 172-5
Light and Shadow (Reid) 208
light red colour 78
Llanberis Rocks (Blockley) 90-1
Lone Performer (Szabo) 95

M

Mcnamara, William, *Early Autumn*
 103
manganese blue 78
March Thaw (Jamison) 149
Market Street (Jamison) 32
masking fluid 128-9
masking tape, for crisp edges 12
meadow landscape demonstration
 40-3
Millard, David
 colour examples 77, 80-3
 dark tones still life 60
 Garlic and Limes 86
 Harbour Scene 87
 modelling form with colour, still
 lifes 64, 65
 spring lilacs 71
 townscape 141
 Tropical Scene 86
mist and fog 194-7
mixing colours 16-18, 76-8, 102
 darks 60-3
 greens 38-43
 greys and neutrals 32-7
 pigments 47
 warm and cool effects 28-31
 weathered textures 134, 136
modelling form with colour 64-9
mood 146, 148, 194, 208
Moore's Farm (Jamison) 148
Moorland Scene demonstration
 (Szabo) 116-17
mottled patterns, sponging 115
mountains, sunset demonstration
 (Petrie) 193
mouths, painting exercise 215
movement and rhythm in figures 200

N

Naples yellow 78
neutral colour mixes 17, 32-7
nudes 200-11

O

Old Cartwheel (Bolton) 137
opaque (Chinese) white 122-7
opaque pigment group 44-7, 50
oriental child demonstration (Reid)
 220-1
Osterman, Barbara, *Last of the
 Season* 46-7
outdoor painting 138-97

P

paintboxes 10-11, 16
paints, equipment 10-11, 140
palettes 11, 140
paper 11
 dampening 12
 hot-pressed 104
 medium-rough for figures 202
 outdoors quality 140, 150
 pre-stretched 11
 skyscapes 188
 stretching 11
 white space 87
Paper Flowers, Rhea's Studio (Reid)
 31
pencils, range of 11
permanent rose 78
petals, painting technique 21, 22, 23

Petrie, Ferdinand
 Autumn on the Riverbank
 demonstration 104-7
 Early Morning Mist demonstration
 196-7
 Foggy Landscape 194-5
 Forest Road demonstration 56-9
 Rain-filled Afternoon Sky 189
 Summer Landscape
 demonstration 154-7
 sunset paintings 192-3
 Verdant Meadow demonstration
 40-3
phthalo blue 78
pigments 10, 28, 44-7, 50 *see also*
 colours
Pike, John
 Early Riser 172
 *Evening Sky, Lock 44, on the Ohio
 River* 172, 173
 Lakes of Killarney demonstration
 34-7
Ploughing in the Fall (Hilder) 138-9
Pointillist technique 103, 109
portraits and figures 198-221
pre-stretched paper 11
primary colour mixes 16

Q
Quiller, Stephen, *Winter Storm* 122-3

R
reflections in water 73-5, 173-5
Reid, Charles
 Back View I 206
 Blue and White Iris 29
 Calla Lilies demonstration 131-3
 Eddie 212
 Figure in Sunlight demonstration
 209-11
 flowers, still lifes 78, 79
 head, basic demonstration 213
 House at Two Lights, 1927 63
 Jar of Anemones demonstration
 24-7
 Jennifer 200, 201
 John at Silvermine 198-9
 Judith in San Antonio 130
 Keri by the Pool 206-7
 Light and Shadow 208
 oriental child demonstration 220-1
 Paper Flowers, Rheas's Studio 31
 Sarah at High Hampton 218, 219
 seated nude demonstration 203-5
 Study of a Pink Camellia 22
 Summer Garden demonstration
 142-5
ridging technique 92
Robinson, E. John
 Storm brewing demonstration
 186-7
 Winter Waves 176-7
rocks
 Llanberis Rocks (Blockley) 90-1
 seascapes 176-81

shoreline demonstration (Croney)
 110-13
rounded forms 64, 65-9

S
*Sailing Craft at Low Tide, Morning
 Light* (Hilder) 182-3
salt, for snowflakes 166-7
Sarah at High Hampton (Reid) 218,
 219
Schink, Christopher
 aerial perspective 168
 Desert Scene demonstration
 49-51
Scottish Farm demonstration
 (Blockley) 169-71
scratching out technique 96-101
scrubbing technique 92
seascapes 168-71, 176-81
seated nude demonstration (Reid)
 203-5
shadows 60, 64, 68, 106
 human figures 202, 210
Silverman, Burt, *Karen* 218
Sims, Graeme, *Canada Goose*
 demonstration 124-7
sky 182-7
 clouds 34-7, 188-91
 graded washes 49, 50-1
 landscapes 152
 limited palette 72-5
 sunsets 192-3
 wet-in-wet technique 14-15
skyscapes 182-7
smearing techniques 92
smooth washes, laying 12
snow effects 122-3, 164-7
snowflakes, made with salt 166-7
soft edges 13, 204
space, aerial perspective 168
spattering technique 108-13
special techniques 90-137
spheres in light and shade 65
spider's web demonstration (Szabo)
 98-9
sponging 114-17, 150
staining pigment group 44-7, 50
stars, made with salt 166-7
still life 60, 64-9, 78, 79, 80, 81
stools, outdoor use 140
Storm brewing demonstration
 (Robinson) 186-7
storm clouds 185, 186-7, 190, 191
stormy sky demonstration (Rowland)
 185
strato-cumulus clouds 190, 191
stratus clouds 187
stretching paper 11
stroke techniques 19-21, 102-7
Study of a Pink Camellia (Reid) 22
style 69
 creating impact with colour 80-3
 extended palette 76-9
 limited palette 72-5
Summer Day demonstration 14-15
Summer Day (Jamison) 146

Summer Garden demonstration
 (Reid) 142-5
Summer Landscape demonstration
 (Petrie) 154-7
Summer Morning in the Market (Hill)
 76
sunlight 40-3, 209-11
Sunset Sky, wet-in-wet technique 15
sunsets 192-3
Szabo, Zoltan
 cloud studies 190-1
 Frost and ice demonstration 120-1
 heavy downpour 96
 Homebody 99
 Jewel Case 175
 Lone Performer 95
 masking fluid demonstration 129
 Moorland Scene demonstration
 116-17
 snow, ice and frost effects 164-7
 spider's web demonstration 98-9
 The Flirt demonstration 128, 129
 Tree stump and Weeds
 demonstration 100-1
 waterscape sketch 173
 windblown grass 97
 Wishing Pool 45

T
techniques 90-137
 adding/removing colour 18
 brushstrokes 19-21, 102-7
 colours, creating impact 80-3
 correcting errors 150
 crisp edges 12
 drybrush 20, 92-5
 glazing and graded washes 48-51
 granulation 33
 knifing out 96-101
 lifting out 118-21
 masking fluid 128-9
 mixing colours 16-18
 modelling form with colour 64-9
 salt snowflakes 166-7
 scratching out 96-101
 smooth washes 12
 soft and hard edges 13
 spattering 108-13
 sponging 114-17
 stretching paper 11
 tones, demonstration 56-9
 vignetting 130-3
 wet-in-wet effects 14-15
textures
 drybrush 20, 92
 fabric impressions 117
 graded washes/glazes 48-51
 granulation effect 33
 salt snowflakes 166-7
 spattering effects 108-9
 sponging technique 114-17
 weathering effect 134-7
The Flirt demonstration (Szabo) 128,
 129
The Lakes of Killarney demonstration
 (Pike) 34-7

tone and colour 52-89
 colour impact 80-3
 darks 60-3
 extended palette 76-9
 flesh tones 198, 200-1
 limited palette 70-5
 modelling form 64-9
 white spaces 84-9
townscapes 141
transparency
 glazing technique 48-51
 greens 38, 39
 modelling form with colour 64
 pigment group 44-7, 48, 50
 sunsets 192
Tree Lane sketch (Hilder) 54-5
trees
 Autumn on the Riverbank
 demonstration (Petrie) 104-7
 planning a landscape picture 152-
 7
 stump/weeds demonstration
 (Szabo) 100-1
 tone and colour 54-9
 Verdant Meadow demonstration
 (Petrie) 40-3
Tropical Scene (Millard) 86
tube paints 10

V
Verdant Meadow demonstration
 (Petrie) 40-3
vignetting 130-3
Vinalhaven Shoreline (Jamison)
 146-7

W
warm colours 28-31
washes 12
 adding and removing 18
 graded 48-51
 lifting out 119, 150
 stroke technique demonstration
 104
waterscapes 171-5
waves, sponging technique 115
weathered textures 134-7
wet-in-wet technique 14-15, 56-9
white space 52-3, 83, 84-9
windy sky demonstration (Hilder)
 184
winter landscapes 158-63, 164-7
Winter Storm (Quiller) 122-3
Winter Waves (Robinson) 176-7
Wishing Pool (Szabo) 45
wood, different effects 92, 100-1,
 137
woodland 56-9, 70, 196-7

Y
Yacht Race demonstration (Hilder)
 89
young people, portraits
 218-21

Artists' credits
Judi Betts p 47; John Blockley pp 90-
91, 114, 118-119, 169-171; Richard
Bolton pp 4-5, 72-75, 93, 134-135,
137; Claude Croney pp 66-69, 110-
113, 178-181; Sue Fowler p 23;
Lawrence C. Goldsmith p 108;
Rowland Hilder pp 6-7, 8-9, 54-55,
88-89, 138-139, 182-183, 184-185;
Tom Hill pp 76, 216-217; Philip
Jamison pp 32, 52-53, 87, 146-147,
148, 149, 151, 158, 159; John Koser
p 70; William McNamara p 103;
David Millard pp 60, 64, 65, 71, 77,
81, 82, 83, 141; Paul Osborne p 134;
Barbara Osterman pp 46-47;
Ferdinand Petrie pp 41-43, 56-59,
104-107, 155-157, 160-163, 189,
192, 193, 194-195, 196, 197; John
Pike pp 34-37, 159, 172, 173;
Stephen Quiller pp 122-123; Charles
Reid half title, title, pp 22, 24-27, 29,
31, 62, 63, 78, 79, 84, 85, 86,
130-133, 142-145, 198-199, 200,
201, 202, 203-205, 206, 207, 208,
209-211, 212, 213-215, 219, 220-
221; Sarah Reid p 78; E. John
Robinson pp 176, 177, 186-187;
Christopher Schink pp 49-51, 168;
Sue Shorvon p 115; Burt Silverman
p 218; Graeme Sims pp 124-127;
Zoltan Szabo pp 45, 95, 96, 97,
98-99, 100-101, 116-117, 120-121,
129, 164, 165, 166, 167, 173, 174,
175, 190-191.

Photographers' credits
John Shaw pp 40, 194. All other
photography by John Suett.

Index
Index compiled by Richard Raper of
Indexing Specialists, Hove, East
Sussex.